Ruskin, Turner and the Pre-Raphaelites

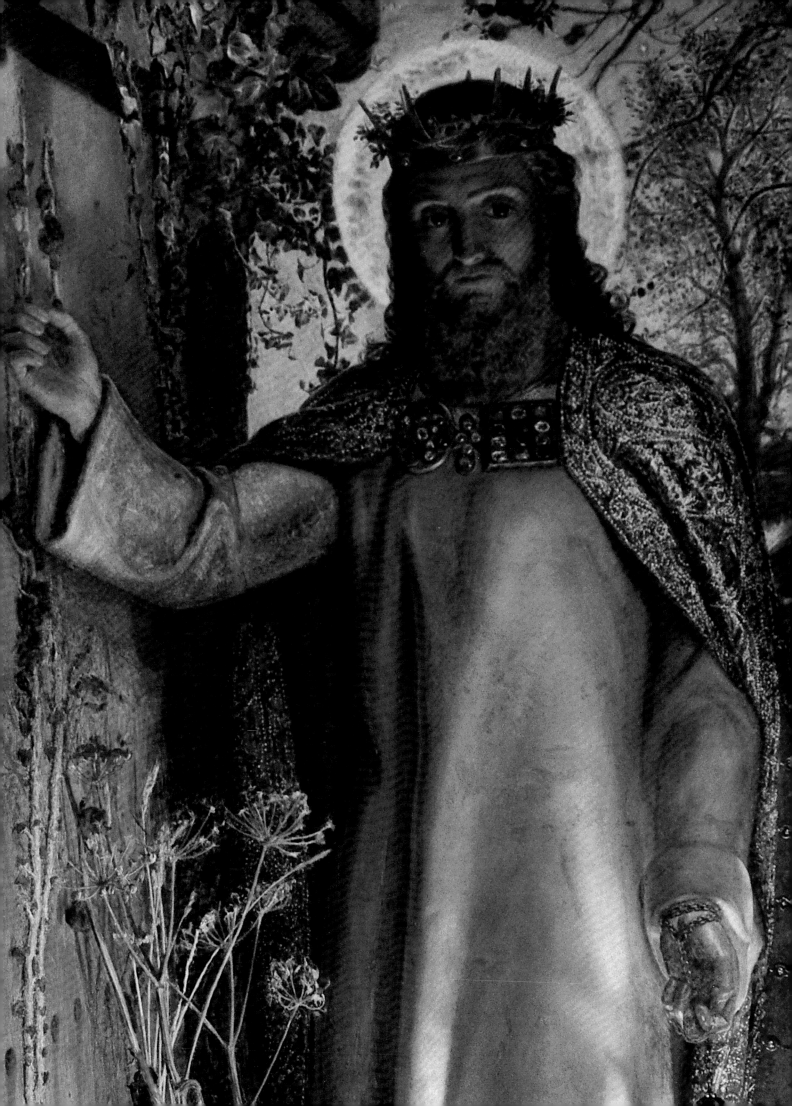

Ruskin, Turner and the Pre-Raphaelites

Robert Hewison

Ian Warrell and Stephen Wildman

Tate Gallery Publishing

Sponsored by
Sun Life and Provincial Holdings plc

A Member of the Global AXA Group

In honour of J.S. Dearden

cover: John Ruskin, *The Walls of Lucerne* (cat.162, detail);
J.M.W. Turner, *Slavers* (cat.47, detail); Sir John Everett Millais, Bt,
Mariana (cat.6, detail)
back cover: Sir John Everett Millais, Bt, *John Ruskin* (cat.1, detail)
frontispiece: William Holman Hunt, *The Light of the World*
(cat.192, detail)

Published by order of the Trustees of the Tate Gallery 2000
on the occasion of the exhibition at Tate Britain, London,
9 March – 28 May 2000

ISBN 1 85437 203 X

A catalogue record for this publication
is available from the British Library

Published by Tate Gallery Publishing Limited,
Millbank, London SW1P 4RG

Cover design by Slatter-Anderson, London

Printed and bound in Great Britain by Balding + Mansell,
Norwich

Contents

Sponsor's Foreword

Sun Life and Provincial Holdings plc is extremely proud to be sponsoring *Ruskin, Turner and the Pre-Raphaelites* at Tate Britain. This major exhibition contains some of the most important British paintings of the nineteenth century, including works by Turner, Rossetti, Burne-Jones, Millais, Holman Hunt and Ford Madox Brown.

The exhibition provides a cornerstone to a programme of events entitled 'Ruskin To-Day' dedicated to the great Victorian artist and cultural critic John Ruskin, whose reputation is currently enjoying a revival. It reappraises Ruskin as a contemporary art critic, defender of Turner, inspirer and then defender of the Pre-Raphaelites.

Sun Life and Provincial Holdings plc is a UK-listed, FTSE 100 company, 56 per cent owned by the AXA Group, one of the world's leading insurance and asset management companies. We believe that successful companies should make a contribution to supporting the arts and this particular exhibition concentrates on a most interesting period in the development of British painting. We are sure the exhibition will bring pleasure to the public and satisfaction to our staff, shareholders and customers.

Lord Douro
Chairman, Sun Life and Provincial Holdings plc

Director's Foreword

John Ruskin (1819–1900) was perhaps Britain's best-known and most influential writer on art. He is remembered not just for his passionate advocacy of J.M.W. Turner, or for his parallel commitment to the artists of the Pre-Raphaelite Brotherhood – in both cases against prevailing tides of taste – or for that equally committed disparagement of J.M. Whistler which seems so curious to the contemporary eye. Above all his reputation and his continuing magnetism for scholars across many disciplines, and from many countries, derive from his integration of a varied investigation into the nature and purposes of art and aesthetics with an increasingly zealous exploration of the social fabric within which art was made, and to which art contributes. In the course of some 250 publications he addressed art history, contemporary art, architecture, museology, mythology, geology, botany, the environment, conservation, politics and surprisingly more besides. It is true that his unswerving moral confidence and ethical convictions, and his emerging reforming agenda for much of the society he found around him, struck some of his contemporaries, as well as later generations, as overbearing in its certainty. D.H. Lawrence, for one, remarked about his followers that 'the deep damnation of self-righteousness lies thick all over the Ruskinite, like painted feathers on a skinny peacock'. But the undeniably audacious range of his interests and his authority, and perhaps above all his resounding declaration (almost to the point of actual demonstration) of the social value of art have made him an enduringly engaging figure for historians of, and participants in, British cultural life. And since he was an avid collector of pictures, as well as a very talented artist in his own right, his life and art, his output and enthusiasms, are rich ingredients indeed for an exhibition.

For one so insistent on national identity and the role of art and artists in helping to express it, it is fitting that the present survey and celebration of Ruskin should form the inaugural exhibition of the twenty-first century's new gallery of national art, Tate Britain, launched in March 2000 at Millbank shortly after the opening of this show. Moreover, Ruskin had himself argued, some thirty years before the sponsorship of Sir Henry Tate was to make it possible, that a new national gallery should be built in place of the Pimlico Penitentiary on this very site. In *The Present State of Modern Art, with reference to the advisable arrangements of a National Gallery*, a lecture given at the British Institution in 1867, he also set out his requirements for such a museum. Beginning with the guiding principle 'You should have no bad art visible anywhere,' he despaired that much modern British art seemed to convey few nobler ideas 'than that home-made ginger

is hot in the mouth and that it is pleasant to be out on the lawn in fine weather'. In Turner and in the Pre-Raphaelites, however, he saw exemplars of a higher plane, symptomatic of Britain's wider potential as a nation. For Ruskin, art and national fibre were inseparable. 'The art of a nation much resembles the corolla of a flower; its brightness of colour is dependent on the general health of the plant, and you can only command the hue, or modify the form of the blossom, by medicine or nourishment applied patiently to the root, not by manipulation of the petals.' More than a century later, Tate Britain's tone and purposes may be of a different kind to Ruskin's but they do share his premise that, as long as there are nations, the notion of national art as an object of contemplation by a broad cross-section of society is both valid and self-evidently relevant.

This exhibition is one of a number of events in 2000 organised to mark the centenary of Ruskin's death. An extraordinary programme for the year, Ruskin To-Day, has been co-ordinated by its chairman David Barrie, with joint secretaries Cynthia Gamble, Ruth Hutchison and Christopher Newall. As well as lectures, conferences and related events, there are other exhibitions in London, Lancaster, Sheffield and Oxford, and further afield at Yale and Harvard, in New York and Tokyo. Through its size and scope Tate Britain's exhibition is the focal point for the celebration in this country, and we are indebted to Robert Hewison – Slade Professor at Oxford University, as of course once was Ruskin – for the energy and erudition with which he has guided the project from the outset as its creator, mentor, and principal executor. He has worked closely with co-curator Ian Warrell from Tate Collections, with Stephen Wildman of the Ruskin Library, and with the exhibition's designer Richard MacCormac, architect of the award-winning Ruskin Library in Lancaster. To Professor Hewison's own acknowledgements to colleagues and collaborators I should like to add our warm thanks to the Bowland Charitable Trust, whose support for the exhibition was fundamental to its inception, and to our sponsors Sun Life and Provincial Holdings plc, whose chairman Lord Douro has been a keen and engaged ally throughout.

As ever, we are very grateful to the lenders to this exhibition from public and private collections in Britain, the United States and beyond. There have been many gestures of notable generosity – not least the Boston Museum of Fine Arts' loan of Turner's *Slavers throwing overboard the Dead and Dying – Typhon coming on* of 1840 (cat.47), so beloved by Ruskin, its former owner. And, in its opening season, Tate Britain is particularly pleased to be exhibiting paintings by Verrocchio, Catena and the School of Botticelli (courtesy of the National Gallery of Scotland, the National Gallery, and the Ashmolean Museum, Oxford, respectively), also all once Ruskin's. These are works of a kind rarely seen at Millbank and reflect our renewed wish to explore the world of British art in its broadest historical and cultural contexts. Of this Ruskin would certainly have approved.

Stephen Deuchar
Director, Tate Britain

Acknowledgements

'Government and co-operation are in all things and eternally the laws of life. Anarchy and competition, eternally, and in all things, the laws of death' (7.207). When Ruskin summarised his aesthetic and social principles in *Modern Painters* as 'the Law of Help', he might have had exhibition-making in mind. Help has come from every quarter, the management of the Tate Gallery has provided good government, and there has been truly Ruskinian co-operation from a host of lenders (both public and private), experts, curators, archivists, and colleagues, together with generous private support and public patronage.

My personal thanks go first of all to Ian Warrell, with whom the project for a Ruskin centenary exhibition was first devised, and whose expertise on Ruskin, Turner and the Pre-Raphaelites has made him the ideal colleague in preparing the exhibition. I am also immensely grateful to Stephen Wildman for taking on responsibility for the section at its heart, devoted to Ruskin's own drawings. As Curator of the Ruskin Library at Lancaster University, Stephen has also had the arduous task of preparing the largest group of loans to the exhibition, works from the Ruskin Library and from Ruskin's house, Brantwood. I am indebted to the Trustees of the Ruskin Foundation for agreeing to strip their walls, at the very start of Ruskin's centenary year.

All admirers of Ruskin will share my gratitude to the Trustees of the Tate Gallery, and its Director, Sir Nicholas Serota, for agreeing to the mount this exhibition. I should like to acknowledge the valuable contribution made by Andrew Wilton, Senior Research Fellow, in refining the original proposal. As the exhibition has evolved, so have new structures at the Tate, so that the gallery at Millbank has become Tate Britain, with its own Director, Stephen Deuchar, who has given invaluable advice, and seen to it that the exhibition has had all the resources that it needs. These have included the services of Richard MacCormac, of MacCormac Jamieson Pritchard, as exhibition designer, working in collaboration with Gerald Fox and Rogier van der Heide. His eye and sensibility have had a transformative effect on the appearance of the exhibition, as have those of Rose-Innes Associates on the layout of the catalogue. My thanks go to Ruth Rattenbury, formerly Head of the Exhibitions Department, for helping to launch the project before her retirement, and to Sheena Wagstaffe for seeing it through. I have enjoyed working closely first with Sarah Tinsley, now at Tate Modern, and then her successor Christine Riding, to whom I owe a special debt for her enthusiastic response to the challenges this exhibition has thrown up. Throughout the project, Ben Tufnell has been a steady source of practical support and sound advice. All three contributors to the catalogue are profoundly grateful for the patience and care shown by our editors, first Liz Alsop, who brought the text into being before taking maternity leave, and then Nicola Bion, who saw it through the press.

Outside the Tate, another institution has made a significant contribution to the development of the exhibition, the Ruskin Programme at Lancaster University. My thanks go to its now former Director, Michael Wheeler, who encouraged me to use the Programme's weekly seminars as a 'research engine' for the project, and to all the participants in those discussions. None of this would have been possible, nor would the Programme's parallel publication, *Ruskin's Artists*, have appeared, without the unfailing support of the Programme's administrator, Ruth Hutchison. It is impossible to name all those who contributed ideas and information, but I would like to thank especially Dr James S. Dearden for his help with Ruskin's portraits, David Elliott for information about his grandfather Fairfax Murray, Denise Bethel for information on J.C. Hook, and Christopher Newall for advice about Alfred Hunt.

In addition, the curators of this exhibition would like to thank: Jaynie Anderson, Simon Bailey, Janet Barnes, David Barrie, Chris Beetles, David Beevers, Dinah Birch, Peter Brown, Simon Carter, Jane Colbourne, Alan Davis, John Dawson, Harriet Drummond, Sionaigh Durrant, Stephen Farthing, Michael Feigen, Rebecca Finnerty, Rosie Freemantle, Robert Graham, Stephen Hackney, Robin Hamlyn, David C. Hanson, Adrian Le Harivel, Colin Harrison, Ray Haslam, Sarah Hobrough, Howard Hull, Reyahn King, Anne Lyles, Lovedy Manners-Price, Jane Marlin, David Mason, Andrew Middleton, Jehannine Muadhvech, Jane Munro, Gabriel Naughton, Christopher Newall, Charles Nugent, Francis O'Gorman, the late Leslie Parris, Judith and David Peacock, Brian Pilkington, Nicholas Shrimpton, Jacob Simon, Kim Sloan, J.T.G. St Lawrence, Keith Thompson, Julian Treuherz, Henry Wemyss, Jon Whiteley, Stephen Whittle, Timothy Wilson, Christopher Wood, David Wootton.

RH

'The Beautiful and the True'

When public *taste seems plunging deeper and deeper into degradation day by day, and when the press universally exerts such power as it possesses to direct the feeling of the nation more completely to all that is theatrical, affected, and false in art … it becomes the imperative duty of all who have any perception or knowledge of what is really great in art, and any desire for its advancement in England, to come fearlessly forward, regardless of such individual interests as are likely to be injured by the knowledge of what is good and right, to declare and demonstrate, wherever they exist, the essence and the authority of the Beautiful and the True. (Modern Painters* 1, 3.4)

John Ruskin published these words in May 1843, at the age of 24. By the time he died on 20 January 1900, at the age of 80, the critical manifesto from which they are drawn had become recognised as one of the shaping statements of the Victorian age.

But it is not a mere accident of the calendar that causes us to reconsider these – and the several million more – words that Ruskin wrote in defence of the Beautiful and the True. The centenary of Ruskin's death cannot be sufficient in itself to explain the widespread interest in his work a hundred years later. The exhibition this catalogue accompanies has been created to explore, not Ruskin's distance from us as a Victorian sage, but his modernity: his modernity in his own time, and his modernity as someone who still has something to say, now. To conduct this exploration, the aim is to present Ruskin as a contemporary critic. The art, necessarily, is the art of his own time – a unique selection of many of the key works that Ruskin saw – but we wish to strip away the accretions of more than a hundred years to recover the radicalism of the man who called his first book *Modern Painters*.

Ruskin should be remembered not just as a critic writing in his own time, but as the first to make his reputation by championing contemporary art. Hence the polemical tone, the engagement with the present, that give the preface to the first volume of *Modern Painters*, quoted above, such vigour. These show him to be a contemporary critic in the fullest sense and, like all truly great critics, he is remembered for the artists he celebrated: Turner and the Pre-Raphaelites – Millais, Rossetti, Holman Hunt, Burne-Jones – to name the most prominent. He is also remembered for the artists that he condemned, among them Whistler, and time and taste have questioned his judgements. What is important to recover is the context in which he thought and wrote in order to understand why he appreciated such different kinds of art as that of Turner and the Pre-Raphaelite Brotherhood. Turner's life was devoted to serving the Royal Academy, and his work was the culmination of a long academic tradition; the Pre-Raphaelites were in revolt against the Academy, and their art sought a directness of vision free of traditional conventions. Yet even as Ruskin set out to explain and defend the motivations of the PRB during the 1850s, his appreciation of Turner continued to deepen. His critical principles, his commitment to challenging public opinion with what he saw as 'the essence and the authority of the Beautiful and the True', may indeed have a value and an application that reach beyond the fascinating contingencies of his day. In his universality, as well as his modernity, Ruskin remains contemporary.

History does not repeat itself, but there are curious parallels between the situation of artists in mid-Victorian Britain and of those working now. With the end of the Napoleonic wars and the profitable peace that followed, there was a rapid expansion in demand for visual imagery of all kinds, driven by burgeoning, mainly middle-class, wealth, and fed by new technologies in printing and engraving. The numbers of artists, patrons and the means to bring seller and buyer together through public exhibitions all increased, as did the demand for critical commentary and guidance in the form of reviews in newspapers, periodicals and books on art. We have seen an even greater expansion in what we may term this visual economy since the end of the Second World War. The technology of film and television has proved so powerful that it has shifted the cultural emphasis from the word to the image. In the year 2000 the new culture of visual consumption is officially celebrated in the Millennium Dome, just as the Victorian culture of material production was celebrated in the Crystal Palace in 1851.

The Great Exhibition displayed no great art, an omission of the Beautiful and the True that may have ironic parallels with the

commercial imperatives of the Dome, yet at the end of the twentieth century there is a confidence about the state and international status of British art that matches that of the mid-nineteenth. When the journal of the *Art-Union* (a project financed by a lottery) was launched in 1839 its first editorial declared:

We take it as indisputable that the Artists of Great Britain greatly surpass the existing Artists of any other nation; and if, in some respects, they fall short of the power for which the Old Masters are so renowned, at least they paint from the heart, and with greater certainty excite those sympathies, to produce and foster which is the noblest privilege of Art.[1]

Though we must acknowledge the influence of the promotional activities of late-twentieth-century institutions such as the Arts Council of England and the Department for Culture, Media and Sport, there has been a similar sense of confident cultural nationalism in the celebrations of Cool Britannia and the Young British Artists. Ruskin shared in the cultural nationalism of his time, arguing that the PRB had the potential to found 'a new and noble school in England' (12.358n).

When, then, we look at Ruskin's relationship to the visual economy of his day, it is immediately apparent that he was writing for a new, middle-class audience – and that no one could be more representative of that class than Ruskin and his father (cat.10). John James Ruskin, born in Edinburgh in 1785, plays an important part in this story, for it was his wealth, made entirely by his own efforts, that both inducted his son into the habits of the new middle-class patron, and then allowed him to stand apart, freed from the obligation to earn his living as a professional writer, a teacher or clergyman. Financial independence brought a significant intellectual independence and security, even an unconscious arrogance.

Once John James Ruskin had successfully established the sherry-importing firm of Ruskin, Telford and Domecq, and had settled his wife Margaret and their only child John in the still semi-rural South London suburb of Herne Hill, he began to collect art. His son formally dated the start of the Ruskin family art collection to 1832, the year of the Great Reform Act that marked the arrival of the middle-class voter as a political, as well as commercial and cultural power in the land. By the time of John James's death in 1864 the collection contained the works of some fifty artists, nearly all of them British, and the vast majority of them active when Queen Victoria came to the throne.[2]

The Ruskins – for this collection was a joint activity where the son tried to lead the father – were friends and rivals of a group of similar new patrons: the Presbyterian banker and amateur poet Samuel Rogers (1763–1855; cat.17); the ship-owner and merchant Elhanan Bicknell (1788–1861); the coach-builder and propriety medicine manufacturer Benjamin Godfrey Windus (1790–1867), access to whose collection (cat.38) was, according to Ruskin, 'the

means of writing *Modern Painters*' (35.254) – to name only the closest in the Ruskin circle.[3] These were collectors of a contemporary British art – principally watercolours – that Ruskin recognised as having a middle-class modesty. He wrote of the work of two artists much favoured by the Ruskins and their friends, Samuel Prout (1783–1852) (cat.20) and William Hunt (1790–1864) (cats.35, 121):

drawings of this simple character were made for these same middle classes, exclusively; and even for the second order of the middle classes, more accurately expressed by the term bourgeoisie. *The great people always bought Canaletto, not Prout, and Van Huysum, not Hunt. There was indeed no quality in the bright little watercolours which could look other than pert in ghostly corridors, and petty in halls of state; but they gave an unquestionable tone of liberal-mindedness to a suburban villa, and were the cheerfullest possible decorations for a modest-sized breakfast parlour opening on a nicely-mown lawn.* (14.373)

Ruskin emphasises the distance between this and aristocratic taste, but the *nouveaux riches* still acknowledged the traditional hierarchy of art and artists laid down by Sir Joshua Reynolds, which placed history painting as the highest achievement, and the painters of the High Renaissance as the measure of true mastery. As a young man Ruskin gave due respect to Raphael and Michelangelo, heirs to the classical tradition represented by the 'Elgin marbles' that he studied in the British Museum. It was only later that the demands of polemical argument caused him to attack them. His appreciation of the culture of Ancient Greece was to deepen.

The point about new collectors like the Ruskins, however, was that they were supporters of contemporary artists. Turner was undoubtedly the most important of these, although the Ruskin family collection was already well advanced when they bought their first Turner watercolour in 1839. George Cattermole (1800–63), David Cox (1783–1859) (cat.26), Edward Duncan (1803–82), Frederick Tayler (1802–89), besides Hunt and Prout, exemplified the contemporary taste for the picturesque landscape watercolour and the genre scene. Ruskin absorbed what he called 'this – perhaps slightly fenny –atmosphere of English common sense' (14.390), in the most direct way possible, by being taught to draw by two of its leading exponents, first the President of the Old Water Colour Society, Copley Fielding (1787–1855) (cat.21) and then by the more progressive James Duffield Harding (1798–1863) (cat.37), who had absorbed the lessons of Turner. Ruskin was thus in a position to respond to the fresh impetus given to the English watercolour in the 1840s, when – partially as a result of technological developments which enabled the introduction of a reliable zinc oxide bodycolour, or 'chinese white', first marketed by Winsor and Newton in 1834 – the eighteenth-century style of washes and pen outline gave way to careful stippling. Citing Turner, Ruskin called this 'gradation' (15.149), and it allowed a new, detailed naturalism, as for instance in the work of J.F. Lewis (1805–76) (cat.120), with whom Ruskin was to have influential dealings.

Ruskin would not have had such critical importance, however, if he had been merely an exemplar of contemporary taste. His significance lay in the extent to which – like his hero Turner – he transcended the artistic conventions of his own time, and strove to push them in a new direction. The changes in his own drawing style are a visual record of the drive to refine his perception, but his emphasis on the process of seeing had a more than technical significance. He wrote at the end of his life that he had 'a sensual faculty of pleasure in sight, as far as I know unparalleled' (35.619), a visual facility that allowed him both to see, and to describe in evocative words, the Beautiful and the True. In an image-culture such as the present one, a critic who sees and, to adapt one of Ruskin's phrases, tells what he saw in a plain way, has a particular value: 'Hundreds of people can talk for one who can think, but thousands can think for one who can see. To see clearly is poetry, prophecy, and religion, – all in one' (5.333).

The 'faculty of pleasure in sight' that made the poetry and the prophecy possible was, however, tempered by Ruskin's religion. It is the fundamental implications of Ruskin's religious training and outlook that most clearly distance him from the present day. Ruskin's upbringing as an Evangelical Protestant not only gave him an enviable confidence in his moral and critical convictions, but directed them down now unfashionable paths, away from the human body and towards the natural landscape. The puritanism learned at his mother's knee undoubtedly inhibited his sexual as well as his aesthetic responses. As Michael Wheeler has argued in *Ruskin's God*, 'Ruskin's denial of the body, which helps to explain not only the agonies of his private life but also his negative reading of the architecture of the Renaissance and much of its art, has its origins in an Evangelical world of physical concealment and linguistic circumlocution.'[4] (See cat.32.)

Yet Evangelicalism also offered Ruskin revelation. The practice of typological interpretation, meaning the reading in terms of symbols not only of the Bible, but of God's word made manifest in his creation of the natural world, gave him a coherent visual and verbal world-view. As the Reverend Thomas Dale, one of Ruskin's early teachers, whose sermons the family regularly heard, declared, 'The works of God in nature are constantly symbolical of the works of God in grace; and they who are acute to discern and diligent to explore the correspondence, may "read sermons in stones, and find good in every thing".'[5] Ruskin applied this typological reading to works of art as well as to nature, making a profound impact on the young Holman Hunt in the process (cats.7, 192), but the licence to read sermons in stones also encouraged him to place the sciences of geology and botany, which he so much enjoyed, at the service of Natural Theology. Scientific observation led to the perception of a higher truth, provided that the observation was accurate:

Nothing must come between Nature and the artist's sight; nothing between God and the artist's soul. Neither calculation nor hearsay, – be it the most subtle of calculations, or the wisest of sayings, – may be allowed to come between the universe, and the witness which art brings to its visible nature. The whole value of that witness depends on it being eye-*witness; the genuineness, acceptableness, and dominion of it depend on the personal assurance of the man who utters it. All its victory depends on the veracity of the one preceding word, 'Vidi'.* (11.49)

This is the ruling and constant theme of Ruskin's aesthetic: the synthesis of the dialectical relation between natural fact and symbolic truth, which leads to the perception of a yet higher truth, 'a moral as well as material truth, – a truth of impression as well as of form, – of thought as well as of matter' (3.104). Ruskin's patronage of Turner – for the Ruskins ceased to be mere collectors when they began to commission watercolours from him in 1842 (cats.53, 54, 111) – revealed that higher truth properly to him for the first time: 'it seemed to me that in these later subjects Nature herself was composing with him' (35.310). Yet the search for a synthesis between fact and symbol, between truthful perception and imaginative expression, between the actual and the eternal, while it made Ruskin a critic of lasting stature, created problems that were difficult to overcome. The synthesis he sought became an ever-wider inclusiveness, in order to bring all things into one. *Modern Painters*, originally conceived as a newspaper article or a pamphlet, grew to five long volumes and took seventeen years to complete. The openness of his enquiry involved discussions of science as well as art, architecture and literature, and spread to linguistics, mythology, history and economics, so that in this century Ruskin has become recognised as a 'pioneer in inter-disciplinary thinking'.[6] At the opposite pole to this ever-widening synthesis stood a Ruskinian form of synecdoche. In formal rhetoric, a part, when named, is understood to refer to the whole. In Ruskin's visual argument the minute particularity, the single image or the single detail of a building, when analysed, stood as synecdoche for the whole. In Ruskin's aesthetic, 'a stone, when it is examined, will be found a mountain in miniature' (6.368).

Originally destined by his parents for the Church, Ruskin had his aesthetic principles shaped for him by his religion. But it was art – specifically art criticism – that gave him his vocation. When young he measured his judgements as a private collector against those of the makers of public opinion, the critics. At the age of 18, in his first article for *The Architectural Magazine*, he showed his concern with patronage and 'public taste', immediately citing the most important places where taste and patronage could be seen in operation, the annual spring exhibitions of the Royal Academy and the Old Water Colour Society (1.7). The then anonymous practice of art criticism, though still in its infancy, and heavily literary in its bias, was burgeoning beside the art market which it documented and mediated. The critics' attacks on Turner, first in 1836 and then again in 1842, provoked Ruskin to intervene. The first time, his father's

bourgeois caution meant the article in Turner's defence was not published, but the fresh attacks in 1842 were the catalyst for *Modern Painters*, where, although sheltering behind the relative anonymity of signing himself 'A Graduate of Oxford', Ruskin proved to be an art critic with a moral mission. Turner, he declared, was 'sent as a prophet of God to reveal to men the mysteries of His universe, standing, like the great angel of the Apocalypse, clothed with a cloud, and with a rainbow upon his head, and with the sun and stars given into his hand' (3.254).

This hyperbole, dropped from later editions, risked blasphemy and probably offended the artist he was anxious to please (see cat.50), but it shows that Ruskin wished to place himself above the often crudely insulting ordinary reviewer. As he explained in the preface to the second edition of *Modern Painters* in 1844, 'I do not consider myself as in any way addressing, or having to do with, the ordinary critics of the press. Their writings are not the guide, but the expression, of public opinion' (3.16). Yet Ruskin was as in the moment as the reviewers. The publication of the first edition of *Modern Painters* was timed to coincide with the Royal Academy summer exhibition, and the text was constantly revised in the light of successive annual exhibitions. It was not long before his power was recognised by the critics he claimed to ignore. As William Michael Rossetti observed in *The Crayon* in 1855, 'A word from Ruskin will do more to attract notice to merit, as yet unadmitted, than anything else whatever.'7

Yet even as he began to explain why Turner exemplified the aesthetic that he was beginning to define, the drive for inclusiveness drew Ruskin onto fresh ground. In order to demonstrate the superiority of modern painters 'in the art of landscape painting to the ancient masters' – to quote his book's subtitle – he had to study the ancients with more diligence than his limited access to their work in England had previously allowed. His journey through France and Italy in 1845 brought him a life-changing appreciation of the great tradition of European art, reflected in the writing of *Modern Painters* volume II (1846). He also became more aware of Gothic architecture, and felt impelled to intervene in the contemporary religious and critical debate about the Gothic Revival. His Evangelical hostility to Roman Catholicism made him oppose the High Church ideology of the founding Gothic Revivalists, so that his interpretation of the historical Gothic was shaped by a polemical argument that sought to make Protestant, and secular, the Gothic of the present. Both *The Seven Lamps of Architecture* (1849) and *The Stones of Venice* (volume I, 1851; volumes II and III, 1853) were written to influence contemporary patronage. As he wrote in the preface to the first volume of *The Stones of Venice*, 'I am especially anxious to rid this essay of ambiguity, because I want to gain the ear of all kinds of persons' (9.9).

The persons he had most in mind were the politicians and wealth-creators of England, for his study of Venice had led him yet further afield, into judgements, not just on civil architecture, but

civil society. The condition of England, and the conditions in which it kept its workers, became part of an argument that we now recognise, for all its religious language, as a form of critical cultural history. The purpose of his account of the Venetian past was to influence the English present: 'the principles it inculcates are universal; and they are illustrated from the remains of a city which should surely be interesting to the men of London, as affording the richest examples of architecture raised by a mercantile community, for civil uses, and domestic magnificence' (9.10). The logical next step was for Ruskin to involve himself with a modern, secular, and scientific new building, the Oxford Museum of Natural History (cat.89).

To quote Sir Charles Eastlake's near-contemporary *History of the Gothic Revival* (1872), 'for all his errors and failings, Mr Ruskin *was* heard'.8 As the architects and their clients, 'the men of London', began to give a Southern Gothic surface to their offices and mills – and, to Ruskin's regret, their public houses – artists took note of Ruskin's growing influence. For the young Holman Hunt, wrestling with his religious principles and struggling with his painting technique, 'It was the voice of God'.9 Ruskin's initial influence on the PRB was partial and indirect, through his books. Arguably, the original PRB had broken up before he was persuaded to intervene. But when in 1851 he was appealed to on their behalf, his intervention was decisive.

What attracted the Pre-Raphaelites to Ruskin was, as Holman Hunt recalled telling Millais, 'He feels the power and responsibility of art more than any I have ever read'.10 Ruskin offered an intellectual leadership such as these young men were looking for. It is not anachronistic to call them an *avant-garde*, and Ruskin saw an opportunity to guide them towards his particular vision for contemporary art, away from the High Church, Tractarian tendencies they displayed and towards the study of landscape that he favoured. His justification for intervening on their behalf by writing two letters to *The Times* in May 1851 was that they were at a turning point in their careers which could lead up or down: 'whether they choose the upward or the downward path, may in no small degree depend on the character of the criticism which their works have to sustain' (12.319). As the critic and biographer Tim Hilton comments:

*This is the first time that one meets the modern notion of a young artist, or group of young artists, at a turning point: a point that could be a 'breakthrough' in a career. On all these matters, Ruskin was convinced of his own rightness. Now, in the year when the aged Turner no longer had the strength to exhibit, he suddenly became the arbiter of a new generation.*11

There are other links to Turner. The reviewers' attacks on the PRB recalled those on Turner, and presented an opportunity to defend and patronise a group of artists in a way that Turner had only grudgingly permitted. While always acknowledging that Millais

and Turner 'stand at opposite poles, marking culminating points of art in both directions' (12.361), and praising Millais for his keenness of vision, Turner for his breadth of imagination, Ruskin tried to bring his enthusiasms into synthesis in the pamphlet titled *Pre-Raphaelitism* (1851), which sets the agenda for the opening section of this catalogue. In spite of its title the pamphlet is largely devoted to Turner, and Ruskin achieved a much more practical and art-historically significant synthesis by commissioning Millais to paint a *plein-air* portrait that focussed the Pre-Raphaelites' attention to visual fact on what Ruskin identified as Turnerian subject-matter (cat 1).[12]

Yet although Ruskin did indeed believe that the Pre-Raphaelites could be 'a new and noble school in England', his praise was not unqualified, as William Michael Rossetti noted with satisfaction, for these qualifications had the effect of 'doing away with the accusation of partisanship'.[13] Ruskin warned them not only against Roman Catholicism, but romantic medievalism, and even against one of their most distinctive characteristics, their intense realisation of detail, recommending that 'they sometimes worked on a larger scale, and with a less laborious finish' (12.159). Above all, he pushed them to transcend imaginatively their own intense sense of fact. In the preface to *Pre-Raphaelitism* he claimed that the PRB had followed his injunction in *Modern Painters* volume 1 to 'go to nature in all singleness of heart, and walk with her laboriously and trustingly, having no other thought but how best to penetrate her meaning; rejecting nothing, selecting nothing, and scorning nothing' (12.339). Thus far he was evidently satisfied that the 'young artists of England' (12.339) had taken his advice. But in *Modern Painters* the quotation continues, 'Then, when their memories are stored, and their imaginations fed, and their hands firm, let them take up the scarlet and the gold, give the reins to their fancy, and show us what their heads are made of' (3.624). Ruskin wanted both Millais *and* Turner, keenness of sight *and* breadth of vision.

Between 1851, when he took up the cause of the Pre-Raphaelites, and 1860, when he published the final volume of *Modern Painters*, Ruskin spent the most intense period of engagement with contemporary art of his life. He discovered, first with Millais, and then Rossetti (cats.117, 118), that his double power as patron and critic did not make for easy friendships, while other artists like Brett (cat.207) and Inchbold (cat.211) found that his patronage carried a critical penalty. The 1850s were also a period of intense activity for the visual economy as a whole, with exhibitions and exhibitors increasing in numbers, and prices for the works of the contemporary generation rising, as well as those of the previous one represented by the now dead Turner and Constable. The dealer Ernest Gambart (who persuaded Ruskin to supply the text for one of his print-publishing ventures and arranged one of his lecture tours) was leading the way with paying exhibitions for works such as Hunt's *The Light of the World* (cat.192) and multiplying his profits through the sale of reproductions. Criticism followed the market. As Helene Roberts has written:

The periodicals reveal that to Victorians a work of art was not usually a hallowed object invoking awe; art more frequently was looked upon as an entertainment, a show and a commodity to be bought and sold. To the critics writing for the Victorian periodicals the artist seemed not so much a lonely genius, unknown and unappreciated, but a producer of goods that brought enjoyment and edification, and that, if purchased, would embellish the home and bring pleasure to its inhabitants.[14]

Criticism certainly affected prices, as the Pre-Raphaelites had found to their cost in 1850. By January 1853, however, as W.M. Rossetti noted, 'Our position is greatly altered. We have emerged from reckless abuse to a position of general and high recognition.'[15]

During the 1850s Ruskin took up art journalism – though on his own terms. Shedding the conventional critic's anonymity, in 1855 he began publishing what have become known as *Academy Notes*, an annual series of pamphlets carrying short reviews of pictures not only in the Royal Academy summer exhibition, but on occasion the Old Water Colour Society, the New Water Colour Society, Gambart's French Exhibition and the Society of British Artists. The pamphlets were on sale at the door of the Academy within a few days of the private view, to which critics had only been admitted for the first time in 1850. In a sense, Ruskin was doing no more than institutionalising what he had already done privately for collectors, like the Belfast cotton spinner Francis McCracken or the philanthropist Ellen Heaton, who sought his personal guidance. But *Academy Notes* were also a means of gaining access to a public that might not read his heavier volumes, but was happy to carry his pamphlet as a guide. In June 1857 *The Economist* commented – and also warned:

Mr Ruskin's Notes *have by this time attained a degree of popularity that renders their verdicts of extreme practical importance to all exhibitors. They are in almost as universal use as the catalogues, and to many must serve as sole guide to the excellences of the yearly Exhibitions. Such success entails great responsibility upon their author.* (14.147n)

Ruskin's selections are rushed, mentioning only thirty-five to forty out of the more than a thousand works in the official Academy catalogue, and his judgements are capricious, often seizing on a single, representative, detail. His principal purpose was to continue the campaign for 'Pre-Raphaelitism', but a Pre-Raphaelitism of a distinctly Ruskinian kind. The value that he had seen in Turner and carried over into the PRB was an emphasis on landscape, the repository of the values of God; in the Pre-Raphaelites he discovered a symbolic realism, such as in Holman Hunt's *The Awakening Conscience* (cat.193). He discovered the virtues of these approaches in a far larger group of artists than the now looser Pre-Raphaelite

circle, and in emphasising the significance of landscape he was going against the grain of current taste. Such was his influence, however, that the widespread acceptance of 'Pre-Raphaelite' realism caused a confusion in the public's mind with Ruskinian naturalism that led the one to be identified with the other. Ruskin was prepared to enjoy popular narrative pictures such as Frith's *Derby Day* (1856–8, Tate Gallery) and genre painters such as Edouard Frère (cat.205) if there was a moral to be drawn. Ruskin's nationalistic commentary on J.C. Hook's *Luff, Boy!* (cat.208) reads more like the writing of a newspaper columnist than that of an art critic. Under the influence of Thomas Carlyle, and a troubled social conscience, we begin to hear the voice that during the 1870s in *Fors Clavigera*, his monthly public letters 'to the workmen and labourers of Great Britain', attempted to synthesise the public and the private, the contingent and the eternal, the trivial and the profound.

Ruskin broke off his *Academy Notes* in 1859 for reasons that were more momentous than would at first appear. He was tired and under pressure from his father to concentrate on finishing *Modern Painters*. He was also becoming disenchanted with the art market upon which he had such effect. In spite of its greater loyalty to landscape than the Royal Academy's, he bitterly attacked the Old Water Colour Society in 1857 for having ambitions no higher than those of purveyors of strawberries and asparagus:

A Society which takes upon itself, as its sole function, the supply of these mild demands of the British public, must be prepared ultimately to occupy a position much more corresponding to that of the firm of Fortnum and Mason, than to any hitherto held by a body of artists; and to find their art becoming essentially a kind of Potted Art, of an agreeable flavour, suppliable and taxable as a patented commodity, but in no wise to be thought of or criticised as Living Art. (14.122)

There is more than a burst of typically Ruskinian wit to this devastating image of cultural consumption. Ruskin was exercised by the moral implications of the market in general, not just the market for contemporary art. In 1857 he travelled to Manchester to tweak the tails of the industrialists with two lectures titled *The Political Economy of Art*. The occasion for these lectures was the Manchester Art-Treasures Exhibition, a vast display of historic and contemporary paintings and sculptures that attracted more than a million visitors, and more than made up for the lack of fine art in the Great Exhibition of 1851. At the same time the event asserted the culture and wealth of Britain's second city. Ruskin's view of what constituted wealth was rather different, and when he suggested, 'you might not be uninterested in tracing certain commercial questions connected with this particular form of wealth' (16.17), he was satirising the Manchester economists by talking about art and artists in terms of production and consumption. In 1860 he moved directly into the field of social criticism with his essays *Unto This Last*. On the occasion of the celebrations of the centenary of

Ruskin's birth in 1919, George Bernard Shaw memorably summed up the argument, 'Ruskin's political message to the cultured society of his day, the class to which he himself belonged, began and ended in this simple judgement: "You are a parcel of thieves".' [16]

Ruskin's abandonment of *Academy Notes* in 1859 coincided with a downturn in the visual economy itself, which was feeling the effects of the Crimean War, the Indian Mutiny and bank failures in America. As Jeremy Maas writes, 'artists, printsellers and picture dealers fell on very hard times. One gallery after another went bankrupt as confidence and cash ebbed away; and the art trade, after a decade of expansion, was gripped by panic.' [17] The decline was temporary, and the boom resumed until the Franco-Prussian war and the agricultural depression of the 1870s, but its effects were felt in the 1859 Royal Academy where there were no 'sensation pictures' to stimulate demand – or Ruskin's eye and pen.

There were cultural as well as material reasons for a loss of confidence. Dianne Sachko Macleod argues that no sooner had the new middle class 'achieved a sense of identity and had successfully staked out claims to a cultural system of its own', as reflected in the narrative, figurative and naturalistic paintings of the 1850s, than it was challenged by an intellectual shift that undermined its security. [18] Charles Darwin's *On the Origin of Species*, published in 1859, and the supposedly heretical Broad Church collection *Essays and Reviews* of 1860, undermined the bedrock of Biblical authority on which Protestant England was built.

Ruskin was doubly in tune with his time. He not only helped to provoke this crisis of authority by challenging orthodox economic morality, but experienced it profoundly within himself. In 1858 he sloughed off his dogmatic Evangelicalism, leaving himself rawly exposed to religious doubt, and at odds with his ageing and as ever confining parents. He also appears to have had an emotional, indeed sexual awakening after meeting Rose La Touche in 1858 (see cat.230), with whom by the early 1860s he was to be tragically in love. He had also gained a deeper and more disturbing knowledge of Turner through his work on the Turner Bequest. The change in his critical position is indicated by his new appreciation of the 'magnificent Animality' (7.xl) of the Venetian Renaissance painters Titian and Veronese, and a renewed interest in the heritage of Hellenic culture. The effect of this crisis was to widen his field of thought and action even further, but it produced another of Ruskin's recurrent depressions. He told Elizabeth Barrett Browning in November 1860:

I have got people to look a little at thirteenth-century Gothic, just in time to see it wholly destroyed (every cathedral of importance is already destroyed by restoration) – and have made them think about Turner only when he has been ten years dead, and when all his greatest works, without exception, are more or less in a state of decay and all the loveliest of them, utterly and for ever, destroyed. What I am now to do, I know not. I am divided in thought between many things, and the strength I have to spend on them seems to me nothing. (36.350)

When Ruskin emerged from this period of crisis, much of it spent living abroad until the death of his father in 1864 brought him home, he found himself distanced from the immediate activities of the visual economy. He declared in 1869, 'art is the monster of a caravan; our exhibitions are neither more nor less than bazaars of ruinously expensive toys, or of pictures degraded to the function of toys' (19.210). Middle-class patrons had been persuaded by his support for Turner and the Pre-Raphaelites, but once he began to challenge the morality of the economic foundations of their taste, he entered into a new relationship with his audience. The ever observant William Michael Rossetti commented, also in 1869:

[Ruskin's] sway is now, to a considerable extent, remote, abstruse, and ceremonial. He no longer wields the practical powers of government, but remains a great unfamiliar abstraction of sovereignty. When the idea of authority has to be invoked, he is there for the purpose: but, when people want immediate instructions as to what they are to do next, it is not to him that they recur … Mr Ruskin has, to a certain extent, already won the day. His theories have been embodied in practice which meets with popular acceptance.[19]

What had happened was that Ruskin had begun to absorb his art criticism into the wider question of education. Appropriately, in 1869, he was elected Oxford's first Slade Professor of Fine Art. Ruskin had always been an educator, for teaching is a practical part of preaching. He was already known as a teacher of drawing, to private pupils (cat.225) and at the London Working Men's College in the 1850s. He had published a popular manual, *The Elements of Drawing* in 1857, followed by *The Elements of Perspective* in 1859. At Oxford he was to continue his fight with the Utilitarian system of art-teaching imposed by the government's Department of Science and Art by founding his own school of drawing, with its own series of teaching examples, which remains a living link with his legacy today (cat.255). He was now able to put into practice his conviction that 'the teaching of Art … is the teaching of all things' (29.86), and the range – and occasional rage – of his lectures is almost as inclusive as the discourse of his ongoing ruminations and fulminations in *Fors Clavigera*, launched in 1871. Outside Oxford, Ruskin taught by practical example, through the creation of the Guild of St George and his battle to save St Mark's in Venice from restoration (see cat.257). The utopian schemes of the Guild, its one museum, its 'shepherd's library', its non-existent schools and its tiny farming and manufacturing experiments must be seen as more a synecdochic fragment than a synthesis of the great schemes for social reform that he dispersed his fortune in promoting.

It is in the nature both of art and art criticism that a movement and its spokesmen will have their day. W.M. Rossetti's comment above of 1869 points the way towards the position of venerable sage that the youthful Graduate of Oxford finally attained. When Ruskin began to spend much of his time at his house, Brantwood, in the Lake District in the 1870s he became physically more remote from the London art world, even before outbreaks of mental illness from 1878 onwards detached him further. Yet Ruskin was more sympathetic to the developments in English art than the Whistler *v* Ruskin libel case of 1877–8 has traditionally led us to suppose (see cat.224). John Christian points out 'the correspondence between what Ruskin was saying and the priorities of the Aesthetic movement', whose maturation was formally marked by the appearance of Burne-Jones's paintings at the Grosvenor Gallery in 1877.[20] Ruskin attacked Whistler's paintings in that same exhibition (cats.224, 225), and we now see the libel case that followed as a moment of bifurcation, with Whistler showing the high road to modernism and Ruskin the old road to stuffy reaction. But Burne-Jones was as radical as Whistler when they showed at the Grosvenor Gallery. It was Burne-Jones, not Whistler, who made his reputation there.[21]

Burne-Jones, who found his vocation as a painter through reading *The Stones of Venice* as an Oxford undergraduate, and who received encouragement and financial support from Ruskin so that he could enlarge his appreciation of the Italian masters of the High Renaissance (see cat.123), appealed to the imaginative, as opposed to naturalistic polarity in Ruskin's aesthetic. He was the primary exponent of what Ruskin termed 'constant art' in a lecture on 'The Present Condition of Modern Art' in 1867 – the lecture in which he advocated the building of what became the Tate Gallery. He argued, 'Constant art represents beautiful things, or creatures, for the sake of their own worthiness only; they are in perfect repose, and are there only to be looked at. They are doing nothing. It is what they are, not what they are doing, which is to interest you' (19.203). The statement anticipates the Whistlerian argument that art exists for art's sake, but with this crucial difference: the beauties of constant art must also represent moral worth, and not mere sensual self-indulgence. Burne-Jones, like another artist Ruskin knew and admired, George Frederic Watts (cat.216), was a symbolist before Symbolism had been critically codified, as was Rossetti, whom Ruskin continued to appreciate (cat.215).[22]

In spite of attacks of mental illness, Ruskin's engagement with contemporary British art continued into the 1880s. Although grief at the loss of Rose La Touche, mental breakdown and the hostile verdict of Whistler *v.* Ruskin had caused him to resign the Slade Professorship in 1878, in 1883 he took it up again. The title he gave to his Oxford lectures in the spring, summer and autumn of 1883, *The Art of England*, reflects the cultural nationalism of his hopes for the original Pre-Raphaelite school. They are yet another attempt at synthesis, an assertion of the continuity, rather than antagonism, between 'Classic' and 'Gothic'. The series was partly prompted by the retrospective exhibitions of Rossetti's work following his death in 1882, and this and other recent exhibitions inform his commentary. The artists he discusses – Reynolds, Gainsborough,

Copley Fielding, Rossetti, Burne-Jones, Holman Hunt, Watts, Leighton, Alma Tadema – and the two lectures on illustrators – Leech, Tenniel, Du Maurier, Greenaway, Allingham – show the breadth of his continuing interests. His commentary was of the moment in its contemporary reference as it always was.

But while the lectures themselves are calm, even elegaic in tone, Ruskin's anger and disenchantment with the contemporary world could not be contained. In a postscript written early in 1884 his obsession with the deterioration of society, emblematised by 'the plague-cloud and plague-wind' of environmental pollution, breaks in (33.399). Ruskin feared that the great battle between the forces of Life and the forces of Death – symbolised in visual terms as the opposition of light and darkness – was being lost. His concluding words contrast the natural world with what the nineteenth century had done to it:

perceiving as I do the existing art of England to be the mere effluence of Grosvenor Square and Clapham Junction, – I yet trust to induce in my readers, during hours of future council, some doubt whether Grosvenor Square and Clapham Junction be indeed the natural and divinely appointed produce of the Valley of the Thames. (33.408)

There was little time for future council as Ruskin's demons closed in. His next set of Oxford lectures dismayed the authorities, and early in 1885 he resigned his chair. In 1886 Millais and Holman Hunt were given retrospective exhibitions, at the Grosvenor Gallery and the Fine Art Society respectively. Both catalogues were edited by the bookman A.G. Wise, who arranged with Ruskin to reprint a selection of his previously published comments. To the Millais catalogue Ruskin added some brief fresh notes, including praise for the artist's *The Ornithologist* of 1885. He also supplied a short preface in which he gave his last words on the Pre-Raphaelites:

I must in the outset broadly efface any impression … of my criticisms having been of any service to the Pre-Raphaelite school, except in protecting it from vulgar outcry. The painters themselves rightly resented the idea of misjudging friends that I was either their precursor or their guide; they were entirely original in their thoughts, and independent in their practice. Rossetti, I fear, even exaggerated his colour because I told him it was too violent; and to this very day my love of Turner dims Mr Burne-Jones's pleasure in my praise. (14.495)

In 1889 *Modern Painters*, the defence of Turner that had launched him on his career, was reissued in a new edition with a short 'Epilogue' that finally concluded the great over-arching work of his life. In it he repeated the ruling principle of his criticism 'All great Art is Praise' (7.463). But following increasingly severe mental attacks, Ruskin gradually lapsed into silence, leaving his auto-biography unfinished, broken off as Rose La Touche enters the story.

Ruskin's final words on the Pre-Raphaelites, and the reference he makes to Turner, are sad, even bitter, as the critic bows to the artists. But they also point to another aspect of Ruskin's modernity, and that is his tragedy. His unhappiness, his sexuality, his insanity are not to be ignored, but confronted and learned from. What these words tell us is that in the end Ruskin was unable to achieve the ultimate synthesis that he was seeking, and that finally it broke him, broke him into little fragments that only imaginatively, and never practically, could be assembled into a greater whole. To that extent Ruskin's disintegration heralded not a modern, but a post-modern fragmentation.

Yet when the storm-cloud of the nineteenth century over-whelmed him, he was only giving one more teaching example of that great principle enunciated at his inaugural lecture in 1870 as Slade Professor: 'the art of any country *is the exponent of its social and political virtues*' (20.39). The lack of social and political virtue in late Victorian England helped to destroy his capacity to make or write about art.

The virtues that Ruskin has to offer the twenty-first century are his intellectual openness, and his moral certainty. It was the con-tradiction between openness and certainty that drove the Ruskinian dialectic, and which could only find its resolution in fragmentary synecdoche, not an all-embracing synthesis. Yet how much are these virtues needed today, and we may envy Ruskin's possession of them, even as we pity what their conflict did to him.

In 1893, by which time the contradictions in Ruskin's life had overcome him, one of the artists encouraged, supported, irked, but most importantly loved by Ruskin, Burne-Jones, paid this tribute:

That was an awful thought of Ruskin's, that artists paint God for the world. There's a lump of greasy pigment at the end of Michael Angelo's hog bristle brush, and by the time it's been laid on the stucco, there is something there that all men with eyes recognise as divine. It is the power of bringing God into the world – making God manifest. [23]

A hundred years after his death, Ruskin still has the power to make manifest, to those with eyes, the essence and authority of the Beautiful and the True.

RH

NOTES

1. *Art-Union Monthly Journal*, vol.1, no.1, Feb. 1839, p.1.

2. For an extended discussion of the Ruskin family art collection, see my introduction to *Ruskin's Artists: Studies in the Victorian Visual Economy*, ed. R. Hewison, London 2000.

3. For the biographies and collections of these and other collectors, see D. Sachko Macleod, *Art and the Victorian Middle Class: Money and the Making of Cultural Identity*, Cambridge 1996.

4. M. D. Wheeler, *Ruskin's God*, Cambridge 1999, p.22.

5. T. Dale, *A Memorial of Pastoral Ministrations: Sermons, principally on Points of Christian Experience, delivered in St Matthew's Chapel, Denmark Hill*, London 1857, p.93; cited in Wheeler, *Ruskin's God*, 1999, p.31.

6. D. Birch, Introduction to *Ruskin and the Dawn of the Modern*, ed. D. Birch, Oxford 1999, p.2

7. W.M. Rossetti, *The Crayon*, 23 June 1855, cited in G.H. Fleming, *That Ne'er Shall Meet Again: Rossetti, Millais, Hunt*, London 1971, p.64.

8. C.L. Eastlake, *A History of the Gothic Revival* (1st pub. 1872), ed. J. Mordaunt Crook, Leicester 1970, p.277.

9. Holman Hunt, writing to Ruskin in 1880 (though he did not post the letter until 1882). Landow 1976–7, p.43.

10. Hunt 1905, vol.1, p.90.

11. Hilton 1985, p.154.

12. The significance of the portrait is discussed in Grieve 2000, ch.4.

13. W.M. Rossetti, *The P.R.B.Journal: William Michael Rossetti's Diary of the Pre-Raphaelite Brotherhood 1849-1853*, ed. W.E. Fredeman, Oxford 1975, p.94.

14. H. Roberts, 'Exhibition and Review: The Periodical Press and the Victorian Art Exhibition System', in *The Victorian Periodical Press*, ed. J. Shattock and M. Wolff, Leicester 1982, p.80.

15. Rossetti, *The P.R.B.Journal*, 1975, p.97.

16. G.B. Shaw, *Ruskin's Politics*, London 1921, p.11.

17. J. Maas, *Gambart: Prince of the Victorian Art World*, London 1975, p.97.

18. Macleod, *Art and the Victorian Middle Class,* 1996, p.267.

19. W.M. Rossetti, 'Ruskin as a Writer on Art', *Broadway*, Mar. 1869, reprinted in J.L. Bradley, *Ruskin: The Critical Heritage*, London 1984, p.320.

20. J. Christian, 'A New Voice', in *Edward Burne-Jones: Victorian Artist-Dreamer*, S. Wildman and J. Christian, exh. cat., Metropolitan Museum of Art, New York 1998, p.116. See also Shrimpton 1999, pp.131-51.

21. For the relative receptions of Burne-Jones and Whistler at the Grosvenor Gallery, see L. Merrill 1992, p.18.

22. See A. Wilton, 'Symbolism in Britain' in Wilton & Upstone 1997.

23. Burne-Jones 1904, vol.2, p.257.

Catalogue

Authorship of catalogue entries is as follows:

Robert Hewison: Parts I, IV, V, VII (where initialled),
VIII, IX and X

Ian Warrell: Parts II, III, VII (where initialled)

Stephen Wildman: Part VI

Measurements are given in centimetres,
height before width

References to Ruskin's published works are taken from
The Works of John Ruskin, Library Edition, edited by E.T.
Cook and Alexander Wedderburn, 39 vols., London and
New York, 1903–12, unless otherwise stated. They are
indicated by volume and page number in the text, thus:
28.312

A full list of abbreviations for Ruskin's writings and
other editions can be found on p.280

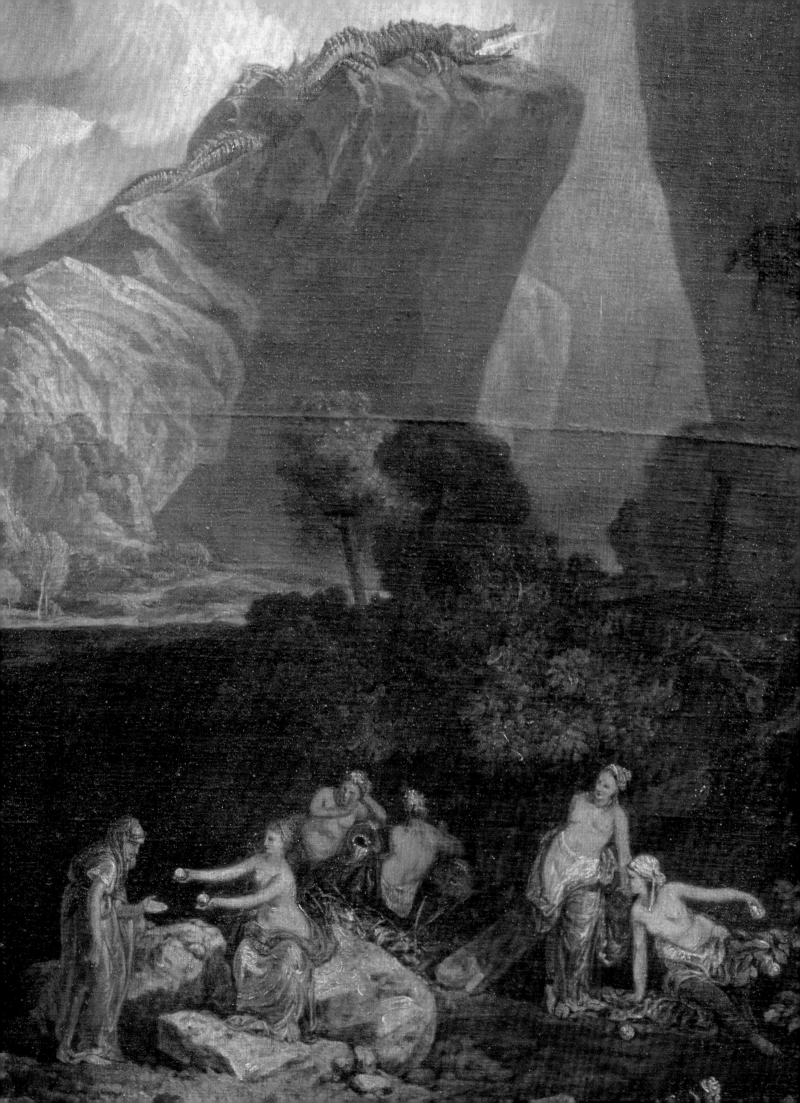

Introduction

'All great art is praise.'

Perhaps some of my hearers this evening may occasionally have heard it stated of me that I am rather apt to contradict myself.
I hope I am exceedingly apt to do so. I never met with a question yet, of any importance, which did not need, for the right solution
of it, at least one positive and one negative answer ... For myself, I am never satisfied that I have handled a subject properly till
I have contradicted myself at least three times. (Inaugural address, Cambridge School of Art, 1858, 16.187)

It is quite possible that when Ruskin spoke these words in 1858 one of the contradictions he had in mind was that between his love of Turner and his praise for the Pre-Raphaelites. What could be more different than the romantic, poetic canvases of Turner, and the minute realism of the Pre-Raphaelites, whose works have all the hard-edged finish that Turner's scumbled surfaces and idealised imagery lack? By placing such contradictory artists side by side, this section presents the challenge of the exhibition. On the one hand is Turner, responding to the elemental forces of nature, or presenting mythological and literary subjects that sum up and transcend the great academic tradition of historical landscape painting. On the other, are some of the first mature works of a group of young artists who challenged the academic tradition that had shaped Turner's career.

The exhibition as a whole offers an answer to this visual contradiction, but, from Ruskin's point of view, Turner and the Pre-Raphaelites had essential factors in common. To begin with, they were artists that other contemporary critics had attacked. Ruskin's relations with Turner are considered in detail in Part III, but it is clear that from the 17-year-old Ruskin's first defence of Turner (see cat.2) onwards, he saw himself as a polemicist, a defender of the unjustly abused. In 1851, the year of Turner's dying, the attacks on the Pre-Raphaelites, whose ideas his own writings had influenced, presented a fresh challenge and, he hoped, an opportunity to shape a new generation.

What is important, however, is what Ruskin chose to defend these artists *for*. In both cases, he celebrated above all the value of what he called 'truth': '*I* never said that [Turner] was vague or visionary. What *I* said was that nobody had ever drawn so well: that nobody was so certain, so *un*-visionary; that nobody had ever given so many hard and downright facts' (5.174). This may indeed seem contradictory in the face of a work like the *Garden of the Hesperides*

(cat 4), but Ruskin argued that 'there is a moral as well as material truth, – a truth of impression as well as of form, – of thought as well as of matter' (3.104). His point was that the imaginative truth of Turner and the symbolism that conveyed it could only be achieved by accurate observation, and that the factual accuracy of the Pre-Raphaelites represented its own truth, a truth of form that could also be deployed in the service of moral symbolism.

Ruskin did not equate Turner and the Pre-Raphaelites, although he sought to synthesise the values of both by commissioning his own portrait, with dramatic personal consequences (cat.1). Praising them in the same pamphlet, *Pre-Raphaelitism*, he was careful to say that Turner and Millais stood at opposite poles of achievement, but he recognised their common search for a truth that involved a necessary break with accepted convention, a re-opening of the eyes:

I wish it to be understood how every great man paints what he sees or did see, his greatness being indeed little else than his intense sense of fact. And thus Pre-Raphaelitism and Raphaelitism, and Turnerism, are all one and the same, so far as education can influence them. They are different in their choice, different in their faculties, but all the same in this, that Raphael himself, so far as he was great, and all who preceded or followed him who ever were great, became so by painting the truths around them as they appeared to each man's own mind, not as he had been taught to see them, except by the God who made both him and them. (12.385)

As this quotation shows, Ruskin believed that what an artist saw as the natural world was the work of God. The artist's responsibility was then to reveal the beauty of that world to the best of his ability. Hence Ruskin's abiding maxim: 'All great art is praise' (15.351). As a critic, Ruskin contributed his own distinct form of praise.

RH

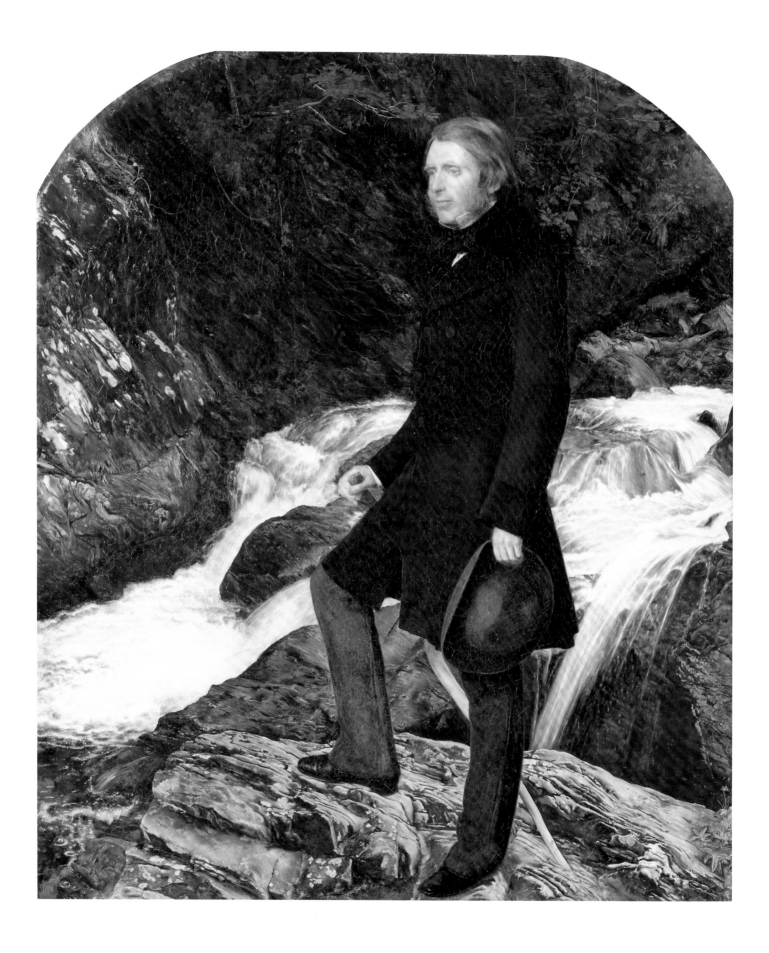

I

Sir John Everett Millais, Bt
(1829–1896)

John Ruskin

1853–4

Oil on canvas
78.7 x 68, arched top

Inscribed 'JM 1854'
(initials in monogram)

First exhibited
Fine Art Society 1884

Private collection

'We shall have the two most wonderful torrents in the world, Turner's St Gothard and Millais's Glenfinlas' (Letter to his father, 6 July 1853, 12.xxiv)

'Millais is painting a picture of a torrent among rocks, which will make a revolution in landscape painting' (12.xxiv). No portrait of a critic has been conceived with higher ambitions, or completed in more dramatic circumstances. Millais's commission, begun on 28 July 1853, was to realise in paint the argument of Ruskin's pamphlet *Pre-Raphaelitism* that Millais and Turner 'are among the few men who have defied all false teaching, and have therefore, in great measure, done justice to the gifts with which they were entrusted' (12.360–1). Ruskin acknowledged their differences: 'They stand at opposite poles, marking culminating points of art in both directions' (12.361), but he wanted to bring these polarities together.

The location, the bed of a stream in Glenfinlas in the Trossachs, Scotland, where the rocks and rushing water evoke the geology of mountains, is Turnerian, comparable with the background to *Garden of the Hesperides* (cat.4). Hence Ruskin's reference to Turner's *The Pass of Faido*, which the Ruskins already owned (see cat.54). But the subject is modern, and the treatment Pre-Raphaelite: a closely delineated figure in a confined space. Millais did not agree with Ruskin about Turner, but this depiction of nature is not the 'rascally wirefenced garden-rolled-nursery-maid's paradise' that Ruskin had privately complained of in Millais's earlier paintings (Grieve 2000, p.72). By getting Millais to explore at least the foothills of Turnerian topography, Ruskin hoped that a revolution in landscape painting would follow. Arguably, it did.

In the lectures that he wrote while the painting was in progress, Ruskin stated, 'Every Pre-Raphaelite landscape background is painted to the last touch, in the open air, from the thing itself. Every Pre-Raphaelite figure, however studied in expression, is a true portrait of some living person' (12.157–8). After preliminary studies (cat.191), Millais worked from July until the end of October, concentrating on the background and leaving the figure only blocked in. (Ruskin made his own study of the rocks on the left, cat.143.) Ruskin then posed for the figure in Millais's London studio in April the following year, and Millais returned to the site in May and June 1854 to finish the background, while Ruskin had to give further sittings in London that autumn.

Between 1853 and 1854, however, the relationship between painter and sitter had changed completely. By the time the portrait was delivered in December, and Millais paid £350, Ruskin's six-year marriage to Euphemia Gray was over. Effie, as she was known, went with Ruskin to Glenfinlas, and she and Millais fell in love. In April 1854 Effie returned to her parents. In July her marriage was annulled on the grounds that 'the said John Ruskin was incapable of consummating the same by reason of incurable impotency' (Lutyens 1967, p.230). On 3 July 1855 Effie and Millais were married.

Ruskin, who had learned much from the association with Millais, continued to write about him as though nothing had happened, but his father refused to allow the portrait to be exhibited. In 1871, after his parents had died, Ruskin decided to move out of London, and he gave the portrait to his friend Dr Henry Acland (1815–1900), who had been a visitor to Glenfinlas that fateful summer of 1853.

2

George Hollis
(1793–1842)

*St Mark's Place,
Venice (Moonlight)*
1842

after Joseph Mallord
William Turner
Juliet and her Nurse
1836

Open etching
plate line 53.5 x 65
image line 41.9 x 56.5

Tate Gallery.
Purchased 1988

The original oil painting
was first exhibited at the
Royal Academy in 1836,
and is now in a private
collection

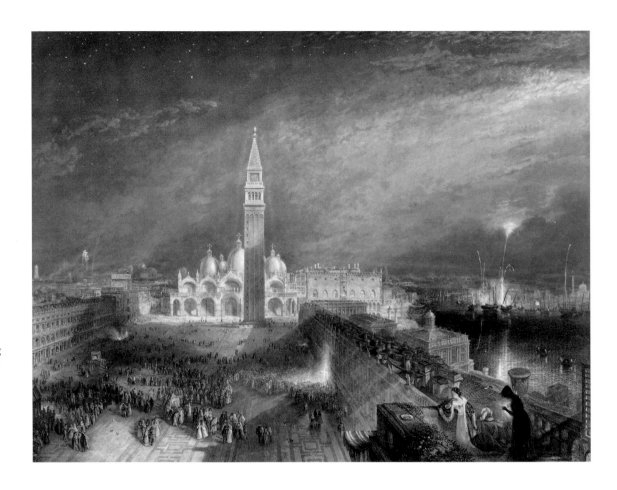

*'Turner is an exception to all rules, and can be judged by
no standard of art'* (Reply to *Blackwood's*, 1836, 3.639)

In 1836 Turner showed three canvases at the Royal
Academy, *Mercury and Argus; Rome, from Mount Aventine*
and *Juliet and her Nurse*, all of which were attacked by the
Reverend John Eagles, art critic of *Blackwood's Magazine*.
Eagles described *Juliet and her Nurse* as 'a composition
as from models of different parts of Venice, thrown
higgledy-piggledy together, streaked blue and pink and
thrown into a flour tub' (Butlin & Joll 1984, p.216). The
17-year-old Ruskin was so infuriated that he immediately
wrote a reply. Drawing on his knowledge of Venice,
which he had visited for the first time the year before,
he rejected the 'higgledy-piggledy' insult: 'it is no such
thing … The view is accurate in every particular, even
to the number of divisions in the Gothic of the Doge's
palace' (3.637). This emphasis on visual accuracy was,
however, juxtaposed with praise for Turner's powers of

imaginative transformation: 'The picture can be, and
ought only to be viewed as embodied enchantment,
delineated magic' (3.639).

Ruskin had not yet met Turner, or bought any of
his works, although he was an intense admirer of the
engraved vignettes to Samuel Rogers's *Italy* (cat.17).
Ruskin's father advised him to send the reply first to
Turner, which he did, signing himself simply 'J.R.'.
Turner wrote back, 'I beg to thank you for your zeal,
kindness, and the trouble you have taken in regard of the
criticism of *Blackwood's Magazine* for October, respecting
my works; but I never move in these matters' (35.218).
So the reply was never published in Ruskin's lifetime. It
was not until 1842, when he read further critical attacks
on his hero, that Ruskin began the defence of Turner
that became *Modern Painters*.

Turner had *Juliet and her Nurse* engraved in 1842,
changing the title to *St Mark's Place, Venice (Moonlight)*.
The original canvas (92 x 123) is in a private collection.

3

Joseph Mallord
William Turner
(1775–1851)

*Snow Storm –
Steam Boat off a
Harbour's Mouth
making Signals in
Shallow Water, and
going by the Lead.
The Author was
in this Storm on
the Night the Ariel
left Harwich*
1842

Oil on canvas
91.5 x 122

First exhibited
Royal Academy 1842

Tate Gallery. Bequeathed
by the artist, 1856

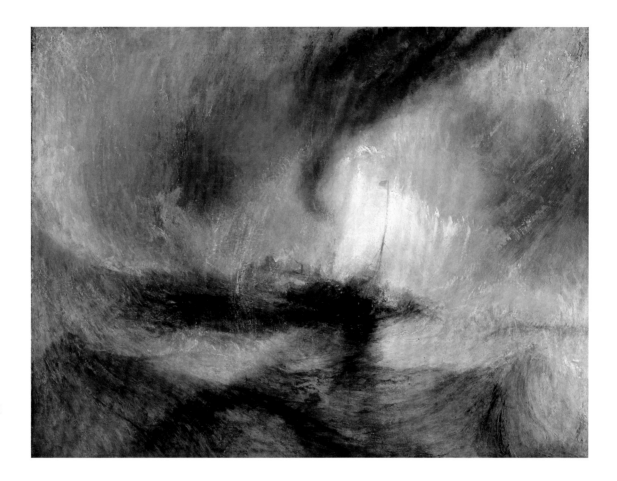

*'One of the very grandest statements of sea-motion, mist,
and light, that has ever been put on canvas, even by Turner.
Of course it was not understood; his finest works never are'*
(*Modern Painters* 1, 1843, 571)

Ruskin was visiting Geneva in the summer of 1842 when
he read some reviews sent from England of that year's
Academy exhibition, which he had seen before he left for
the Continent. The attacks on this and the other works
by Turner, couched in similar terms to those on *Juliet and
her Nurse* (see cat.2) in 1836, made him decide to 'blow
the critics out of the water' (3.666) and begin the work
that became *Modern Painters*. The first volume, published
in 1843, is quoted above.

 Snow Storm is indeed a modern painting, in its treat-
ment and its subject, a steamer, struggling in shallow
water as it is overwhelmed by the forces of Nature. Both
Turner, in the way he presented the painting and his
relationship to it in the long title he gave it in the
Academy catalogue, and Ruskin, in his subsequent
criticism, chose to emphasise its truth to nature and basis
in fact. There have been doubts cast on whether Turner
was on the ship in question (see Butlin & Joll 1984,
p.247), but there is evidence from Ruskin and others
that Turner did experience such a storm, and that is what
he intended to convey. Ruskin quotes Turner as saying,
'I did not paint it to be understood, but I wished to show
what such a scene was like' (13.162). In this case, the
event was impressive enough in itself not to be given a
deeper meaning. To Ruskin the painting was thus both
a powerful image and a natural fact. (After longer
acquaintance with the picture, however, he decided in
1856 the sea 'is not quite right: it is not yeasty *enough*'
(13.162).) The difference between this work and both
cat.4 and the Pre-Raphaelite paintings in this section
could not be more marked.

4

Joseph Mallord
William Turner

*The Goddess of
Discord Choosing the
Apple of Contention
in the Garden of
the Hesperides*
1806

Oil on canvas
155.3 x 218.4

First exhibited
British Institution 1806

Tate Gallery. Bequeathed
by the artist, 1856

*'Among all the wonderful things that Turner did in his day,
I think this nearly the most wonderful. How far he had really
found out for himself the collateral bearings of the Hesperid
tradition I know not; but that he had got the main clue of it,
and knew who the Dragon was, there can be no doubt'*
(*Modern Painters* v, 7.401–2)

In the first volume of *Modern Painters*, Ruskin called
Turner 'the father of modern art' (3.258). Turner was able
to reveal the splendour of the natural world to a society
that was fast destroying it, and he was an artist-hero who
had mastered the conventions of historical landscape
painting in order to transcend them, adding a new level
of symbolism to give imaginative life to the visual 'facts'
that he portrayed. As Ruskin's knowledge of Turner
deepened, and his own view of the world darkened, the
development of Turner's art in itself became emblematic
of the tragedy of modern life. His commentaries on
Garden of the Hesperides, written during the 1850s, when
he was closely engaged with the promotion of Pre-
Raphaelitism, show why he called Turner a 'modern
painter'.

Turner's subject is the story of the apple which was to
disrupt the wedding of Peleus to Thetis by falling at the
feet of Hera, Athene and Aphrodite, leading to a beauty
contest decided by the judgement of Paris, and ultimately
to the Trojan wars. It was thrown by Eris – Turner's
'Discord' – who had not been invited to the wedding.
The apple came from the orchard given by Mother Earth
to Hera, where lived the Hesperides, guarded by the
dragon Ladon. Turner shows the witch-like figure of
Discord obtaining the fateful apple. Ruskin reads Turner's
placing of two apples in the nymph's hands as suggestive
of conflict, and points out that although emblematic of
the fruits of the earth, their weight has broken the tree,

'not healthily, but as a diseased tree would break' (7.407).

Ruskin, who became familiar with the painting
when he began to visit Turner's private gallery from 1841
onwards, fully recognised its neo-classical conception.
When it went on display at Marlborough House in 1856
he contrasted Turner's emulation of the old masters in the
foreground with the evidence of his romantic experience
of nature behind: 'Nearly all the faults of the picture are
owing to Poussin; and all its virtues to the Alps' (13.114).
In 1806 Turner is still trapped in the neo-classical gloom
from which he would not escape until such works as
cat.259. In the third volume of *Modern Painters*, published
the same year, 1856, however, Ruskin also linked the
symbolic aspects of the painting – what he called
'the noble grotesque' – with contemporary works by
G.F. Watts and Dante Gabriel Rossetti, citing these as
'the dawn of a new era of art, in a true unison of the
grotesque [i.e. the symbolic] with the realistic power'
(5.137).

When Ruskin reconsidered the painting in 1860,
Turner's gloom acquired a psychological significance that
was a projection of Ruskin's own. This work and another
neo-classical subject, also featuring a serpentine creature,
Apollo and Python (1811, Tate Gallery) became the climax
of the final volume of *Modern Painters*, from which Turner
emerges not merely as a great landscape painter, but a
symbolist. Ruskin's critical concerns have widened from
the morality of art to the morality of society as a whole.
The Edenic garden has been polluted by competition, the
dragon has become 'the evil spirit of wealth' (7.403), his
environment a nineteenth-century 'paradise of smoke'
(7.408) and the painting as a whole 'our English painter's
first great religious picture; and exponent of our English
faith' (7.407) – that faith being 'the "Goddess of Getting-
on", or "Britannia of the Market"' (18.448).

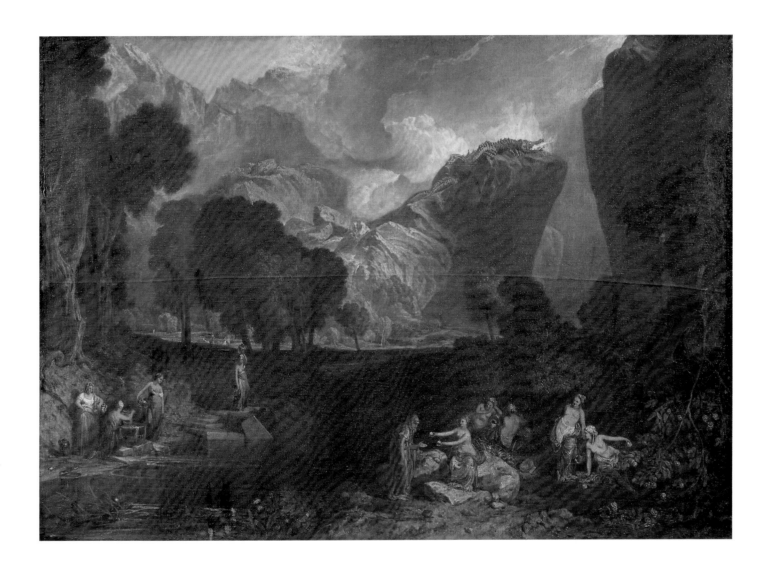

5

Sir John Everett Millais, Bt

Christ in the House of His Parents (The Carpenter's Shop)
1849–50

Oil on canvas
86.4 x 139.7

Inscribed 'JMillais 1850' (initials in monogram)

First exhibited
Royal Academy 1850

Tate Gallery. Purchased with assistance from the National Art Collections Fund and various subscribers 1921

'My real introduction to the whole school was by Mr Dyce, R.A., who dragged me, literally, up to the Millais picture of "The Carpenter's Shop" which I had passed disdainfully, and forced me to look for its merits' (Letter to Ernest Cheseau, 1882, 37.427–8)

The 20-year-old Millais first exhibited this work without a title, but with the Biblical quotation 'And who shall say unto him, What are these wounds in thine hands? Then he shall answer, Those with which I was wounded in the house of my friends' (Zechariah 13:6). The subject matter and symbolism, however, would have been obvious: the young Christ has pierced his palm and blood has fallen on his foot, pre-figuring the crucifixion. His cousin John brings the water of baptism; the instruments of the crucifixion are behind his head. But the radically realistic, unidealised (and thus Pre-Raphaelite) treatment of the scene caused great offence, and Millais was fiercely attacked, notably by Charles Dickens, and Ruskin's old enemy, *Blackwood's Magazine.*

As his story about Dyce (see cat.201) suggests, Ruskin never liked the picture, but his reasons were as much religious as aesthetic. The picture was inspired by a sermon, probably by the High Churchman Edward Pusey,

that Millais heard at Oxford in 1849, when he was close to members of the Oxford Movement, notably his patron Thomas Combe. Alastair Grieve has comprehensively demonstrated the High Church, or Tractarian, programme of the painting, with its emphasis on child baptism, regeneration through baptism, and the necessary separation of church and laity, represented by the penned sheep (Grieve 1969). As an Evangelical, Ruskin would have understood and objected to this programme. When he decided to take up the Pre-Raphaelite cause in 1851 he warned against their 'Romanist and Tractarian tendencies' (12.320). The same year he published his Evangelical pamphlet *Notes on the Construction of Sheepfolds*, the title deploying the same symbolism as in Millais's painting.

Yet Ruskin's objection may also have made him wish to intervene, just as he had already intervened against the Romanist tendencies of the Gothic Revival (see cat.106). He could not object to Millais's use of symbolism. In 1847 Holman Hunt had read to Millais Ruskin's analysis of the iconography of Tintoretto's *Annunciation* in *Modern Painters* volume II, where carpenters' tools also have symbolic significance. While this may have had some influence on Millais, Ruskin conceded in turn that 'Millais first showed me the beauty of extreme minuteness and precision' (37.428).

6

Sir John Everett Millais, Bt

Mariana
1850–1

Oil on panel
59.7 × 49.5

Inscribed 'JMillais 1851'
(initials in monogram)

First exhibited
Royal Academy 1851

Tate Gallery. Accepted by
H.M. Government in lieu
of tax and allocated to the
Tate Gallery 1999

'On the whole the perfectest of his works, and the representative picture of that generation' ('The Three Colours of Pre-Raphaelitism', 1878, 34.165)

When Millais and Holman Hunt showed at the Royal Academy in 1851 their collective endeavour, the Pre-Raphaelite Brotherhood, formed in 1848, was again vilified in the press. Millais decided to seek allies. He was friendly with the poet Coventry Patmore, who had supplied the subject of one of his three 1851 paintings, *The Woodman's Daughter* (Guildhall Art Gallery, City of London). Patmore knew Ruskin, and appealed to him on Millais's and Hunt's behalf. Ruskin immediately responded by writing two letters to *The Times*, published on 13 and 30 May. *The Times* had been particularly vicious, accusing them of 'servile imitation of the cramped style, false perspective, and crude colour of remote antiquity' (12.319n).

In his first letter Ruskin stressed 'I have no acquaintance with any of these artists, and very imperfect sympathy with them' because of their High Church tendencies (12.320). But he had grasped the point that these were *modern* painters: 'They intend to return to early days in this one point only – that, as far as in them lies,

they will draw either what they see, or what they suppose might have been the actual facts of the scene they desire to represent, irrespective of any conventional rules of picture-making; and they have chosen their unfortunate though not inaccurate name because all artists did this before Raphael's time, and after Raphael's time did *not* do this, but sought to paint fair pictures, rather than represent stern facts' (12.322).

Millais's source for *Mariana* is doubly literary, first Tennyson's poem of the same name, and then *Measure for Measure*, where Shakespeare's Mariana spends five long years in a moated grange waiting to be reunited with the man she loves. But Millais assembled what, in Ruskin's words, he supposed 'might have been the actual facts of the scene' by studying the stained glass in Merton College Chapel and painting the view of his patron Thomas Combe's garden.

Ruskin thought this the only one of the paintings attacked by *The Times* that had even a minor error of perspective, in the top of the green curtain above the 'idolatrous toilet table' (12.320). He praised especially the white drapery. It was only after Ruskin's letters to *The Times* were published that the artists and the critic met.

7

William Holman Hunt
(1827–1910)

Claudio and Isabella
1850–3
retouched 1879

Oil on panel
77.5 x 45.7

Inscribed 'W. HOLMAN HUNT
1850 | LONDON'

First exhibited
Royal Academy 1853

Tate Gallery. Presented
by the Trustees of the
Chantrey Bequest, 1919

'He who represents deep thoughts and sorrows, as, for instance, Hunt, in his Claudio and Isabella ... *is of the highest rank in his sphere' (Modern Painters* III, 1856, 5.49)

Holman Hunt was always the most 'Ruskinian' of the original PRB, and by his own account he introduced Ruskin's ideas to the group after reading the first two volumes of *Modern Painters* in 1847. In 1848 he resolved to paint his next picture, *Rienzi Vowing to Obtain Justice for the Death of his Brother* (1849, private collection) on Ruskinian principles, 'abjuring altogether brown foliage, smokey clouds and dark corners, painting the whole out of doors, direct on the canvas itself, with every detail I can see' (Hunt 1905, vol.1, p.91). He agreed with Rossetti however that the PRB 'were never realists. I think art would have ceased to have the slightest interest for any of us had the object been only to make a representation elaborate or unelaborate, of a fact in nature' (Hunt 1905, vol.1, p.150).

It was Hunt's combination of realism with symbolism that appealed to Ruskin. He defended Hunt's 1851 Academy picture, *Valentine Rescuing Sylvia from Proteus* (Birmingham Museums and Art Gallery) for its 'marvellous truth in detail and splendour in colour' (12.324), and persuaded the Belfast collector Francis MacCracken to buy it.

Hunt was most gratified by Ruskin's support. Ruskin visited his studio for the first time in August 1852, where he would have seen work in progress on *Claudio and Isabella*, which Hunt had begun in 1850. As with Millais's *Mariana* (cat 6) the subject is taken from *Measure for Measure*, where the condemned Claudio tries to persuade his sister to sacrifice her virginity in exchange for his freedom. Their moral struggle is suggested by the contrast between light and dark, while in the background a church spire stands between the two figures. The lute with its scarlet ribbons – symbolising sexual passion as Judith Bronkhurst has suggested (Parris 1994 p.104) – was painted *in situ* in the Lollard Prison in Lambeth Palace which Hunt used as his setting.

In spite or because of their temperamental similarities, the friendship between Ruskin and Holman Hunt developed slowly (see cats.192, 193, 258).

8

Sir John Everett Millais, Bt

The Return of the Dove to the Ark
1851

Oil on canvas
87.6 x 54.6, arched top

Inscribed 'JMillais 1851'
(initials in monogram)

First exhibited
Royal Academy 1851

The Visitors of the
Ashmolean Museum,
Oxford

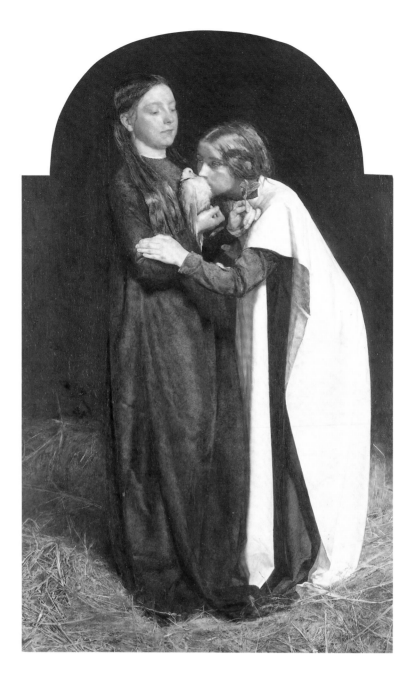

'There is not a single study of drapery in the whole Academy, be it in large works or small, which for perfect truth, power and finish could be compared for an instant with … the right-hand figure'
(Letter to *The Times*, 13 May 1851, 12.322–3)

The artists of the Pre-Raphaelite Brotherhood were encouraged to appeal to Ruskin for critical support in 1851 when they heard that Ruskin's father had offered to buy *The Return of the Dove to the Ark*. (It had, however, already been sold to Millais's patron Thomas Combe.) Ruskin praised the 'intense harmony of colour in the exquisitely finished draperies' (12.325) of the two daughters-in-law of Noah, who hold the dove and the olive-sprig with which it has returned. Privately he criticised the painting of the olive leaves, and publicly

expressed his dislike for the faces and hands of the models. In 1851 he had not yet seen Rossetti's *Ecce Ancilla Domini!* (1850, Tate Gallery), but he later suggested that Millais's picture was influenced by 'the leading genius of Dante Rossetti' (14.267).

The painting is an important link between Ruskin and the first and second generation of Pre-Raphaelites. Edward Burne-Jones recorded that he and William Morris, undergraduates at Oxford, first became aware of the Pre-Raphaelites by reading Ruskin's Edinburgh lectures in 1854, the fourth of which was titled 'Pre-Raphaelitism'. Later that year *The Return of the Dove to the Ark* was put on display in Oxford at the art dealer James Wyatt's shop in the High Street. 'And then', Burne-Jones is recorded as saying, 'we knew' (Burne-Jones 1904, vol.1, p.99).

9

Charles Allston Collins
(1828–1873)

Convent Thoughts
1850–1

Oil on canvas
82.6 x 57.8, arched top

Inscribed 'CAC 51'
(initials in monogram)

Frame designed by
Sir John Everett Millais, Bt

First exhibited
Royal Academy 1851

The Visitors of the
Ashmolean Museum,
Oxford

*'As a mere botanical study … this picture would be invaluable
to me, and I heartily wish it were mine'* (Letter to *The Times*,
13 May 1851, 12.321)

Technically, Collins was not a member of the PRB, a
reminder that the original group had started to break up
before Ruskin's intervention. Millais had proposed that
Collins be elected to replace James Collinson (1825–81),
who resigned in 1850, but he was over-ruled. Millais
and Collins worked closely together in Oxford in 1850,
Collins painting for some of the time in Thomas Combe's
garden. Millais designed the frame for the picture, which
is evidently related to *The Return of the Dove to the Ark*
(cat.8), begun the following year. Combe became the
owner of both pictures.

Collins's High Church sympathies are clearly evident:

the nun – wearing the costume that Holman Hunt had
used in *Claudio and Isabella* (cat.7) – contemplates a passion
flower, while her missal is open at a depiction of the
Crucifixion, and her finger marks the Annunciation. The
lily is associated with the Annunciation, and the nun's
thoughts are on the life of the Virgin, a piece of Mariolatry
not calculated to appeal to Ruskin. In the second of his
two letters to *The Times*, however, he reported the Pre-
Raphaelites' denial of any Romanising tendencies. In
1852 Millais's painting *A Huguenot, on St Bartholomew's Day,
Refusing to Shield Himself from Danger by Wearing the Roman
Catholic Badge* (Makins Collection) made clear his
Protestantism, and Ruskin may indeed have steered the
PRB away from Tractarianism through his influence.
While not ignoring Collins's doctrinal position, Ruskin
argued for the truthfulness of his rendition of nature.

II

Foundations

'Landscape ... the ruling passion of my life.'

The young John Ruskin grew up in a carefree environment in which he was the focus of all his parents' energies and hopes. His father, John James Ruskin, was a successful sherry importer with the firm Ruskin, Telford and Domecq, providing from his profits the comforts of the late Georgian era. With his wide-ranging interests in poetry and art, he acted as a nurturing influence on his son's imagination, countering the more austere, Evangelical regime of his wife Margaret. Both parents were, however, united in seeking to instil a sense of mission in their son. 'You may be doomed to enlighten a People by your Wisdom & to adorn an age by your learning,' Ruskin's father impressed on the 10-year-old boy (RFL.209–10).

Such stern puritanical dictates did not result in an iconoclastic attitude to the trappings of this world, and even Ruskin's earliest home was adorned with a few inherited pictures (cat 20). But his first direct encounter with the art world came in the early 1820s, when his father commissioned a set of family portraits from James Northcote (cat.11–12), an act that proclaimed their new-found respectability. However, the choice of artist was somewhat conservative, as Northcote was by then rather out of touch with the latest developments.

Other unspecified pictures followed in 1828 and 1831, but it was only at the end of the latter year, after paying off the debts accumulated by his father, that John James Ruskin was able to embark on a pattern of buying regularly from the Society of Painters in Water Colours' exhibitions in Pall Mall East. His first acquisition there of a drawing by Anthony Vandyke Copley Fielding took place in 1832 when his son was 13 (cat.21). More than fifty years later, Ruskin could still vividly recall the shared excitement of its arrival at the family home (33.380).

The Old Water Colour Society, as Ruskin generally referred to it, was then enjoying a golden age, its exhibitions featuring the work of many of the generation who had consolidated the technical advances made by J.R. Cozens, J.M.W. Turner and Thomas Girtin in the 1790s. This included Cox (cat.26), Prout (cat.20), Copley Fielding (cat.21), Hunt (cat.35), Harding (cat.37), James Holland (1799–1870), George Cattermole (1800–68), Frederick Tayler (1802–89) and J.F. Lewis (cat.27). By the early 1840s, the Ruskins

owned examples by all of these figures. Ruskin later acknowledged that he and his father were part of a shift in the patronage of British art, and that it was specifically this group of artists that appealed to the new type of middle-class collector (14.373–4), although, significantly, watercolours by these men were also collected by Queen Victoria at the beginning of her reign (see RFL.518–19).

As well as visiting the watercolour shows from early in the 1830s, Ruskin attended the annual Royal Academy exhibitions, then still in Somerset House, making his first visit in 1833. He had by then received the precious copy of Samuel Rogers's poem *Italy*, which included Turner's vignettes (cat.17), and the spell of Turner pervaded the ensuing years. The Ruskins bought their first drawing by him in 1839, restricting themselves to his watercolours, no doubt, partly because his oils were at this stage beyond their budget. John James intended this first watercolour to suffice as a 'specimen of Turner's work', rather than as the foundation of a collection, but inevitably others followed (see cat.29).

Like many of his contemporaries, Ruskin was initially bemused by the artist's use of colour (35.217), but he became increasingly angry at the deliberate misunderstandings perpetrated in criticism of Turner's work (cat.2). His response in 1836 effectively planted the seeds of *Modern Painters*, and forced him to question the nature of criticism and its impact on the public. In 1837 he wrote of this matter in his essay *The Poetry of Architecture*: 'it is not to the public that the judgement is intrusted. It is by the chosen few, by our nobility and men of taste and talent, that the decision is made, the fame bestowed, and the artist encouraged' (1.7). It was not long, however, before Ruskin considered himself fit to join the ranks of those who arbitrated on public taste.

Gaps in his incomplete visual education continued to be filled at nearby Dulwich Picture Gallery, and at the nascent National Gallery. But he was also greatly indebted to the generosity of various collectors, who gave him access to their pictures. Perhaps most significant in the training of his critical faculties, however, were his own studies with a succession of drawing masters, through which he came to appreciate the practice and the imaginative limitations of drawing from nature.

IW

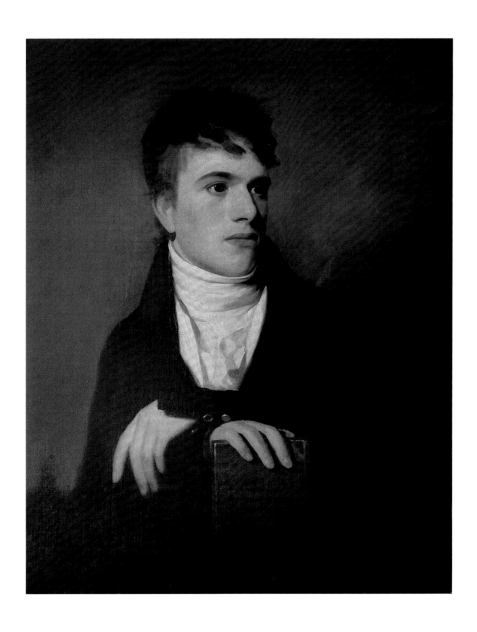

10

George Watson
(1767–1837)

Portrait of
John James Ruskin
1802

Oil on canvas
77.5 x 61

Ruskin Foundation
(Ruskin Library,
University of Lancaster)

'we both of us had alike a subdued consciousness of being
profane and rebellious characters, compared to my mother'
(*Praeterita*, 35.95)

Ruskin's father, John James (1785–1864), was born in
Edinburgh, the son of a grocer. He attended the Royal
High School there for six years from 1795, making
good progress that seemed to bode well for his hopes
of becoming a lawyer. However, when he was 16, his
father put pressure on him to go to London and take
up trade.

Unlike his father, whose business skills were seriously
flawed, John James had a real aptitude for commerce,
founded on unstinting hard work, as much as instinctive
flare. By 1808 he was working for the wine importing
firm Gordon, Murphy and Co., where he met Pedro
Domecq, whose family owned extensive vineyards in
Spain (cat.27). The two men were unhappy with the style

of their employers, and around 1814 decided to found
their own company, seeking financial support from
a third partner, Henry Telford.

The firm quickly prospered, but it was not until
after his father's suicide that John James was able to end
his nine-year engagement to his cousin Margaret Cock
(cat.12). He married her on 2 February 1818, and they
shortly afterwards set up home in Hunter Street, London.
By 1823 the couple had left this home for no. 28, Herne
Hill, where they lived until 1842, at which date they
moved into an even bigger house close by, no. 163,
Denmark Hill. As a result of his Scottish schooling,
John James had a love of literature, especially the works
of Byron and Scott. He also had an amateur interest
in painting (cat.13). To his son's lasting benefit and
salvation, he was able to communicate these passions,
continuing to share in the discoveries of Ruskin's
ongoing education.

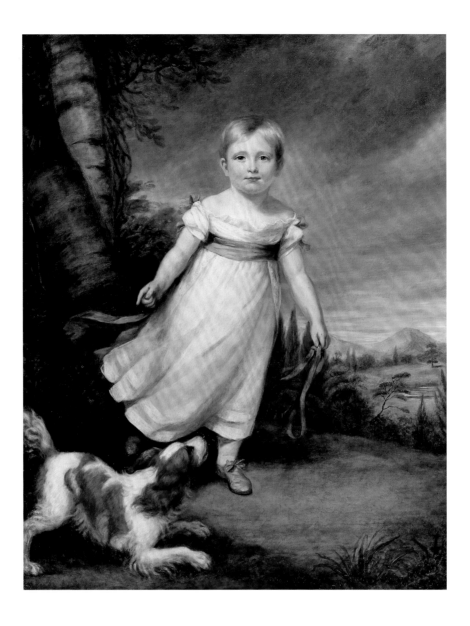

II

James Northcote
(1746–1831)

Portrait of John Ruskin at the age of three and a half
1822

Oil on canvas
126.7 x 101

Inscribed

National Portrait Gallery, London

'I am represented as running in a field at the edge of a wood with the trunks of its trees striped across in the manner of Sir Joshua Reynolds; while two rounded hills, as blue as my shoes, appear in the distance, which were put in by the painter at my own request; for I had already been once, if not twice, taken to Scotland' (*Praeterita*, 36.21)

This record of Ruskin's early childhood was the first significant commission made by John James, and represents the future critic's first contact with an artist. The family was currently living in Hunter Street, near the British Museum, from where Ruskin was taken to Northcote's studio in Argyll Street. In recalling his sittings, he regretted that he was unable to remember taking any real interest in the application of pigment to canvas.

The traditional title of the portrait suggests that it may have been painted during the summer of 1822, probably in August. By this stage in the year it would have been clear that the income from John James's business investments had fallen substantially for the first time since 1816 (RFL.107n). However, this does not seem to have deterred him from spending 40 guineas on this portrait (double what he paid for the smaller pictures of his wife and himself; cat.12). Typically, the Ruskins put their son first, though the production of the pair of portraits of themselves a couple of years later suggests they always planned the set as a family trinity.

Northcote had been a pupil of Sir Joshua Reynolds, and was by the 1820s an established member of the Royal Academy, noted for his standard range of bust and half-length portraits. He had begun his career in Italy, intending to become a history painter, and continued to retain hopes of succeeding in this line, a motive which lies behind a second picture he painted using the infant Ruskin as his model (Sotheby's, 20 May 1931, untraced; 35 pl.III).

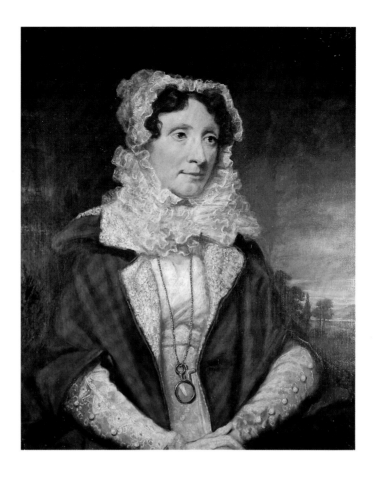

12

James Northcote

Portrait of
Margaret Ruskin
1825

Oil on canvas
75 x 62.2

Inscribed 'JS. Northcote
Pixt. 1825'

Ruskin Foundation
(Ruskin Library,
University of Lancaster)

'My mother had, as she afterwards told me, solemnly "devoted me
to God" before I was born; in imitation of Hannah … Very good
women are remarkably apt to make away with their children
prematurely, in this manner … "Devoting me to God," meant,
as far as my mother knew herself what she meant, that she would
try to send me to college, and make a clergyman of me: and I was
accordingly bred for "the Church"' (Praeterita, 36.24)

It is certainly true that the fixed Evangelical beliefs of
Margaret Ruskin cast a profound shadow over the entire
life of her son. Throughout his childhood he was made to
study the Bible every day, absorbing a few chapters until
the book was completed and was then begun again. This
disciplined practice infused his later writings with the
language and music of the Bible, equipping Ruskin with
the skills to extract a moral from any given text.

Margaret Ruskin (1781–1871) was born in Croydon,
the daughter of William Cock, landlord of the King's
Head tavern. She was a first cousin, through her mother,
of her future husband, with whose family in Edinburgh
she had gone to live by 1801. After their engagement in
1809, she waited patiently for John James to establish him-
self in business, coping with his increasingly ailing father.

John James was an attentive suitor, even after they
were married, writing ardent letters almost daily. One
of these letters concerns his disappointment in the
representation of her by Northcote, which he considered
'very far below the original in every feature in every
expression except a certain Benignity of aspect & of
feminine retiring sweetness a certain mildness & quiet-
ness & extreme modesty of demeanour … To have a
good likeness of you I conceive the painter must be
freer from evil than painters ever are. They are not the
best of men, & they cannot portray the best of Women'
(RFL.132–4).

The commission to paint Mrs Ruskin in 1825 also
involved a companion picture of her husband, now sadly
untraced (Christie's, New York, 5 Nov. 1982; 35 pl.VII).
Ruskin was demonstrably proud of the portrait of his
father, comparing it with Reynolds's *Banished Lord*, one
of the first British pictures to enter the national collection
(Tate Gallery). He later wrote, 'I always rejoice to think
that my father had the good taste and the good sense to
have his portrait painted by so clever an artist' (34.668).
Strangely, he does not seem to have commented on
this work.

13

John James Ruskin
(1785–1864)

Conway Castle
c. 1795–1800

Watercolour
26 x 35.5

Ruskin Foundation
(Ruskin Library,
University of Lancaster)

'Conway Castle, to show how boys were taught to draw in Edinburgh in the olden time' (Notes by Mr Ruskin on his Drawings by the Late J.M.W. Turner, 1878, 13.400)

In one of the letters published under the collective heading *Fors Clavigera*, written in June 1875, Ruskin identified this drawing by his father as having played a key role in the development of his powers of imagination. He related how his father had sought to please him, 'without infringing any of [his] mother's rules', by inventing stories as he shaved about the view of Conway that hung over his dressing-table: 'The custom began without any initial purpose of his, in consequence of my troublesome curiosity whether the fisherman lived in the cottage, and where he was going to in the boat. It being settled, for peace' sake, that he did live in the cottage, and was going in the boat to fish near the castle, the plot of the drama afterwards gradually thickened; and became, I believe, involved with that of the tragedy of "Douglas," and of the "Castle Spectre"' (28.346–7).

John James Ruskin learnt to paint while a schoolboy in Edinburgh, probably as a result of studying with Alexander Nasmyth (1758–1840), who instilled a whole generation with the importance of drawing as a tool of empirical investigation. In this account of the drawing,

and in the later repetition of these details in *Praeterita* and elsewhere, Ruskin deliberately sought to link his father's efforts with J.M.W. Turner's adolescent work, noting that the view of Conway Castle had been made at exactly the same time that Turner was learning the techniques of the tinted drawing from Dr Thomas Monro. Ruskin recalled that his father continued to paint using this method at times during his own childhood, when he would 'sit reverently by and watch' (28.171). The drawing remained with Ruskin until his death, hanging among the group of Turner watercolours in his bedroom (fig.1; top left).

fig.1 Arthur Severn, *John Ruskin's Bedroom, Brantwood*, 1900 (Ruskin Foundation, Ruskin Library, Lancaster)

14

John Ruskin

*Ruskin's First
Sketchbook*
c. 1829–32

Pencil
21 x 26 (open)

Inscribed 'Gateway of
a College at | Maidstone
inside view'

First exhibited Coniston
Institute, Ruskin Memorial
Exhibition 1900

Ruskin Foundation
(Ruskin Library,
University of Lancaster)

*'I never saw any boy's work in my life showing so little original
faculty, or grasp by memory. I could literally draw nothing, not
a cat, not a mouse, not a boat, not a brush "out of my head," and
there was, luckily, at present no idea on the part either of parents
or preceptor, of teaching me to draw out of other people's heads'*
(*Praeterita*, 35.75)

Up until the age of 10, Ruskin studied at home under
the watchful gaze of his parents. The nature of the
Ruskins' beliefs ensured that much of what he studied
was religious in tone, but he also learnt Latin and Greek,
as well as developing an interest in geology (see cat.23).
On a parallel front, the co-ordination of his hand and eye
was encouraged through the laborious copying of maps
or book illustrations, such as those Cruikshank made for
an edition of Grimms' fairy-tales.

Throughout his childhood Ruskin was accustomed
to travelling around Britain with his parents, and in 1825,
aged 6, he accompanied them on a brief tour to Waterloo
and other places on the Continent. From around 1829
he began to try to record his impressions of these travels
in his own sketches. He may have started to make use
of this book during a tour of Derbyshire in 1829, but it
also includes views of places in southern England, such
as Dover and this study at Maidstone, made a couple of
years later in 1832. One of the pages formerly in the book
shows a view of a street in Sevenoaks (dated 1831), which
Ruskin claimed was his first sketch from nature. Looking
at them nearly fifty years later, he recalled that he 'got
little satisfaction and less praise by these works; but
the native architectural instinct is instantly developed
in these, – highly notable for any one who cares to note
such nativities' (35.77–8).

The sketchbook is open at a view of a college gate-
way at Maidstone, with a sketch of a decorative boss,
and notes derived from a military parade.

15

Thomas Jeavons
(*c.* 1800–1867)

Vesuvius
1830

after Joseph Mallord
William Turner

Illustration to
The Friendship's Offering
1830

Line engraving on steel
16 x 22 (open)

Ruskin Foundation
(Ruskin Library,
University of Lancaster)

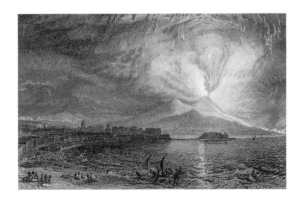

'it was the first piece of Turner I ever saw' (*Notes by Mr Ruskin
on his Drawings by the Late J.M.W. Turner*, 1878, 13.428)

Though the direction of Ruskin's subsequent devotion
to Turner has rightly been attributed to the illustrations
he discovered in the 1830 edition of Rogers's *Italy*
(cat.17), it has generally been overlooked that he knew
other examples of the artist's work somewhat earlier.
This view of Vesuvius, for example, was identified by
Ruskin as his first contact with Turner's art. He later
owned the original watercolour and its pair (Williamson
Art Gallery, Birkenhead, and private collection) (13.428).

The Friendship's Offering, in which Turner's
design appeared, is typical of the 'Annuals' that were
competitively produced in the years around 1830.

These luxurious volumes combined generally light
literary pieces with exquisite illustrations, and
represented, as Ruskin later noted, 'the practical and
artistic inspiration of the age' (34.93–4). Between
1835 and 1844 Ruskin was a regular contributor to
The Friendship's Offering, which was published by Smith,
Elder. His cousin worked for the firm as an apprentice,
and had alerted its editor Thomas Pringle to Ruskin's
ambitions as a poet.

Ruskin's familiarity with this view of Vesuvius
contributed significantly to his perception of Turner as
an artist who was scrupulously faithful to nature. Writing
from Naples in 1841, he recalled the design as 'a glorious
thing – all sparkle and whizz', saying of Turner, 'He is
the only man of whom nature now reminds me; the only
one, of all landscape painters, ancient or modern, to
whom she seems to have laid her heart open – to have
really requited the attachment. How he has watched her
humours night and day – as I can trace in every touch –
down or up – to the black shades in the cone of Vesuvius
who is insulted by every other representation but his'
(Letter to W.H. Harrison, 30 Jan. 1841, 1.445). Ironically,
Turner had not actually seen Vesuvius when he painted
his watercolour, and was dependent on a *camera obscura*
drawing by James Hakewill.

The Friendship's Offering is open at p.27, 'Vesuvius,
from a Painting by J.M.W. Turner, R.A. in the collection
of Benjamin Godfrey Windus' (see cat.38).

16

John Ruskin

Trees and Pond
c. 1831–2

Watercolour and ink
over pencil
30.8 x 23.2

The Visitors of the
Ashmolean Museum,
Oxford

'It must have been in the spring of 1831 that the important step was taken of giving me a drawing master' (*Praeterita*, 35.76)

Charles Runciman (fl. 1825–67) was the first artist to try to shape Ruskin's draughtsmanship. He was originally employed to instruct Ruskin's cousin Mary Richardson (1815–49), who had lived with his family since 1828, following the death of her mother. However, Ruskin was soon also the beneficiary of an hour a week from the 'pleasant' drawing master (35.76). Little is known of Runciman, who subsequently sent works to the annual exhibitions at the Society of British Artists, the British Institution and the Royal Academy. He was principally a landscape artist, but occasionally turned his hand to genre or literary subjects. Ruskin remembered him as a

'rigidian' in his approach to perspective, and, many years later, took great pleasure in disproving his teacher's criticism of how Turner had depicted a building in the family painting, *The Grand Canal, Venice* (19 Sept. 1851, Bradley 1978, p.16) (see cat.44).

Perhaps because Ruskin spent so much of his adult life teaching rudimentary and elementary drawing skills, he was especially inclined to be critical of his first tutor. Nevertheless, Runciman cultivated in him an understanding of composition, while stimulating his pupil to more imaginative endeavours than simple copying. This watercolour is typical of the fanciful inventions Ruskin produced during this period of his studies, in which he brought together details from various models supplied by Runciman (RFL.262–3; I.xxxiin).

43

MARGUERITE DE TOURS.

17

Henry Le Keux
(1787–1868)

Aosta
engr. 1829

after Joseph Mallord
William Turner

Illustration to
Samuel Rogers, *Italy* 1830

Line engraving
20 X 13.5

Tate Gallery Library

'This book was the first means I had of looking carefully at Turner's work: and I might, not without some appearance of reason, attribute to the gift the entire direction of my life's energies' (*Praeterita*, 35.29)

On 8 February 1832, his thirteenth birthday, Ruskin reportedly received a copy of the revised edition of Samuel Rogers's poem *Italy* from his father's business partner, Henry Telford. This new edition included illustrations by contemporaries such as Thomas Stothard (1755–1834) and Samuel Prout. But most importantly, it contained twenty-five exquisitely engraved vignette designs by Turner. Though evidence that this tradition was correct eluded Ruskin in old age, Telford's gift was clearly an event of tremendous significance in the development of his regard for Turner's work, consolidating what he knew from other recent engravings (cat.15). Indeed, within the family, the present was perceived as a turning point: 'Poor Telford', Ruskin recalled, was held to be 'primarily responsible for my Turner insanities' (35.29).

In his autobiography, Ruskin stressed that the essential significance of this gift was that he 'could understand Turner's work, when I saw it'. He went on to chide those biographers inclined to attribute to a particular event 'all the circumstances of character' that subsequently develop, rather than the specific factors that made the event important at the time (35.29). However, later in the same book he focuses again on Telford's present, giving it a slightly different meaning: 'At that time I had never heard of Turner, except in the well-remembered saying of Mr.Runciman's, that "the world had lately been much dazzled and led away by some splendid ideas thrown out by Turner". But I had no sooner cast eyes on the Rogers vignettes than I took them for my only masters, and set myself to imitate them as far as I possibly could by fine pen shading' (35.79). Here is a sensibility transformed by something new, whereas the first account suggests Ruskin had simply been waiting for stimulus of exactly the kind that Turner's works offered. The shift of emphasis is subtle, but significant: Ruskin admitted that the precise details had perhaps been lost in the endless retellings over the years.

What he particularly admired in Turner's designs was what he called their 'mountain truth' (35.254). This quality shaped the way he approached mountain scenery in the following years, so that when he visited the Lake of Como in 1835, he measured the reality against Turner's depiction of it (35.117). The subjects he most admired tended to be the distillations of the alpine border region, several of which he copied himself. And much later, once the original drawings were accessible as part of the national collection, he encouraged others to copy these for themselves to understand Turner's skills (see 13.616–18).

It is interesting to note that it was the black and white line engravings that so enthralled the young Ruskin. In his forties he admitted to a certain disappointment in Turner's original watercolours for the series (29 Feb. 1868, D2.643; 35.216). However, this was attributable to his fuller knowledge of Turner, and his uneasy perception that the artist was a flawed hero (see cat.63). Back in the 1830s, he aspired to equal these engraved works in his own draughtsmanship; Turner's colour was to be something he had to confront later.

Rogers's *Italy* is open at pp.24–5, to illustrate the poem 'Marguerite de Tours'.

18

John Ruskin

Hotel de Ville, Brussels
1833

after Samuel Prout

Pen and ink
17.2 x 11

First exhibited Coniston Institute, Ruskin Memorial Exhibition 1900

Ruskin Foundation (Ruskin Library, University of Lancaster)

'Copy from Prout's wonderful drawing in his Sketches in Flanders and Germany. Made at home (Herne Hill), with other such, to "illustrate" my diary of that first Continental Travel' (Notes by Mr Ruskin on his Drawings by the Late J.M.W. Turner, 1878, 13.505)

Ruskin's lifelong fondness for the works of Samuel Prout originates from the same kind of intense childhood experience as his parallel devotion to Turner. In this case, the specific event was the acquisition of Prout's latest set of lithographs prior to the family's summer tour of 1833. John James Ruskin had been one of the subscribers to the volume, which enthralled the whole family on its completion, and tempted them to plan their own journey to some of the places depicted. This was not, as Ruskin suggests, altogether his 'first' foreign tour. It was, none the less, the first journey abroad on which he was old enough to comprehend what he was seeing and to respond to it (see cat.19).

Prout had established his reputation as an architectural draughtsman, with a partiality for tumble-down, picturesque subject-matter (cat.20). His work may have appealed especially as his finely shaped lines found a ready echo in Ruskin's own early manner, though in this copy the delicacy of Prout's style is not always successfully replicated, and the nuances of perspective have sometimes eluded Ruskin.

In the first volume of *Modern Painters* (1843) Ruskin celebrated Prout as one of the greatest contemporary artists: 'I repeat there is nothing but the work of Prout which is true, living, or right, in its general impression, and nothing, therefore, so inexhaustibly agreeable' (3.217–18). Justifying this praise, he pointed especially to the *Facsimiles of Sketches made in Flanders and Germany*, claiming 'The spirit of the Flemish Hôtel de Ville and decorated street architecture has never been, even in the slightest degree, felt or conveyed except by him, and by him, to my mind, faultlessly and absolutely' (3.219).

19

John Ruskin

Ehrenbreitstein
1833–4

From the manuscript known as 'An Account of a Tour on the Continent'

Pen and ink
7.6 x 11.4 (image only)

Beinecke Rare Book and Manuscript Library, Yale University, New Haven

[Not exhibited]

'The winter of '33 and what time I could steal to amuse myself in, out of '34, were spent in composing, writing fair, and drawing vignettes for the decoration of the aforesaid poetical account of our tour, in imitation of Rogers's Italy' (Praeterita, 35.81)

The text and illustrations of this manuscript are an attempt to synthesise the formative experiences of the Ruskin family's 1833 summer tour. This took them across Belgium to the Rhine, and thence to Switzerland (D1.1; cf. *Praeterita*, 35.80, which gives different details for this

journey). Most significantly, in terms of his later interest in the mountains of this region, it was on this journey that Ruskin first visited Chamonix (see cat.34).

Ruskin at first intended to produce a poem with 150 verses, but found he was unable to complete such an ambitious project, leaving it unfinished when he moved on to other schemes (for the full text, see 2.340–87). Two sections subsequently appeared in *The Friendship's Offering* for 1835, and were among the first of his poems to be published. As well as demonstrating the extent to which the 14-year-old Ruskin was influenced by the wanderlust poetry of Byron and Rogers, this manuscript reveals the obvious visual links between his vignettes and those made by Turner for the collected works of these two poets in the early 1830s. In particular, this well-known view seems to epitomise Ruskin's desire to imitate the page lay-out and the illustrations of Rogers's *Italy*. But, in fact, the image is a direct copy of a view by Turner from another source: his watercolour depiction of Ehrenbreitstein, as it looked in 1817 (Bury Art Gallery and Museum), was engraved for *The Keepsake* annual for 1833, and it was from a copy of this print that Ruskin must have worked when drawing his version.

'Sometimes I tire somewhat of Turner, but never of Prout'
(In conversation with M.H. Spielmann, 1884, 34.668)

This is one of at least 19 drawings by Prout that were
formerly part of the Ruskin family collection. Their first
example was a modest view of a cottage, apparently
bought by Ruskin's grandfather (35.75; repr. Dearden
1994, p.185). Ruskin recalled that it 'hung in the corner
of our little dining parlour at Herne Hill as early as I can
remember', and claimed it had had 'a most fateful and
continual power over my childish mind' (14.385).

To add to the lithographs they had acquired the
previous year, in 1834 John James Ruskin purchased
this drawing at the annual exhibition of the Old Water
Colour Society. In these early days of the family's
collecting activities, there was some anxiety about the
cost and means of acquiring pictures, and it is clear they
felt Prout's prices were rather inflated (RFL.313). Though
the sum paid was only 9 guineas, Ruskin retained a sense
of the drawing as an extravagance, and later suggested it
had cost double this price (14.403).

Ruskin was charmed by Prout's rugged picturesque
style, but felt compelled to voice various reservations in
Modern Painters (3.256). In a private letter, prompted by
the artist's objection to these publicly expressed doubts,
he reassured Prout that he admired his works for their
genuineness, purity and truth (38.336). In spite of this
awkwardness, Prout became a good friend of the family,
and from 1844 was regularly invited to Ruskin's birthday
dinners. Furthermore, on at least two occasions in the
mid-1840s, he produced watercolours that he developed
from sketches by Ruskin (Hewison 1978, pp.42–3;
Sumner 1989, p.32; cat.67).

Ruskin went on to champion Prout more extensively,
both in an article for the *Art Journal* in 1849 (12.305–15),
and thirty years later in an exhibition at the Fine Art
Society, which brought together the work of Prout and
William Henry Hunt (14.365–454; cat.35). This view of
Lisieux was included in the 1879 show, where Ruskin
observed that Prout was more properly a draughtsman
of stone, rather than of wood, but that the drawing was
nevertheless 'one of the best in the room' (14.414).

21

Anthony Vandyke
Copley Fielding
(1787–1855)

Loch Achray
early 1830s

Watercolour
18 x 26

Birmingham Museums
and Art Gallery

'My father and I were in absolute sympathy about Copley Fielding, and I could find it in my heart now to wish I had lived at the Land's End, and never seen any art but Prout's and his'
(*Praeterita*, 35.213)

The first picture that John James Ruskin bought from the Old Water Colour Society was Fielding's *Scene between Inveroran and King's House, Argyllshire*, which appeared in the 1832 exhibition, priced at the not inconsiderable sum of 45 guineas (plus another 12 for the frame). It was joined a year later by a seascape, specifically

commissioned by the Ruskins. These works remained in the family collection for many years, prominently displayed in the Drawing Room. Ruskin attempted to part with them only in 1869, when he sold a large group of pictures, some of which were particularly associated with his father, who had died five years earlier (13.569–72; 33.379n).

Fielding was a tremendously successful artist during the 1830s and 1840s, producing a relentless succession of watercolours for the annual exhibitions, though many of these were repetitive and formulaic. (Another version of this composition, dated 1836, was sold recently at Sotheby's (25 Nov. 1999).) During his first years in London he studied with the influential watercolourist John Varley, and soon afterwards began to take pupils of his own. By 1812 he had become a full member of the Old Water Colour Society, which was the chief forum for his work. He was thoroughly involved in the business of the society, so that, when the post of President fell vacant in 1831, he was the obvious candidate. John James Ruskin's acquisitions came in the years immediately after Fielding assumed this role, and his new prominence must also have been a factor influencing the decision to employ him as a more advanced drawing master for Ruskin from 1834–5.

22

John Ruskin

Copy of A.V. Copley Fielding's 'Loch Achray'
c. 1834–5

Pencil and watercolour
17.8 x 25.8

First exhibited Consiston
Institute, Ruskin Memorial
Exhibition 1900

Ruskin Foundation
(Ruskin Library,
University of Lancaster)

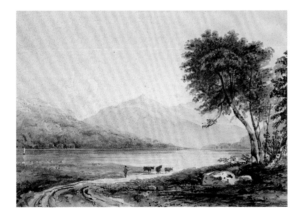

'I cannot bear to paint in oil
C. Fieldings tints alone for me'
(Letter to his father, 11 Mar. 1835, RFL.312)

Ruskin's studies with Runciman may have included rudimentary attempts to paint in oil, but this was a medium he was never happy with. In contrast, he found the lessons in watercolour that he undertook with Fielding far more suited to his temperament and abilities. These began in 1834, costing a guinea for a lesson lasting an hour, of which Ruskin had something like eight or nine. They were also attended by his father, who was

delighted at the opportunity of becoming acquainted with the celebrated artist.

Ruskin recalled that Fielding taught him to 'wash colour smoothly in successive tints, to shade cobalt through pink madder into yellow ochre for skies, to use a broken scraggy touch for the tops of mountains, to represent calm lakes by broad strips of shade with lines of light between them, … to produce dark clouds and rain with twelve or twenty successive washes, and to crumble burnt umber with a dry brush for foliage and foreground' (35.215). Following these techniques, he produced a copy of one of Fielding's views of Loch Achray, quite possibly this drawing, with which he was so satisfied that he hung it over his bedroom chimney-piece. He woke to see it the following morning 'with a rapture, mixed with self-complacency and the sense of new faculty, in which I floated all that day, as in a newly-discovered and strongly buoyant species of air' (35.216).

Fielding was one of the artists that Ruskin particularly celebrated in the first volume of *Modern Painters* (1843). He wrote of the intense and healthy pleasures that Fielding's watercolours imparted: 'healthy, because always based on his faithful and simple rendering of nature, and that of very lovely and impressive nature, altogether freed from coarseness, violence, or vulgarity' (3.196).

23

John Ruskin

Geological Diary
1835

Pen and ink
18 x 11.3 (page size)

Text transcribed in Diaries,
1.2–72. Inscribed 'Lent
by Mr Ruskin Junior to
J.C.Loudon, and with
Mr Ruskin's consent to
Mr Bakewell to see if there
is anything in them for
M[agazine of] N[atural]
H[istory], April 12th, 1836'

Ruskin Foundation
(Ruskin Library,
University of Lancaster)

'The granite ranges of Mont Blanc are as interesting to the
geologist as they are to the painter' (*Facts and Considerations
on the Strata of Mont Blanc, and on Some Instances of
Twisted Strata Observable in Switzerland*, 1834, 1.194)

In his youth, Ruskin was consumed by his interest in
geology to a far greater extent than his interest in art.
He professed, in retrospect, to have an 'unabated, never
to be abated, geological instinct' (35.120–1), and on one
occasion even voiced his regret at being distracted from
his fascination for mineralogy by the 'unlucky gift' of
Rogers's *Italy*, with its Turner illustrations, believing that

it had prevented him from making further contributions
to this budding science (26.97).

His father appears to have set this passion in train
by buying a box of rock samples while travelling in the
Lake District. 'No subsequent possession has had so
much influence on my life' was Ruskin's later opinion,
and he identified these first stones as 'the beginning of
science to me which never could have been otherwise
acquired' (26.294n; 27.62). By the time he was 12 he had
begun a mineralogical dictionary founded on his studies
of specimens in the British Museum (35.121). His
ambition at this stage was to become President of the
Geological Society, an institution he attended regularly
from at least as early as 1837, and of which he became
a Fellow in 1840. A year before setting out on the tour
recorded in this notebook, two of his geological essays
had been published in J.C. Loudon's *Magazine of Natural
History*, though he was then only 15 (1.191–6). His
birthday present in 1835 had been a copy of the book
Voyage dans les Alpes by Horace Bénédict de Saussure
(1740–99). This suggested a number of lines of scientific
enquiry that Ruskin followed as he travelled, and which
are recorded in his notes, including his attempts to make
notations of variations in the intensity of blue in the
firmament as observed with a tool called a cyanometer.

Ruskin's Geological Diary is open at pp.50–1.

24

John Ruskin

*The Piazzetta and
St Mark's, Venice*
1835

Pencil, pen and ink
24 x 33

Inscribed 'Part of
St Mark's Church,
and entrance to Doges
Palace / VENICE'

Ruskin Foundation
(Ruskin Library,
University of Lancaster)

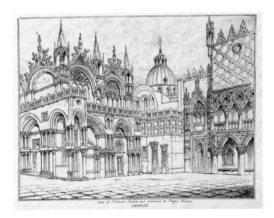

'The drawings I made in 1835 were really interesting even to
artists, and appeared promising enough to my father to justify
him in promoting me from Mr Runciman's tutelage to the higher
privileges of artistic instruction' (*Praeterita*, 35.214)

While it is certainly true that the drawings resulting from
the 1835 tour were a real milestone in the development
of Ruskin's confidence as a draughtsman, he had, in fact,
already begun his studies with Anthony Vandyke Copley
Fielding prior to the journey (see cat.22). In terms of

what he produced on his travels, however, Fielding's
influence is barely discernible. For, rather than pursuing
the soft tonal approach to landscape that was charac-
teristic of his teacher, Ruskin persevered with his linear
architectural studies in a manner that is ultimately derived
from Prout. The surviving drawings were generally
worked up in pen and ink from (or over) the pencil
sketches made on the spot. In his selection of subjects,
he continued to focus most frequently on important or
picturesque buildings, though he also undertook several
pure landscapes. Often he would experiment with
subjects where the perspective overlapped in a highly
complicated way, such as in this view showing the
meeting point between the southern side of St Mark's
Basilica and the western façade of the Ducal Palace.

The stay in Venice, between 6 and 12 October 1835,
was Ruskin's first visit to the city, and came towards the
end of the tour, after he had already spent more than
two months travelling through the Alpine region. He is
known to have made at least four drawings, all of which
focus on the area close to the Ducal Palace, the building
that was to be so important to him in later years
(cats.76, 83, 84; for another of the 1835 views of Venice,
see 35 pl.VIII).

25

John Ruskin

*Comparative Types
of Chimneys*
1838

Figs. 53–70, from
'The Poetry of
Architecture; or,
The Architecture of
the Nations of Europe
considered in its
Association with Natural
Scenery and National
Character', in *The
Architectural Magazine*,
Apr. 1838

Woodcut engravings
22.4 x 13.8 (page size)

Ruskin Foundation
(Ruskin Library,
University of Lancaster)

*'No boy could possibly have been more excited than I was by
seeing Italy and the Alps; neither boy nor man ever knew better
the difference between a Cumberland cottage and Venetian palace,
or a Cumberland stream and the Rhone'* (Praeterita, 35.220)

The 18-year-old Ruskin spent the summer of 1837 in
Yorkshire and the Lake District, which prompted him
to contrast its vernacular architecture with what he had
seen during his earlier foreign travels. His deliberations,
founded on his already ingrained habit of close
observation, mark the beginning of a more disciplined
approach on his part to the study of architecture. The
result was an extended discussion entitled 'The Poetry

of Architecture', focusing on the nature of national styles,
which appeared in monthly instalments in J.C. Loudon's
Architectural Magazine (1.5–188). This was Ruskin's first
truly promising literary work, but, as with the first
volume of *Modern Painters*, he did not publish it under
his own name, adopting in this case the nom-de-plume
Kata Phusin (literally 'According to Nature').

The central focus of the piece attempted to
explain the differences between the cottages found in
Westmorland and the Swiss Alps. In the illustration
shown here, the chimneys of three English cottages
(figs. 53–4) are contrasted with examples from the
Netherlands (fig. 56), Germany (figs. 57–8), Italy (figs. 59,
65–6), Spain (figs. 60–4), and Switzerland (figs. 68–70).
As Ruskin had not visited either the Netherlands or
Spain, he presumably drew his examples from prints or
pictures in the family collection. He described the chief
characteristic of the English types as a 'down-right
serviceableness of appearance, a substantial, unaffected,
decent, and chimney-like deportment, in the contem-
plation of which we experience infinite pleasure and
edification, particularly as it seems to us to be strongly
contrasted with an appearance, in all the other chimneys,
of an indefinable something, only to be expressed by the
interesting word "humbug"' (1.57).

The Architectural Magazine for April 1838 is open at
pp.148–9.

26

David Cox
(1783–1859)

*Watermill, near
Dolbenmaen*
1837

Watercolour over pencil
in its original frame
21.5 x 29.2

First exhibited
Old Water Colour Society
1837

Private collection

*'Cox is a much more agreeable artist, as to results, than De Wint,
and a much simpler one than Harding. De Wint is always true,
always wonderful, and always ugly. Cox is neither so true, nor
so powerful, but his sketch is twenty times more beautiful'*
(Letter to Edward Clayton, 3 Dec. 1840, 1.427)

At the time he expressed these sentiments about David
Cox, the Ruskin family collection already included three
exhibition watercolours by him, including this work,
from the Old Water Colour Society. But in these com-
ments to his former college friend, there is a sense that
Ruskin is trying to justify the artist's appeal within his
self-imposed criterion that art should be true to nature.

A couple of years later, in the first volume of *Modern
Painters*, he was similarly inclined to view Cox in these
terms. He alluded to Cox's 'seemingly careless execution'
and his 'loose and blotted handling' (3.193, 195), remarks
which forced him to justify the notion of an individual's
style, though this argument seemed to run counter to his
promotion of the objective presentation of visual fact
(3.193–4). Developing his point in relation to Cox, he
claimed, 'There is no other means by which his object
could be attained; the looseness, coolness, and moisture
of his herbage, the rustling crumpled freshness of his
broad-leaved weeds, the play of pleasant light across
his deep heathered moor or plashing sand, the melting
of fragments of white mist into the dropping blue above;
all of this has not been fully recorded except by him'
(3.195).

By 1871, however, he was more resolute in his
views about Cox, having by that stage sold this water-
colour at Christie's (13.572). In his *Lectures on Landscape*
he delivered a forceful criticism of Cox and Constable
(1776–1837), who he claimed 'represented in their
intensity the qualities adverse to all accurate science
or skill in landscape art; their work being the mere
blundering of clever peasants … [with] the pretence
of ability which blinds the public to all the virtue of
patience and to all the difficulty of precision' (22.58).

27

John Frederick Lewis
(1805–1876)

*A Fiesta Scene in
the South of Spain –
Peasants &c., of
Granada dancing
the Bolero*
1837

Watercolour
and bodycolour
66.7 x 86.1

First exhibited
Old Water Colour Society
1837

Bristol Art Gallery

*'The painter of greatest power, next to Turner, in the English
School'* (*Praeterita*, 35.373)

J.F. Lewis is now best known for his almost photographic
studies of Egyptian life (cat.120), but in his own lifetime
he was generally referred to as 'Spanish Lewis'. This was
partly to differentiate him from other members of his
artistic family, but also because he was one of a number
of artists who brought back images of the Iberian
peninsula when the region was largely unfamiliar to
British travellers.

This festive scene by Lewis was shown at the Old
Water Colour Society in 1837, but entries in John James
Ruskin's account books suggest that he had already
reserved the painting at the end of the previous year,
and that he paid for it in instalments. Presumably, on
one level, it appealed because of its connection with
Spain, the source of the sherry merchant's prosperity.

At 130 guineas, it was easily the family's most expensive
acquisition to date, but Ruskin later stated that it had
been 'the pride of Herne Hill ever since' (13.593).

Though Ruskin knew other examples of Lewis's
work, it is likely that he was thinking of this picture
when he wrote of the artist in *Modern Painters* in his
discussion of the 'Force of national feeling in all great
painters'. In this section of his book he argued that, as
a general rule, only a native artist could give perfect form
to his country's life and landscape. He was, however,
prepared to concede that an artist with a powerful
imagination might be able 'to throw himself well into
the feeling of foreign nations of his own time; thus John
Lewis has been eminently successful in his seizing of
Spanish character. Yet it may be doubted if the seizure
be such as Spaniards themselves would acknowledge; it
is probably of the habits of the people more than their
hearts' (3.230–1).

28

David Roberts
(1796–1864)

El Khasnè, Petra
1840

from ***The Holy Land,
Syria, Idumea, Arabia,
Egypt & Nubia***

Lithograph 32.8 x 49,
on a sheet 42.3 x 61

Inscribed in the image
'PETRA March 7 1839'

The British Museum

Another artist who explored picturesque Spain in the mid-1830s was David Roberts, whose drawings were engraved to accompany Thomas Roscoe's narrative *The Tourist in Spain* in the *Landscape Annual* (1835–8). One of these, a view of Vittoria, was acquired by John James Ruskin for £21 in March 1840, in part exchange for a drawing by Prout.

A couple of years afterwards, Ruskin joined the impressive list of around six hundred names, whose subscriptions underwrote the production of lithographs charting Roberts's recent travels in the Near East, *The Holy Land, Syria, Idumea, Arabia, Egypt & Nubia. From Sketches made on the Spot*. This landmark project was published serially between 1842 and 1849, and was supplemented by commentaries from the Rev. George Croly (1780–1860), rector of St. Stephen's, Walbrook, and Ruskin's godfather. Ruskin first saw some of the original drawings in 1840, and these had an immediate impact on his own draughtsmanship, particularly during the Continental tour that year (see cats.32, 66). Late in life, he recalled, 'They were faithful and laborious beyond any outlines from nature I had ever seen, and

I felt also that their severely restricted method was within reach of my own skill, and applicable to all my own purposes' (35.262, 35.625).

The value to him of Roberts's style was short-lived, however, even though he continued to appreciate his 'fidelity of intention and honesty of system'. The reservations he expressed in *Modern Painters* concerned his suspicions about the popularity that Roberts shared with Landseer in France, which he attributed to a 'smoothness and over-finish of texture' in his oil paintings. And while he continued to admire the architectural element of the *Holy Land* series, he was critical of what he felt to be a contrived placing of figures in the foregrounds, deliberately overlooking the fact that these were sometimes used to give a sense of scale, as in this work. More seriously, he detected a flaw in Roberts's approach: 'it is bitterly to be regretted that the accuracy and elegance of his work should not be aided by that genuineness of hue and effect which can only be given by the uncompromising effort to paint, not a fine picture, but an impressive and known *verity*' (3.223–6).

29

Joseph Mallord
William Turner

*Christ Church
College, Oxford*
c. 1832

Watercolour
29.9 x 41.9

Engraved by J. Redaway
(fl. 1818–57) for *Picturesque
Views in England and Wales,*
1832

First exhibited
Moon Boys and Graves,
Pall Mall East 1833

Courtesy of Agnew's,
London

In January 1837 Ruskin went up to Oxford to study at
Christ Church. His father had bought him the privileged
rank of a Gentleman-Commoner as a means of gaining
entry to one of the most aristocratic colleges in Oxford.
As a result, Ruskin did not have to face the ordeal of the
usual entrance examination. Ever attentive to his needs,
his mother effectively came with him to Oxford, taking
rooms in the High Street, so that Ruskin could come
and visit her each evening, while his father joined them
at weekends. He was then still on course to enter the
church, though he continued to have aspirations as a
poet: his poem on 'Christ Church' was published in
The Friendship's Offering in 1838 (2.25–6); and in the
following year he won the Newdigate Prize at the third
attempt, receiving the award at a ceremony attended by
William Wordsworth. Despite his official vocation, he
seems to have remained quite apart from the High
Church sentiment prevalent in Oxford at the time.

Ruskin had already been in Oxford for two years
when his father bought their first work by J.M.W. Turner,
the view of *Richmond Hill and Bridge, Surrey* (British

Museum). Like the following six watercolours they
acquired, it came from the series of *Picturesque Views in
England and Wales,* which Turner had begun in the mid-
1820s, but which had come to a premature end in 1839.
The watercolours for this series represent one of the true
highpoints in Turner's career, repeatedly demonstrating
his technical accomplishment. Ruskin, however, felt his
father had not chosen wisely in buying the views of
Gosport (Portsmouth Art Gallery) and *Winchelsea* (British
Museum). He was consequently given the freedom to
make his own decisions as a collector in 1840, when his
father gave him stocks worth £200 a year. During that
year he bought three Turner watercolours including this
view of Oxford. At £50 it was slightly cheaper than his
other *England and Wales* designs, but it remained in his
collection only until February 1846, when he passed it
to the important Turner collector H.A.J. Munro of Novar
(1797–1864) in part exchange for one of the late Swiss
watercolours known as *The Red Rigi* (National Gallery of
Victoria, Melbourne).

30

John Ruskin

*Christ Church from
St Aldate's, Oxford*
1842

Ink, crayon and
watercolour over pencil
32 x 47

Private collection

*'The Dean ... stumbled on the sketch – said it was beautiful –
that he had heard a great deal of my drawings – said he would
be much obliged to me if I would send them in'*
(Letter to his father, 15 March 1837, RFL.450)

Ruskin won the approval of even the heartiest of his
Oxford contemporaries as a result of his abilities as a
draughtsman. Continuing to work in the style of Prout,
he produced complex drawings of the architectural
settings of his college life (Hewison 1996, pp.58–62;
35 pl.xi). Among his admirers were his lifelong friend
Henry Acland (1815–1900) (see cat.89), and Henry
Liddell (1811–98), then Professor of Greek, whom
Ruskin described as 'the only man in Oxford among the
masters of my day who knew anything of art' (35.204).

The renown of Ruskin's abilities as a draughtsman
also came to the attention of the incumbent Dean,
Thomas Gaisford, who 'sent for the portfolio, and
returned it with august approval' (35.lxiv). This may

have been the occasion on which Ruskin offered him a
study of the interior of Christ Church cathedral. Sub-
sequently, the Dean was supportive when Ruskin was
forced by ill health to break off his studies before taking
his degree. This kindness prompted Ruskin to write to
him in January 1842, prior to his return to Oxford to
complete his studies, offering this distinctly Turnerian
impression of the college as a token of his gratitude. He
proposed that 'it has at least the merit of being perfectly
faithful to every part of the principal subject – though
some liberties have been taken with the accessories. I
much regret that I should be unable to produce a better
drawing of so impressive a subject' (Letter from Denmark
Hill, 11 Jan. 1842). Rather disingenuously he suggested,
'it is taken from a point which I think new – and which
permits every feature of importance being seen at once',
though he was clearly indebted to Turner's example
(see cat.29).

31

William Miller
(1796–1882)

after Joseph Mallord
William Turner

*The Grand Canal,
Venice*
1838

Line engraving
37.9 x 58.2
on wove paper
60 x 81.2;
plate-mark
51.8 x 68.1

Tate Gallery.
Purchased 1990

*'There was nothing out of the common way in Oxford I wanted
to buy, except the engraving of Turner's Grand Canal, for my
room wall-'* (*Praeterita*, 35.256)

Ruskin confided in his autobiography that he did not
fall into the habit of reckless spending, despite the funds
his father had set aside for him, because 'there were no
Turners to be had in Oxford, and I cared for nothing
else in the world of material possession' (35.188). He did,
however, become an habitué of the print shop belonging
to James Ryman in the High Street, where he was able
to see engravings of Turner's work. As a result of such
visits, he wrote to his father in April 1839, 'The French
certainly can not come near us in delicate engraving –
besides – they have no landscape artists at all – much
less any who could stand up for two seconds besides
J.M.W.T.' (RFL.609). One luxury he allowed himself
towards the end of his time in Oxford was an impression
of this print, which is based on a painting exhibited
at the Royal Academy in 1835 (*Venice, from the Porch of
Madonna della Salute*, Metropolitan Museum of Art,
New York).

Turner's actual picture was by then already in the
possession of H.A.J. Munro, who owned one of the finest
collections of Turner's works. After 1842, with Ruskin, he
was among the four or five collectors who commissioned

the series of late Swiss watercolours (cats.53, 54, 111–14).
But while Ruskin developed good relations with other
members of this small group, jealousy or competitiveness
prevented him from becoming friendly with Munro.

The print was one that Ruskin referred to frequently.
He praised its sky especially (7.149), and on another
occasion used it to highlight what he felt were Canaletto's
'absurd' shortcomings in perspective in a picture of the
same viewpoint in the Louvre (13.498) (the painting is
now thought to be by Michele Marieschi; Reg.No.1203 /
Inv.162). This was just one of his numerous attacks on the
great Venetian topographer (see also 1845L.209; 12.468).

Though Ruskin does not refer to it himself, Ryman's
print shop may well have been the venue of his first
encounter with Turner. Intriguingly, several respectable
sources repeat this probability (35.305n). Such a meeting
challenges the celebrated, but carefully constructed
account that Ruskin created in his autobiography for
22 June 1840, which has been shown to be at variance
with his actual diary entry for the day of the supposed
introduction (see Warrell 1995, pp.11, 29 n12). Moreover,
an informal introduction to the artist in Oxford is quite
plausible, since Turner had been commissioned to
produce a view of the city for Ryman, and consequently
travelled there a couple of times in the late 1830s (Lyles
1992, pp.56–8).

32

John Ruskin

*Piazza S.Maria
del Pianto, Rome*
1840

Pencil and wash
34.4 × 45.7

Reproduced in
lithograph for
*The Amateur's
Portfolio of Sketches*
1844

First exhibited
Royal Society
of Painters in
Water Colours,
Ruskin Memorial
Exhibition 1901

Gabinetto Communale
delle Stampe, Rome

*'Making up my mind thenceforward that the sentiment of
Raphael and tints of Titian were alike beyond me, if not wholly
out of my way; and that the sculpture galleries of the Vatican
were mere bewilderment and worry, I took the bit in my teeth, and
proceeded to sketch what I could find in Rome to represent in my
own way, bringing in primarily, – by way of defiance to Raphael,
Titian, and the Apollo Belvedere all in one, – a careful study of
old clothes hanging out of old windows in the Jews' quarter'*
(*Praeterita*, 35.276)

Ill health, brought on by overwork and the news of the
engagement of his first love, Adèle Domecq, resulted in
Ruskin leaving Oxford prematurely in April 1840. At the
end of that summer he and his parents set out for Italy,
ostensibly to recuperate. Inevitably, he found the journey
rich in stimuli, though he disliked most of the classical
architecture he found in Rome. Many of his initial,
strongly-worded objections were rooted in his Protestant
upbringing, including his opinion that the interior of
St Peter's 'would make a nice ballroom' (Letter to Dale,
1.380–1; 35.282–3).

Such outbursts would not have been in sympathy
with the views of the artists Joseph Severn (1793–1879)
and George Richmond (1809–96), whom he met shortly
after arriving. Indeed, after a visit to see the Vatican
collections together, Richmond confided to his diary that
he felt Ruskin was blinded by theory from responding
openly and directly to the great works there, and con-
cluded 'he has too much of the amateur' (Lister 1981,
p.59). The attitudes noted by Richmond perhaps
prevented Ruskin from discovering things that would
have interested him, such as the work of the German
Nazarenes, whose principles anticipated those of the
Pre-Raphaelites (see cat.201).

Something of Ruskin's distaste for the supremacy of
the classical style can be found in his expressed motives
for undertaking this Proutish drawing, the subject of
which he found on 1 December, and which he sketched
on the following days. This was one of two drawings
that were given to Mussolini in 1932, on behalf of the
Italian nation, by J.H. Whitehouse (1873–1955), a devoted
collector of Ruskin's works.

33

John Ruskin

*Vesuvius
in Eruption*
1841

Watercolour
22 × 16.4

First exhibited
Coniston Institute,
Ruskin Memorial
Exhibition 1900

Ruskin Foundation
(Ruskin Library,
University of Lancaster)

*'For full ten years, since earliest geologic reading, I had
thoroughly known the structure and present look of Vesuvius
and Monte Somma; [but new to me were] the first feeling of
being in the presence of the power and mystery of the under
earth, unspeakably solemn'* (*Praeterita*, 35.288)

Ruskin travelled on from Rome to Naples at the
beginning of 1841, where his first, moonlit sighting of
Vesuvius on 8 January had an immediately restorative
effect on him. In contrast with some of the things he had
seen in Rome, here was something to which he felt fully
equipped to respond. The day after his arrival he set out
to study the volcano more intently, noting in his diary
how it 'lay under a mass of white cloud[s], its own smoke
mixing with them in magnificent changing volumes;
the sun catching on the snowy cone, and locally on the
rolling bodies of vapour, which fell heavily down its
slope, far from anything I ever expected from Vesuvius'.
He concluded the entry in his journal, having spent the
day continually monitoring the changing light on the
volcano, with the sentiment, 'Vesuvius certainly a far
nobler thing than I ever supposed it' (D1.140–1).

Throughout the next few weeks, Ruskin recorded his
daily observations of the clouds of sulphurous vapour, but
it was not until 20 February that he ascended to the edge
of the crater itself (D1.155–6). During his time at Naples
he produced a number of views that were primarily pen
and ink exercises in the picturesque style. But he also
seems to have painted this Turnerian vignette during,
or shortly after, the Italian tour, which demonstrates his
increasing 'mania' for Turner's works and his attempts
to develop a response to nature that was in sympathy
with the artist's.

Le Glacier Des Bois

34

John Ruskin

The Glacier des Bois
c. 1843–4

Watercolour
32 x 21.5

Inscribed 'Le Glacier
Des Bois' and 'J.R.'

Ruskin Foundation
(Ruskin Library,
University of Lancaster)

'Chamonix is such a place! There is no sky like its sky. They may talk of Italy as they like. There is no blue of any firmament visible to mortal eye, comparable to the intensity and purity and depth of an Alpine heaven seen from 6000 feet up. The very evaporation from the snow gives it a crystalline, unfathomable depth never elsewhere seen' (Letter to the Rev. W.L. Brown, Aug. 1842, 2.223n)

During the summer of 1842 the Ruskins were once again abroad, their travels focusing this time on Switzerland, and the Alps at Chamonix (frequently referred to by Ruskin as 'Chamouni'). Ruskin's keen interest in geological matters found much to engage it in the glaciers and the soaring aiguilles in the immediate vicinity of this small town, which was afterwards to be such an important source of intellectual enquiry and consolation (see cat.140, 141). But in 1842, as he recalled in *Praeterita*, 'the month's time set apart for the rocks of Chamouni was spent in merely finding out what was to be done, and where' (35.315). Climbing on and around the Glacier des Bossons, he investigated the local flora, as well as geological features, making notes and sketches of his discoveries, so that he could later verify more precisely what he had seen by reference to published data (D1.225–30).

In this vignette Ruskin echoes the looser style of the designs Turner produced in the later 1830s. It was engraved by J.C. Armytage to illustrate Ruskin's poem 'A Walk in Chamouni' when published in *The Friendship's Offering* for 1844 (2.222–6). A second design, showing the Aiguille du Dru, may also have been painted at the same time as an alternative subject (3 pl.7, opp. p.372).

35

William Henry Hunt
(1790–1864)

A Peach and Grapes
c. 1858

Watercolour on
prepared ground
37 x 44.5

First exhibited
Old Water Colour Society
1858 as *Fruit*

Ruskin Foundation
(Ruskin Library,
University of Lancaster)

'*Here you see the most beautiful painting of fruit Hunt*
ever did, and it hangs amongst the Turners like a brooch'
(In conversation with M.H. Spielmann, 1884, 34.670)

William Henry Hunt was widely acclaimed as the greatest
still life painter of his generation, a facility that earned
him the soubriquet 'Bird's Nest' Hunt, although he also
painted landscape, figure and interior subjects (see cat.121).

This watercolour had the distinction of being one
of the few pictures not by Turner to hang on the walls
of Ruskin's bedroom at the end of his life (fig.1). It was
bought at the Old Water Colour Society exhibition of
1858 by his father (costing £40), and was one of thirty
works by the artist to enter the Ruskin family collection;
they had acquired their first example at the society in
1833 (*The Loiterers*; untraced).

Two years before his father acquired the drawing,
Ruskin complained of a profusion of grapes by Hunt in

that year's exhibition: 'when not on the vine, grapes are
precisely the dullest fruit that can be painted; and I can
only advise, or beg, any reader who is inclined to attend
to me, never in future to buy any of Hunt's grapes. He
wastes an inconceivable quantity of time on them, and
this is the fault of the public; for the grapes always sell'
(14.79–80). Since John James paid for the watercolour
in March 1858, Ruskin must have been aware of this
purchase before writing that year's *Academy Notes*. Not
surprisingly, there was a shift from his earlier pronounce-
ment and he instead took pains to elucidate the virtues of
this work: 'note the wonderful light of the peach's dark
side, and the subtle finish of composition by help of the
strawberry, whose stalk follows and relieves the curve of
the round peach, and with the raised point of its green
receptacle (or whatever the botanists call it) expresses its
sympathy, as far as a strawberry can, with the descending
curve of the bunch of grapes' (14.204).

36

John Ruskin

An Italian Village
c. 1845

Pencil, ink, bodycolour
and wash on grey paper
22.5 x 29.5

First exhibited
Royal Society of Painters
in Water Colours, Ruskin
Memorial Exhibition 1901

Birmingham Museums
and Art Gallery

'Architecture I can draw very nearly like an architect, and trees a great deal better than most botanists, and mountains rather better than most geologists' (Letter to his mother, 24 Aug. 1845, 1845L.187)

Ruskin's 1845 tour was the first he made without his parents. However, he did not travel entirely alone, as he was accompanied by his servant John 'George' Hobbs, and they were assisted for much of the journey by the professional guide Joseph Maria Couttet. After leaving Geneva they skirted the Italian Riviera (cat.131) and then spent longer than expected scrutinising the monuments at Lucca and Pisa (cats. 68, 69), until the summer heat

forced them to withdraw to the mountains, where Ruskin sought the location of Turner's view on the St Gotthard Pass (cat.55). Shortly afterwards, at Baveno on Lago Maggiore, they were joined by Ruskin's current drawing master, J.D. Harding, who persuaded him to press on to Venice (cats.70, 71), though not before they paused at Verona for a couple of days (cat.37).

By this date Ruskin's drawing style had developed into something much more personal, partly as a result of his continuing studies with Harding. In particular, his line had softened, and he was less inclined to bring his drawings to an even finish, focusing intently only on certain areas that particularly caught his attention.

37

James Duffield Harding
(1797–1863)

Verona
*c.*1845

Pencil with grey wash
and bodycolour
37.2 x 51.7

Inscribed, lower left,
'Verona / Sept 5 1845 / JDH'

Royal Watercolour Society,
Bankside Gallery, London

'The days spent at Verona in 1845 passed … in mere happy activity, drawing what I best could in alliance with Harding, whose sketches were always perfectly faithful, in his manner and according to his outsight – insight he had not; but of the plainly then visible and material Verona, the records he made were most precious, and are so, if yet they are at all' (Praeterita, 35.371n)

By 1845 Ruskin had already been taking drawing lessons with James Duffield Harding for four years. Harding had begun as a pupil of Prout, but quickly established himself as a lithograph specialist. In his teaching he demonstrated a deep commitment to the improvement of art education, publishing a number of drawing manuals to assist the amateur. Ruskin viewed his early book, *Elementary Art, or the Use of the Chalk and Lead Pencil* (1834), as 'a thing to be learnt by heart' (1.428), and interspersed many of Harding's ideas about the benefits of direct observation from nature among his own in the first volume of *Modern Painters*. Similarly, the theories Harding expressed in

Lessons on Trees (1850) were distilled in Ruskin's *The Elements of Drawing* (1857).

At Baveno in 1845, a few days before travelling on to Verona together, Ruskin noted a crucial difference between himself and Harding in their respective approaches to sketching: 'His sketches are always pretty because he balances their parts together & considers them as pictures – mine are always ugly, for I consider my sketch only as a written note of certain facts, & those I put down in the rudest & clearest way as many as possible. Harding's are all for impression – mine all for information' (1845L.189). A comparison of cat.36 with this view of Verona reflects the validity of this opinion. Harding's composition is beautifully arranged so that the eye is drawn steadily deeper into the picture space, passing under the towers of the Castel S. Pietro to the Ponte Pietra. This bridge was the subject of some of the highly idiosyncratic studies of individual motifs that Ruskin made when he returned to Verona in 1869 and 1872 (Mullaly 1966, cats.59–65, figs. 63–6).

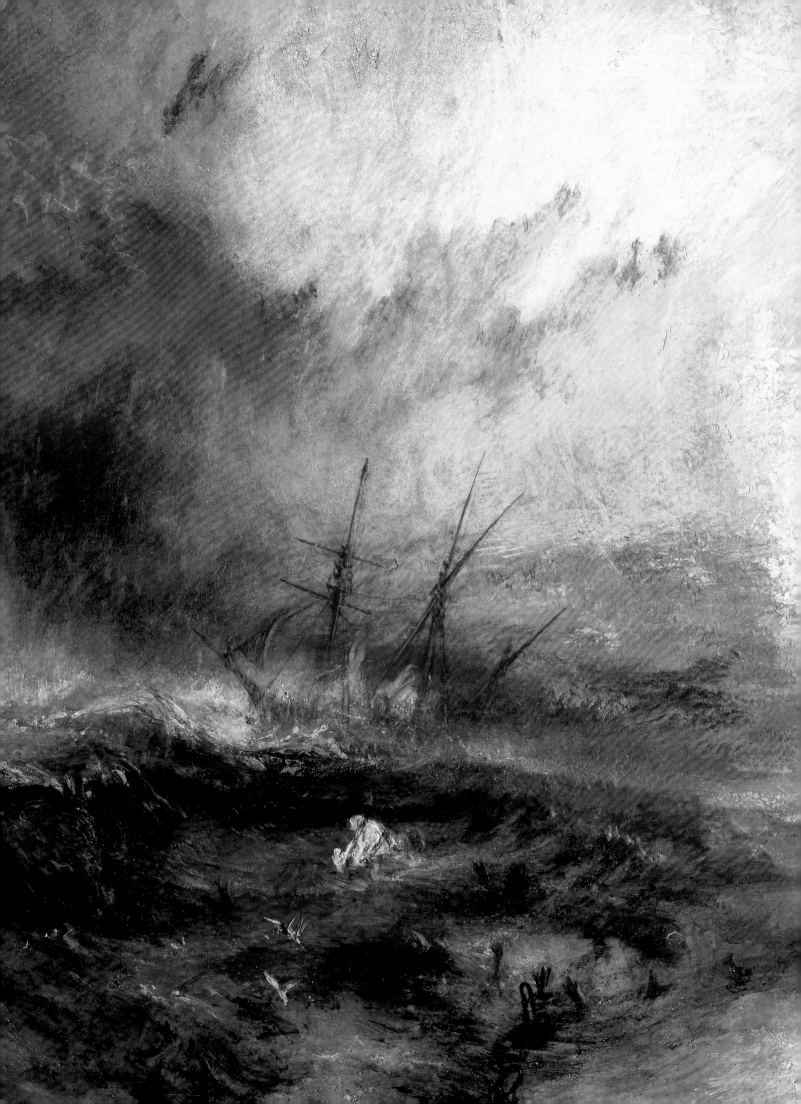

Learning from Turner

'the father of modern art, J.M.W. Turner'

By 1840 Ruskin had become increasingly single-minded in his admiration for Turner, whose pictures seemed to him to embody the highest principles of landscape art. Their impact is evident in the style and forms of Ruskin's own drawings, and his reverence for the 65-year-old Turner thoroughly permeated his youthful sensibility. Such veneration could not help but be enriched by his personal association with the artist, which began about this time (cat.31).

In the following years Ruskin succeeded in making the family art collection a true reflection of this new, concentrated absorption in Turner's recent work, though he frequently had to contend with his father's wariness of making extravagant purchases. When Turner died at the end of 1851, the Ruskins owned two of his oil paintings and around thirty watercolours, at least eight of which they had commissioned. The combined value of these works in 1852 approached £4,000, but would be substantially more today. Of these, the most significant was *Slavers*, which Ruskin received as a New Year's gift in 1844 (cat.47). His recollection of this event indicates the intensity of his response: 'The pleasure of one's own first painting everybody can understand. The pleasure of a new Turner to me, nobody ever will, and it's no use talking of it' (35.319). By the time of his own death in 1900 Ruskin had owned, at one time or another, perhaps as many as 300 works by Turner (13.597–606).

The impulse to defend Turner from criticism, which had first prompted Ruskin to send a letter of support in 1836 (cat.2), was intensified by the continued mockery of Turner's annual exhibits in the early 1840s. This resulted in the first part of *Modern Painters*, published in May 1843 (cat.43). Its aim was to counter the sustained ridicule of Turner's presentation of nature by characterising him as the first artist to break free from the blind conventions of earlier landscape painters. This was only implicit in Ruskin's proposed title for the book: *Turner and the Ancients*. But he was persuaded by his publishers to amplify this to *Modern Painters: Their Superiority in the Art of Landscape Painting to all the Ancient Masters, Proved by Examples of The True, the Beautiful, and the Intellectual, from the Works of Modern Artists, especially from those of J.M.W. Turner, Esq., R.A.*

This was just the first stage of what became an all-consuming mission, lasting until 1860. Indeed, what began as a pamphlet defending Turner 'turned into a seventeen-year, five-volume project which mobilised scientific and religious arguments in pursuit of an aesthetics of landscape' (Barringer 1998, p.59).

The first volume impressed its readers, although some were unhappy with the prominence given to Turner (cats.43, 50). Significantly, Ruskin had to wait until 22 October 1844, a full year and a half later, before Turner himself expressed any thanks. This was no doubt because the painter was unhappy at seeing his peers slighted by the comparisons with his own work. He repeatedly told Ruskin that he considered criticism useless, and also rebuked him for the harshness of his judgements with the words, 'You don't know how difficult it is' (36.406; 20.25).

But while Turner was largely unconcerned with the critical response to his pictures, the general public was delighted to be guided in its appreciation by such a passionate advocate. For, though Ruskin was not the first to praise Turner, he defined for a generation the aims of landscape painting in relation to the qualities he discerned in the artist's works, inextricably binding them together. Ironically, in making his case, he ignored the very features of modernity that Turner himself was so keen to embrace.

Ruskin's text also served as a kind of aesthetic manual. His exhortation to study nature at first hand inspired countless young painters, including those of the Pre-Raphaelite circle in England, and their contemporaries in America.

Thereafter Ruskin's name became so closely aligned with Turner's that there was a general expectation that he would write the official biography at the time of the artist's death. But, though he was afterwards involved in making the contents of Turner's studio available to the public (cat.63), during the first half of the 1850s Ruskin pursued a more personal quest, seeking to comprehend the nature of Turner's idiosyncratic and expressive response to landscape (cats.53–8).

Such was his passion for Turner that in his essay *Pre-Raphaelitism* of 1851, he attempted to suggest a link with the younger artists he approved of, especially Millais. Developing this point in his *Lectures on Landscape* at Edinburgh in 1853, he hailed Turner as 'the first and greatest of the Pre-Raphaelites' (12.159).

IW

38

John Scarlett Davis
(1804–1844)

*The Library at
Tottenham, the Seat
of B.G. Windus, Esq.,
showing his collection
of Turner
watercolours*
1835

Watercolour with gum
28.8 x 55.1

Inscribed
'SCARLETT DAVIS 1835'

The British Museum

*'I believe the really first sight [of a Turner watercolour] must
have been the bewildering one of the great collection at Mr.
Windus's … bewilderment repeating itself every time I entered
the house, and at last expanding and losing itself in the general
knowledge to which it led'* (*Praeterita*, 35.253n)

One of the greatest collections of Turner's watercolours
was that owned by the former coachmaker Benjamin
Godfrey Windus (1790–1867), consisting ultimately
of over two hundred finished drawings, plus a group
of six oil paintings. Pride of place was given to the
watercolours from Turner's series *Picturesque Views in
England and Wales*, of which Windus owned nearly forty,
many of which are seen hanging in this interior study
by Davis. Three of the drawings on the right-hand side
were afterwards acquired by Ruskin (as well as others not
depicted): *Oakhampton* (to the right of the door, top rank;
National Gallery of Victoria, Melbourne); *Richmond,
Yorkshire* (next along; Fitzwilliam Museum, Cambridge);
and, from the *Keepsake* annual, *Palace of La Belle Gabrielle*
(on the chair; private collection).

By the mid-1830s Turner had largely ceased
sending watercolours to any of the usual exhibitions.
Consequently, Windus's home at Tottenham, to which
the public was admitted each Tuesday, was one of the
only places where an overview of his recent work in
this medium could be obtained. The *Art Union*'s critic
no doubt spoke for many, and certainly for the young
Ruskin, when he professed that, 'It is, at all events, utterly
impossible to inspect these drawings without being satis-
fied of [Turner's] wonderful genius … we can see in his
wildest perpetrations proofs of the highest talents, and
believe he has painted nothing he has not seen – nothing
that is not TRUE' (1 Apr. 1839).

The date of Ruskin's first visit is not known, but must

have occurred before the end of the 1830s, at about the
time the Ruskins began to acquire their first Turner water-
colours. Ruskin's diaries record that he spent much time
there in 1843 and 1844, when he was writing and then
revising *Modern Painters*, and that he received permission
on one occasion to work there in Windus's absence
(D1.252). He claimed later, 'Nobody, in all England, at that
time, – and Turner was already sixty, – cared, in the true
sense of the word, for Turner, but the retired coachmaker
of Tottenham, and I' (35.253), but this overstates the close-
ness of both men to the artist. There were other collectors
who were just as loyal to Turner in his last years, such as
J.H. Maw, Elhanan Bicknell, Charles Stokes, and especially
H.A.J. Munro of Novar (see cat.31). Moreover, Windus
actually fell out with Turner, and subsequently failed
to become one of the initial patrons of the sets of Swiss
subjects begun in 1842 (cats.53, 54, 111–14).

As well as Turner, Windus favoured many of the
artists featured in the Ruskin collection, such as Lewis,
Harding, Cattermole, Roberts, Tayler, Etty and Bonington.
But he also possessed a substantial body of sketches by
Wilkie and Stothard, and one of the versions of Girtin's
White House. In 1852 Ruskin noted enviously, 'He has a
most true instinct in painting – never buys a bad thing –
yet does not know why it is good' (RLV.240). Windus
later went on to acquire many important Pre-Raphaelite
pictures, such as Hunt's *Scapegoat* (cat.196), Madox
Brown's *Last of England* (Birmingham Museums and
Art Gallery), and a group of works by Millais, including
Isabella (Walker Art Gallery, Liverpool), *Waterfall at
Glenfinlas* (cat.191), and *The Vale of Rest* (Tate Gallery).
However, rather than buying directly from the artists in
the role of a nurturing patron, he seems to have acquired
his pictures mostly through dealers, such as D.T. White.

39

Joseph Mallord
William Turner

*Scene on the Loire;
a distant view
of the Château
de Clermont*
c. 1826–8

Watercolour and
bodycolour
on blue paper
14 x 19.1

The Visitors of the
Ashmolean Museum,
Oxford

*'I forgot to count among my college expenses, very early
(I recollect feasting on [it] the first night in my little bedroom at
Peckwater,) the cost of Turner's* Rivers of France *(how little
thinking what was to become of the Loire series!), and the book
thenceforward became the criterion of all beauty to me'*
(MS of *Praeterita*, 35.626)

Between 1832 and 1835 Turner produced a group of
sixty-one designs illustrating the scenery bordering
the rivers Loire and Seine. These originally appeared
in three volumes known as *Turner's Annual Tour*, but in
1835 they were brought together as the *Rivers of France*,
in an edition that was internationally successful and
which was republished in modified forms throughout
the nineteenth century including an edition with text
by Ruskin in 1886.

Just as the acquisition of Prout's lithographs had
shaped the family's travels in 1833 (cat.18), Ruskin was
determined to visit the riverside towns depicted by
Turner during the early stages of his journey to Italy
in 1840 (his first foreign tour since the beginning of
his studies at Oxford and shortly after his earliest
documented encounter with Turner). As a result of this
on-the-spot research, he wrote to his friend Edward
Clayton, advising him to study Turner's engravings
closely, particularly those of the *Rivers of France*: 'He is
the epitome of all art, the concentration of all power;
there is nothing that ever artist was celebrated for, that
he cannot do better than the most celebrated. He seems
to have seen everything, remembered everything,
spiritualised everything in the visible world; there is
nothing he has not done, nothing that he dares not
do; when de dies, there will be more of nature and her
mysteries forgotten in one sob, than will be learnt again
by the eyes of a generation' (1.428–9).

Towards the end of the 1840s, Ruskin had the
opportunity of acquiring the complete set of drawings
for the French series for just 25 guineas each. However,
he was unable to get his father to agree to this purchase,
and so, shortly afterwards, the Loire series was sold and
broken up. In 1858 he had a second chance to acquire
these long coveted works from the collector Hannah
Cooper (who had inherited most of the finished set and
bought others), as well as some of the related studies,
such as this work. The market value for Turner's work
had risen in the meantime, partly because of Ruskin's
efforts on his behalf, and on 11 February he was forced
to pay 60 guineas for each of the seventeen finished
works (Warrell 1997, p.201).

The watercolour exhibited here was not one of
the published set. Ruskin alleged that it was beyond
the capabilities of the engravers to translate it into black
and white, because 'there was, to their notion, nothing
in it' (33.348). He persisted, wrongly, in seeing it and
many of the other Loire scenes as evocations of twilight
or sunset (whereas they are in fact sunrises), thereby
imposing a sombre symbolism of his own (see also
cat.64).

Having spent so much on acquiring the drawings,
it is surprising that he was prepared to relinquish them
just three years later, when he presented the Loire and
other Turner watercolours to the university museum at
Oxford (Herrmann 1968). Also in 1861 he sent a smaller
group to the museum at Cambridge. Of the twenty-four
Loire subjects that Ruskin owned in 1861, this was the
only one he retained. He called it his 'Blue Loire', and
did not donate it to Oxford until 1870, when he began
his lectures there as Slade Professor. In these he stressed
the value to the student of copying such works.

40

John Ruskin

Amboise
1841

Watercolour over pencil
44 x 28.5

Engraved by Edward
Goodall (1795–1870)
to illustrate Part v of
'The Broken Chain' in
The Friendship's Offering,
1844

First exhibited
Royal Society of Painters
in Water Colours, Ruskin
Memorial Exhibition 1901

Private collection

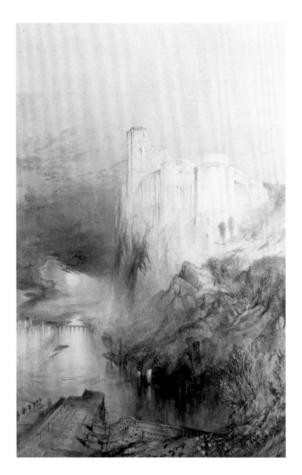

'Those orbèd towers obscure and vast,
That light the Loire with sunset last;
Those fretted groups of shaft and spire,
That crest Amboise's cliff with fire,
When, far beneath, in moonlight fail
The winds that shook the pausing sail'
(*The Broken Chain*, part v, xiv:
Poems 2.169–170)

The château of Amboise, beside the River Loire, provided the scene for the last part of Ruskin's poem 'The Broken Chain' (1840–3). It was one of the sites he had visited in September 1840 as a result of studying Turner's *Rivers of France* (D1.214: see cat.39). While in Italy, at the beginning of the following year, he began to work on this design, resuming his efforts later that autumn, as he continued to recuperate from ill health at Leamington.

The drawing is one of a group that was produced at the height of Ruskin's period of 'morbid Turnerism' (2.xli; see also cat.33). In these he worked obsessively to capture Turner's style, in the process adopting and exaggerating many of the painter's mannerisms. For example, in this watercolour, he greatly surpassed Turner's tendency to distort the height of architectural motifs. Indeed, he ruefully admitted that he had represented the 'castle as about seven hundred feet above the river', when it is actually 'perhaps eighty or ninety' (35.302).

He was, however, particularly pleased with his depiction of the late fifteenth-century St Hubert's Chapel, which rises above the château's walls, later suggesting that he had painted the fretwork 'perhaps a little better than Turner' (35.302). In a note to the published poem, he deemed this 'one of the loveliest bits of rich detail in France', but also observed that, 'In reality it is terminated by a small wooden spire, which I have not represented, as it destroyed the grandeur of the outline' (2.169–70). This was not the only detail he altered for pictorial purposes. In fact, he shifted the whole alignment of the château, so that the chapel hangs out over the Loire, when in fact it, and the Tour Heurtault to its right, are on the southern, landward side of the structure.

The drawing was originally to be engraved by Thomas Jeavons. But Ruskin objected to his work in the *Rivers of France*, approving only his engraving of Turner's *Vesuvius* (cat.15). Subsequently his father took on the responsibility for having the watercolour engraved, and decided to engage Edward Goodall, who had worked on both sets of Turner's vignettes illustrating the poetry of Samuel Rogers (2.xlii–xliii; see cat.17). Though he admired the drawing as a pastiche of Turner, Goodall was apparently critical of its perspective.

41

Joseph Mallord
William Turner

*Falls of the Rhine,
Schaffhausen*
1841

Pencil, red ink and water-
colour, and scratching-out
on white paper prepared
with a grey wash
22.8 x 29.2

Museum zu Allerheiligen,
Schaffhausen,
Sturzenegger-Stiftung

42

John Ruskin

Falls of Schaffhausen
1842

Pencil, pen, watercolour
and bodycolour
on cream paper
31.4 x 47.3

First exhibited Noyes &
Blakeslee, 127 Tremont
Street, Boston, October
1879 and the American Art
Gallery, Madison Square,
New York, December 1879

The Fogg Art Museum,
Harvard University
Art Museums.
Gift of Samuel Sachs

*'That drawing of the falls of Schaffhausen is the only one
[of mine] I ever saw Turner interested in. He looked at it long,
evidently with pleasure, and shook his finger at it one evening,
standing by the fire in the old Denmark Hill drawing-room'*
(Letter to C.E. Norton, 1879; 3.529n, 327.92)

Although Ruskin was certainly acquainted with Turner
by 1840, it was not until the end of 1841 that he began
to visit the artist's gallery. Earlier that autumn Turner had
come back from a tour of Switzerland, during which he
made a large group of studies of the falls at Schaffhausen.
According to one tradition, these sketches were coloured
on the spot, which, though not his usual practice, may
explain the sketchiness apparent in some of the less
finished studies, such as cat.41. None of the group was
developed for the set of ten watercolours he produced
the following spring. However, it is possible that the
larger assortment of unrealised 'sample studies', which
was shown to potential patrons, could have included a
Schaffhausen subject.

By 1842 Ruskin already knew Turner's view of
Schaffhausen for the *Keepsake* annual, which he went on
to buy in 1851 for £210 (Birmingham Museum and Art
Gallery), but it is not known if he saw any of these more
informal Schaffhausen studies. Whatever the case, his
concentrated attempts to enter into Turner's sensibility
in the early 1840s found a successful outlet in studies
such as cat.42, which he produced during his own visit
to Schaffhausen in the summer of 1842: another of his
unconventional watercolours is held by the Fogg Art
Museum (see 38.281). Not surprisingly, Turner seems to
have been conscious of the tribute he was being offered
in such imitations, and paid Ruskin one of his rare,
inarticulate compliments.

In this striking drawing, one of his most technically
experimental, Ruskin chose a viewpoint that had
prompted him to respond in standard sublime terms
during his 1835 visit: 'Standing on the Gallery at Laufen
you feel as if you were being sucked down into the
abysses of an Atlantic. The mountains of foam which are
relieved whitely against the blue sky appear to be closing
over you and the thunder of the cataract drowns every
sound of the world, and its voice is heard alone' (D1.35).
While working on this drawing in 1842, however, he
made more experienced observations that alerted him to
the shortcomings of most artists in their treatment of
falling water, and which he shortly afterwards gave vent
to in *Modern Painters* (3.529–30).

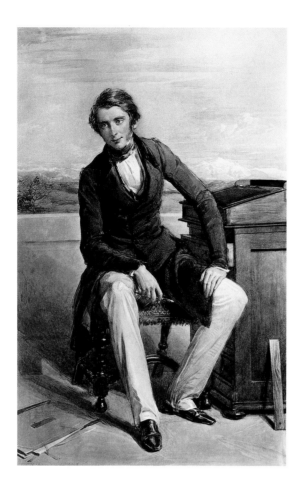

43

after George Richmond
(1809–1896)

*John Ruskin
(also known as
'The Author of
"Modern Painters"')*
1843

Photogravure of a lost
watercolour that was first
exhibited at the Royal
Academy in 1843 as John
Rusken, jun., Esq.
47.2 x 30.2, image size;
59.7 x 39.2, plate size;
72.5 x 50.8, sheet size

Published in the *Magazine
of Art*, January 1891,
as 'The Author of
"Modern Painters"'

Ruskin Foundation
(Ruskin Library,
University of Lancaster)

*'A charming water-colour of me sitting at a picturesque desk
in the open air, in a crimson waistcoat and white trousers,
with a magnificent port-crayon in my hand, and Mont Blanc,
conventionalized to Raphaelesque grace in the distance'*
(*Praeterita*, 35.398)

Ruskin sat for this portrait in February 1843, at exactly
the time he was completing the first volume of *Modern
Painters*. Three months later the book was published
anonymously as the work of 'A Graduate of Oxford',
and it was therefore a little while before even those close
to Ruskin knew for sure that he was its author. This
included Richmond, who did not always agree with the
opinions Ruskin expressed in print or in private. For
example, the prominence Ruskin gave to Turner in his
book's pages was at once its central purpose and the topic
that proved most controversial. But on one occasion,
'when a tirade of Claude was pouring out of Ruskin's
mouth like a cataract, in order that he might put Turner
upon a yet higher pedestal', Richmond intervened to say
'"Ruskin, when your criticism is constructive you talk
like an angel, when it is destructive you declaim like a
demon"' (Cook 1911, vol.1, p.143).

Nearly a decade after the publication of the book,
Ruskin was able to judge his achievement more objec-
tively, discussing it in a letter to his father: 'When

I wrote the first volume of *Modern Painters* I only
understood about *one third* of my subject; and one third,
especially of the merits of Turner. I divided my admir-
ation with Stanfield, Harding and Fielding. I knew
nothing of the great Venetian colourists – nothing of the
old religious painters – admired only, in my heat, Rubens,
Rembrandt, and Turner's gaudiest effects: my admiration
being rendered however right as far as it went – by
my intense love of nature' (15 Feb. 1852, RLV.179). That
Ruskin went on to acquire a passionate admiration for
the Venetian school is largely attributable to Richmond,
who helped him to see the truth in a picture by Veronese,
owned by Samuel Rogers (35.337). Richmond also
encouraged him to consider the achievement of William
Blake (1757–1827), but was unsuccessful in his attempt
to get Ruskin to buy some of his drawings (36.32–3).
It is also believed that Richmond may have effected
Ruskin's introduction to the philosopher and historian
Thomas Carlyle (see cat.204).

When first exhibited at the Royal Academy in 1843,
Richmond's portrait hung in the popular, but not
prominent room devoted to miniatures. He charged the
Ruskins £105 for the watercolour, now lost, which was
added to their growing collection of images of their son
(they had commissioned a profile of him while in Rome
in 1841; see Dearden 1999, p.28).

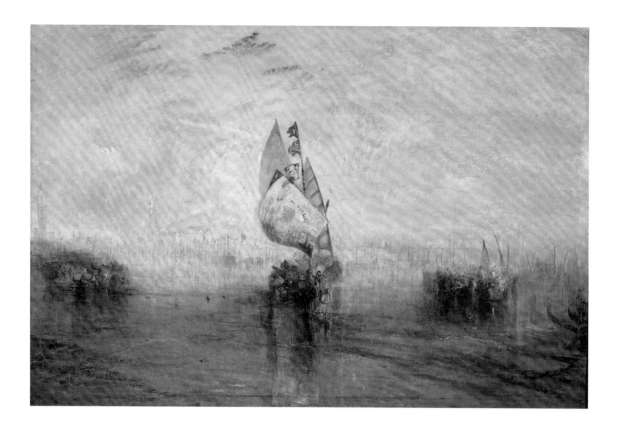

44

Joseph Mallord
William Turner

*The Sun of Venice
Going to Sea*
1843

Oil on canvas
62 x 92

Inscribed on sail,
'Sol di VENEZA'

First exhibited
Royal Academy 1843,
with the following text
from the 'Fallacies of
Hope': 'Fair shines the
morn, and soft the zephyrs
blow, Venezia's fisher
spreads his painted sail
so gay, Nor heeds the
demon that in grim repose
Expects his evening prey.'

Tate Gallery. Bequeathed
by the artist 1856

*'The marvellous brilliancy of the arrangement of colour in this
picture renders it, to my mind, one of Turner's leading works in
oil' (Notes on the Turner Gallery at Marlborough House, 1856,
1857, 13.164)*

On an almost annual basis from 1833 onwards, Turner
exhibited views of Venice at the Royal Academy,
beginning with a work that was both a tribute to
Canaletto and a deliberate attempt to outclass depictions
of the city by contemporaries such as Clarkson Stanfield.
These glowing evocations had become increasingly
ethereal and indistinct by the early 1840s, yet they
continued to appeal to collectors far more readily than
Turner's other exhibits.

From as early as 1841, Ruskin had been convinced
that Venice, as a subject, was 'quite beyond everybody
but Turner' (1.447). In particular, he was captivated by
four of the Venetian subjects that Turner painted between
1842 and 1844, variously favouring one or other of them,
though this was the work he most often singled out for
praise. The others were the *Campo Santo, Venice* (1842;
Toledo Museum of Art, Ohio), *St Benedetto looking towards
Fusina* (1843; Tate Gallery), and *Approach to Venice* (1844;
National Gallery of Art, Washington DC). Of these, he
described the latter in the revised edition of *Modern
Painters* as 'the most perfectly *beautiful* piece of colour
of all that I have seen produced by human hands, by any
means, or at any period' (3rd edn. 1846, 3.250). These
comments, along with those quoted above for this canvas,
indicate that Ruskin's response to Turner was as much
stirred by the sensuous, as the literal element.

Remarkably, the two favoured 1843 pictures did not
sell, a fact that may be partly due to Ruskin's difficulties
in deciding which he preferred, while they were held in
reserve. For it appears that his father offered to buy him
one, but that Ruskin turned the offer down, hoping to
encourage Turner to produce more works of the same
quality (RLV.127; see also D1.273–4). Ironically, when the
Ruskins did eventually acquire one of Turner's Venetian
paintings, in 1847, they did not do so from the artist
himself, and instead paid the dealer Thomas Rought
£840 for *The Grand Canal, Venice*, more than double
the prices asked by Turner a few years earlier (1837;
Huntington Library and Art Gallery, San Marino).

Turner appended a poem to the title of this work
that alluded to the dark fate awaiting the Venetian
fishermen. Such portents were eagerly seized by Ruskin,
who developed from them a perception of Turner as
a fundamentally pessimistic artist, even though he
sometimes had to distort the visible evidence to justify
this conclusion. In his 1855 discussion of maritime
subjects, he claimed that this was 'the most cheerful
marine [Turner] ever painted', but that the poem
indicated 'the uppermost feeling in his mind' (13.43).
And in his notes on the pictures in the Turner Bequest,
he similarly noticed that Turner 'would constantly
express an extreme beauty where he meant that there
was most threatening and ultimate sorrow' (13.159).

45

John Ruskin

*A copy of the Doge's
Palace and the
Campanile from
Turner's 'The Sun of
Venice going to Sea',
with colour notes*
1843

Pencil and chalk
on grey paper
13.1 x 20

First exhibited
Royal Society of Painters
in Water Colours, Ruskin
Memorial Exhibition 1901

Birmingham Museums
and Art Gallery

46

John Ruskin

*A copy of the boats
and the Campanile
of S. Francisco della
Vigna on the right
of Turner's 'The Sun
of Venice going to
Sea', with colour notes*
1843

Pencil and chalk
on grey paper
13.1 x 20

First exhibited
Royal Society of Painters
in Water Colours, Ruskin
Memorial Exhibition 1901

Birmingham Museums
and Art Gallery

'For which I got turned out by the police' (quoted by Cook &
Wedderburn in 'Catalogue of Ruskin's Drawings', 38.290)

After seeing the Royal Academy exhibition in 1843,
Ruskin rejoiced in his diary entry for 10 May, 'Turner
greater than he has been these five years' (D1.246). This
was just a week after *Modern Painters* had been published,
and he must have been thrilled to have his publicly
expressed faith in Turner demonstrably vindicated.
However, others persisted in their petty carping,
including the critic for *The Times*, who remarked of the
Sun of Venice Going to Sea, 'The Sun appears to be a fishing
vessel. It is a very silly sort of craft.'

The resumption of such 'ignorant unmeasured vapid
abuse' clearly grieved Ruskin, and he was presumably
especially angered by these objections to Turner's boats,
which he knew to be appropriate to the Venetian lagoon.
During the early days of the exhibition he spent many
hours studying Turner's painting, making detailed copies
that transcribe the groups of boats and buildings, as well
as the colours deployed (see Hewison 1978, pp.40–1,
for another pair of studies). The act of executing these
studies appears to have caused him to be ejected from
the exhibition, because the Academy's rules specifically
prohibited copyists (the date of this occurrence is not
known, as it does not appear in his diary).

By undertaking such exercises, Ruskin gained a better
understanding of the difficulties involved in representing
the visual world accurately. Consequently, in Venice,
two years later, he had Turner's image in mind when he
grumbled to his father about his own inability to draw
the fishing boats satisfactorily (1845L.207). And amidst
his disappointment at the recent changes to the city,
Turner's idealisation offered consolation because of
the veracity of its details: Ruskin even saw a boat with
a painted sail setting forth at dawn (1845L.202). This
further confirmation of Turner's perceptiveness called
forth an evocative description of the treatment of water
in the painting, which was added to the revised edition
of *Modern Painters* in 1846 (3.545–6).

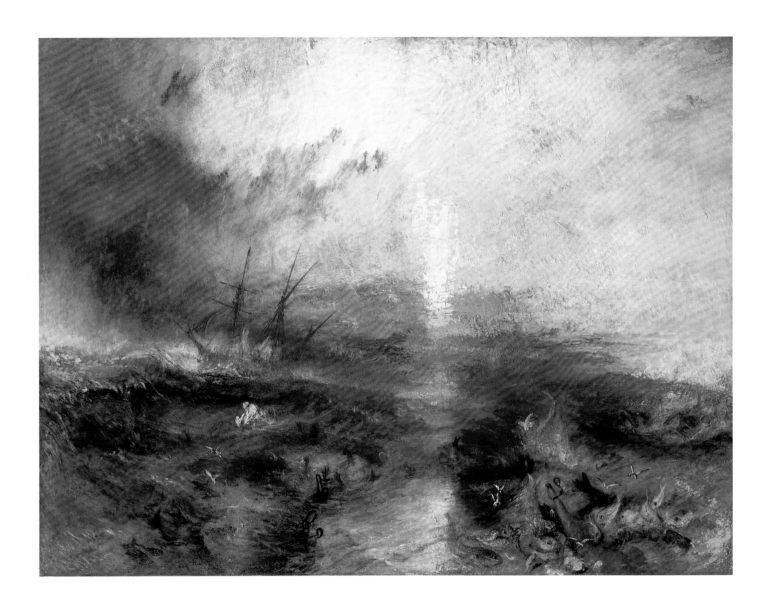

47

Joseph Mallord
William Turner

*Slavers throwing
overboard the Dead
and Dying –
Typhon coming on*
1840

Oil on canvas
91 x 138

First exhibited
Royal Academy 1840,
with the accompanying
text from the 'Fallacies of
Hope': 'Aloft all hands,
strike the top-masts and
belay; Yon angry setting
sun and fierce-edged
clouds Declare the
Typhon's coming.
Before it sweeps your
decks, throw overboard
The dead and dying –
ne'er heed their chains
Hope, Hope, fallacious
Hope! Where is thy
market now?'

Museum of Fine Arts,
Boston

*'I believe, if I were reduced to rest Turner's immortality upon
any single work, I should choose this. Its daring conception,
ideal in the highest sense of the word, is based on the purest truth'*
(*Modern Painters* i, 1843, 3.572)

Turner's now celebrated canvas was first shown at the
Royal Academy in 1840, where it met with derision, and
so returned to the artist's gallery unsold. It was one of
an ongoing series of paintings, in which Turner directly
confronted awkward subjects from contemporary life.
In this case, he entered the raging anti-slavery debate
as a critic of the trade, which had continued to escalate
outside Britain during the 1830s. His picture was painted
just two years after a bill calling for the abolition of
slavery in the British colonies was finally passed, and at
a time when momentum was gathering for the universal
abolition of the trade. The specific focus of his picture
falls on a vessel that flees towards the uncertainties of an
impending storm, after casting its human cargo, weighed
down by chains, to the terrors of death at sea to be
feasted on by sharks. Although it was an appalling, but
standard practice for slave traders to throw the dead
and dying overboard in order to claim insurance money,
Turner concentrates here on another more contentious
issue. The practice he shows was known as jettison, and
also occurred when slave ships were pursued by Royal
Navy vessels, who were able to earn head money for the
number of slaves they liberated. This was controversial
because it was thought that unscrupulous captains waited
for the trading vessels to be loaded and under sail before
intervening, thus endangering the lives of the slaves, who
were cast into the waters in order to lighten the pursued
boat, or as a means of getting rid of the evidence.

That Ruskin deemed the ship 'guilty' indicates he
was aware of the nature of the subject, but inexplicably
he relegated his only reference to this topical issue to a
footnote: 'She is a slaver, throwing her slaves overboard.
The near sea is encumbered with corpses.'. Though it
seems his own sentiments on slavery were largely in
sympathy with the abolitionist movement (17.438), he
must surely have felt some unease about the many subtle
allusions in the picture to Spain, which was still heavily
involved in the slave trade, especially as Spanish grapes
were the fountain from which the family's wealth poured.
However, in the context of his book, Ruskin was more
concerned with truth to nature, and therefore conjured
up Turner's image for his readers in an impassioned word
picture as part of his analysis 'Of Water, as painted by
Turner'. This became perhaps the most celebrated passage
in all of Ruskin's writings on Turner: in the short term,

prompting *Punch* to renew its attacks at the beginning of
1844; and afterwards infusing a generation of American
readers with a hunger to see the artist's pictures. It was a
passage that was fervently chanted by the young William
Morris, and which ultimately came to stand in for the
picture itself, although Ruskin himself expressed
reservations about its style (38.81–2; 22.514–15).

As 1843 came to a close, Ruskin obviously had some
hopes that his father might acquire the painting (D1.255).
He was not to be disappointed, for John James presented
it to him on the first day of the New Year, as a reward
for writing *Modern Painters*. The canvas thereafter hung
in their dining room, where it was noted, but not com-
mented upon by Turner. Though such family guests
were able to see it, the general public had only Ruskin's
imagery as a means of visualising the painting, for, unlike
many of Turner's canvases, it was not engraved (a single
detail of the rainclouds was transcribed by Ruskin, under
the title 'The Locks of Typhon', for the fifth volume of
Modern Painters in 1860; fig.2).

Ruskin later complained that the painting's subject
made it difficult to live with, and so in 1869 he attempted
to sell it at Christie's. But if the great critic himself no
longer wanted it, neither did anyone else, and so he
was forced to negotiate a private sale to the American
collector, J.T. Johnston. There were then almost no other
works by Turner in America, so the triumph of acquiring
such a celebrated example was a matter of content to
all concerned (37.689). However, when the picture was
exhibited in New York in 1872, the inflated expectations
created by Ruskin's text resulted in widespread outrage
at the perceived discrepancies between his words and
the image in reality. As a consequence, the reputation of
the artist was sullied, while that of the critic was widely
discredited. (For a full account, see McCoubrey 1998.)

fig.2 John Ruskin, *The Locks of Typhon*,
(*Modern Painters*, vol. v)

48

John Ruskin

Amalfi
1841

Pencil and watercolour
on buff paper
32.3 x 44.7

Inscribed, lower right,
'Amalfi'

First exhibited Royal
Society of Painters in
Water Colours, Ruskin
Memorial Exhibition 1901

Ruskin Foundation
(Ruskin Library,
University of Lancaster)

49

John Ruskin

Amalfi
1844

Pencil and watercolour
34.1 x 49.3

The Fogg Art Museum,
Harvard University
Art Museums. Gift of Mr
and Mrs Philip Hofer

'Saw no more of Amalfi than I sketched, but that was glorious'
(Diary, 11 Mar. 1841, D1.164)

Three years after making a detailed pencil outline at
Amalfi, during a rather rushed visit in 1841, Ruskin
returned to it in order to develop another watercolour
that is imbued with his recently acquired knowledge
of Turner's latest style. This was undertaken in February
1844 at the request of Sir Robert Inglis (1786–1855),
a prominent anti-Catholic and ultra-Tory Member of
Parliament for Oxford University and a participant of
various literary and antiquarian societies. Ruskin had first
come close to meeting him in 1842, while still an under-
graduate, but, much to his frustration, his friend Henry
Acland had not introduced him on that occasion. At the
beginning of 1844, however, as the recognised author
of *Modern Painters*, Ruskin had been invited to one of Sir
Robert's gatherings, at which he promised to make the
Amalfi drawing.

His intervening Turner studies had taught him to
combine the rudimentary truth of experience with
deeper truths registered in the imagination. This was
something he analysed in a letter to the Rev. W.L. Brown:
'Turner takes it for granted that more is to be learned by
taking [Nature's] lessons individually and working out
their separate intents, and thus bringing together a mass
of various impressions which may all work together as a
great whole, fully detailed in each part, than by cooking
up his information in the sort of "potage universelle"
of Claude' (Nov. 1843, 36.34).

The benefits of this approach are apparent in his
1844 drawing, which brings to life impressions he set
down in 1841, not in his sketch, but in a more potent
form in his diary: 'the burning sun of the afternoon,
with the light behind the mountains, the evening mist
doubling their height – I never saw anything, in its way,
at all comparable. Moonlight on the terrace before the
inn very full of feeling, smooth sea and white convent
above, with the keen shadows of the rocks far above'
(D1.164).

50

Joseph Mallord
William Turner

*The Angel standing
in the Sun*
1846

Oil on canvas
78.5 x 78.5

First exhibited Royal
Academy 1846, with lines
from Revelation (xix, 17,
18), and the following from
Samuel Rogers's 'Voyage of
Columbus': 'The morning
march that flashes to the
sun; The feast of vultures
when the day is done'

Tate Gallery. Bequeathed
by the artist 1856

*'And Turner – glorious in conception – unfathomable in
knowledge – solitary in power – with the elements waiting upon
his will, and the night and the morning obedient to his call, sent
as a prophet of God to reveal to men the mysteries of His universe,
standing, like the great angel of the Apocalypse, clothed with a
cloud, and with a rainbow upon his head, and with the sun and
stars given into his hand'* (Modern Painters 1, 1843, 3.254).

Ruskin's apocalyptic pen-portrait of Turner in the passage
quoted above was one of the climactic moments in his
protracted hymn of praise to the artist. Yet, when he
came to revise the first volume of *Modern Painters* in 1846,
this was one of a number of references to Turner to be
dropped. The consensus of opinion about the book was
that it was unmeasured in its enthusiasm for Turner. Even
Ruskin's father remarked that he wished 'the Devotion to
Turner had been less', and that he had suggested 'a little
modification in the style towards him … but the author
would alter nothing but the careless astronomy' (Letter
to W.H. Harrison, Lancaster, 27 Mar. 1844).

It has been suggested that Ruskin's imagery in the
discarded text may have stimulated Turner to paint this

canvas, which he specifically linked with ideas of the
Apocalypse through his choice of related quotations,
one of which was from the book of Revelation. Ruskin's
tribute had also caught the attention of the critic of
Blackwood's Magazine, who questioned whether it was
not blasphemous. He went on to ponder whether Turner
ought to be represented as the 'great angel' in a national
Temple of Fame, suggesting that perhaps he would have
'his cloud nightcap tied with a rainbow riband round
his head, calling to night and morning, and little caring
which comes, making ducks and drakes of the sun and
stars, put into his hand for that purpose' (3.254–5n).
Though a private riposte to this insult may lurk in
Turner's motives for painting the image, the seriousness
of his vortex-like conflation of Biblical time – showing
its beginnings and its ending – suggests a more profound
purpose, which in 1846 other critics were beginning to
acknowledge: 'It is all very well to treat Turner's pictures
as jests; but things like these are too magnificent for jokes;
and the readers of the Oxford Graduate know that many
of these obscurities are not altogether unaccountable'
(*The Times*, 6 May 1846).

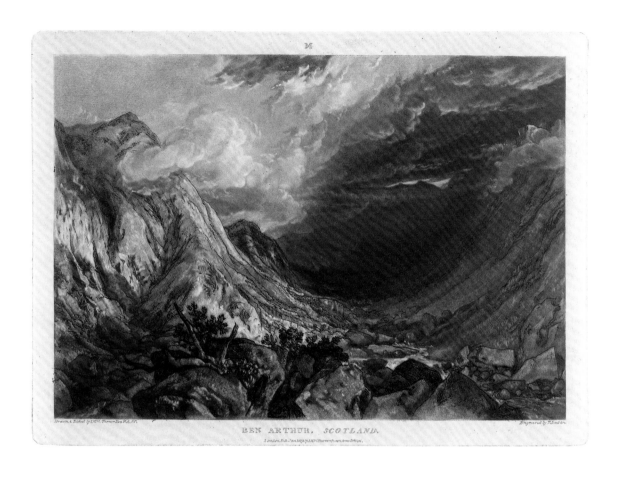

BEN ARTHUR, SCOTLAND.

51

Joseph Mallord
William Turner
and Thomas Lupton
(1791–1873)

Ben Arthur, Scotland
1819

Plate 69 from
The Liber Studiorum
Etching and mezzotint
printed in brown inks
18.4 x 26.7
on wove paper 29.6 x 43.5
plate mark 21 x 29

Inscribed with title
and publishing details:
'Drawn. & Etched by
J.M.W.Turner Esq. R.A.P.P.'
'Engraved by T.Lupton'

Tate Gallery. Presented
by A. Acland Allen
through the National Art
Collections Fund 1925

'[Turner's Liber Studiorum] *is precious to me beyond all I could conceive – there is no art like it in the world'* (Letter to his father, 6 Aug. 1845, 1845L.168)

Turner worked on his *Liber Studiorum* between 1806 and the early 1820s, undertaking the project partly as a tribute to Claude Lorrain, but more crucially as a personal manifesto in which he set out his aspirations for the range of landscape art. Each print bore a letter linking it with one of six types of landscape: Architectural; Historical; Mountainous; Marine; Pastoral; and 'E.P.', probably 'Elevated Pastoral', the category closest to the compositions of Claude. The published plates were restricted to warm sepia tones, generally created in mezzotint over Turner's preliminary etching work.

From the mid-1840s onwards, Ruskin rated this series as one of Turner's finest achievements, believing that the unpublished etchings were especially valuable as manifestations of the artist's unparalleled thought processes: 'it is Turner's brain I want, not his hand' (RLV.202; this assumption was based on a misunderstanding of the purpose of the preparatory drawings in the Turner Bequest; 13.96, 338). References to specific subjects pepper his public and private writings, culminating in *The Elements of Drawing* (1857), with its recommendation that students learning to draw make copies of the prints,

something that Ruskin had been encouraged to do in his lessons with J.D. Harding (see cats.36–7). Subjects from the Mountainous category were among those he most frequently endorsed, and particularly *Ben Arthur*. In the fourth volume of *Modern Painters*, for example, he used a detail from its foreground as a means of high-lighting, by comparison, the deficiencies he found in Claude's representation of stones (6.373–4, pl.49). Moreover, once he started to collect the proofs that had been corrected or annotated by Turner, he was especially pleased to have one of this image (RLV.212; see Forrester 1996, p.313).

As many pages of the first volume of *Modern Painters* had been devoted to a castigation of Claude's poetic landscapes, it is not surprising that Ruskin disliked those aspects of Turner's work that came closest to the earlier artist's model. Ironically, the very *Liber* subjects that he went on to reject in the 1850s as 'quite useless' were among those that Turner had decided to resurrect in the important group of late canvases, the most famous of which is *Norham Castle, Sunrise* (Tate Gallery; see 15.98). There is perhaps the further irony that Turner's interest in the *Liber* in the mid-1840s was renewed because Ruskin, in his keenness to acquire a set, paid for the plates to be reprinted. His references to the *Liber* only appear in the 1846 edition of *Modern Painters* onwards.

52

John Ruskin

*View of Bologna,
from the south*
?1845/6

Pen and ink and wash
34.3 x 48.9

Tate Gallery.
Purchased 1920

'I have been trying everywhere to find a copy of the Liber
Studiorum, *Turner's all being given away. I have succeeded in
getting about 45 of the plates – half of them very fair proofs –
which I shall take with me to tumble about imitate. I propose
making as many studies as possible in the same manner'*
(Letter to B.G. Windus, 30 Mar. 1845; Whittingham
1993, pp.104–5)

Ruskin's studies of the *Liber Studiorum* prior to his trip
to Italy in 1845 literally transformed his approach to
drawing, forcing him to concentrate on the realisation
of light and shade. In 1852, seven years on, he looked
back to recognise that he had as a result set out on
the tour 'with a new perception of the meaning of the
words drawing and chiaroscuro' (36.131). Restricting
his palette to the earthy browns favoured by Turner, he
pursued many of his on-the-spot studies in this manner
(cats.68, 131–3).

As well as pervading the drawings he made in 1845,
this style lingered on into those of the following year,
a factor that has made it difficult to date some of these
works. In the case of this subject, for example, there has
been some uncertainty about whether it relates to the visit
to Bologna in July 1845, or to the subsequent one in June
1846. Significantly, it was at Bologna in 1845 that Ruskin
complained to his mother that he felt deprived of the
leafy verdure of England, as he had not had the chance to
study its equivalent in Italy during that tour (1845L.140).
In contrast, there was a noticeable shift towards the
depiction of the boughs and branches of overhung glades
in the 1846 drawings. And it was also in that year that
Ruskin visited the church of SS. Annunziata at Bologna,
not far from the viewpoint shown in this drawing. His
diary entry for 3 June bears further testimony to his
interest in tree drawing at that time, in its comments
on this aspect of the church's paintings (D1.342).

53

Joseph Mallord
William Turner

*The Pass of
St Gotthard,
near Faido;
sample study*
c. 1842–3

Pencil and watercolour,
applied with pen
22.9 × 29

Turner Bequest;
CCCLXIV 209

Tate Gallery. Bequeathed
by the artist 1856

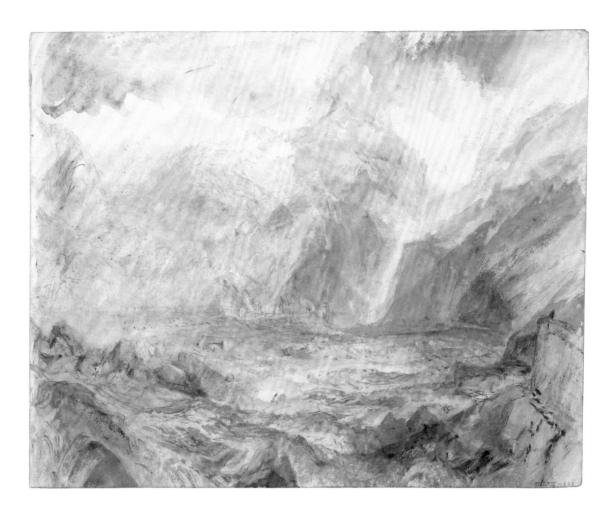

54

*The Pass of
St Gotthard,
near Faido*
1843

Pencil, watercolour,
with scratching out
30.5 × 47

Etched by John Ruskin
for *Modern Painters* IV, 1856
(6 pl.21, as 'Turnerian
Topography')

First exhibited
'Mr Ruskin's Collection
of Turner Drawings',
Fine Art Society 1878.
Commissioned by Ruskin
in 1843

Thaw Collection, Pierpont
Morgan Library, New York

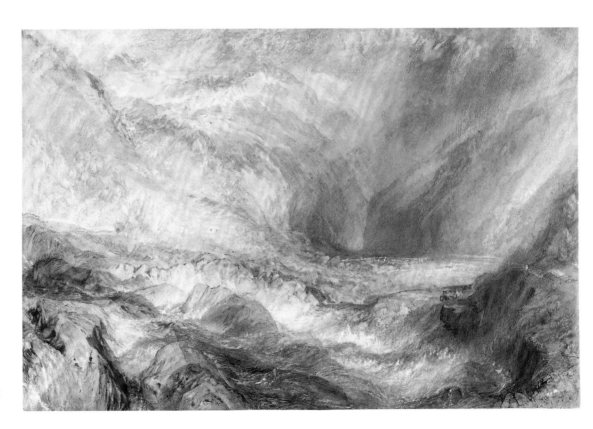

'This was a favourite sketch of Turner's. He realised it for me in 1843, with his fullest power; and the resultant drawing is, I believe, the greatest work he produced in the last period of his art' (Catalogue of the Turner Sketches in the National Gallery, part 1, 1857, 13.206–7; Warrell 1995, pp.82–3)

Up until the early 1840s, the majority of Turner's finished watercolours were produced with the aim that they would be engraved for sets of topographical prints, such as the *Picturesque Views in England and Wales* (cats.29, 58–9). However, invitations to participate in such projects had very largely dried up by 1842, which forced Turner to modify the way he presented his latest water-colours. Retaining his preferred method of creating batches of drawings, he proposed making ten (originally twenty) watercolours based on his recent travels through Germany and Switzerland. Four of the finished works were shown to potential clients, including Ruskin, and at the same time they were presented with a range of preliminary designs, or 'sample studies', that Turner offered to develop in the same style once he received commissions. Of these works, Ruskin was frustrated in not being able to buy the drawing of the Splügen (cat.112), but went on to become Turner's patron for the first time by commissioning finished watercolours from two of the studies (see Warrell 1995, p.149 ff).

The process was repeated the following year, at the beginning of which Ruskin wrote in his diary, 'Turner is going to do ten more drawings and I am in a fever till I see the subjects' (16 Jan. 1843, D1.239). In fact, Turner produced just six finished works, two of them for Ruskin. These were the views of Goldau (cat.111) and this scene near Faido (cat.54), both of which were completed some time before August.

Throughout his career, it had been Turner's practice, almost without exception, to make only pencil sketches on the spot, and to work in colour later, away from the motif. This was a tendency that Ruskin had chastised Roberts for in his views of the Holy Land (cat.28), because he believed that pictures produced by this means could not accurately reflect the truth of what they sought to depict. He presumably assumed that Turner was not guilty of the same vice, and would not have been immediately aware that this was the case from the sample studies of the Swiss scenes. Though presented as 'sketches', these are actually more fully realised than the informal impressions that Turner kept to himself, and are products of the studio, rather than of the *plein air* process. Yet, in spite of this, it is remarkable how a work like cat.53 creates a vivid sense of having transcribed a specific site and its atmosphere.

In working up his material, Turner had initially considered the option of working over his sketches to create the finished works, but thereafter elected to begin again on larger sheets of paper. The greater width of this format resulted in more expansive designs that open up the original compositions, changing the relationships between forms, and giving a more profound sense of pictorial depth. The placing and intensity of the colours used was also revised, in some cases dramatically, and did not always meet with Ruskin's approval. In order to furnish additional details during this process, Turner seems to have drawn on other preparatory sketches: in this finished drawing, for example, the coach turning the corner of the road on the right, above the twisting torrent of the Ticino, was probably taken from one of the group of a hundred sketches that Ruskin catalogued in 1857 (Warrell 1995, p.123). At the time Ruskin was having his portrait painted by Millais (cat.1), he wrote to his father, 'we shall have the two most wonderful torrents in the world, Turner's "St. Gothard" and Millais's "Glenfinlas"' (12.xxiv).

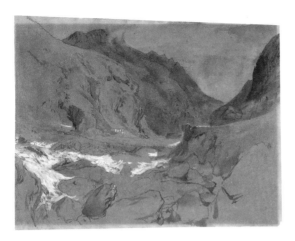

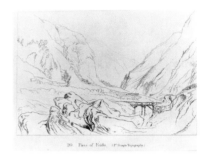

fig.3 John Ruskin, *Simple Topography*
(*Modern Painters*, vol. IV)

55

John Ruskin

*The Pass of Faido
on the St Gotthard*
1845

Brown ink and
watercolour, with
bodycolour,
on brown paper
24.8 x 34.5

Etched by Ruskin for
Modern Painters IV, 1856
(6 pl.20, as 'Simple
Topography')

The Fogg Art Museum,
Harvard University Art
Museums. Gift of friends
and former pupils of
Professor C.H. Moore in
recognition of his service

*'… as I shall have to speak much of the Torrent Turner, I must
see its actual scene, that I may know what is composition &
what is verity'* (Letter to his father, 1 Aug. 1845, 1845L.166)

This is one of two sketches that Ruskin made on 15
August 1845, after tracking down the site depicted by
Turner a couple of years earlier (cat.54). It was not the
first time he had attempted to compare one of Turner's
representations with the actual place, as he had habitually
undertaken such enquiries from about 1840, first in
France and Italy (see cats.15, 39) and subsequently at
Worcester and Warwick (D1.209, 211). But in 1845,
having made such fervent claims about the accuracy
of Turner's work in *Modern Painters*, there was a new
intensity to his plans to locate this setting. Turner was
aware of Ruskin's objective, and was possibly equivocal
about the prospect of having his work measured in this
way. Indeed, such concerns perhaps underlie his attempt
to deter (and 'frighten') Ruskin from setting out on his
tour in 1845, although he was clearly also concerned for
Ruskin's safety during a period of political upheaval in
Switzerland (35.341–2; Whittingham 1993, pp.103–4).

At Faido Ruskin at first found it difficult to recognise
the exact location shown, even with reference to the
drawing, which he seems to have carried with him on
his travels. He told his father, 'I have found his subject,
or the materials of it, here; and I shall devote tomorrow
to examining them and seeing how he has put them
together. The Stones, road, and bridge are all true, but
the mountains, compared with Turner's colossal con-
ception, look pigmy & poor. Nevertheless Turner has
given their act[u]al, not their apparent size' (1845L.172).
In comparison with other Turner sites he had visited, it
appears to have been both a surprise and a puzzle to him
to discern the complexity of the finished composition.
His analysis continues: 'The road on the left is the <u>old</u>
one, which has been carried away in the pass, and that
on the right is the new one, which crosses the stream

by the shabby temporary bridge. It has been carried
away twice, so that there are the remains of two roads
& two bridges, & three new bridges, of wood, which
Turner has cut out, keeping the one he wanted.' He also
made a point of collecting samples of the gneiss rocks,
which he noted were 'coloured by iron ochre processing
from decomposing garnets' (1845L.175–6). A previously
unidentified daguerreotype in the Ruskin Library,
Lancaster University quite possibly shows the rocky
escarpment in the distance of Turner's image, and may
have been taken on this visit, or on one of Ruskin's later
journeys through the pass.

This valuable research was not put to use until a
decade later, when he was writing the fourth volume of
Modern Painters, in which he sought to justify 'Turnerian
topography' as the presentation of reality with the benefit
of accumulated experience and expressive imagination.
To heighten his reader's understanding of this pictorial
category, he included an etching of Turner's drawing
alongside one based on his own on-the-spot obser-
vations, which together were meant to reveal the nature
of Turner's exaggerations. Intriguingly, this second
illustration, with the misleading title 'Simple Topogra-
phy' (fig.3), was as much a conflation of visual
information as Turner's. For, in fact, only the upper left
half of the etching is taken from cat.55; and presumably
the right side, with the bridge and foreground stones,
was based on the second sketch, made on the same day
(now untraced), or was partly dependent on the Turner.
The value of Ruskin's existing sketch as an entirely
objective presentation of the scene is, however, somewhat
undermined by the extent to which his eye was in thrall
to Turner's aesthetic. For example, Ruskin adopted a
lower viewpoint than Turner in an attempt to replicate
the grandeur of the 1843 watercolour. Though such
echoes were perhaps unconscious, they no doubt served
to convince Ruskin of the point he was trying to prove
about Turner's greatness (1845L.176).

56

John Ruskin

The Gates of the Hills (detail from Turner's 'The Pass of St Gotthard, near Faido')
1855

Watercolour
28.5 x 25.5, vignette

Engraved by John Cousen
for *Modern Painters* IV, 1856
(6 frontispiece)

The Ruskin Gallery, Guild
of St George Collection

57

John Ruskin

Rocks in Unrest (study of the foreground of Turner's 'The Pass of St Gotthard, near Faido')
c. 1845–55

Pencil, watercolour, with
some scratching out
18.5 x 30.8

Inscribed below, in ink,
'Drawn from my favourite
St Gothard, for Mod
Painters 4th vol / (J.Ruskin
Brantwood 23d Aug.86)'
Engraved by J.C. Armytage
for *Modern Painters* V, 1860
(7 pl.81)

Thaw Collection, Pierpont
Morgan Library, New York

In seeking to present evidence for his belief that Turner's *Pass of St Gotthard* (cat.54) was 'the last mountain drawing he ever executed with perfect power', or 'unfailing energy', Ruskin produced a number of comparative illustrations of details from the watercolour to support his discussion in the text of *Modern Painters* IV (6.380 pls.20–1, 37; 7.435n). As a keynote to the volume, he created this vignette, which focuses on the narrowing route below the oppressive cliffs of the pass. Compressing Turner's image to this detail produces an acute sense of the sublime, with the rain clouds closing out the sky above. A further means of suggesting the inhospitable nature of this spot was to omit the carriage and horses in the foreground from the published engraving of the subject, just as Ruskin had considerably reduced them in his etching of the full composition: 'Turnerian Topography' (6 pl.21; Davis 1995, p.11). In selecting a vignette format, Ruskin was perhaps paying homage to Turner's designs for Rogers's *Italy*, which he had admired for their 'mountain truth' (see cat.17).

The second detail from Turner's watercolour, cat.57, is less easy to date. As its inscription suggests, late in life, when his memory was not always reliable, Ruskin thought that it had been included in the fourth volume of *Modern Painters*, in which he paid tribute to the precision of Turner's geological observations. But though it may well have been prepared as an engraving with that work in mind, it was not until 1860, when the final, fifth volume appeared, that a plate of this subject was issued (though the text mentions it only in a footnote: 7.435n). The difficulties Ruskin had in placing this drawing, may suggest that it arose from a different line of enquiry from those produced with *Modern Painters* in mind. A remark in one of the letters from the 1845 tour may be relevant here. This refers to a sketch Ruskin made while at Macugnaga: 'the rain has swelled the torrent before my window and put it into a condition so like Turner's St Gothard that I got a capital study of it to engrave as a parallel with the bit I took from Turner' (1845L.164). This clearly indicates that Ruskin had already begun his detailed analysis of the component parts of his highly-prized watercolour as early as 1845, and perhaps implies that this work was the 'bit' Ruskin had already extracted. By focusing on the boulders strewn in the path of the Ticino he concentrates on the essential force at work on this particular landscape.

Ruskin is known to have returned to Turner's viewpoint on various occasions: less certainly in 1852, but definitely in 1858 and 1869, on which occasion he wrote to his American friend Charles Eliot Norton to declare his continuing belief that Turner had selected his view of the Ticino, not just as elevated topography, but as 'his exponent of Alpine torrent rage' (LN.154, annotated with a thumbnail sketch of Turner's drawing).

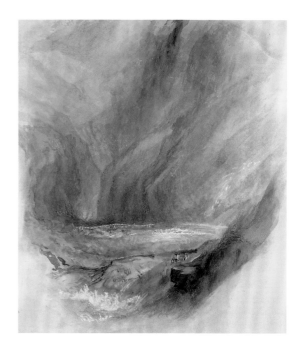

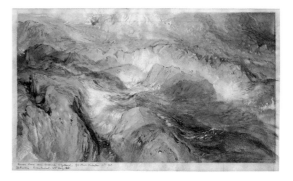

58

Joseph Mallord
William Turner

*Bolton Abbey,
Yorkshire*
*c.*1825

Watercolour
29 x 39.4

Signed, lower left:
'TURNER RA'

Engraved by Robert Wallis
(1794–1878) for the
*Picturesque Views in England
and Wales*, 1827; details of
one of the trees engraved
by John Cousen for *Modern
Painters* III, 1856 (pl.5); a
detail of the rocks on the
right-hand side was etched
by John Ruskin as 'The
Shores of the Wharfe' for
Modern Painters III (pl.12)
and subsequently engraved
in mezzotint by Thomas
Lupton for *Modern Painters*
IV, 1856 (pl.12A)

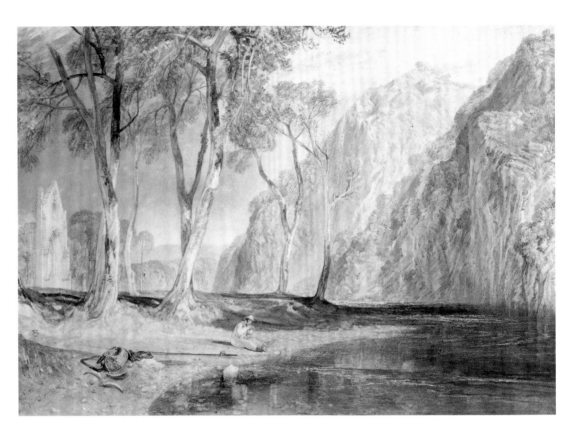

'unrivalled as a piece of lovely art' (*Notes by Mr Ruskin on his
Drawings by the Late J.M.W. Turner*, 1878, 13.444)

In the five volumes of *Modern Painters* published between
1843 and 1860, certain works recur as touchstones, their
meanings becoming increasingly complex as Ruskin
himself developed. His opinions about this watercolour,
from Turner's *England and Wales* series, have exactly this
type of intricacy, and were compounded by the fact that
in May 1851 he added it to his collection, then consisting
of thirty other Turner watercolours.

In the first volume of *Modern Painters* he cites the
drawing in a chapter entitled 'Of Truth of Vegetation',
where Turner's representations of trees are presented as
superior in their accuracy to those of other artists (both
living and dead): 'the woody stiffness through muscular
line, and the inventive grace of the upper boughs, have
never been rendered except by Turner; he does not
merely draw them better than others, but he is the only
man who has ever drawn them at all' (3.586). This theme
was developed at length in *Modern Painters* volume III
many years later, where he included a couple of details
of one of the ash trees in the Bolton Abbey drawing.
These are reproduced in a plate entitled 'Good and Bad
Tree Drawing', with examples from two of Constable's
paintings that Ruskin describes as 'wholly barbarous'

as faithful representations, a charge he had also made
against Claude in the preceding argument (5.162 pl.5;
see Surtees 1979, pp.54, 61–3).

With the publication of *Modern Painters* volume IV,
the focus of Ruskin's interest reverted to geological
matters in a discussion that had as its preamble his
justification of the exaggerations in Turnerian topography
(cats.54–5). In another of the book's set-pieces, he
developed this theme in relation to the view of Bolton
Abbey. His account begins by describing the literal facts
of the setting, implicitly conceding in the process that
Turner's view is really a representative vision, with
justifiable exaggerations informed by the surrounding
scenery: 'But the scene in reality does affect the
imagination strongly, and in a way wholly different from
[the actual] lowland hill scenery … Noble moorlands
extend above, purple with heath, and broken into scars
and glens; and around every soft tuft of wood, and gentle
extent of meadow, throughout the dale, there floats
a feeling of this mountain power, and an instinctive
apprehension of the strength and greatness of the wild
northern land' (6.305). However, if the overall effect
was partly fanciful, he reassured his readers, through
an analysis of the Yoredale Shales on the opposite bank
of the river (supported by illustrations), that Turner was
true in his details.

59

Joseph Mallord
William Turner

*Salisbury, from Old
Sarum Intrenchment,
Wiltshire*
*c.*1828

Watercolour
27.7 x 40.7

Engraved by William
Radclyffe (1783–1855)
for *Picturesque Views in
England and Wales*, 1830

First exhibited
Egyptian Hall,
Piccadilly 1829

Salisbury and South
Wiltshire Museum

'*My Turner Salisbury is on its own account one of the most
precious drawings I have – all full of sheep – wet grass – &
summer rain*' (Letter to Pauline, Lady Trevelyan, July 1855;
RLPT.105)

During the 1850s Ruskin's collection of Turner water-
colours continued to expand, becoming the principal
reference point in his writings on the artist. Though he
frequently collated lists of the drawings he most coveted,
and included amongst these the less finished studies he
knew to be in Turner's own collection, the unpredictable
nature of the market place ultimately determined which
works he was able to acquire. This included many of the
drawings that had whetted his appetite for Turner when
they belonged to B.G. Windus (cat.38), such as this work,
which was bought from the dealer White in 1855.

The qualities in the watercolour that Ruskin specifi-
cally praised when writing to Pauline, Lady Trevelyan
(1816–66) in 1855 also formed the basis of a section of
a chapter on clouds in *Modern Painters* volume v (1860).
This begins by claiming a portentous meaning for the
clouds in Turner's landscapes: 'to him, as to the Greek,
the storm-clouds seemed messengers of fate. He feared
them, while he reverenced; nor does he ever introduce
them without some hidden purpose, bearing upon the
expression of the scene he is painting' (7.189). As he
warmed to his theme, he coupled the *Salisbury* drawing
with another from the *England and Wales* series of

Stonehenge (formerly owned by Samuel Rogers, but sold at
auction in 1856 to Henry Wallis; now also at Salisbury).
The pair had been created by Turner, he suggested, as a
means of contrasting the 'monuments of the two great
religions of England – Druidical and Christian'. The fore-
grounds of both works are peopled by shepherds, and
Ruskin declared these were symbolic of ecclesiastical
types. Thus, in the Stonehenge view, vengeful lightning
illuminates the ruins of the pagan religion, striking dead
the shepherd, while its companion drawing offers a
gentler, less 'distressful' effect. Ruskin considered the re-
alisation of the rain-clouds in this latter work unequalled,
noting that 'It is the rain of blessing – abundant, but full
of brightness' (7.190).

When Ruskin exhibited this and more than a hundred
other examples of Turner's work from his collection at
the Fine Art Society in 1878, he took the opportunity to
lament the passing of the England depicted in many of
the watercolours: 'And instead of Cathedrals, Castles, or
Abbeys, the Hotel, the Restaurant, the Station, and the
Manufactory must, in days to come, be the objects of
[England's] artists' worship'. This was clearly a prospect
that appalled him, causing him to protest that 'the future
England and Wales will never be painted by a Turner'
(13.441). Typically, however, Ruskin includes in his list
of reviled subjects many of the features of modernity
that Turner had actually represented, and which make his
paintings and drawings such a vibrant reflection of his age.

60

Joseph Mallord
William Turner

Ramsgate
1827

Watercolour
16.1 x 23.2

Engraved in mezzotint
by Thomas Lupton for
The Ports of England, 1827;
reissued in *The Harbours
of England*, 1856 (13 pl.II)
Turner Bequest; CCVIII Q

Tate Gallery. Purchased
1986. Bequeathed by the
artist 1856

*'The lifting of the brig on the wave is very daring; just one of
the things which is seen in every gale, but which no other painter
than Turner ever represented; and the lurid transparency of the
dark sky, and wild expression of wind in the fluttering of the
falling sails of the vessels running into the harbour, are as fine
as anything of the kind he has done'* (*The Harbours of England*,
1856, 13.53)

Not all of the engraving projects that Turner worked on
during the 1820s came to fruition. Just seven plates for
The Ports of England were issued between 1826 and 1828,
leaving another six related drawings unpublished until
the mid-1850s. At that time the dealer and publisher
Gambart, working with Turner's own engraver Thomas
Lupton, decided to reprint the original engravings and
to complete the set. He invited Ruskin to compose an
accompanying text, for which he offered to pay 150
guineas, although ultimately the payment Ruskin
received seems to have been two of the watercolours from
the set (one of these was *Margate*, now in the Ashmolean
Museum, Oxford, but the other, unidentified subject had
left the collection by 1860; see 13.xx, 556–7).

Ruskin planned a period of intensive fact-finding
before putting pen to paper, telling his friend Pauline,
Lady Trevelyan in 1854 that he intended to go to Whitby

that winter to study the boats depicted by Turner in
one of the views (RLPT.86). Further research was pursued
at Deal during the following summer. The resulting text
develops ideas adumbrated in *Modern Painters*, and acts as
a kind of coda to the first four volumes. Its discussion of
British marine painting has been seen as one of the finest
of Ruskin's books, causing the editors of his collected
works to state that it links 'even more definitely than does
Modern Painters, the names of Turner and Ruskin' (13.xxii).
A usually hostile contemporary reviewer, writing in the
Athenaeum, was also swayed by Ruskin's eloquence: 'Since
Byron's "Address to the Ocean," a more beautiful poem
on the sea has not been written than Mr. Ruskin's pre-
liminary chapter. It is a prose poem worthy of a nation at
whose throne the seas, like captive monsters are chained
and bound' (26 July 1856; 13.xxi).

A glimpse of the acuteness of Ruskin's knowledge
of Turner's works can be gained from his comments on
this watercolour. Who else would have noticed, as he did,
that Turner shows here the same atmospheric conditions,
the same boats, at the same moment, but from a different
position, as in another view of Ramsgate that he had
produced for the earlier set of *Picturesque Views on the
Southern Coast*.

fig.4 John Ruskin, detail of trees from Turner's
Crossing the Brook 1815 (*The Elements of Drawing*, fig. 4)

61

John Ruskin

*Study of Trees
(from Turner's
'Crossing the Brook')*
c. 1857

Pencil and watercolour,
with pen and ink
42.7 × 32.3

The Visitors of the
Ashmolean Museum,
Oxford

*'For three hundred years back, trees have been drawn with
affection by all the civilized nations of Europe, and yet I repeat
boldly, what I before asserted, that no men but Titian and Turner
ever drew the stem of a tree'* (*Modern Painters* I, 1843, 3.585)

Throughout *Modern Painters* Ruskin had been concerned
with the four essential elements of landscape – sky, earth,
water, and vegetation. As he sought to demonstrate how
Turner excelled in these, his own draughtsmanship
continued to improve, particularly his rendering of trees
(see cats.131, 132). By 1852 his father considered that this
was one aspect in which he surpassed Turner's greatest
drawings: 'even then he has no foliage nor Trees equal
to your own' (Letter of 26 Feb.). Such praise was not
acceptable to Ruskin, who insisted that 'All the practice
I have had in tree drawing would not enable me even
to copy the little jutting branch of the tree next the river
on the right hand [of Bolton Abbey, cat.58]: His is a
power essentially above mine; of a different and totally
unattainable class' (RLV.199).

In the 1850s Ruskin was increasingly involved in
teaching, instructing students at the Working Men's
College (cat.109), or through manuals such as *The
Elements of Drawing*. In the latter he attempted to set

down readily grasped principles for the beginner,
encouraging them in one of the earliest lessons to make
meticulous studies of trees, rather than drawing idealised
forms. His comments directing this exercise are illustrated
by a detail of the trees in Turner's painting *Crossing the
Brook* (1815, Tate Gallery; 15.41 fig.4) (fig.4). The focus
of his diagram falls on the same trunks and branches as
those he copied in this, possibly contemporary study, but
here he examines the section a little higher up. The grace
and truth of these forms impressed him greatly, though
he was unhappy about the colour of the actual painting,
which he considered unnatural (3.297; see also *Pre-
Raphaelitism*, 1851, which develops this idea, 12.297).

In 1858, a year or so after making these studies,
Ruskin's didactic engagement with Turner's trees induced
him to detach a preliminary pencil study for the finished
group from one of the artist's sketchbooks in order that it
could be included in the first comprehensive display from
the Turner Bequest (13.276–7; Warrell 1995, p.28 fig.17).
In the same vein, he later donated this copy to the study
collection at Oxford, with the intention that students
would contemplate 'its complexities of light and shade'
(21.297).

62

Joseph Mallord
William Turner

*Erotic Sketches from
the Turner Bequest:
The Amorous Satyr
and the Reluctant
Nymph*
c. 1822–3

Academy Auditing
sketchbook

Pencil

Turner Bequest:
CCX (a) f.34

Tate Gallery. Bequeathed
by the artist 1856

63

Joseph Mallord
William Turner

*Three Studies of
Sexual Activity*
c. 1832–4

Life Class (1) sketchbook

Pencil

Turner Bequest;
CCLXXIX (a) f.45v

Tate Gallery. Bequeathed
by the artist 1856

'They are kept as evidence of the failure of mind only'
(MS notes on the Turner Bequest: A.B.42 P.B.)

Ruskin was named in Turner's will as one of eight executors. But when the contents of the badly drawn up document were challenged by the artist's family, he followed his father's advice and managed to extricate himself from his responsibilities. The business of settling Turner's estate rumbled on in the Court of Chancery for five years or so, at the end of which it was decided to retain all the paintings, watercolours and sketches for the nation, resulting in a bequest of well over 20,000 items.

Given the limited space at the National Gallery, there was much uncertainty about how to make this material available, and indeed whether all of it was fit to be shown, because many of the less finished oil and water-colour studies were thought to be intelligible only to other artists. Ruskin volunteered to undertake the task of putting the collection in order, and, after demonstrating how colour sketches could be shown in frames hung on the walls, or stored in cabinets, he was eventually given the go-ahead (13.xxxi–xlv; Warrell 1995). This work preoccupied him for most of the winter of 1857 as well as the following spring, leaving him exhausted physically and mentally.

Though he had visited Turner's gallery frequently in the 1840s, he had never before seen the full extent of its contents, much of which had been produced before he was born. Among the riches of this personal collection, the most troubling discovery concerned various groups of erotic sketches. These revealed to him Turner's earthy humanity, a quality he had not anticipated, and further contributed to his increasing conviction that his idol had ultimately succumbed to mental illness. Indeed, the weight of this disappointment may have been one of a number of factors that led to Ruskin's spiritual crisis in the autumn of 1858.

Contrary to received opinion, the intimate sketches had, in fact, been parcelled up and put to one side, as inappropriate for others to see, by Turner's executors, even before Ruskin began his work on the bequest. Nevertheless, it was Ruskin, in agreement with the National Gallery's Keeper, Ralph Wornum (1812–77), who decided that the material ought to be destroyed. Accordingly, as Ruskin recalled in 1862, the 'parcel was undone by me, and all the obscene drawings it contained burnt in my presence in the month of December 1858'. He justified their decision by claiming that such sketches 'could not be lawfully in any one's possession', and that they had acted 'for the sake of Turner's reputation' (Robertson 1978, p.303). Somehow a number of examples, such as those displayed here, survive in the bequest, but there is no way of knowing the true extent of what was lost. In the letter already quoted, Ruskin talks of 'sketchbooks', a term that, when it is coupled with his profound disgust, implies a substantial body of material.

64

Joseph Mallord
William Turner

The Baying Hound
(also known as 'Dawn
after the Wreck')
*c.*1841

Pencil, watercolour
and bodycolour
25.1 x 36.8

Etched by Ruskin, and
engraved in mezzotint
by Thomas Lupton for
Modern Painters v, but
not used (7 pl.86)

Courtauld Gallery,
Courtauld Institute,
London

*'The scarlet of the clouds was [Turner's] symbol of destruction.
In his mind it was the colour of blood'* (*Modern Painters* v,
1860, 7.438n)

This is one of a cache of sixteen late sketches by Turner
that came on the market at the beginning of 1857. Ruskin
noted that they previously belonged to 'a foreigner who
has had them at Berlin and Paris'. He considered buying
some of the group for himself, and also recommended
them to the Leeds collector Ellen Heaton (S1.202–3;
D2.526), but was unable to acquire this subject, which
was one of six that had already been bought by his
friend, the Rev. William Kingsley.

A couple of years later he attempted to engrave the
design. Though the moon in Turner's watercolour is lit
from the right, Ruskin reversed this, so that it appears to
be directly illuminated by the patch of what he thought
was the growing light of dawn on the horizon. The plate
was intended to illustrate a passage in *Modern Painters*:
'one of the saddest and most tender [of Turner's momen-
tary dreams] is a little sketch of dawn, made in his last
years. It is a small space of level sea shore; beyond it a
fair, soft light in the east; the last storm-clouds melting
away, oblique into the morning air; some little vessel – a
collier, probably – has gone down in the night, all hands
lost; a single dog has come ashore. Utterly exhausted, its
limbs failing under it, and sinking into the sand, it stands
howling and shivering. The dawn clouds have the first
scarlet upon them, a feeble tinge only, reflected with the
same feeble blood-stain on the sand' (7.438).

Powerfully evocative though this interpretation is, the
assumption that the effect depicted is a sunrise has been
both refuted and supported in recent years (Davis 1996).
The location may have a bearing on this. One of the
sketches was identified by Ruskin as a view of Calais
(now Tate Gallery, catalogued as 'Yarmouth'). However,
they are just as likely to recall the shore at Margate.
There is, for example, a close relationship between this
subject and the oil painting of 1840, *The New Moon* (Tate
Gallery) which depicts the onset of dusk at Margate.

65

William Bell Scott
(1811–1890)

A View of Edinburgh
*c.*1863

In the style of Turner,
with a letter from Scott
(dated 6 Sept. 1863)
and descriptive notes
in the manner of Ruskin

Watercolour
25.4 x 35.4

Wallington, The Trevelyan
Collection (The National
Trust)

The Pre-Raphaelite associate William Bell Scott first
met Ruskin in July 1855 as the result of an introduction
from their mutual friend Pauline, Lady Trevelyan. The
relationship got off to an inauspicious start, as Ruskin
was dismissive about Scott's recently dead brother, David
(1806–49), also an artist. At the time of this meeting,
Scott had already been teaching drawing by the tra-
ditional means at the Government School of Design in
Newcastle for more than a decade, and felt some hostility
towards Ruskin's alternative methods at the Working
Men's College (cat.109), which he claimed 'repudiated
every point of the curriculum of the Government system'
(see Trevelyan 1978, p.117; and 15.492n).

The resentment Scott harboured is especially
palpable in his recollections of the visit Ruskin made to
Northumberland in 1861, as Scott's decorative scheme

for the central hall of Wallington, the Trevelyan home,
was nearing completion (15.494).

Scott was clearly an embittered man, but he was not
alone in viewing Ruskin as fundamentally the 'exponent
of Turner'. Recognising that this was Ruskin's Achilles'
heel, he tried to deflate him by mocking Turner's Cockney
accent (Trevelyan 1978, pp.116–17). This drawing, and the
notes that go with it, which he sent to Lady Trevelyan, are
another deliberate attempt to use Turner to sneer at his
rival. Conflating details from Turner's various topographi-
cal series, Scott produced a richly exaggerated Turnerian
pastiche. His letter proposes in sub-Ruskinian tones that it
is 'artistically and practically one of the most wonderful
works of human genius'. To complete his jest, he attached
a parody of the catalogue entries written by Ruskin for the
display of works from the Turner Bequest: 'The variety of
invention of the great soul, so little appreciated hitherto,
and the luxurious colour of this greatest of modern artists,
were never more astonishing than in this work. They
are only equalled by the fidelity to nature and the Pre-
Raphaelite truth of the details, especially the figures'. He
ended the joke by suggesting that the sailor in the fore-
ground was a portrait of Turner himself, making the
rather knowing insinuation that the identity of the sailor's
companion was 'a question to be investigated, we under-
stand, by one of the leading critics of the day'. It is not
known what response Scott's piece drew from Ruskin's
loyal friend Lady Trevelyan. The documents are part of
an album which also contains three drawings by Ruskin.

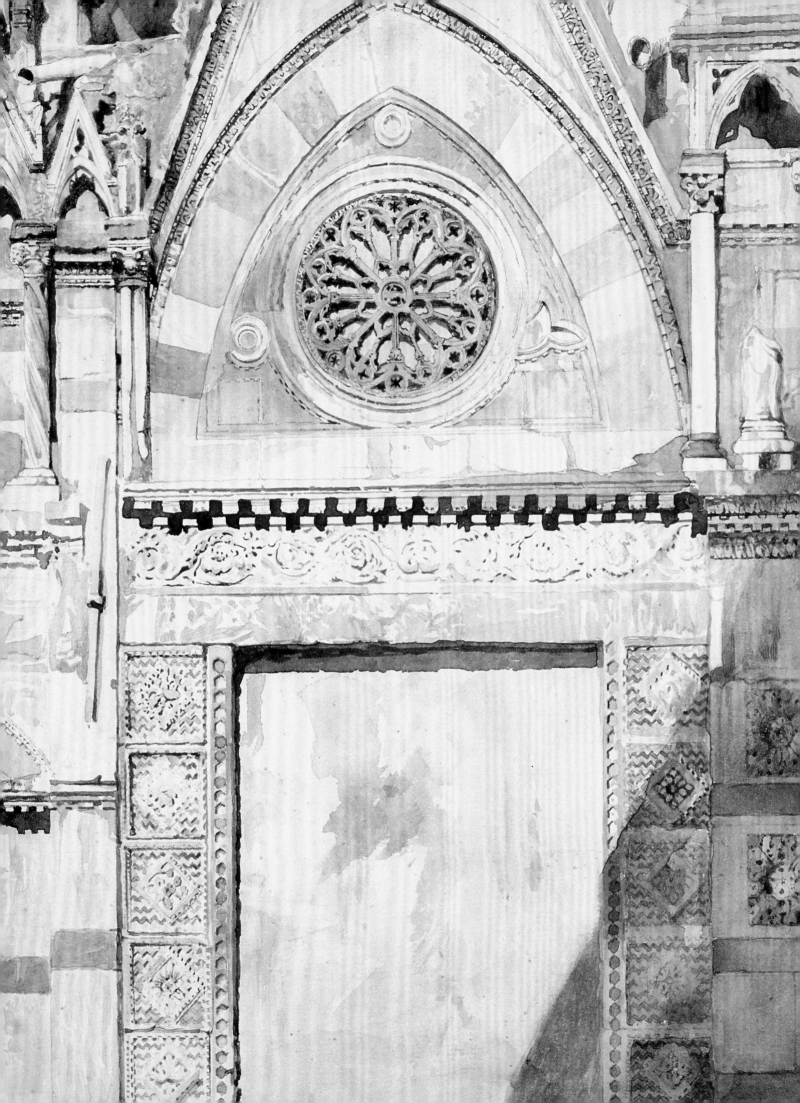

IV

Venice and
the Nature of Gothic

'this magnificently human art'

In 1892 William Morris, artist, craftsman, social reformer and disciple of Ruskin, published a special edition of the central chapter of Ruskin's great work, *The Stones of Venice* (cat.107). Morris said in his preface, 'it is one of the most important things written by the author, and in future days will be considered as one of the very few necessary and inevitable utterances of the century. To some of us when we first read it ... it seemed to point out a new road on which the world should travel' (10.460). Part IV shows Ruskin's engagement with Gothic and Venetian architecture from his early enjoyment of its picturesque decay, through his increasingly serious study of its history, to his development of principles governing the moral and social purpose of architecture, and their articulation in the design of a new building, the Oxford Museum.

Ruskin's interest in architecture was first expressed while he was still an undergraduate at Oxford. These studies, *The Poetry of Architecture*, made the essential Ruskinian connection, through landscape, between God and man. For Ruskin, the organic forms of Gothic architecture represented a kind of landscape, and he argued that when Renaissance buildings supplanted the Gothic, landscape painting was developed to supply the images of Nature that cities now lacked. Nature was the template, not just for good architecture, but for a good society.

Ruskin did not invent the Gothic Revival, any more than he invented Pre-Raphaelitism. The Revival's leading exponent was the Roman Catholic convert Augustus Welby Pugin, and as with the Pre-Raphaelites, Ruskin both popularised and made Protestant ideas current among an avant-garde. He also helped to secularise the Gothic, arguing for its use in new domestic buildings as well as churches. The Oxford Museum declared its modernity with its function, its use of iron, and its dedication to science.

Ruskin's turn to Gothic in 1849 with *The Seven Lamps of Architecture* (cat.106) was prompted by the economic and political changes that produced the destructive work of 'the Restorer, or Revolutionist' (8.3n). The 'lamps' of the title were the moral categories governing good building he wished to see applied in contemporary design.

These principles were expressed in the threatened pre-Renaissance buildings of Venice. Ruskin's original romantic perception of the city gave way to a more critical understanding of the medieval builders and the values of their society. This change affected his drawings, which became more accurate, and then purely investigative, as in his notebooks he constructed an architectural history (cats.92–100). *The Stones of Venice* (1851–3) (cat.107) is about much more than stones however; it is an argument about the rise, decline and fall of empires that Ruskin applied to the England of his own day.

Ruskin's delight in the colour, encrustation and sculpture of Venetian architecture appealed to contemporary architects such as George Gilbert Scott, William Butterfield and George Edmund Street. His moral argument also inspired two Oxford undergraduates, William Morris and Edward Burne-Jones. Burne-Jones wrote in 1853 that Ruskin was 'in prose what Tennyson is in poetry, and what the Pre-Raphaelites are in painting' (Burne-Jones 1904, vol.1, p.92). Morris found his vocation as a designer, and Burne-Jones his as a painter, while reading Ruskin. His architectural ideas influenced Edward Woodward, the young Irish architect chosen in 1854 to build Oxford University's new Museum (cat.89). The Pre-Raphaelite sculptors Thomas Woolner and Alexander Munro had commissions, while Rossetti, Munro, Hughes, Morris, Burne-Jones and other members of the widening Pre-Raphaelite circle were engaged in decorating Woodward's other Oxford building, the University Union's new library and debating hall (see cat.91).

For Ruskin the Oxford Museum was a social as well as aesthetic mission: 'literally the first building raised in England since the close of the fifteenth century, which has fearlessly put to new trial this old faith in nature, and in the genius of the unassisted workman, who gathered out of nature the materials he needed' (16.231). The Irish stone-masons who carved its decorations, the O'Shea brothers (fig.6), were examples of the workers that he wished to see liberated from industrial production; the roots of Ruskin's social criticism are to be found here.

RH

66

John Ruskin

*Santa Maria
della Spina, Pisa*
1840

Pencil and bodycolour
on light blue paper
35.3 x 50.7

Inscribed by Ruskin
in grey wash 'Sta Maria
della Spina, PISA'

First exhibited
Royal Society of Painters
in Water Colours, Ruskin
Memorial Exhibition 1901

Courtauld Gallery,
Courtauld Institute,
London (Witt Collection)

*'In the year 1840 I first drew it, then as perfect as when it
was built'* (*Fors Clavigera*, Letter 20, 1878, 27.349)

Ruskin began this drawing on 10 November 1840, while
travelling with his parents on the long recuperative tour

he took following his breakdown at Oxford at the
beginning of the year (see cat.32). His diary shows him
unimpressed by Pisa, though he conscientiously made
notes on the Cathedral and its environs, and went up the
leaning tower.

The chapel of Santa Maria della Spina had been built
almost overhanging the River Arno, which flows under
the bridge in the distance; its southern side features
statues of Christ and the twelve apostles in intricately
carved niches. Ruskin is content however to paraphrase
these with dots and dashes in the manner of Samuel
Prout, while being careful to balance his composition
with the building and figures on the left, and the castello
in the distance. The use of wash and chinese white owes
something to the more up-to-date manner of David
Roberts (cat.28). When Ruskin returned to Pisa in 1845,
he looked at this building using an entirely different
medium, and began to see it in an entirely different way
(cat.72).

67

John Ruskin

*Casa Contarini
Fasan, Venice*
1841

Pencil and wash with
ink and bodycolour
42.4 x 30.5

First exhibited
Royal Institution 1869,
given to the Ruskin
School of Drawing 1872

The Visitors of the
Ashmolean Museum,
Oxford

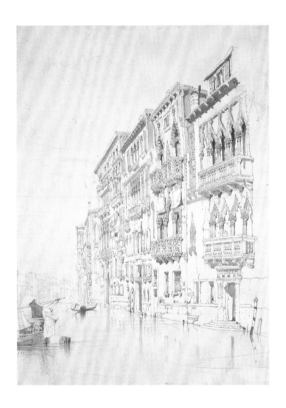

'Almost the only thing I have got in Venice worthy of Venice'
(Diary, 14 May 1841, D1.187)

Ruskin's recuperative continental tour extended into
1841, and he and his parents stayed in Venice from 6 to
16 May. The Casa Contarini Fasan, the second frontage
from the right, had particularly romantic associations
because it was popularly believed to have been the house
of Othello's Desdemona. Characteristically, when Ruskin
used this drawing as an illustration to his lecture on 'The
Flamboyant Architecture of the Somme' at the Royal
Institution in London in 1869, he revised his earlier
good opinion. For Ruskin, the flamboyant decoration
of the late fifteenth-century façade foreshadowed the
Renaissance. His comment was 'Corrupt. The richness
remaining, but the fancy gone' (19.275).

The closeness between Ruskin's drawing style at
this time and that of the family friend Samuel Prout
is demonstrated by a watercolour by Prout, now in the
Victoria and Albert Museum, which is an elaborated
version of Ruskin's drawing. Ruskin recorded that Prout
had borrowed this drawing in order to make his own
(28.756), a case of the master following the pupil.

68

John Ruskin

*Interior of
San Frediano, Lucca*
1845

Pencil, brown ink
and wash
33.3 x 48

Manchester City Art
Galleries

*'I began, in the nave of San Frediano, the course
of architectural study which reduced under accurate
law the vague enthusiasm of my childish taste'*
('Epilogue', *Modern Painters* 11, 1846, 4.347)

In 1845 Ruskin made his first continental tour without his parents. The purpose of his journey was to carry out research into French and Italian old masters in preparation for the second volume of *Modern Painters* cats.34, 135), but his interest was caught by early Italian architecture as well as painting.

He arrived in Lucca on 3 May, and wrote to his father on the following day, a Sunday, 'I have discovered enough in an hour's ramble after mass, to keep me at work for a twelvemonth. Such a church [San Frediano] – so old – 680 probably – Lombard – all glorious dark arches & columns – covered with holy frescoes – and gemmed gold pictures on blue grounds. I don't know when I shall get away, and all the church fronts charged with heavenly sculpture and inlaid with whole histories in marble – only half of them have been destroyed by the Godless, soulless, devil hearted and brutebrained barbarians of French – and the people here seem bad enough for anything too' (1845L.51). Ruskin was becoming aware that the political upheavals in an as yet un-unified Italy were a threat to its heritage, as was the work of contemporary restorers. He began to make drawings as records, rather than simply for pleasure.

Ruskin has been criticised for failing to understand the principles of architectural construction, and for only being interested in surface decoration and external façades. This drawing however is of an interior, and is concerned with space, mass and structure.

69

John Ruskin

*Part of the Façade,
San Michele, Lucca*
1845

Pencil and watercolour
on pale cream paper
33 x 23.3

Given to the Ruskin
School of Drawing 1871

The Visitors of the
Ashmolean Museum,
Oxford

*'I sit in the open warm afternoon air, drawing
the rich ornaments on the façade of St Michele'*
(Letter to his father, 6 May 1845, 1845L.54)

Ruskin remained in Lucca in 1845 until 11 May. He drew in San Frediano (cat.68) in the mornings, then at midday, when the light was brightest, moved on to study early Italian paintings in the Church of San Romano and the Duomo, and after a late lunch made studies of the façade of San Michele, of which three survive. These drawings

were the basis for an illustration etched by Ruskin for *The Seven Lamps of Architecture* (1849) (see cat.106) and of 'wall-veil decoration' in volume 1 of *The Stones of Venice*. Ruskin explained in a letter to his father, 'It is white marble, *inlaid* with figures cut an inch deep in green porphyry, and framed with carved, rich, hollow marble tracery. I have been up all over it and on the roof to examine it in detail. Such marvellous variety & invention in the ornaments, and strange character. Hunting is the principal subject' (1845L.54).

At a time when such twelfth-century romanesque architecture, like early Italian painting, was described as 'primitive', Ruskin was exploring the sources of the distinctly sculptured and decorated southern Gothic. He was alarmed by the state of decay of the inlaid carving, and describes putting back pieces that had fallen out and pocketing three or four fragments. Like all the major historic buildings Ruskin drew and studied, San Michele has subsequently been restored.

The working day in Lucca would end at sunset with a visit to the tomb of Ilaria di Caretto in the Duomo, carved by Jacopo della Quercia after her death in 1430. This figure became Ruskin's touchstone for judging all sculpture. It was 'as art … in every way perfect – *truth* itself' (1845L.55). No drawings of the tomb survive from 1845, but Ruskin made studies when he visited Lucca in 1874, by which time the recumbent figure had acquired additional personal significance (see cats.102, 237).

Ruskin's subject is the upper colonnades at the north end of the façade, paying special attention to the intaglio sculpture. Working in pure watercolour, he allows the whiteness of the paper to make them stand out, as though struck by the afternoon sun, with deep shading thrown into the vaults.

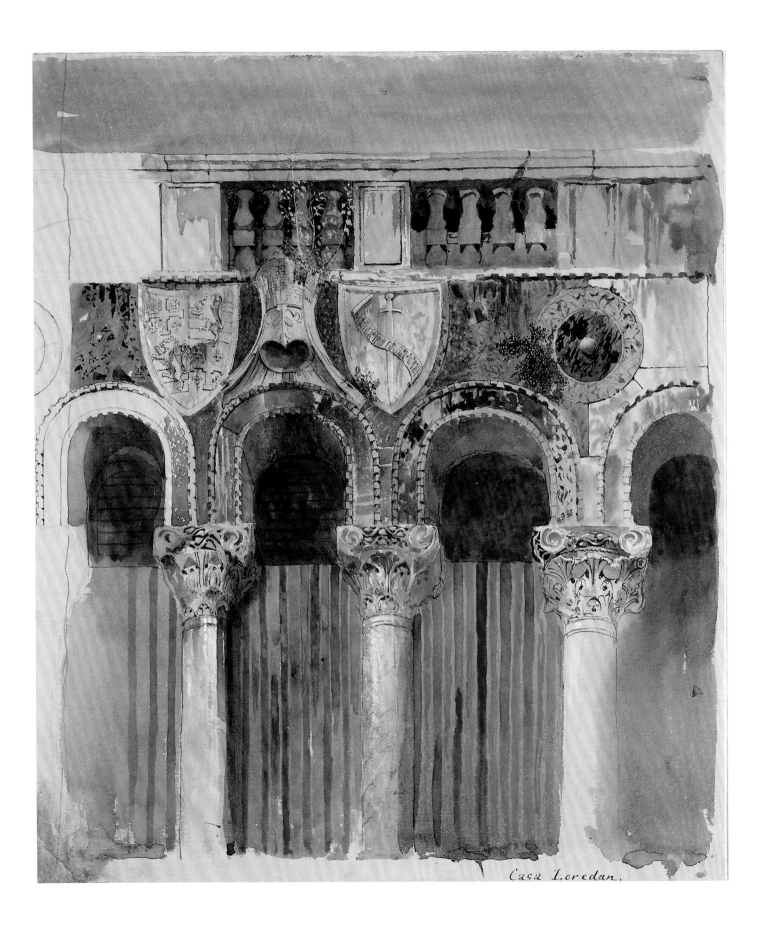

Casa Loredan.

70

John Ruskin

Study of the Marble Inlaying on the front of the Casa Loredan, Venice
1845

Pencil, watercolour
and bodycolour
32 x 26.7

Inscribed by Ruskin
in ink lower right
'Casa Loredan';
given to the Ruskin
School of Drawing 1872

The Visitors of the
Ashmolean Museum,
Oxford

'Of all the fearful changes I ever saw wrought in a given time, that on Venice since I was last here beats' (Letter to his father, 11 Sept. 1845, 1845L.199)

When Ruskin arrived in Venice on 9 September 1845 he was shocked by the changes to the cityscape that were being introduced by the Austrian authorities. A railway bridge had been thrown across the lagoon, and a church demolished to make way for a railway station. Gas lighting had been installed, and many of the palaces on the Grand Canal were under repair – 'we know what that means' was Ruskin's comment, fearing the worst (1845L.198).

Ruskin's study of the central pillars on the first floor of the Casa Loredan, which lies on the lower reach of the Grand Canal, is a key transitional drawing. He is interested in the picturesque weeds that grow out of the sculptured casque of the Lusignan arms (added to the façade by the Correr family in the fourteenth century), but he has taken a squarely frontal view in order to record the details of the mouldings of the twelfth-century arcade.

Ruskin wrote an extensive commentary on this drawing in 1878, after he had presented it as a teaching aid to the Ruskin School of Drawing at Oxford: 'The building is of three dates: its capitals, and the arches they bear, are Byzantine; the shields and casque, inlaid with modifications of the earlier work, presumably in the fifteenth century; the balustrade above, barbarous seventeenth. But nothing could surpass the beauty of the whole when I made this sketch in 1845; the lovely wild weeds being allowed to root themselves in the sculptures. Although I did not in 1845 know how to paint, the extreme fault of this and other drawings of mine at the time are owing to the fact that I was always working, not for the sake of the drawing, but to get accurate knowledge of some point in the building ... If you will look with a magnifying-glass at the bit of foliage in the front of the casque and at the door and window of the castle that surmounts it, you will see that the accuracy with which these are drawn was wholly incompatible with picturesque effect unless I had been John Lewis, instead of John Ruskin, and given my life to such work' (21.175–6).

When Ruskin came to write *The Stones of Venice* (cat.107) there is a parallel tension in Ruskin's prose-style between a concern for architectural detail and the romantic sweep of his argument. For Ruskin's study and ownership of works by John Frederick Lewis, see cats.27 and 102. The Casa Loredan was restored more than once in the nineteenth century, and the present façade dates from 1881.

71

John Ruskin

The Casa d'Oro, Venice
1845

Pencil and watercolour, with bodycolour
33 x 47.6

Inscribed by Ruskin
'Ca d'Oro. J.Ruskin 1845'
and 'Casa d'Oro'

First exhibited
Fine Art Society,
London 1879

Ruskin Foundation
(Ruskin Library,
University of Lancaster)

'What an unhappy day I spent yesterday before the Casa d'Oro, vainly attempting to draw it while the workmen were hammering it down before my face' (Letter to his father, 23 Sept. 1845, 1845L.209)

The Casa d'Oro, so-called because of the gilding originally applied to the relief decorations on its façade, was built between 1420 and 1434. By the 1840s it was in a ruinous state, and the architect G.B. Meduna (1810–80) began the first of a number of restorations. Meduna's unsympathetic work was in progress in 1845; in 1836 he had begun the restoration of the north side of St Mark's. Ruskin was later to protest at his proposals for the west front (see cat.257). Ironically, Meduna was himself a pioneer of the Gothic Revival in Italy.

Ruskin's drawing shows the two left-hand arches of the water entrance closed, whereas they are now open. The drawing remains unfinished, possibly because of the building work in progress. For Ruskin's detailed study of the façade in 1849, see cat.92.

72

John Ruskin

Part of Santa Maria della Spina, Pisa
1846–7

Watercolour, ink and pencil
50 x 36.7

Inscribed by Ruskin in pencil 'Not to be [?put in]' and 'J.[?R.]'; given to the Ruskin School of Drawing 1872, later placed in the Museum of the Guild of St George

The Ruskin Gallery, Guild of St George Collection

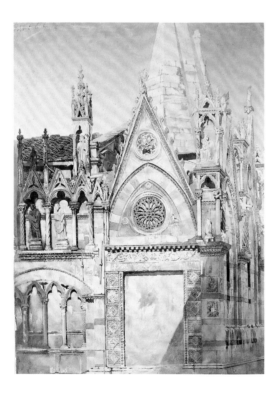

'I daguerreotyped the eastern end of it … and copied the daguerreotype' (*Fors Clavigera*, Letter 20, 1872, 27.349)

Ruskin first heard of the recently invented daguerreotype at Oxford in 1842 and owned some plates by 1844 (36.38), see pp.119–25. He appears to have commissioned daguerreotypes in 1846, before acquiring his own equipment. Visiting Pisa at the end of June 1846 he obtained at least two views of the chapel, which are now in the Ruskin Library, Lancaster University, including one which corresponds to this view of the east end of the building. The following winter he made a copy in watercolour, 'that people might not be plagued in looking, by the lustre' (27.349) – by which he means the reflective surface of the daguerreotype. This explains the distinctive tone of the drawing, and its flat composition, where the narrow angle of the daguerreotype has compressed the image, while at the same time carrying the same amount of detail across the whole picture surface. This is a complete contrast to the picturesque composition he made of the same building in 1840 (cat.66), with its use of framing and selective focus. The visual convention in which Ruskin had been educated is challenged by a new way of seeing.

Following fire and flood damage in 1871 the chapel was rebuilt at a higher level above the River Arno. Ruskin was horrified by the reconstruction, and in protest engraved the drawing as the frontispiece to Letter 20 of *Fors Clavigera* (Aug. 1872) (27.349 pl.VII). He had originally placed the drawing in his teaching collection at Oxford, but later sent it to the Museum of the Guild of St George in Sheffield, where it remains (see fig.10).

73

John Ruskin

Part of St Mark's, Venice, Sketch after rain
1846

Pencil, watercolour, ink and bodycolour on grey paper
42.1 x 28.6

Inscribed by Ruskin in pencil bottom left '27th May 1846' and with numbers 1–5 on architectural details; given to the Ruskin School of Drawing 1871

The Visitors of the Ashmolean Museum, Oxford

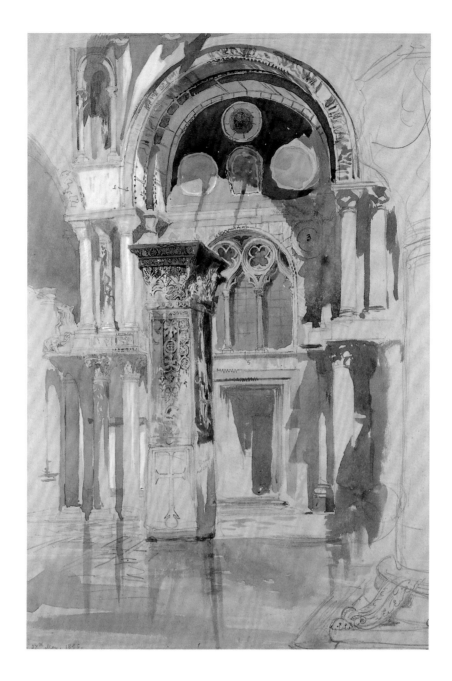

'I have been especially struck, in saying goodbye to St Mark's this evening, with its amazing variety of composition'
(Diary, 27 May 1846, DI.339)

Ruskin visited Venice between 14 and 28 May 1846, and was reading the discussion of St Mark's in Robert Willis's *Remarks on the Architecture of the Middle Ages, especially of Italy* (1835). His scholarly approach is indicated by the pencil numbers in the arch above the Baptistery door. These refer to notes in his diary: 'In the details drawn in yellow paper book in the circle marked three, the brown bands should be so shaped and so thick that the blue, green and central yellow spaces should be nearly perfect circles, while the red and outer yellow spaces should be rather pear shaped, the stalks inward. The opposite

circle, that concealed by the column, had I think the same border, and certainly a simple square cross inside; I think a white cross on gold ground, 3*a*' (DI.340).

The focus of the drawing is the front of the capital of one the two freestanding pillars brought by the Venetians as booty from St Jean d'Acre. Ruskin's handling becomes freer with his pencil and brush as he moves away from this point. He has been able to suggest a thin skin of rain water lying on the marble pavement, and in it the reflection of the pillar. The Baptistery door, Ruskin's favourite entrance to St Mark's, is now closed off.

With the second volume of *Modern Painters* published in April 1846, Ruskin's thoughts are turning towards architecture as a separate topic.

74

John Ruskin

*Study of Portal and
Carved Pinnacles,
Cathedral of St Lô,
Normandy*
1848

Pencil, pen and wash
45.4 x 32.7

First exhibited
Noyes & Blakeslee,
127 Tremont Street,
Boston, October 1879 and
the American Art Gallery,
Madison Square, New
York, December 1879

The Fogg Art Museum,
Harvard University
Art Museums.
Gift of Samuel Sachs

*'I have got a very beautiful subject here – but these
architectural pieces take an awful time'* (Letter to
his father, 16 Sept. 1848, Links 1968, p.53)

By 1848 Ruskin was committed to writing a book on
the Gothic, *The Seven Lamps of Architecture*, published in
1849 (cat.106). On 10 April 1848 he had married Effie
Gray, but he was unable to take his bride to Venice, as
he had hoped, because of the Venetian uprising against
the Austrian occupiers on 22 March, and the revolution

in France. Instead they went to Salisbury, to study the
Cathedral, the purest example of English thirteenth
century Gothic. By August the situation was calm
enough in France to travel to Normandy, to study further
examples of Northern Gothic.

The new Mrs Ruskin found herself spending much
time waiting for her husband as he drew the churches
of Abbeville, Rouen, Caen and Caudebec. They arrived
in St Lô from Coutances on 13 September and left on 21.
The drawing shows a chapel attached to the west front
of the Church of Notre-Dame, which, following John
Murray's *Handbook for Travellers in France*, Ruskin
mistakenly described as a cathedral. Ruskin etched a
detail of the drawing, the head of the left-hand niche
with its curious 'beehive' (8.211) as plate II of *The Seven
Lamps of Architecture* (8.81), interpreting the beehive as the
broken remains of a burst of light above an Annunciation
scene. The niches at St Lô, he wrote, were an example
of 'The Lamp of Life', expressive of the 'vital energy'
(8.190) of the Gothic, where proportion is not a matter
of mechanical regularity, but organic rhythm.

In 1873 Ruskin gave the drawing to his American
friend, Charles Eliot Norton, who in 1875 became
Professor of Fine Arts at Harvard University, a position
he used to promote Ruskin's ideas in America. Norton
wrote asking for an example of his 'careful architectural
drawing … to show how a master does work when he
sets himself to tell the truth about a sight' (LN.299). In
November 1878 he proposed arranging an exhibition of
Ruskin's drawings, including those in his collection. The
exhibition duly took place in Boston in October 1879,
and moved to New York in December.

75

John Ruskin

Caen, St Sauveur
1848

Pencil and wash
44.8 x 27.3

Inscribed by Ruskin
'Rue Notre Dame'

Ruskin Foundation
(Ruskin Library,
University of Lancaster)

'One lives in the midst of decay – moral and material'
(Letter to his father, 27 Sept. 1848, Links 1968, p.57)

The Ruskins arrived in Caen on 22 September 1848,
and Ruskin began to make a drawing of St Sauveur
from a window on the first floor of a café opposite. This
led to a conversation with an idle group of young card
players who, to the Evangelical Protestant Ruskin's
priggish disgust, proved neither to go to Church, to pray,
nor read the Bible (8.262–3n). He told his father, 'the
utter corruption to the core of the system of life in this
nation strikes me more and more – and I was equally
disgusted yesterday with our own congregation of
expatriated English – and their fat futile feeble clergy'
(Links 1968, p.57).

Ruskin made a copy of this drawing and sent it and
cat.75 to Charles Eliot Norton in Boston, but it does not
seem to have been included in the exhibition of Ruskin's
drawings arranged by Norton in 1879 (see cat.74).

76

John Ruskin

*Exterior of
the Ducal Palace,
Venice*
1852

Pencil and wash
with some ink
36.2 x 50.5

Inscribed by Ruskin
'interval of pillars on
top of balustrade 5 : 6'
and [illegible]

First exhibited
Royal Institution 1870,
given to the Ruskin
School of Drawing 1872

The Visitors of the
Ashmolean Museum,
Oxford

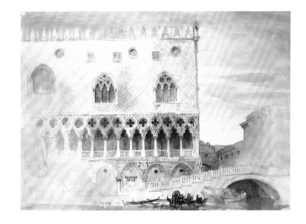

*'No one had ever drawn the traceries of the Ducal Palace till I
did it myself. Canaletti [sic], in his way, is just as false as Prout;
Turner no better'* (*Notes on Prout and Hunt*, 1879, 14.424)

Ruskin gave two dates for this drawing. When he
included it in the exhibition of drawings and photo-
graphs that accompanied his lecture 'Verona and its
Rivers' at the Royal Institution on 4 February 1870,
he dated it to 1852. But when he gave it to the Ruskin
School of Drawing, he catalogued it as 1845. Ruskin's
very careful drawing, his use of a ruler to square up the
façade, and his annotation show that 1852 is the correct
date. By 1852 Ruskin had abandoned the picturesque
methods of Samuel Prout; his opinion of Canaletto
(1697–1768) was that he was 'less to be trusted for
renderings of details, than the rudest and most ignorant
painter of the thirteenth century' (11.365).

For Ruskin, the Ducal Palace was 'the central
building of the world' (9.38) because it was a synthesis of
what he termed Roman, Lombard and Arab architecture.
A chapter on the palace formed the climax to *The Stones
of Venice* volume II: 'I used to feel as much awe in gazing
on the building as on the hills' (10.439). It was in Venice
that Ruskin began to turn his attention from the works
of nature to the works of man.

77

John Ruskin

*The North West
Porch of St Mark's*
1877

Pencil, watercolour
and bodycolour
64.8 x 77

First exhibited
Royal Society of Painters
in Water Colours 1879

Ruskin Foundation
(Ruskin Library,
University of Lancaster)

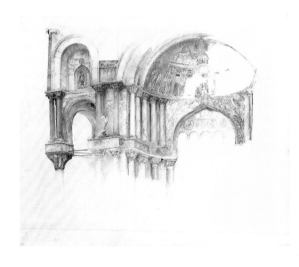

*'St Mark's is not, in the real nature of it, a piece of architecture,
but a jewelled casket and painted reliquary'* (*Circular Respecting
Memorial Studies of St Mark's*, 1879, 24.414)

This drawing dates from a much later period in Ruskin's
life, the winter of 1876–7, when he had returned to
Venice to revise, and possibly write a fourth volume
to, *The Stones of Venice*. Ruskin's many projects and his
perilous mental state prevented this, although he did
produce a *Guide to the Principal Pictures in the Academy of
Fine Arts at Venice* (1877), and begin to publish *St Mark's
Rest: The History of Venice, written for the help of the few
travellers who still care for her monuments*. As the latter title
suggests, Ruskin was concerned by both the neglect
and the restoration of Venetian buildings. He chose
this aspect of St Mark's because the thirteenth-century
mosaic above the porch was the only one to survive from
the original façade, and was under threat of restoration,
along with the whole west front, by the architect G.B.
Meduna (see cat.71). He supported local protests against
the proposed restoration, and on his return to England
backed the campaign mounted by William Morris and
Burne-Jones through the recently formed Society for the
Protection of Ancient Buildings. He began a programme
of copying mosaics through the Guild of St George.
While in Venice he commissioned John Bunney's
painting of the west front (cat.257). The campaign halted
the proposed restorations.

78

John Ruskin

North West Angle of the façade, St Mark's, Venice
c. 1851

Pencil and watercolour on ten sheets of paper
94 x 61

Tate Gallery. Presented by the National Art Collections Fund 1914

'Nothing is so rare in art … as a fair illustration of architecture; perfect *illustration of it does not exist'*
(*The Stones of Venice* II, 1853, 10.114)

Ruskin produced this and cat.80 with the intention of having them made into plates for *Examples of the Architecture of Venice* (1851) which were to serve as large-scale illustrations to *The Stones of Venice* (see cat.107). In both cases the drawing was produced with the aid of a daguerreotype taken by Ruskin's servant (see cat.103). His particular interest in the northern and southern porticos of St Mark's – 'of *no use whatever* except to consummate the proportions of the façade' (10.153) – was that his careful measurements had shown the extent to which they were a different size and shape, as he had first noted in his diary in 1846 (D1.340). This irregularity and variety was what gave the building 'Life'.

The jigsaw effect of Ruskin's collage accidentally replicates the use of thin sheets of marble to coat the brick structure beneath. Ruskin thought this use of materials entirely legitimate because there was no pretence that the marble had a structural function.

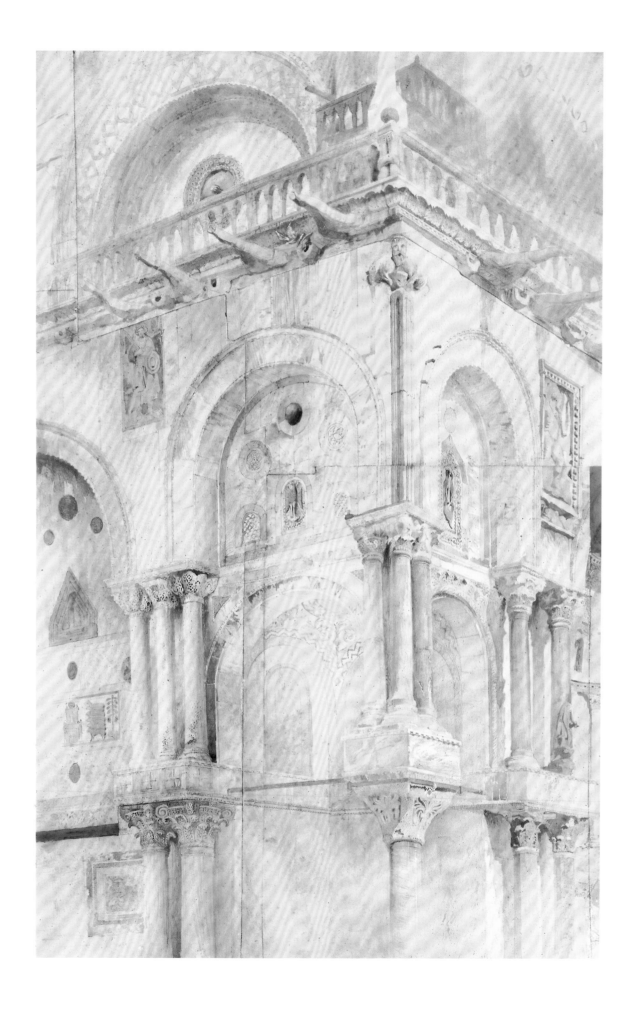

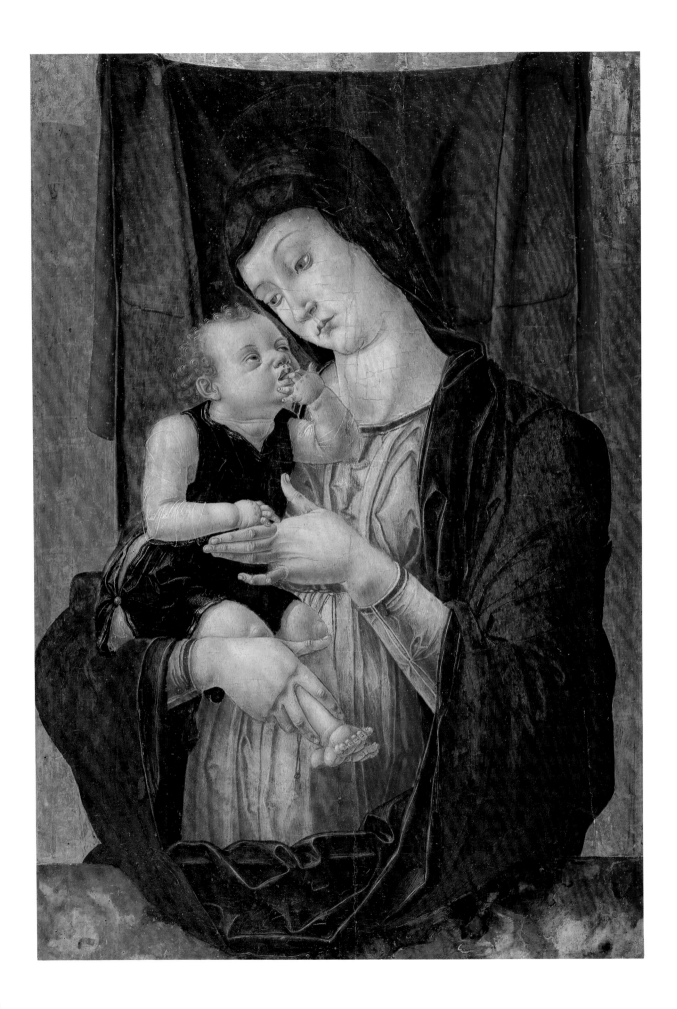

79

Bartolomeo Vivarini
(active 1450–1499)

Virgin and Child

Tempera on poplar panel
92.1 x 66.8

Acquired by Ruskin
in 1878

The Fogg Art Museum,
Harvard University
Art Museums. Gift of
Edward W. Forbes

'The throned Madonnas of Vivarini and Bellini were to Venice what the statue of Athena … was to Athens' (Guide to the Academy at Venice, 1877, 24.153)

Although Ruskin knew works by Vivarini when writing *The Stones of Venice*, his main comments appear in his *Guide to the Principal Pictures in the Academy of Fine Arts at Venice*. There Vivarini stands for the Gothic period in Ruskin's schematisation of Venetian painting, which follows the pattern of rise, maturity and incipient fall: 'The first we may call the Vivarini epoch, bright, innocent, more or less elementary, entirely religious art, – reaching from 1400 to 1480; the second (which … we will call the Carpaccian epoch), sometimes classic and mythic, as well as religious, 1480–1520; the third, supremely powerful art corrupted by taint of death, 1520–1600, which we will call the Tintoret epoch' (24.155– 6). Ruskin's references to the 'classic and mythic' and to Athena reflect the development of his ideas after 1860, when he began to discover a universal, spiritual quality in all art, as opposed to his earlier narrow Evangelical Protestant views, and a continuous tradition that linked the Gothic with Pre-Raphaelite painting (24.27).

Ruskin bought the picture, which had previously belonged to the Inspector of the Venice Academy of Fine Arts, in 1878 through Charles Fairfax Murray (1849–1919), whom he used both as a copyist and a dealer (see cats.125, 127). In 1879 however he sold it to Frederic Leighton (see cat.218).

80

John Ruskin

*The South Side
of St Mark's from
the Loggia of the
Ducal Palace*
c. 1851

Pencil and watercolour
heightened with white,
on three pieces of paper
95.9 x 45.4

Private collection

*'The chief value of these plates will be their almost servile
veracity – a merit which will be appreciated when the buildings
themselves are no more'* (Prospectus for Examples of the
Architecture of Venice, 1856, 11.314)

As with cat.78, this unfinished drawing for a projected
plate in *Examples of the Architecture of Venice* was based
on a daguerreotype (see cat.104). It gives a particularly
good view of the so-called 'lily capitals' that cap the
freestanding columns supporting the portico (cat.85),
but Ruskin's adherence to truth has not prevented him
suppressing the Austrian gas lamp. Although part of
the present attraction of the drawing is its incompletion,
Ruskin was concerned with making an architectural
record. John Unrau points out in *Ruskin and St Mark's*
that this southern portico was later widened to regularise
the façade (Unrau 1984, p.54), so Ruskin's insistence
on the value of the 'servile veracity' of this drawing is
justified.

Ruskin specifically recommended this viewpoint
of St Mark's to the young artist George Price Boyce
(1826–97), who travelled to Italy armed with *The Stones
of Venice* in 1854. Meeting Ruskin in London later that
year, he noted that Ruskin 'hoped I was a confirmed
Pre-Raphaelite' (Surtees 1980, p.14).

81

John Ruskin

*Study from
Tintoretto's 'Adoration
of the Magi'*
1852

Pencil, watercolour
and bodycolour
69.8 x 101.6
in original frame

First exhibited
Royal Society of Painters
in Water Colours,
Ruskin Memorial
Exhibition 1901

Ruskin Foundation
(Ruskin Library,
University of Lancaster)

*'I should be afraid of offending the reader, if I were to define
to him accurately the kind and the degree of awe, with which
I have stood before Tintoret's* Adoration of the Magi*'*
(Modern Painters IV, 1856, 6.86)

As Ruskin's 1845 study of Tintoretto's *Crucifixion*, also in
the Scuola di San Rocco (cat.135) shows, the paintings by
Tintoretto that he encountered in Venice had a profound
effect on the development of his criticism. Jacopo Robusti
(1518–94), known as Tintoretto, combined the painterly
skills of Turner with the religious faith that Turner
lacked. His use of visual symbolism within a nominally
realistic visual vocabulary appealed to Ruskin, trained
as he was to interpret the typological symbolism of the

Bible. He comments of this picture, for instance, 'The
placing of the two doves as principal points of light in
the front of the picture, in order to remind the spectator
of the poverty of the mother whose child is receiving
the offerings and adoration of three monarchs, is one of
Tintoret's master touches … As if to illustrate the means
by which the Wise Men were brought from the East,
the picture is nothing but a large star, of which the
Christ is the centre (11.406).

Ruskin's description of Tintoretto's paintings in the
Scuola di San Rocco in the second volume of *Modern
Painters* was a revelation to the young Holman Hunt. In
his memoirs Hunt records a conversation with Millais in
which he tells Millais that Ruskin 'describes pictures of
the Venetian School in such a manner that you see them
with your inner sight, and you feel that the men who did
them had been appointed by God, like old prophets, to
bear a sacred message, and that they delivered themselves
like an Elijah of old' (Hunt 1905, vol.1, p.90). Hunt's
reading of Ruskin in 1847 encouraged him to develop his
own use of naturalistic symbolism in such works as *The
Light of the World* (cat.192) and *The Awakening Conscience*
(cat.193). In 1869 the artist and the critic met by chance
in Venice and paid a visit to the Scuola di San Rocco,
where Ruskin read aloud the passages that had inspired
Holman Hunt more than twenty years before.

82

John Ruskin

*Doorhead from
Ca' Contarini,
Porta di Ferro*
1851

Pencil and black ink,
brown wash and
bodycolour
22.5 x 27.6

First exhibited
Coniston Institute, Ruskin
Memorial Exhibition 1900

Yale Center for British Art,
Yale University Art Gallery.
Gift of Chauncey
B. Tinker, B.A. 1899

'A very interesting stone arch of the early thirteenth century'
('The Venetian Index', *The Stones of Venice* III, 1853,
11.368)

Mezzotinted by the engraver Thomas Lupton, the
drawing became the upper image in plate 11 of *Examples
of the Architecture of Venice.* Ruskin explained there that 'I
never draw architecture in outline, nor unless I can makes
perfect notes of the forms of its shadows, and foci of its
lights. In completing studies of this kind, it has always
seemed to me, that the most expressive and truthful
effects were to be obtained ... by bold Rembrandtism;
that is to say, by the sacrifice of details in the shadowed
parts, in order that greater depth of tone might be
afforded on the lights' (11.311–2). Hence his choice of
mezzotint as a medium. He admitted that the results
resembled a daguerreotype.

Ruskin was particularly interested in the decoration
of Venetian doorheads because it was a focal point for
sculptural decoration expressive of Venetian Gothic
values: 'there is always an intimation that they have
placed their defence and their prosperity in God's hands'
(10.323). The doorhead can still be seen.

83

John Ruskin

*The Ducal Palace,
Renaissance Capitals
of the Loggia*
1849–50

Pencil and watercolour
47 x 29.2

Lent by the Metropolitan
Museum of Art, Rogers
Fund, 1908

*'The Capitals seen in this Plate will give a general idea of
the workmanship of the fifteenth century Gothic of the Ducal
Palace'* (*Examples of the Architecture of Venice*, 1851, 11.348)

During the winter of 1849–50 Ruskin made a careful
study of the principal buildings of Venice (see cats.92–
100). This was a formidable task, because there was no
secure documentary record, even of the history of the
Ducal Palace. He therefore had to use the evidence of
his eyes, particularly in distinguishing those parts of the
Palace built in the fourteenth century, on the seaward
side, and those parts looking onto the Piazzetta built in
imitation of them in the fifteenth (cat.36). This minute
examination led to the discovery of an important
aesthetic principle, that the necessary delicacy and details
of carvings had to be judged in relation to their distance
from the spectator, just as the amount of detail in a
painting helped or harmed the overall effect.

'On my first careful examination of the capitals of
the upper arcade of the Ducal Palace at Venice, I was
induced, by their singular inferiority of workmanship,
to suppose them posterior to those of the lower arcade.
It was not until I discovered that some of those which
I thought worst above, were the best when seen from
below, that I obtained the key to this marvellous system
of adaptation; a system which I afterwards found carried
out in every building of the great times which I had
opportunity of examining' (9.292–3).

The drawing was lithographed by T.S. Boys as plate
15 of *Examples of the Architecture of Venice.* The red tinge
to the first two shafts on the left come from the use of a
different coloured marble to mark the place from which
sentences of death were proclaimed.

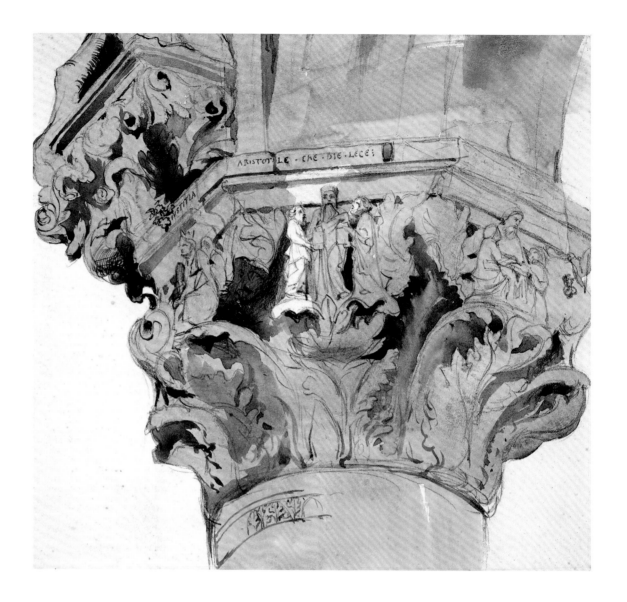

84

John Ruskin

*Capital 36 of
the Ducal Palace*
1849–52

Pencil and wash
22.3 x 23.5

Inscribed by Ruskin
'IUSTITIA' and 'ARISTOTLE –
CHE – DIE – LEGE'

Ruskin Foundation
(Ruskin Library,
University of Lancaster)

'Examples of acts of justice or good government'
(*The Stones of Venice* II, 1853, 10.425)

The second volume of *The Stones of Venice* contains a
detailed study of the 36 capitals that support the lower
storey of the Ducal Palace, 'which, being at a height of
little more than eight feet above the eye, might be read,
like the pages of a book' (10.365). His purpose was to
describe and explicate the personifications of virtues,
vices and other figures on the octagonal capitals, but
also to contrast the fourteenth-century Gothic carvings
on the waterfront side of the palace with the Renaissance
capitals facing the Piazzetta, which were 'base copies'
of them (10.424).

The exception to this typically Ruskinian criticism
of Renaissance work was the final capital, no.36, which
supports a large sculpture of the Judgement of Solomon.

Ruskin's drawing shows on the left, seaward side, the
figure of Justice, in the centre Aristotle the law-giver with
two pupils, and on the right a figure that he was unable
to identify, teaching two boys to read. Ruskin thought
the capital both noble and graceful, but his point was
that it was an assertion by the government of Venice that
'Justice only could be the foundation of its stability, as
these stones of Justice and Judgment are the foundation
of its halls of council' (10.427).

Ruskin employed a local sculptor, Giuseppe Giordani,
(active 1850–76) to make plaster casts of some of the
carvings, which are now in the Victoria and Albert
Museum. He was very concerned about the condition of
the Ducal Palace. Shortly after he left Venice in 1852 a
long-term programme of restoration began which means
that many of the capitals he described have been renewed
and altered.

85

John Ruskin

**Basket and Lily
Capital,
St Mark's
Basilica, Venice**
1849–52

Grey and brown
washes over pencil
22.5 x 18.5

Private collection

'*This lily, of the delicate Venetian marble, has but been wrought,
by the highest human art, into the same line which the clouds
disclose, when they break from the rough rocks of the flank of
the Matterhorn*' (*The Stones of Venice* I, 1851, 9.387)

Ruskin wrote that the Lily Capitals of St Mark's 'called
barbarous by our architects, are without exception the
most subtle pieces of composition in broad contour
which I have ever met with in architecture' (10.164).
Part of their significance for him was that they appeared
to echo the description of the capitals in the Temple of
Solomon in the Old Testament (1 Kings 7) where the
'top of the pillars were of lily work in the porch' (9.387).

The Lily Capitals, so called because they displayed
a stylised lily framed by an open basket-work of pierced
marble, were looted from the sixth-century church of

St Polyeuktos in Constantinople. They were used to
cap the outermost pillars supporting the north and
south porticos of the façade (see cats.78, 80). Ruskin was
attracted not only by their beauty and symbolism, but by
the way their appearance changed as the spectator moved
around the outside of the building, and the light moved
across the façade: 'no amount of illustration or eulogium
would be enough to make the reader understand the
perfect beauty of the thing itself, as the sun steals from
interstice to interstice of its marble veil, and touches with
the white lustre of its rays at midday the pointed leaves
of its thirsty lilies' (10.165). He illustrated them both in
Examples of the Architecture of Venice (pl.7), and in volume II
of *The Stones of Venice* (10.163 pl.IX). A hundred years later
the damage his drawings record to the fragile 'veil' of
basket-work has become even more severe.

86

John Ruskin and
Sir John Everett Millais, Bt,
assisted by Euphemia
Chalmers Ruskin
(1828–1897)

*Edinburgh Lecture
diagram: Decorated
cusped gothic window*
1853

Pencil, charcoal, ink wash,
watercolour, bodycolour,
oil and gold paint; paper
mounted on linen
151.5 x 183

Inscribed with the word
'nine' at the very top
centre, and a large number
'2' in wash on the back

First exhibited
Edinburgh Philosophical
Institution, 4 Queen Street,
4 November 1853

Ruskin Foundation
(Ruskin Library,
University of Lancaster)

*'I trust you will not leave this room, without determining, as you
have opportunity, to do something to advance this long-neglected
art of domestic architecture'* (*Lectures on Architecture and
Painting*, 1854, 12.72)

When Ruskin and his wife Effie, Millais and his brother
William went to Glenfinlas in the Highlands in July 1853,
while Millais's principal occupation was Ruskin's portrait
(cat.1), Ruskin's was to make the index to *The Stones of
Venice*, and then prepare four lectures to be given at the
Edinburgh Philosophical Institution that November. The
invitation to lecture had come from the artist J.F. Lewis
(cats.27, 120), who was in Edinburgh where he was an
exhibitor at, and an honorary member of, the Royal
Scottish Academy. This was to be the first time that
Ruskin, now 34, lectured in public, and he had to over-
come the strong objections of both his father and mother.

Ruskin chose as his subject the three topics at the
forefront of his mind: he gave two lectures on architec-
ture, attacking Edinburgh's neo-classical buildings, and
urging the use of the Gothic in domestic buildings; one
in praise of Turner, who had died in 1851; one on Pre-
Raphaelitism, praising Millais and Holman Hunt as
members of a young school that would succeed to the
place of Turner: 'With all their faults, their pictures are,
since Turner's death, the best – incomparably the best –
on the walls of the Royal Academy' (12.159–60). In
all four lectures, Ruskin addresses his audience (which
numbered about a thousand) as patrons of art with a
moral duty to employ artists and craftsmen as creatively
and usefully as possible.

Ruskin himself employed Millais to help him with
the large-scale illustrations to the lectures, which were
displayed in the lecture hall. These included enlarged
details from Turner and Claude and architectural details.
Millais was inspired to produce designs of his own. In
August he wrote to his close friend the Pre-Raphaelite
artist Charles Collins, 'You will shortly hear of me in
another art beside painting. Ruskin has discovered that
I can design Architectural ornamentation more perfectly
than any living or dead *party*. So delighted is he that in
the evenings I have promised to design doors, arches,
and windows for Churches etc, etc. It is the most amusing
occupation and it comes quite easily and naturally to
my hand … Ruskin is beside himself with pleasure as
he has been groaning for years about the lost feeling for
Architecture. When I make a design he slaps his hands
together in pleasure. He draws the arches and frames
the mouldings for me to fill up' (Lutyens 1967, p.81).

Ruskin was being serious in encouraging Millais's
interest in architectural design. He was currently being
consulted by the new incumbent of the Camden Chapel,
Camberwell, where he and his father worshipped, on the
proposal to extend the building with a new chancel. The
architect was his friend George Gilbert Scott (1811–78),
with whom he had collaborated during the rebuilding
of St Giles, Camberwell (see cat.90). There was a
possibility that Millais and other Pre-Raphaelites would
be employed to design stained glass. Millais produced
a large-scale design for a church window, where in
almost *art nouveau* fashion the tracery is in the form of
angels (all with the face of Effie), but the break with
Ruskin over Effie stopped the idea going any further.
The drawing is in the collection of Lord Lloyd-Webber
(Lutyens 1967, repr. opp. p.147).

Millais's letter to Collins shows that the lecture
diagrams were a collaborative effort. However, there was
a third hand involved. Millais – and not, significantly,
Ruskin – had taught Effie how to use a paint brush
(Lutyens 1967, p.78). On 10 October she wrote to a
friend, 'I have been so busy lately with gilding some of
John's Architectural Diagrams for Edinburgh' (Lutyens
1967, p.95). All three parties to the scandal that was to
break in the following year had a hand in this work.

The diagram here was one of four shown during
Ruskin's second Edinburgh lecture. The lectures,
'eminently clerical' in manner (12.xxxii), were given
partially extempore, and the image is not referred to in
the published version, *Lectures on Architecture and Painting*.
The original manuscript however shows that it was
used to demonstrate how a pointed arch could still be
designed in conjunction with a modern sash window:
'it is the glory of Gothic architecture that it can do
anything' (12.76n). As he had learned from the decorated
doorheads of Venice (cats.82, 108), the arch was an
opportunity for decorative sculpture: 'I do not say such a
window as this could be executed cheaply – yet it would
not be extravagant; all the sculpture here, though rich in
effect, is rude in execution – the whole window would
not cost so much as a very common piece of plate, and
a few such windows as this would produce a marvellous
effect on your streets' (12.77n).

The published version of the *Lectures*, in which he
added praise for Rossetti to that of Holman Hunt and
Millais, publicly mentioning the artist for the first time,
appeared in April 1854, the month that Effie left Ruskin
and began proceedings for the annulment of their
marriage.

87

John Ruskin

Sarcophagus and canopy of the tomb of Can Mastino II, Verona
1852

Pencil, wash and watercolour with some pen
46 x 36

Inscribed by Ruskin 'bases of top [?bay]' and 'base of niche'; given to the Ruskin School of Drawing 1872

The Visitors of the Ashmolean Museum, Oxford

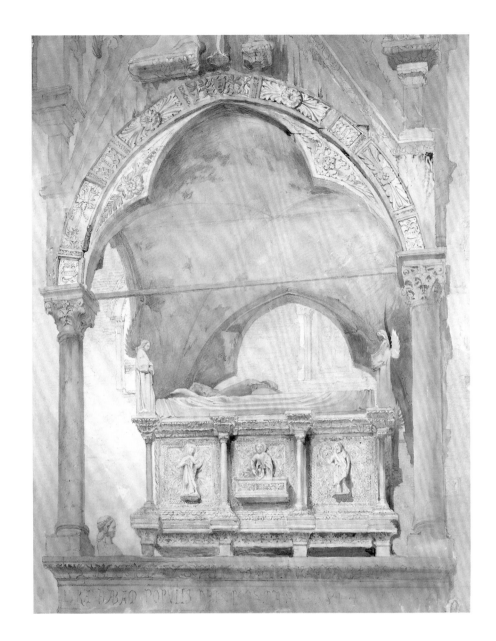

'I think the Gothic of Verona more and more superb every time I examine it' (Letter to his father, 6 June 1852, RLV.297)

Ruskin cited examples from Verona in *The Stones of Venice*, and made a number of excursions to the city in 1851–2, partly so that Effie could attend balls organised by the Austrian military authorities. He was particularly interested in the elaborate, open air, fourteenth-century tombs, notably the Castelbarco Tomb at S. Anastasia (see cat.105), the tomb of Can Grande della Scala, the freestanding monument to Can Mastino II, and the tomb of Can Signoria della Scala nearby. These last three monuments of the Scaliger family succeed each other in date and elaboration. Ruskin drew a moral from this, detecting in the decoration of the monuments signs of

the pride that would bring about the corruption of the Renaissance.

The date for this drawing is the one given by Ruskin's editors Cook and Wedderburn, although he also made an intensive study of the Verona tombs in 1869 (see cat.88). In 1852 Ruskin had casts made of panels of the sarcophagus, and later placed them, with this and other drawings, in his teaching collection at Oxford. After a visit to Verona in June 1852, as he was preparing to leave Venice for home, he wrote to his father, 'I have got to such a pitch of fastidiousness that no drawing will satisfy me at all as regards its expression of mere facts – but I must have a daguerreotype or a cast – and even grumble at those, at the one for exaggerating the shadows – at the other for losing the sharpness of the hollows' (RLV.297).

88

John Ruskin

Study of the North Gable of the Tomb of Can Mastino II, Verona

1852

Pencil and watercolour with some ink, on pale cream paper 40.5 x 27

First exhibited Royal Institution 29 January 1869; given to the Ruskin School of Drawing 1872

The Visitors of the Ashmolean Museum, Oxford

'The finest piece of Gothic in Verona, and the most accomplished example of Gothic tomb in the world' (*Catalogue of the Rudimentary Series*, 1878, 21.196)

After Venice, Verona was the city most studied by Ruskin (see Mullaly 1966). In 1857 he declared, 'if I were asked to lay my finger, in a map of the world, on the spot of the world's surface which contained at this moment the most singular concentration of art-teaching and art-treasure, I should lay it on the name of the town of Verona' (16.66). In 1869 he spent an extended stay, lasting four months, making only excursions to Venice, where he had an important encounter with Holman Hunt (see cat.81). At the behest of the Arundel Society he made further studies of the Scaliger family monuments, and bitterly watched

the restoration of the Castelbarco Tomb (see cat.105). The new roof looked 'like a Venetian gentleman in a Pantaloon's mask' (19.xlix). He contemplated writing a 'Stones of Verona' (19.434) but came to the conclusion, 'the questions I have to consider respecting architectural styles have become difficult and interminable to me in proportion to my knowledge' (19.xlvii). The only published result of this visit was a lecture 'Verona, and its Rivers', given at the Royal Institution on 4 February 1870, in which he advocated damming the flood-waters of the Alps.

This drawing was exhibited to accompany an earlier lecture at the Royal Institution, 'The Flamboyant Architecture of the Somme', in January 1869, and so has been dated to the previous visits of 1852.

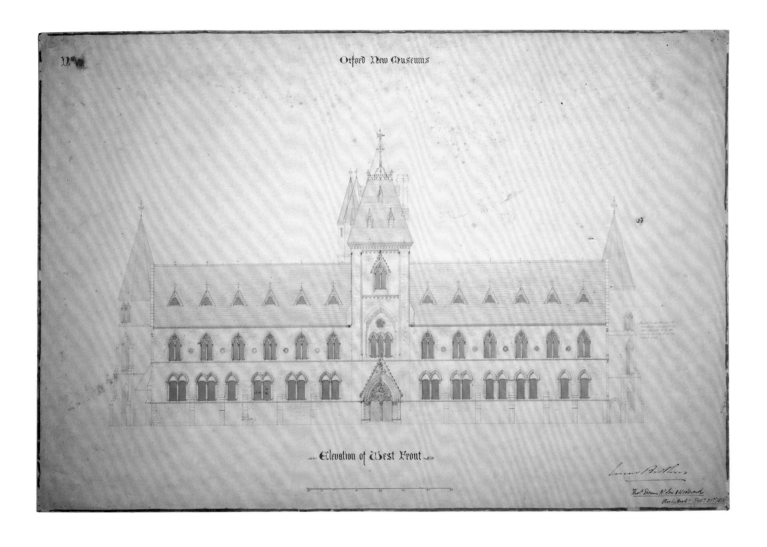

89

Benjamin Woodward
(1816–1861)

*Elevation of the West
Front of the Oxford
Museum*
1855

Pencil, ink and wash,
on linen backed paper
62.5 × 93

Signed 'Thos Deane
[Architct] & Son &
Woodward Architects
Feb 21ˢᵗ 1855' and
'Lucas Brothers', with
additional notations
in ink and pencil

Oxford University
Archives

'*Gothic is not only the best, but the* only rational *architecture,
as being that which can fit itself most easily to all services,
vulgar or noble*' (*The Stones of Venice* II, 1853, 10.212)

The most important building to be built according to
the principles of *The Seven Lamps of Architecture* and *The
Stones of Venice* was Oxford University's new museum
for the natural sciences. Designed in 1854 and opened in
1860, it was the first secular, public building to be built
in the Gothic style since the Houses of Parliament by
Charles Barry (1795–1860) and Augustus Welby Pugin
(1812–52), begun in 1840. Its purpose was not only
secular, but scientific: to house the collections, teaching
rooms and laboratories of the new School of Natural
Sciences, which had recently been established, not
without opposition, by the University. It was therefore
using the Gothic in support of modernity rather than
in an antiquarian or ecclesiological fashion. It also used
modern technology, in the form of iron columns to
support a remarkable iron and glass roof (fig.5).

The architect Benjamin Woodward was a junior
partner in the Dublin firm of Deane, Son and Woodward.
In 1854 work began to the firm's design on a new library
for Trinity College, Dublin, which was Venetian Gothic
in style. The same year Oxford mounted a competition
to choose an architect for its new museum. The prime
mover in the campaign for the museum was Ruskin's
friend from his undergraduate days at Christ Church,
Dr Henry Acland (1815–1900), who had first met
Woodward in 1842. Thirty-two designs were submitted
(anonymously), and six shortlisted, finally two. After
a short 'battle of the styles' between a Palladian design
by Charles Barry's son, E.M. Barry (1830–80) and
Woodward's proposals, Woodward's design was chosen
in December 1854. In 1856 he was separately com-
missioned by the Oxford Union to build them a new
library and debating hall (see cat.91).

Until the two men met in December 1854, Ruskin's
influence on Woodward had been indirect. In her study
Ruskinian Gothic, Eve Blau argues, 'Ruskin's writings not

only served to articulate ideas already nascent in Deane and Woodward's architecture, but they also gave direction and form to these ideas. Thus on the one hand Ruskin's precepts regarding the role of the craftsman and the social responsibility of public art can be seen as providing the ideological framework for Deane and Woodward's architecture, while his more precise prescriptions concerning the 'noble characters' of buildings, the use of particular materials, types of ornament and surface patterns, account for some of the formal qualities of their work' (Blau 1982, pp.138–9).

Ruskin did not have a hand in Woodward's Oxford design, but once Acland had brought the two men together at the end of 1854, he became actively involved in seeing the project through. His primary concern was the decoration of the building, where he saw to it that Pre-Raphaelite artists would be commissioned (see cat.91). The £30,000 budgeted for the project was not enough to cover this, and Ruskin became a key fund raiser, publishing a promotional booklet with Acland, *The Oxford Museum*, in 1859, and making the largest single donation, £300 for the ground-floor windows of the façade. He proposed designs of his own (see cat.90) and lectured to the workmen on the site, reminding them that medieval architects did not treat their men as mere machines: 'they all worked together as one man' (16.434). Sadly, Woodward suffered from tuberculosis, and from 1858 began to have to spend winters abroad, placing more responsibility on Acland and Ruskin. In 1860, though not yet furnished, the museum's library was used to hold the celebrated debate between T.H. Huxley and Bishop Wilberforce on Charles Darwin's *On The Origin of Species*. This book, published in 1859, spelled the end of the natural theology that had inspired Ruskin in his youth, and which made him the advocate of the synthesis of art and science that the Oxford Museum represented. In May 1861 Woodward – in Ruskin's words 'one of the most earnest souls that ever gave itself to the arts, and one of my truest and most loving friends' (18.150) – died, with the decorative scheme unfinished. Ruskin lost interest in the project, and was never to be so closely associated with a Gothic Revival building again, though his ideas continued to influence George Gilbert Scott, William Butterfield (1814–1900) and George Edmund Street (1824–81). When he became Slade Professor of Fine Art at Oxford he lectured in the museum, and began to refer to the building with some bitterness. During his second tenure in 1883–4 he campaigned against the proposal to allow vivisection in its laboratories, finally resigning his professorship over the issue.

Though still decoratively incomplete, and now extended to house the Pitt-Rivers Museum, Woodward's building is a remarkable expression of Ruskinian ideas, even if Ruskin himself thought it only a beginning: 'lovelier and juster expressions of the Gothic principle will be ultimately aimed at' (16.234). It carries out Ruskin's advice to 'adopt the pure and perfect forms of the Northern Gothic, and work them out with the Italian refinement' (11.230) by deploying the regular façade and central tower of a Flanders town hall as a frame for the sculptural decoration. Blau comments, 'The inspiration for this visual sense of composing within a frame – shared by Woodward and the Pre-Raphaelites – is Ruskin' (Blau 1982, p.91). The use of iron columns to support the roof is not contrary to Ruskinian principles, since wrought iron tubes have been used like branches to brace the structure. (The original attempt to use wrought iron throughout had to be abandoned in favour of cast iron columns.) The shafts and capitals of the interior courtyard can, like the columns of the Ducal Palace, 'be read, like the pages of a book' (10.365), for the shafts are individual examples of British rocks, and the capitals examples of British flora and fauna. In the work-practices that Ruskin encouraged, in the use of contemporary artists as embellishers of the building, and in the holistic statement that the interior and exterior make, the Oxford Museum truly represents 'The Nature of Gothic'.

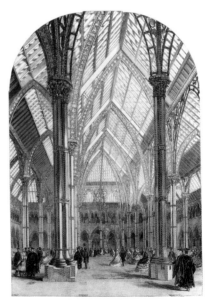

fig.5 *Interior Court of the Oxford Museum*
(*The Illustrated London News* 1859)

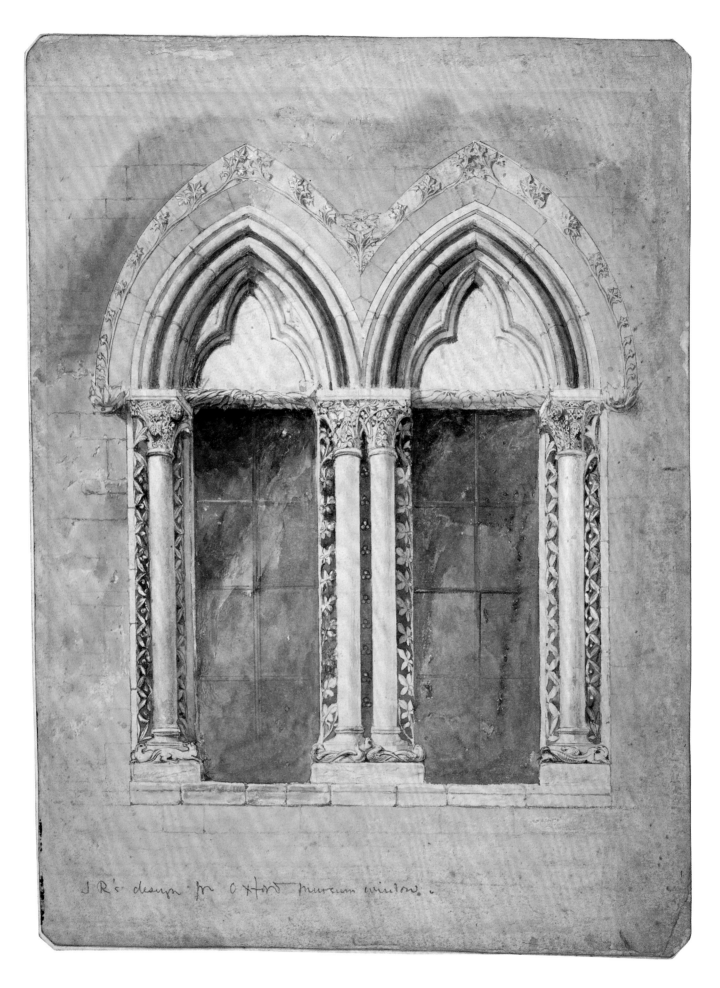

JR's design for Oxford museum window.

90

John Ruskin

*Oxford Museum,
Design for a Window*

Pencil, watercolour
and bodycolour
38.7 x 29

Inscribed by Joan Severn
in pencil 'JR's design for
Oxford Museum window'

Birmingham Museums
and Art Gallery

*'All architectural ornamentation should be executed by the men
who design it'* (*The Oxford Museum*, 1859, 16.215)

Ruskin had no hand in the overall design of the Oxford
Museum, but he sought to influence its external decor-
ation, producing proposals and designs for translating
natural forms such as foliage and animals into sculpture.
None of these designs was precisely carried out, although
this one has many of the features of the second window
to the left of the entrance, on the ground floor, which
was referred to in his lifetime as the 'Ruskin Window'
(Brooks 1989, p.126).

There is a good reason why Ruskin's designs were
not carried out precisely. In 1858 Woodward brought
over from Ireland two stonemasons, the O'Shea brothers
James and John, who together with their nephew Edward
Whellan had worked for him on earlier Irish projects
(fig.6). The O'Sheas were very independent-minded,
and preferred to carve directly, without drawings. This
procedure suited the illustrative purpose of the museum's
decorations. The first Keeper of the museum, the
Professor of Geology John Phillips (1800–74), would
bring in plants and leaves from Oxford's Botanical
Gardens to be copied directly by the masons. The
practice also followed Ruskin's principles outlined in his
chapter on 'The Nature of Gothic' in *The Stones of Venice*,
where he argued for the freedom of the workman to
express himself. The museum thus became 'literally the
first building raised in England since the close of the
fifteenth century, which has fearlessly put to new trial
this old faith in nature, and in the genius of the
unassisted workman, who gathered out of nature the
materials he needed' (16.231).

Ruskin knew that there was a cost involved, in
that the workmen might not reach the highest level of
achievement. In 1858 he awarded James O'Shea the prize
in an annual competition for decorative sculpture which
he had instituted in 1855, but he said of the O'Sheas'
work on the museum, 'it is not yet perfect Gothic
sculpture; and it might give rise to dangerous error, if
the admiration given to these carvings were unqualified'
(16.231).

Ruskin had been involved with two earlier schemes
for architectural decoration, both with the Gothic Revival
architect Gilbert Scott. In 1844 he and Edmund Oldfield
(1817–1902), a former fellow pupil at the Rev. Thomas
Dale's school in Camberwell, who was to become –
with Ruskin – a founder of the Arundel Society, and
a Keeper at the British Museum, jointly produced the
designs for painted glass of the east windows of St Giles,
Camberwell, which Scott was rebuilding in Gothic
Revival style. In 1853 Ruskin was also consulted by
Scott about the remodelling of the Camden Chapel,
Camberwell (now demolished), where Millais's employ-
ment was suggested (see cat.86). Scott's new chancel was
in Romanesque style, using polychromatic stone in the
manner advocated by Ruskin in *The Stones of Venice*.

fig.6 *One of the O'Shea brothers at work on the façade
of the Oxford Museum*

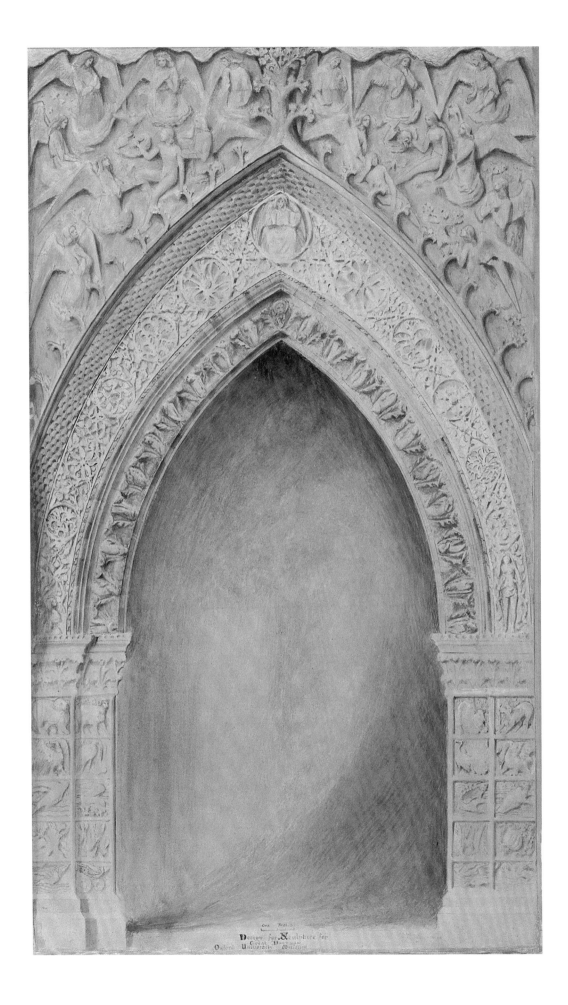

91

John Hungerford Pollen
(1820–1902)

*Design for
the Sculpture of
the Great Doorway,
Oxford University
Museum*
1859

Pencil, pen and wash
with green tint
69 x 39.5

Signed with monogram
and inscribed 'J.H.Pollen
11 Pembridge Crescent. W'

Oxford University Museum
of Natural History

'I shall get all the preRaphaelites to design me – each an archivolt and some capitals' (Letter to Lady Trevelyan, Dec. 1854, RLPT.95)

Ruskin was anxious to employ as many of the Pre-Raphaelite circle as possible on the decoration of the museum. The sculptors Alexander Munro (1825–71) and Thomas Woolner (1825–92) contributed statues of key figures in the history of science. Woolner was also asked to submit a design for the entrance porch but it was rejected on the grounds of cost, and this design was substituted. John Hungerford Pollen, a former Oxford don who became a decorative artist and designer following his conversion to Roman Catholicism in 1852, had worked with the Gothic Revival architect William Butterfield on the restoration of Merton College chapel in 1849–50, and became a collaborator with Woodward. Ironically, the design represents the spiritual evolution of man, with Adam on the left side, and Eve on the right, with the Angel of Life at the top, holding in one hand an open book, in the other a dividing cell. This was not the idea of evolution proposed by Darwin in his *On the Origin of Species*, published in the same year. A comparison between this design and the entrance to the museum in its present state shows that it was only partially carried out, with sections abandoned while only roughly blocked out. The tympanum above the arch was not even begun.

Ruskin also suggested that Millais and Rossetti should be commissioned to paint murals. After Ruskin introduced Rossetti to Woodward late in 1854 both he and Elizabeth Siddal were invited to submit designs, though the latter's proved too delicate for carving. Rossetti was asked to paint a mural depicting 'Newton gathering pebbles on the shores of the Ocean of Truth'. No such mural was forthcoming, although Ruskin's disciple the Reverend Richard St John Tyrwhitt (1827–95) did paint two large murals in the geology department. Instead, Rossetti offered to decorate Woodward's other Oxford building, the new Library and Debating Hall for the Oxford Union, whose fabric was completed in the summer of 1857.

The Oxford Museum thus led to the most celebrated joint project of the Pre-Raphaelite circle. It brought together members of the original brotherhood and their friends, and the new generation, represented by Edward Burne-Jones and William Morris, although Ford Madox Brown, Holman Hunt and William Bell Scott declined Rossetti's invitation to take part. In addition to Morris and Burne-Jones, Arthur Hughes, John Roddam Spencer Stanhope (1829–1908), Val Prinsep (1838–1904) and J.H. Pollen contributed to the murals on the theme of Arthurian legend inspired by Malory's fifteenth-century *Morte d'Arthur*, with carvings by Alexander Munro and the O'Shea brothers.

The paintings, in the upper gallery, were awkwardly set against hexafoil windows, making them difficult to see, and the paint was applied to whitewash over bricks and mortar, so that they soon deteriorated. Nor was the scheme properly finished. William Bell Scott pronounced it 'simply the most unmitigated *fiasco* that ever was made by a parcel of men of genius' (Minto 1892, vol.2, p.41).

Ruskin's response to the Union murals was mixed. When he inspected the work in progress in October 1857 he pronounced Rossetti's *Sir Lancelot asleep before the Shrine of the Sanc Grael* 'to be the finest piece of colour in the world' (Burne-Jones 1904, vol.1, p.168), but thought Morris's ceiling 'clever but not right' (36.273) and Hughes's *The Death of Arthur* 'not decorative enough' (RLPT.278). He offered to knock off 70 guineas from Rossetti's debt to him if he painted another section, with the proviso that 'there's no absolute nonsense in it, and the trees are like trees and the stones like stones' (36.273). Rossetti did not take up the offer. Ruskin disliked the romantic medievalism of the Arthurian legends (see also cat.200). In October 1858 he wrote that he had 'almost got sickened of all Gothic by Rossetti's clique, all the more that I have been having a great go with Veronese' (Chapman 1945, p.153).

Ruskin was reacting against what he saw as a vulgarisation of the nature of Gothic, which became more pronounced as its principles were diluted by popularity. When he published a new edition of *The Stones of Venice* in 1874 he regretted 'the partial use of it which has mottled our manufactory chimneys with black and red brick, dignified our banks and drapers' shops with Venetian tracery, and pinched our parish churches into dark and slippery arrangements for the advertisement of cheap coloured glass and pantiles' (9.11). Nor did he appreciate the use of Verona brickwork for the porch of a pub.

fig.7 *The Orders of Venetian Arches*
(*The Stones of Venice* vol. ii, pl. 14)

92

John Ruskin

Worksheet No 17:
Notes on the Casa
d'Oro
19 Nov. 1849

Pen over pencil
35.6 x 28

Inscribed by Ruskin
(bottom right)
'No 17. Ca' d'Oro:
P.38. M and p 41
Nov 19th' and with
extensive measurements
and notations

Ruskin Foundation
(Ruskin Library,
University of Lancaster)

*'It became necessary for me to examine not only every one of
the older palaces, stone by stone, but every fragment throughout
the city which afforded any clue to the formation of its styles'*
(*The Stones of Venice* i, 1857, 9.4)

When Ruskin began to research the architectural
history of Venice, he quickly discovered, 'the Venetian
antiquaries were not agreed within a century as to the
date of the building of the façade of the Ducal Palace,
and that nothing was known of any other civil edifice
of the early city' (9.3). He therefore had to evolve his
own methodology, which was based on the careful
measurement and stylistic analysis of the buildings them-
selves. From this study he developed a typology (fig.7),
principally based on the evolution of the pointed Gothic
arch from its round-headed Byzantine and Romanesque
predecessors, arguing that the more elaborate the shape
of the arch was, the later it was in date. Ruskin's
historical typology remains largely valid today.

Ruskin's research began by noting measurements
and details *in situ* on sheets of paper such as this one,
which he numbered and sometimes dated. These notes,
and calculations based upon them, would then be written
up in a notebook (cat.93), and a cross-reference to the
page number of the relevant notes added to the work-
sheet. Hence the annotation here: 'P.38. M and p 41'.
The numbered series begins with studies in Verona,
made on the way to Venice in 1849. Sheet no.8 is the
first used in Venice, and the series continues until no.174,
when Ruskin left Venice in 1850. No.175 is from Verona,
and the series ends at no.195 at Bourges Cathedral in
France, although the system appears also to have been
used in 1851–2. Many of the sheets were subsequently
cut up by Ruskin and dispersed, but it is possible to
reconstruct the series from Ruskin's accompanying
notebooks.

This worksheet, analysing the tracery of the two
central windows on the first floor of the Casa d'Oro, and
the notebooks which follow (cats.93–100) demonstrate
Ruskin's working method in the winter of 1849–50. It
is a remarkable achievement of visual analysis and intel-
lectual synthesis.

93

John Ruskin

Diary 1849–50: Notebook M

224 numbered leaves
23.1 x 18.5, on pale blue
unlined paper, bound in
white vellum with brass
clasp. Printed label of
W. Grigg, engraver,
printer and stationer,
books and music binder,
183 Regent Street, on
front pastedown

Inscribed by Ruskin on
spine in ink 'M', and
on torn label '[1]o' and
containing extensive notes,
sketches and diagrams
in pencil and ink

Ruskin Foundation
(Ruskin Library,
University of Lancaster)

Ruskin's diary-notebook is open at the entry for
19 November 1849 folio 47 where he writes up his notes
on the Casa d'Oro, taken from worksheet no 17 (cat.92)
and related studies.

Throughout his life Ruskin kept notebooks on his
current research, using them also as informal diaries to
record personal events such as travel, church-going, bible
reading, health, the weather and, in later life, dreams
(see cat.235). The biographical content of these note-
books has been largely extracted and published in an
edition by Joan Evans and J.H. Whitehouse as *The Diaries
of John Ruskin* (Oxford, 3 vols., 1956–9). These volumes
however omit much of the most interesting material that
reflects his omnivorous reading, the progress of his
research and his spiritual life.

The diary-notebook which Ruskin marked 'M'
contains much of the raw material for the first volume
of *The Stones of Venice.* He was simultaneously using a
second, similar-sized notebook marked 'M2', now in
the Beinecke Rare Book and Manuscript Library, Yale
University. This was originally intended for notes on
his archival as opposed to architectural research, but the
'M' notebook became filled up, and notes on worksheets
appear in the 'M2' volume also.

John Ruskin

*Seven Architectural
Notebooks*
1849–50

Ruskin Foundation
(Ruskin Library,
University of Lancaster)

In addition to the large diary-notebooks 'M' and 'M2'
Ruskin began to use a series of small pocket-books for
gathering material on the spot as he moved around the
city. These too were collated with the diary-notebooks.
The order in which they were brought into use shows
the progress of Ruskin's research and the development
of special topics.

94

House Book 1
140 pp
19.5 x 12.2

(first 4 and last 2 leaves
missing), white lined paper
with embossed border,
with yellow flyleaves,
bound in green marbled
and cardboard covers.
Openings 1–70 numbered
by Ruskin, and inscribed
by him with extensive
notes and sketches in
pencil and ink. On the
right-hand side of each
opening preliminary
categories have been set
out, in Effie Ruskin's hand

First brought into use in late October or early
November 1849. Ruskin used this notebook to
record the distinctive features of the façades of
Venetian houses, using the categories 'Angle',
'Door', 'Water story', '1st story'. Each house
studied received a number for cross-reference.
The notebook is open at folio 45, notes on
the Casa Contarini Fasan (see cat.67).

95

Door Book
120 pp
19.4 x 12.2

On green lined paper with
embossed border, with
pale brown fly leaves,
bound in red and green
marbled cardboard covers.
Openings 1–59 numbered
by Ruskin, and inscribed
by him with extensive
notes and sketches in
pencil and ink. On the
right-hand side of each
opening preliminary
categories have been set
out, in Effie Ruskin's hand:
'Type', 'Masonry',
'Archivolt Breadth',
'Archivolt Section', 'Jamb
Section', 'Pil[lar] Head'

Begun in mid-December 1859, when Ruskin
discovered that he did not have sufficient
room in 'House Book 1' to note the details
of the sculptured doorheads that were such
an important feature of Venetian houses
(see cats.82, 108). 'Door Book' became an
extension of 'House Book 1'. Open at folio
16, House no 45, 'at the bottom of a dark and
filthy alley' which House Book 1 identifies
as 'Sottoportico della Stua'.

96

House Book 2
120 pp
19.2 X 12.2

On green lined paper with embossed border, with lilac flyleaves, bound in purple marbled cardboard covers. Openings numbered by Ruskin 2–60, with extensive notes and sketches in pencil and ink with some watercolour

This notebook was brought into use in mid-December 1849 as a continuation of 'House Book 1'. It is open at folio 52, notes on Palazzo Farsetti.

97

Palace Book
120 pp
(1½ sheets missing at end)
19.4 X 12

On green lined paper with embossed border, with lilac flyleaves, bound in blue, yellow, red and green marbled cardboard covers. Openings numbered by Ruskin 1–60, with extensive notes and sketches in pencil and ink

Ruskin's notebook devoted to the Ducal Palace was begun in mid-December 1849. It is open at folio 6, analysing a section of the archivolts of the lower storey.

98

Gothic Book
160 pp
19.4 X 12.2

On green lined paper with embossed border, with brown flyleaves, bound in blue marbled cardboard covers. Openings numbered by Ruskin 2–80, with extensive notes and sketches in pencil and ink

Ruskin's notebook devoted to details of Gothic buildings was begun in early January 1850. Open at folio 25, it notes the pilasters at the base of pillars in the choir of SS Giovanni e Paolo.

99

Bit Book

162 pp
19.2 x 12.2

On green lined paper
with embossed border,
with pale brown flyleaves,
bound in green marbled
cardboard covers.
Openings numbered
by Ruskin 1–81, with
extensive notes and
sketches in pencil and ink

As the name implies, this is a miscellaneous
notebook begun in January 1850. It is open
at folio 29, showing details of a doorhead
in Ramo dirimpetto Mocenigo (see cat.108).

100

St M Book

204 pp
19.2 x 12.2

On green lined paper
with embossed border,
with yellow flyleaves,
bound in russet marbled
cardboard covers.
Openings numbered
by Ruskin 1–102, with
extensive notes and
sketches in pencil and ink

Ruskin's notebook devoted to St Mark's was
begun in February 1850. It is open at folio 50,
noting the arrangement of the pillars in the
fifth (southernmost) porch.

Daguerreotypes

'Among all the mechanical poison that this terrible nineteenth century has poured upon men, it has given us at any rate one antidote, the Daguerreotype. It's a most blessed invention' (Letter to his father, 16 October 1845, 1845L.225)

Louis-Jacques-Mandé Daguerre's invention, made public in 1839, was known to Ruskin by 1842, although he was not the first, as he claimed in his autobiography, to have brought examples to England. He owned examples by 1844, but his enthusiasm for the medium stems from 1845, when he felt overwhelmed by the task of visually recording so many threatened buildings in Venice. He wrote to his father, 'I have been lucky enough to get from a poor Frenchman here, said to be in distress, some most beautiful, though small, Daguerreotypes of the palaces I have been trying to draw – and certainly Daguerreotypes taken by this vivid sunlight are glorious things. It is very nearly the same thing as carrying off the palace itself – every chip of stone & stain is there – and of course, there can be no mistake about *proportions'* (1845L.220). Ruskin welcomed the new visual technology, and 'allied' himself (3.210n) with the daguerreotype process to produce images such as cats.103, 104, 105.

At first Ruskin either bought ready-made plates, or commissioned particular images that he wanted, such as the source of cat.72. By 1849 however he had acquired his own equipment, which he took with him on his journey to Venice. The technical process of producing the plates was the responsibility of his servant and amanuensis John 'George' Hobbs, and of his successor Frederick Crawley. Ruskin however selected the images. Effie describes him in a letter of 1850 from Venice 'with a black cloth over his head taking Daguerreotypes' (EV.146). This was another aspect of the research process, and the notation 'dag' appears frequently in his notebooks. Ruskin also experimented with the calotype process at this period.

Ruskin built up a collection of 233 plates, according to a manuscript catalogue in the Ruskin Library, of which 124 survive. He also began to collect and commission photographs as the process took over from the daguerreotype. Photographs became an important part of the architectural recording schemes of the Guild of St George (see cat.257) and were included in the teaching collection of the Ruskin School of Drawing.

Ruskin welcomed photography as a means of recording architecture (and made daguerreotypes of the Alps in 1849), but he never thought of it as an art form, partly because of its technical limitations, but principally because a mechanical process could not substitute for the imaginative transformation involved in making a work of art. He wrote in volume III of *The Stones of Venice*, 'as a photograph is not a work of art, though it requires certain delicate manipulations of paper and acid, and subtle calculations of time, in order to bring out a good result; so, neither would a drawing *like* a photograph, made directly from nature, be a work of art, although it would imply many delicate manipulations of the pencil and subtle calculations of effects of colour and shade … But the moment that inner part of the man, or rather, that entire and only being of the man, of which cornea and retina, fingers and hands, pencils and colours are all the mere servants and instruments; that manhood which has light in itself . . . the moment this part of the man stands forth with its solemn 'Behold, it is I', then the work becomes art indeed' (11.201–3).

Ruskin exonerated the Pre-Raphaelites of the charge of using photographs. As photography became more popular, with claims to be an art form, his attitude hardened against it, except as a means of record. In 1870 he dismissed landscape photographs as 'merely spoiled nature' (20.165).

101

Unknown Photographer

Venice: The South Side of St Mark's and the Ducal Palace
?1845

Daguerreotype plate
10 x 15.5

Ruskin Foundation
(Ruskin Library,
University of Lancaster)

The smaller size of this plate, and its composition as a general view, suggest that this may be one of the plates bought in Venice from a 'poor Frenchman' (1845L.220) in 1845.

102

Unknown Photographer

Lucca: Tomb of Ilaria del Caretto
?1846

Daguerreotype plate
6 x 12.9

Ruskin Foundation
(Ruskin Library,
University of Lancaster)

The proportions of the plate do not match those known to have been made with Ruskin's equipment, and Ruskin bought or commissioned daguerreotypes during his continental tour of 1846. The tomb by Jacopo della Quercia (1374–1438) became Ruskin's 'ideal of Christian sculpture' (4.347) and was to acquire additional significance for him in the 1870s (see cat.237).

103

John Hobbs
(1824–1892)

Venice: North West Angle of St Mark's
1849–50

Daguerreotype plate
15.3 x 11.2

Ruskin Foundation
(Ruskin Library,
University of Lancaster)

A plate made under Ruskin's direction, this was used by him to prepare the large illustration intended for *Examples of the Architecture of Venice* (cat.78). John Hobbs (or Hobbes) became Ruskin's valet in 1841, and was given the name 'George' to distinguish him from his master. He copied out Ruskin's manuscripts as well as taking daguerreotypes. He left Ruskin's service in 1854 and emigrated to Australia.

104

John Hobbs

Venice: South Side of St Mark's from the Loggia of the Ducal Palace
1849–50

Daguerreotype plate
15.3 x 11.2

Ruskin Foundation
(Ruskin Library,
University of Lancaster)

A plate made under Ruskin's direction and used to prepare the large illustration intended for *Examples of the Architecture of Venice* (cat.80). The plate shows the gas lamp installed by the Austrian authorities that Ruskin has eliminated from his drawing.

105

John Hobbs

Verona: Castelbarco Tomb
?1852

Daguerreotype plate,
image reversed
15.3 x 11.2

Ruskin Foundation
(Ruskin Library,
University of Lancaster)

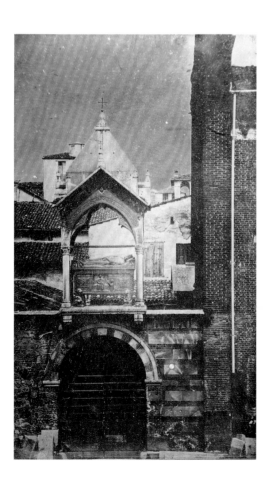

Unless a correction was made by the photographer, the daguerreotype process produced a reversed image, so that objects on the right of the photographer appeared on the left of the plate. This is the case here. Ruskin made a special study of Verona's monuments in 1852 (cats.87, 88). The plate shows the tomb in its unrestored state, before the changes Ruskin witnessed in 1869 (cat.88).

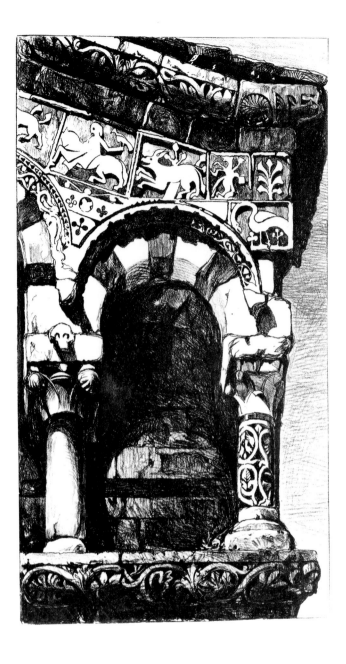

106

John Ruskin

**The Seven Lamps
of Architecture**
issued 10 May 1849
London, Smith, Elder,
& Co

Imperial octavo
pp.xii + 205

14 plates etched by Ruskin

Ruskin Foundation
(Ruskin Library,
University of Lancaster)

The first edition of *The Seven Lamps of Architecture* is open at plate VI, 'Arch from the Façade of The Church of San Michele, Lucca', etched by Ruskin.

Ruskin's first published critical writing had been a series of articles for the *Architectural Magazine* in 1837 and 1838 (broken off when the magazine ceased publication; cat.25) and republished as *The Poetry of Architecture* (1893). By the time *The Seven Lamps of Architecture* appeared he had established his reputation with volumes I and II of *Modern Painters*, and his preface explains that the work grew out of research for its continuation. Architecture became a distinct subject, however, and he was not to publish volumes III and IV of *Modern Painters* until 1856.

The inspiration for *The Seven Lamps* was the contemporary controversy about the Gothic Revival, and especially its Romanist or High Church tendencies. Ruskin was equally concerned about the disappearance of medieval architecture as industrialisation led to its demolition or – in Ruskin's eyes – worse, its unsympathetic restoration by Revivalists. The political upheavals in France and Italy in 1848 added urgency, hence his remark in the preface about the destruction wrought by 'the Restorer, or Revolutionist … [My] whole time has been lately occupied in taking drawings from one side of buildings, of which masons were knocking down the other' (8.3n).

Ruskin's intervention in the architectural debate about the Gothic was concerned much more with architectural theory than practice: 'it is to be remembered that the following chapters pretend only to be a statement of principles, illustrated each by one or two examples; not an Essay on European architecture' (8.5). These principles were intended to influence contemporary architects; the terms in which he discussed the buildings were essentially moral, with each chapter devoted to a separate aspect of conduct. These categories, or 'lamps' as he called them, were Sacrifice, Truth, Power, Beauty, Life, Memory and Obedience.

The sublimity of the Lamp of Power, as demonstrated by San Michele, came from the unity of its façade, its height and mass, and the way the Romanesque builders created a dramatic contrast between deep shade in the recesses of the arcade, while drawing the eye to the incised decoration on the external surface. The use of natural subject matter, in the form of a hunting scene, reinforced the link between Architecture and Nature. Ruskin judged national styles of architecture according to the moral principles he proposed, an approach that led to his next major work, *The Stones of Venice* (cat.107).

The Seven Lamps of Architecture was the first work by Ruskin to be illustrated (editions of *Modern Painters* only began to be illustrated with the third volume). Ruskin was modest about the quality of the plates, which, for the first edition, he drew and etched himself, finishing the last plate in a hotel in Dijon, using his wash-basin as an acid bath (8.xlv).

THE
STONES OF VENICE.

107

John Ruskin

*The Stones of
Venice, volume I:
The Foundations*
issued 3 March 1851
London, Smith, Elder,
& Co

Imperial octavo
pp.xvi + 413

21 plates by John Ruskin,
engraved by J.C. Armytage

Inscribed by Ruskin
on the flyleaf
'J.M.W. Turner Esq.:
R.A. / With the Authors
affectionate & respectful
regards'

Private collection

In a preface to the third edition, published in 1874, Ruskin wrote, 'No book of mine has had so much influence on contemporary art as the *Stones of Venice*' (9.11). After the first volume was published in March 1851 he returned to Venice for a further winter's research, publishing the second volume, *The Sea Stories*, and the third, *The Fall*, in July and October 1853.

Ruskin's purpose in writing the book was not just architectural but socio-historical and, in effect, political. Alarmed by the increasing confidence of Roman Catholicism in England, and the effects of industrialisation on contemporary art and architecture, in his opening paragraph he drew a political parallel between the fate of the Venetian maritime empire and the British: 'Since first the dominion of men was asserted over the ocean, three thrones, of mark beyond all others, have been set upon its sands: the thrones of Tyre, Venice and England. Of the First of these great powers only the memory remains; of the Second, the ruin; the Third, which inherits their greatness, if it forget their example, may be led through prouder eminence to less pitied destruction'(9.17).

After this sonorous opening the bulk of volume I was devoted to a theoretical discussion of the component elements of architecture, a subject that Ruskin's father, and quite a few of his readers, found excessively dry. With these foundations laid, the history of Venice proper, read from its architecture and paintings, begins with volume II, divided between the Byzantine and Gothic periods. The volume contains some of Ruskin's most powerful set pieces, such as the description of St Mark's, and in the chapter on 'The Nature of Gothic' he begins to make a critique of the effects of industrial production on the contemporary worker (see cats.109, 110).

As the title of volume III, *The Fall*, suggests, the story ends with the Renaissance, when architectural forms based on Greek and Roman precedents supplanted the organicism of Gothic, and when humanism, luxury and sensual enjoyment corrupted the previously religious schools of painting. Ruskin could be polemically dogmatic at times: 'I date the commencement of the Fall of Venice from the death of Carl Zeno, 8th May 1418' (9.21), yet he argued that the corruption of Venetian architecture began with the corruption of the Gothic itself, and he admired the works of Renaissance painters such as Tintoretto, Titian, Veronese and Giorgione. Volume III is important because Ruskin begins to develop his ideas about symbolism, but ends with a mass of appendices and over-matter, including his 'Venetian Index', surveying the city's principal buildings and paintings.

The Stones of Venice undoubtedly was influential on contemporary art and architecture. The multi-coloured brick and stonework of Verona and the marbled and encrusted surfaces of Venice became part of the repertoire of Victorian architects. Ruskin's evocation of pre-Renaissance Venice appealed to Burne-Jones's medievalism, his concern for the life of the craftsman appealed to Morris (see cat.110); none the less there is a distinction to be made between Ruskin's critical medievalism, where the past is used to deplore the present, and the romantic medievalism popular with Rossetti or Burne-Jones, where the past is an escape from the present (see cat.119).

Ruskin was able to give only the first volume of *The Stones of Venice* to Turner, for the painter died on 19 December 1851.

108

Thomas Shotter Boys
(1803–1874)

after John Ruskin

*Doorhead in Ramo
dirimpetto Mocenigo*
1851

Hand-tinted lithograph
sheet 57 x 38
image 42.7 x 26.5

Plate 12 of *Examples of
the Architecture of Venice,
selected and drawn to
measurement of the edifices*

Ruskin Foundation
(Ruskin Library,
University of Lancaster)

'*Nearly all the subjects are* portions *of buildings, drawn with
the single purpose of giving perfect examples of their architecture,
but not pictorial arrangements*' (*Examples of the Architecture of
Venice, 1851, 11.313–14*)

Ruskin wrote *The Stones of Venice* because he wanted to
influence taste in architecture (9.9). Accordingly he took
great pains with the book's illustrations. He decided that
the page size of an octavo volume (see cat.107) was too
small for some of the detailed illustrations that he wished
to include, and began a folio-sized part publication,
*Examples of the Architecture of Venice, selected and drawn to
measurement of the edifices*, which was sold separately. His
plan was to publish twelve sets of plates, but the first
three sets, issued in May and November 1851, sold very
badly, and his father, who was meeting the cost, began
to grumble at the expense, calculating that he would lose
£12,000 on the venture. Ruskin abandoned the project,
although he had a number of further drawings ready
(see cats.78, 80).

This plate, issued with numbers 11–15 on 17
November 1851, illustrates the simplest form of door-
head construction that Ruskin identified in Venice. He
discovered it, bricked up, at the end of a small passage
near the Fondaco dei Turchi, on the upper reach of the
Grand Canal, all that remained of the house to which it
had been its landward entrance.

109

John Ruskin

*On the Nature of
Gothic Architecture:
and herein of the
True Function of
the Workman in Art*
issued 30 October 1854

A version of chapter 6
of volume 11 of *The Stones
of Venice*, reprinted for the
London Working Men's
College, London, Smith,
Elder, & Co

Small octavo
pp.48, without wrappers

Ruskin Foundation
(Ruskin Library,
University of Lancaster)

The London Working Men's College was founded in
1854 under the leadership of F.D. Maurice (1805–72) and
others, Christian Socialists who wished to offer working
men the sort of education available to the middle class,
as opposed to the technical instruction available in the
voluntary Mechanics' Institutes or the Government
Schools of Design. Ruskin's argument in his chapter on
'The Nature of Gothic' that industrialisation was turning
men into machines, and provoking social discontent, was
consistent with their views, and Furnivall asked Ruskin
for his permission to reprint the material as a form of
manifesto.

Ruskin not only agreed to the publication, which
went on sale at the College's opening, price fourpence,
but offered to take the art class. Ruskin's Tory politics

did not conform to those of the College – he said his
aim was 'directed not to making a carpenter an artist, but
to making him happier as a carpenter' (13.553) – but his
presence added lustre. He taught regularly on Thursday
evenings from 1854 to 1858. While Ruskin taught an
elementary class in landscape drawing, he quickly re-
cruited Rossetti to take a more advanced class in figure
drawing and colour. Burne-Jones first saw Rossetti at
the College, and in 1856 regularly met Ruskin after
the Thursday classes. Burne-Jones himself taught at the
College from January 1859 to March 1861, first as an
assistant to Ford Madox Brown (see cat.212) Madox
Brown sourly observed in his diary in 1857 that Ruskin
was 'wildly popular with the men and as absurd and
spiteful' (Surtees 1981, p.196).

Ruskin's teaching at the College encouraged him to
publish a manual, *The Elements of Drawing* (1857), which
proved very popular (see cat.210). His attitude hardened
against the officially promoted methodology of outline
and copying from the flat that was taught in the Govern-
ment Schools of Design. His opposition to what became
known as 'the South Kensington system' achieved its
expression in the decision to found his own School of
Drawing at Oxford in 1870 (see cat.255).

Among the clerks, carpenters and printers Ruskin
taught were a number of men who later became his
assistants: his future publisher George Allen (1832–1907),
the artist J.W .Bunney (1828–82) (cat.257), the expert
Turner copyist William Ward (1828–1908) and the wood-
cutter Arthur Burgess (1844–86). The London Working
Men's College also not only brought Ruskin into regular
contact with Pre-Raphaelite artists, but encouraged him
to see himself as a teacher as well as a critic.

110

John Ruskin
with an introduction
by William Morris
(1834–1896)

*The Nature of
Gothic: a chapter of
The Stones of Venice*
issued 24 Mar. 1892

A version of the 1886
edition of chapter 6 of
volume II of *The Stones
of Venice*, printed by
William Morris at
the Kelmscott Press,
Hammersmith, and
published by George Allen,
8 Bell Yard, Temple Bar,
London, and Sunnyside,
Orpington

Small quarto, pp.vi + 128
bound in antique limp
vellum with green, pink,
blue or yellow strings to tie

Ruskin Foundation
(Ruskin Library,
University of Lancaster)

This edition was the fourth publication of Morris's Kelmscott Press, founded in 1890. Morris had become a socialist, a political position he had first declared in a lecture at Oxford in November 1883 at which Ruskin had taken the chair, declaring Morris to be 'the great conceiver and doer, the man at once a poet, an artist and a workman, and his old and dear friend' (33.390n).

Morris and Burne-Jones read *The Stones of Venice* together at Oxford in 1853, and Morris abandoned his plans to enter the Church in favour first of architecture, then after meeting Rossetti, painting, contributing to the Oxford Union murals, and then applied design through the formation of Morris, Marshall, Faulkner & Co in 1861, which became Morris & Co in 1875. He also had a parallel career as a composer of epic sagas. His work in founding the Society for the Protection of Ancient Buildings in 1877 coincided with and supported Ruskin's campaign in Venice to protect St Mark's. Ruskin gave Holman Hunt his private view of Morris in a letter of October 1885: 'Morris has wasted an awful lot of himself in rhyming and that d[amne]d grisaille glass – he ought to have been the centre of all serviceable manufacture for us, from the Oxford Union days' (Landow 1976–7, p.57).

In his preface to the Kelmscott edition Morris emphasised Ruskin's 'ethical and political' contribution to the Victorian visual economy: 'it is just this part of his work, fairly begun in *The Nature of Gothic*, and brought to its culmination in that great book *Unto This Last*, which has had the most enduring and beneficial effect on his contemporaries, and will have through them on succeeding generations. John Ruskin, the critic of art, has not only given the keenest pleasure to thousands of readers by his life-like description, and the ingenuity and delicacy of his analysis of works of art, but he has let a flood of daylight into the cloud of sham-technical twaddle which was once the whole substance of "art-criticism"' (10.462).

V

Patron and Collector

'great good is also to be done by encouraging the private possession of pictures'

Before Ruskin became a critic, he was a connoisseur. He and his father John James Ruskin built up a collection of some 250 works, by nearly fifty different artists. This practical form of criticism – involving the decision whether or not to lay out money for a picture – formed an important part of Ruskin's training, and throughout his career he emphasised the importance of guiding patrons as well as teaching artists. All the works described here come from the Ruskins' collection, or were created as a result of their patronage. After his father's death Ruskin continued to buy works on his own behalf, or for the public collections he founded. The English artists represented in this selection are those with whom Ruskin had personal contact, as patron as well as collector, a type of relationship he found difficult to manage.

In 1839 John James wrote, 'I do rejoice in the power of buying a living artist's picture' (RFL.607). Early acquisitions in Part II such as Cox (cat.26), Prout (cat.20) or Copley Fielding (see cat.21) reflect Ruskin's father's taste. Father and son enjoyed creating their collection together, but once Ruskin had developed his passion for Turner, John James complained of his son's 'sick longing' for more and more examples of the artist's work (13.xlvii). It was through Turner that Ruskin made the transition from collector to patron, when in 1842 he had an opportunity to commission works directly for the first time (see cat.111). But his father would not sanction the purchase of cat.112, a long-term source of friction and regret.

Ruskin's commissions to Turner gave him valuable insight into the artist's working methods, but the close, curmudgeonly – and from 1845 increasingly ailing – Turner was easier to hero-worship than to patronise. When Ruskin came into contact with the Pre-Raphaelite circle in 1851 the relationship was different. He was now the older man, by some ten years, and as well as being a source of financial support, he was the critic with the power to make reputations. Ruskin's self-confidence, and propensity to preach, must have made his patronage irksome at times. Ruskin seems to have been unaware of this, and he was genuinely looking for friendship, though his capacity for keeping friends was probably inhibited by the very closeness of his family background.

The first friendship was with Millais, who betrayed his trust. Holman Hunt's departure for Palestine in 1854 (see cat.196) prevented that relationship developing, and Ruskin transferred his affections to Rossetti (cats.117–119) and his mistress Elizabeth Siddal (cats.115, 116). Ruskin was truly generous to Siddal, calling her a 'genius' (36.204), and he was concerned by her declining health. Rossetti's attitude to Ruskin was more frankly exploitative, while Ruskin's criticism of his personal habits as well as the direction his work was taking became irritating to him. Their friendship was in decline by the early 1860s, but the critic William Michael Rossetti acknowledged Ruskin's vital financial help to his brother, which allowed Rossetti to avoid selling his work through public exhibitions or speculative dealers.

As Ruskin's relationship with Rossetti declined, that with Burne-Jones intensified. They first met in 1856; in 1859 and 1862 Ruskin financed trips by Burne-Jones to Italy which were to have a significant influence on his art, and through that on the development of the Aesthetic movement (see cat.219). They had a falling-out over Ruskin's objections to Michelangelo in 1871, but the relationship was repaired and lasted until the artist's death. When writing to Burne-Jones Ruskin liked to refer to himself as 'Papa' (36.438), a paternalistic attitude acquired from his father, but the genuine affection in which Burne-Jones held Ruskin is emblematised by his design for a tapestry (cat.124), which was intended to help persuade a troubled Ruskin to stay in England.

Two other artists are represented here, John Frederick Lewis (cat.120), to whom the Ruskins were an important help in 1858, and William Henry Hunt (cat.121). Ruskin associated both Lewis and Hunt with the Pre-Raphaelite Brotherhood in his pamphlet *Pre-Raphaelitism* (1851). This was not because there was any direct link between these older artists and the PRB, but because Ruskin saw in their meticulous technique an attention to 'fact' that had an obvious correspondence. In the case of Hunt, his mastery of watercolour was also a link to Turner. That Ruskin knew these artists personally as a collector undoubtedly played a part in his promotion of them as a critic.

RH

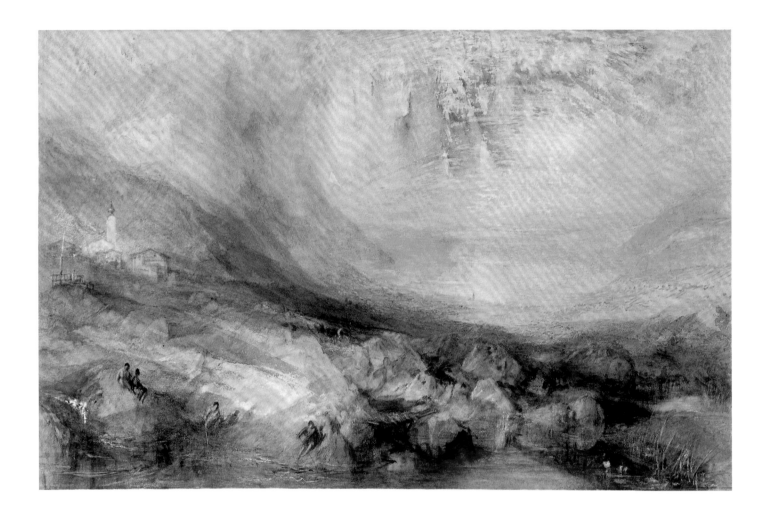

III

Joseph Mallord
William Turner

Goldau
1843

Watercolour
30.5 x 47

First exhibited
'Mr Ruskin's Collection
of Turner Drawings',
Fine Art Society 1878
Commissioned by
Ruskin in 1843

Private Collection

'The mightiest drawing of his final time' (*Notes on his Drawings by Turner*, 1878, 13.456)

In 1842 the Ruskins were invited by Turner's agent Thomas Griffith to take part in a scheme by which they and other collectors could commission finished watercolours, at 80 guineas each. These would be chosen on the basis of 'sample studies' – sketches which Turner had already made. Turner also offered four finished watercolours, one of which Ruskin especially coveted (cat.112). The invitation was made in early 1842, when Ruskin's father was away on business, and Ruskin records that 'my father let me choose at first one, then was coaxed and tricked into letting me have two', but not the finished drawing that he also wanted (35.309).

Turner and Griffith repeated the scheme in 1843, and Ruskin again commissioned two watercolours, cat.54 and *Goldau*. The fascination for Ruskin, who was then in the finishing stages of writing the first volume of *Modern Painters*, was the insight the difference between the sample studies and the finished watercolours gave into Turner's working methods. Here, the preliminary study had none of the red that dominates the finished version, but Turner and Ruskin knew that the rocks in the foreground were the result of a terrible avalanche in which many people had died. As with *Ulysses deriding Polyphemus* (cat.259) Ruskin saw Turner's imagination at work: 'The scarlet of the clouds was his symbol of destruction' (7.438n; see also cat.62).

Goldau was engraved as an illustration to *Modern Painters* volume IV, where the geology as well as the colour symbolism is discussed at length (6.378–81). For a complete account of Ruskin's participation in Turner's final commissioned drawings, 1841–51, see Warrell 1995, pp.149–55.

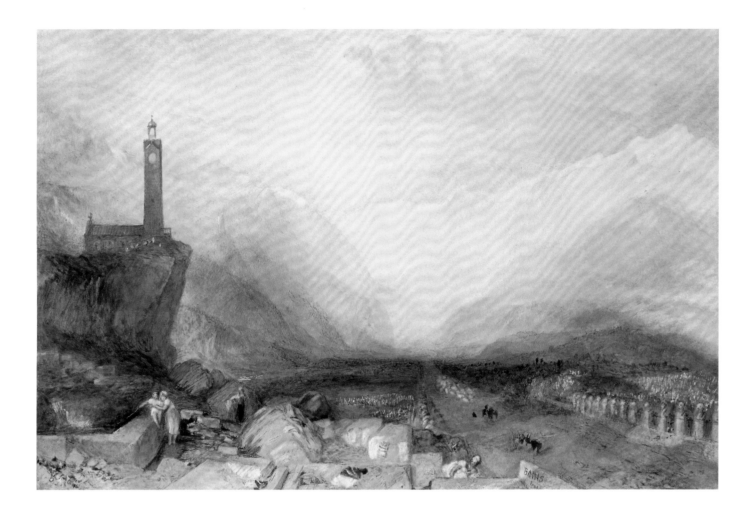

112

Joseph Mallord
William Turner

*The Pass of
the Splügen*
1841–2

Watercolour
29.2 x 45.1

First exhibited
'Mr Ruskin's Collection
of Turner Drawings',
Fine Art Society 1878

Presented to Ruskin 1878

Private collection
[Not exhibited]

'*The best Swiss landscape yet painted by man … the* Splügen *was a thorn in both our sides, all our lives*' (*Praeterita*, 35.309–10)

This was one of the four finished watercolours offered for sale in 1842 alongside the proposed commissions. Because his father was away on business, Ruskin hesitated about buying it, and it went to the rival collector H.A.J. Munro (see cat.31). Ruskin's appetite for Turner drawings was a bone of contention with his father, who wanted both to indulge and discipline his son. In his autobiography *Praeterita* Ruskin makes the failure to acquire the *Splügen* a symbol of that conflict: 'My father was always trying to get it; Mr Munro, aided by dealers, always raising the price on him, till it got up

from 80 to 400 guineas. Then we gave it up, – with unspeakable wear and tear of best feelings on both sides' (35.310).

Ruskin did, however, finally acquire the drawing. In March 1878 the Fine Art Society mounted an exhibition of 'Mr Ruskin's Collection of Turner Drawings', including a selection of Ruskin's own work. He was finishing the catalogue in February when he had his first attack of madness, but recovered by the end of April. That same month the *Splügen* came on the market, and friends raised the necessary 1000 guineas in order to present it to Ruskin, in celebration of his recovery. The subscription was organised by the artist Alfred William Hunt (see cat.194), which shows that at least some artists remained grateful for Ruskin's patronage.

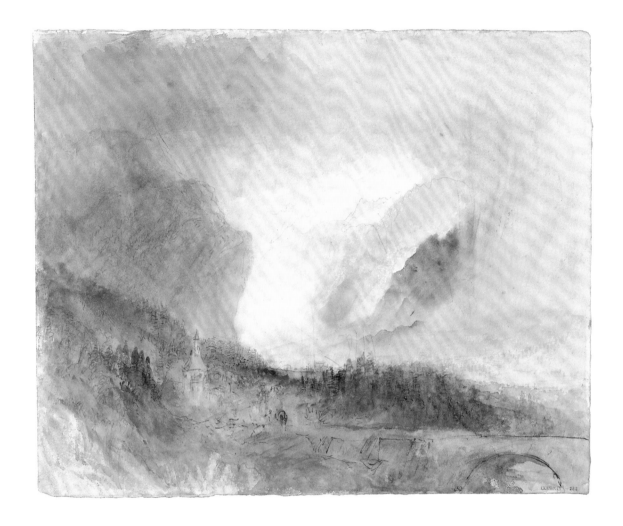

113

Joseph Mallord
William Turner

*Storm in the
St Gotthard Pass.
The First Bridge
above Altdorf:
Sample Study*
c. 1844–5

Pencil and watercolour
with pen
23.9 x 29.7

Inscribed in pencil on
verso 'JR' and 'Altorf'
Turner Bequest;
CCCLXIV 283

Tate Gallery. Bequeathed
by the artist 1856

*'This sketch was realised by Turner for me in 1845, but I having
unluckily told him that I wanted it for the sake of the pines, he
cut all the pines down, by way of jest, and left only the bare red
ground under them'* (Catalogue of the Turner Sketches in the
National Gallery, 1857, 13.206)

This is the sample study for one of the two Swiss scenes
commissioned by Ruskin through Griffith in 1845. The
sketch shows a bank of pine trees to the left of the bridge
in the foreground. However, as Ruskin recounts, Turner
did not include these in the finished version (cat.114).
As a result Ruskin exchanged it for another Swiss subject
in the series, *Fluelen* (Yale Center for British Art), which
had been commissioned by H.A.J. Munro of Novar: 'I did
not like getting wet with no pines to shelter me, and
exchanged the drawing with Mr Munro' (13.206). The
Ruskins regularly traded drawings when creating their
collection.

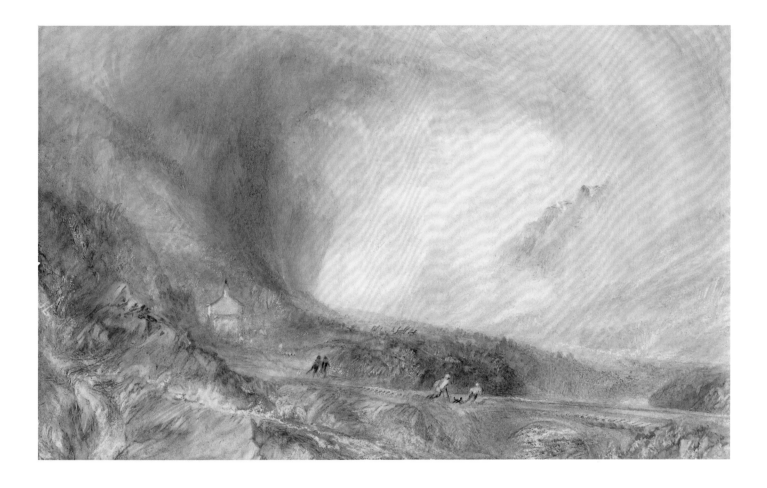

114

Joseph Mallord
William Turner

*Storm in the
St Gotthard Pass.
The First Bridge
above Altdorf*
1845

Watercolour
29 x 47

Commissioned by
Ruskin in 1845

The Whitworth Art
Gallery, University
of Manchester

*'In many respects, I find that the finished drawing was always
liker the place than the sketch; though in this instance the pines
were cut down'* (Letter to his father, 27 Nov. 1861, 13.206n)

In 1861 Ruskin carefully inspected the site of the
drawings in order to compare it with Turner's treatments.
In spite of Turner's change in the finished drawing, he
concluded it was the more truthful version, thus helping
to account for the reduced appeal of the final result: 'the
bridge is really carefully drawn in the finished drawing;
and being a formal and ugly one disappointed me –
the sketch having suggested one far more picturesque'
(13.206n).

Ruskin included the preliminary sketch (cat.113)
for this work in an imaginary tour he devised to show
the National Gallery how the Turner Bequest might
be presented to the public (see Warrell 1995, *passim*).

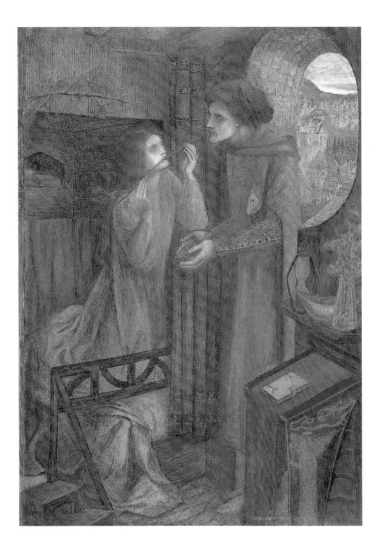

115

Elizabeth Eleanor Siddal,
later Rossetti
(1829–1862)

Clerk Saunders
1857

Watercolour, bodycolour
and coloured chalks
28.4 x 18.1

Inscribed 'EES / 1857'

First exhibited
Russell Place 1857

The Syndics of the
Fitzwilliam Museum,
Cambridge

*'I think you have genius … I don't think there is much genius
in the world; and I want to keep what there is, in it'*
(Letter to Elizabeth Siddal, May 1855, 36.204)

Ruskin became Elizabeth Siddal's patron as a result of
his friendship with Rossetti (see cat.117). A milliner by
trade, in 1849 she was 'discovered' by the painter Walter
Deverell (1827–54), a close associate of the original Pre-
Raphaelite Brotherhood, and she modelled for Deverell,
Holman Hunt, Millais and Rossetti, who became her
lover and taught her to paint.

In March 1855, according to Rossetti, Ruskin 'saw
and bought on the spot every scrap of designs hitherto
produced by Miss Siddal. He declared they were far
better than mine, or almost than anyone's, and seemed
quite wild with delight at getting them. He asked me to
name a price for them, after asking and learning that they
were for sale; and I, of course, considering the immense
advantage of their getting them into his hands, named a

very low price, £25, which he declared too low *even* for
a low price, and increased to £30' (Doughty & Wahl
1965–7, vol.1, p.245).

Ruskin may however have been moved as much by
Siddal's apparent ill-health as her talent. He arranged to
give her £150 a year in exchange for any work that she
might produce, and had her consult his Oxford friend
Dr Acland. Acland found little wrong with her, but
recommended that she went abroad, which she did in
September 1855, returning the following May. Ruskin's
financial support appears to have ended, by mutual
agreement, in mid-1857, about the time Siddal made
her professional debut at the Pre-Raphaelite exhibition
at 4 Russell Place. *Clerk Saunders* – a scene from Sir Walter
Scott's *Minstrelsy of the Scottish Border* where a woman is
confronted by the ghost of her murdered lover – was
shown at Russell Place and then the Modern British Art
show in New York. It was bought by Ruskin's close
friend Charles Eliot Norton (see cat.119).

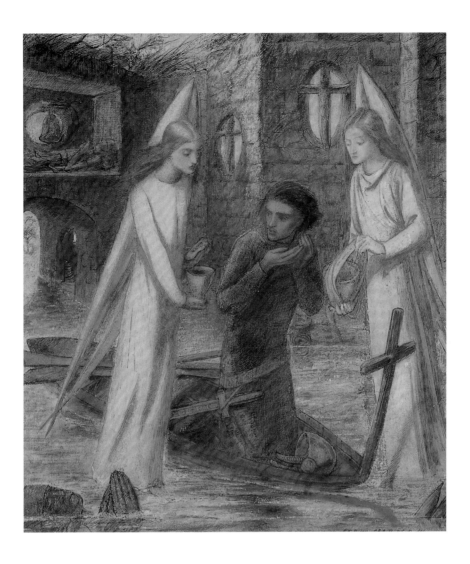

116

Elizabeth Eleanor Siddal,
later Rossetti, and
Dante Gabriel Rossetti
(1828–1882)

*The Quest of the
Holy Grail* or *Sir
Galahad at the Shrine
of the Holy Grail*
*c.*1855–7

Watercolour
28 x 23.8

Inscribed 'EES inv.
EES & DGR del.'

Acquired by Ruskin

Private collection

*'You inventive people pay very dearly for your powers – there is
no knowing how to manage you'* (Letter to Elizabeth Siddal,
May 1855, 36.208)

Ruskin acquired this drawing as a result of the arrange-
ment he made to pay Siddal £150 a year in exchange for
work. As the inscription indicates, the image was devised
by Siddal, but executed jointly by her and Rossetti. It
appears that Ruskin's enthusiasm for Siddal's work caused
Tennyson to suggest that she should contribute to the
illustrated edition of his poems published by Moxon in
1857, to which Rossetti, Holman Hunt and Millais were
the Pre-Raphaelite contributors. The design illustrates
Tennyson's poem 'Sir Galahad', where the knight
encounters angels bearing the Holy Grail. It was not
used in Moxon's edition.

 Siddal's stilted, angular style seems unlikely to
appeal to Ruskin, and he never praised her work in print.
He may have appreciated it in the context of Rossetti's
drawings, though here too he had reservations (see
cat.119). It was the opportunity to help someone who

appealed to Ruskin, though he discovered both Siddal
and Rossetti difficult to deal with. Apologising for her
behaviour when he sent her to Oxford to see Dr Acland,
he explained, 'These geniuses are all alike, little and big.
I have known five of them – Turner, Watts, Millais,
Rossetti and this girl – and I don't know which was,
or is, wrongheadest' (Hilton 1985, p.221). For Ruskin's
friendship with G.F. Watts see cat.216. Ruskin is using the
word genius to describe temperament as much as talent.
Another motive for giving Siddal an allowance was
so that she and Rossetti might marry (36.198, 200).
The bohemian Rossetti however was less eager, and
the couple did not marry until 1860, by which time
Ruskin's relationship with them had begun to deteriorate
(36.342–3). She had a stillborn child in 1861, and died
of an overdose of laudanum while suffering depression
in February 1862. In August 1862 Ruskin wrote to
his friend Charles Eliot Norton, the owner of cat.115,
'I loved Rossetti's wife much, too: and bid *her* goodbye,
and sorrowfully, – with a kiss, in her coffin' (LN.73).

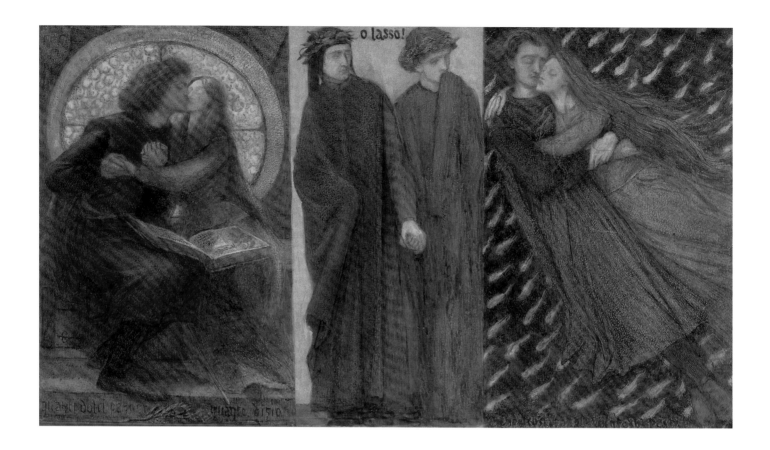

117

Dante Gabriel Rossetti

Paolo and Francesca da Rimini
1855

Watercolour
25.4 x 44.9

Inscribed (bottom left) 'quanti dolce pensierquanto disio', (top centre) 'o lasso!', (bottom right) 'meno costero al dolorosso passo'

First exhibited Burlington Fine Arts Club, Rossetti retrospective 1883

Acquired by Ruskin 1855

Tate Gallery. Purchased with assistance through the National Art Collections Fund from Sir Arthur Du Cros, Bt and Sir Otto Beit 1916

'A great Italian tormented in the Inferno of London; doing the best he could ... but the 'could' shortened by the strength of his animal passions, without any trained control, or guiding faith' (*Praeterita* 35.486)

The first works by Rossetti that Ruskin saw were three watercolours in the Old Water Colour Society's winter exhibition of 1852–3. Early in 1854 the Belfast cotton spinner Francis MacCracken, who the previous year had bought Rossetti's oil painting *Ecce Ancilla Domini!* (1850, Tate Gallery), sent him Rossetti's watercolour *The First Anniversary of the Death of Beatrice* (1853, Ashmolean Museum) for his opinion. (MacCracken's earlier request for permission to show Ruskin *Ecce Ancilla Domini!* had been curtly refused.) Ruskin was enthusiastic about the watercolour, and wrote to Rossetti on 10 April saying so. On 13 April Ruskin visited him in his studio at Blackfriars, and their troubled friendship began.

At this first meeting, according to the artist George Price Boyce, Rossetti 'thought Ruskin hideous' (Surtees 1980, p.13). However, as Rossetti told Ford Madox Brown, Ruskin seemed 'in a mood to make my fortune' (Doughty & Wahl, 1965–7, vol.1, p.185). He told Thomas Woolner, 'As he is only half informed about Art,

anything he says in favour of one's work is of course sure to prove invaluable in a professional way' (Woolner 1917, p.52). Ruskin did prove invaluable, inserting a reference to Rossetti in the printed version of his 1853 Edinburgh *Lectures on Art* (12.162), and commissioning work (see cat.118).

Ruskin was abroad in the summer of 1854, during which time Effie, who had left him on 25 April, secured the annulment of her marriage. Ruskin's friendship with Rossetti blossomed on his return in the autumn. He persuaded him to join him in teaching at the newly opened Working Men's College (cat.109) and in 1855 began to fund both Elizabeth Siddal (cats.115, 116) and Rossetti, offering to buy all his work up to a certain sum. *Paolo and Francesca* had been intended for Ruskin's protégée, the collector Ellen Heaton, but Rossetti finished it quickly in November 1855 to raise funds for Siddal, who had run out of money in Paris on the way to Nice for her health (see cat.115). Ruskin paid 35 guineas for it, and kept it, warning Heaton, 'Prudish people might perhaps think it not quite a young lady's drawing' (si.169). Ruskin's artist friends George and Thomas Richmond (see cat.43) disliked the drawing, and by 1862 Ruskin had passed it to William Morris.

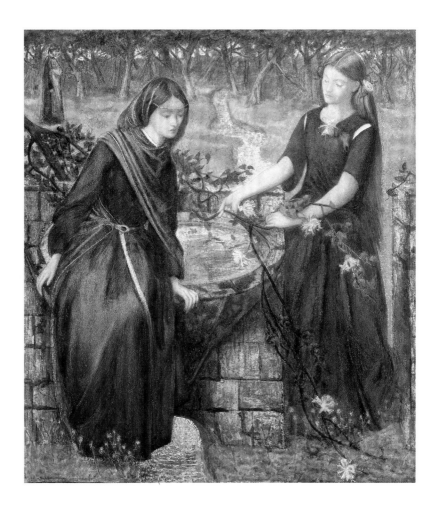

118

Dante Gabriel Rossetti

Dante's Vision of Rachel and Leah
1855

Watercolour
35.2 x 31.4

First exhibited
Burlington Fine Arts Club,
Rossetti retrospective 1883

Commissioned by Ruskin
1855

Tate Gallery. Bequeathed
by Beresford Rimington
Heaton 1940

'A curious instance of the danger of interfering with R[ossetti]'
(Letter to Ellen Heaton, Nov. 1855, SI.174)

In April 1855 Ruskin commissioned Rossetti to make illustrations from Dante, suggesting seven subjects, of which this and one other, now lost, were completed by October. Rossetti was a slow worker, and Ruskin pushed him to complete cat.118, which Ruskin thought accounted for its faults: 'it is only *imperfect* because Rachel does not sit easily – but stiffly, in a PreRaphaelite way – at the fountains edge – and because her reflection is wrongly put in the water' (SI.169). Because he had taken *Paolo and Francesca* (cat.117), intended for Ellen Heaton, he offered this to her instead, and found more virtues in it: 'I think the face of the Rachel very beautiful in expression – spoiled only by small underlip. It is a portrait of the young girl whom I told you of – who draws so well herself [Elizabeth Siddal]. The colour of the purple robe – and the stonework and honeysuckle *flower* – COLOUR – renders the picture unique as far as I know in some points of colour – so strangely delicate and scented' (SI.174–5). Heaton accepted the drawing.

Rossetti worked on the subject – a scene from Dante's *Purgatorio* Canto 27 depicting the sisters Rachel (on the right) and Leah, emblems of the contemplative and active life – while staying with Ford Madox Brown (see cat.212), who suggested putting the figure of Dante in the background. There is a certain irony in the situation, for Brown disliked Ruskin intensely for failing to mention his work, and took Millais's side over Ruskin's marriage. The meditative mood of the drawing anticipates later works by Rossetti and Burne-Jones.

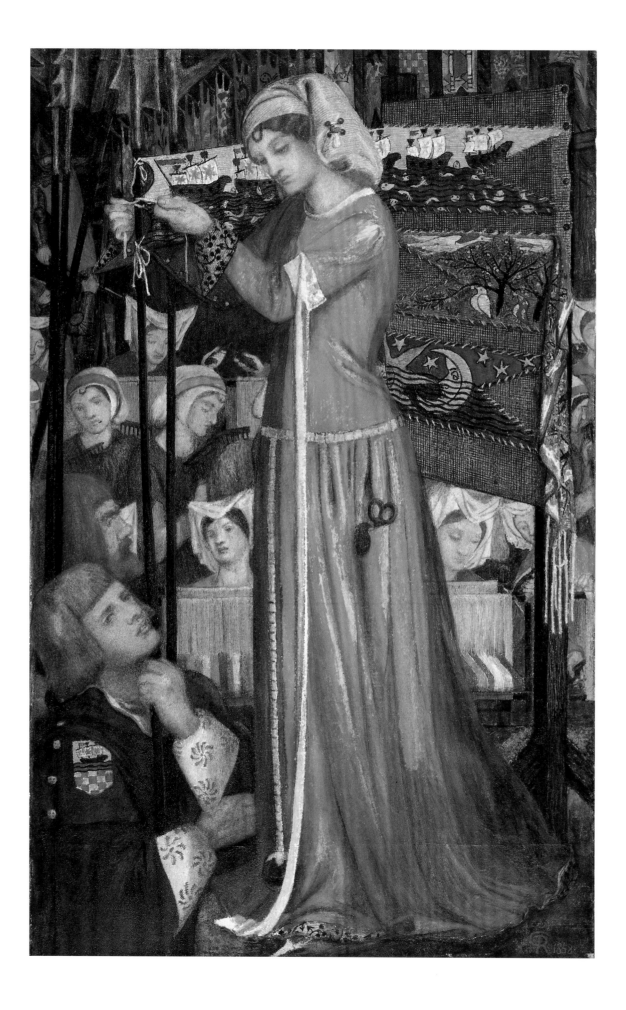

119

Dante Gabriel Rossetti

Before the Battle
1857–8,
retouched 1861–2

Watercolour
42.5 x 28

Inscribed '1858' with
initials in monogram

Commissioned by
Charles Eliot Norton

Museum of Fine Arts,
Boston. Picture Fund, 1912

'Almost the worst thing he has ever done, and will not only bitterly disappoint you, but put an end to all chance of R[ossetti]'s reputation ever beginning in America' (Letter to Charles Eliot Norton, 10 Dec. 1859, LN.55)

Ruskin's influence as a patron was reinforced by being able to recommend commissions by others, and his friend Charles Eliot Norton paid £50 for this work, begun while Rossetti was staying with Elizabeth Siddal at Matlock Spa in 1857 and completed in 1858. (In 1859 Norton commissioned Rossetti to make a portrait of Ruskin in oils, but the project was abandoned in 1865. Rossetti made a chalk sketch of Ruskin in 1861 (Ashmolean Museum).) Ruskin so disliked *Before the Battle* that he would not let it go to Norton until Rossetti had retouched it, which he finally did by January 1862. Ruskin wrote to Norton, 'he has modified and in every respect so much advanced and bettered it, that though not one of his first rate works; and still painfully quaint and hard, it is nevertheless worthy of him, and will be to you an enjoyable possession. It is exceedingly full and interesting in fancy; and brilliant in colour, though the mode of colour-treatment is too much like the Knave of hearts' (LN.69).

Although Ruskin could evidently still force Rossetti to make changes, their relationship began to cool as early as 1857, when Ruskin rejected Rossetti's oil *St Catherine* (1858, Tate Gallery) which he had commissioned (36.272). Ruskin was critical of Rossetti's domestic habits and working methods, which involved much repainting. As Part IV has shown, he unsuccessfully tried to involve Rossetti and Siddal in the decoration of the Oxford Museum (cat.91) and was disappointed by the murals for the Oxford Union. Both *Before the Battle* and *St Catherine* have the same medievalising tendency, against which Ruskin reacted increasingly strongly.

Ruskin owned at least sixteen works by Rossetti at one time or another, and paid for more that did not materialise, ensuring Rossetti's survival before he became more successful in the 1860s. He also advanced £100 to Smith, Elder for the publication of Rossetti's translations *The Early Italian Poets* (1861), though it was Rossetti's turn to reject Ruskin's introduction. When Rossetti moved to 16 Cheyne Walk in 1862, Ruskin tentatively suggested taking rooms there, which came to nothing. In 1865 Rossetti falsely accused Ruskin of selling some of his works, and Ruskin regretfully withdrew, although there were later contacts (see cat.215).

120

John Frederick Lewis

*An Inmate of
the Hareem Cairo*
(formerly *Life in
the Hhareem, Cairo*)
1858

Watercolour
and bodycolour
60.6 x 47.7

Inscribed 'JFL 1858'
initials in monogram

First exhibited
Royal Academy 1858

Bought by
John James Ruskin 1858

The Board of Trustees
of the Victoria and Albert
Museum

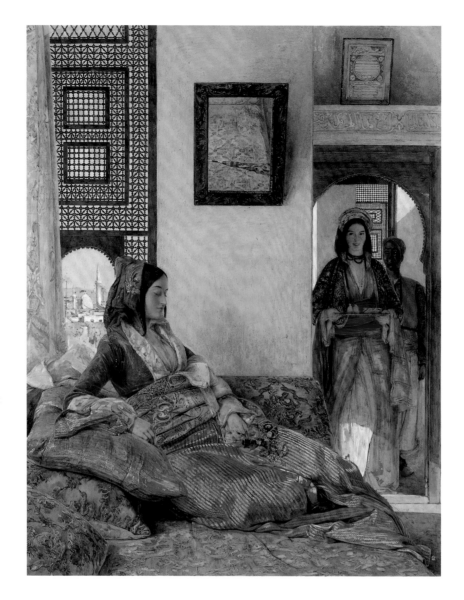

'There never, perhaps, in the history of art was work so wholly
independent as Lewis's. He worked with the sternest precision
twenty years ago, when Pre-Raphaelitism had never been heard
of' (*Academy Notes*, 1858, 14.160)

The Ruskins bought their first work by Lewis in 1837
(cat.27). Ruskin was impressed by Lewis's sensation-
picture of 1850 *The Hhareem* (Nippon Insurance Co,
Osaka), and associated the precision he had developed
while working in Cairo with that of the Pre-Raphaelites
(12.236), though recognising his independence. When
Lewis returned to England in 1851 a friendship developed.
In 1855 Lewis was elected President of the Old Water
Colour Society but there was friction with the member-
ship, and Lewis could make more money painting in oil,
a change of medium Ruskin encouraged (Lewis 1978,
p.28). In 1858 Lewis resigned from the O.W.C.S. in order

to become eligible for election to the Royal Academy,
where he showed an oil and five watercolours that year.

Ruskin's father decided to buy two watercolours, but
did not tell his son, for fear of influencing his review of
the exhibition in his *Academy Notes* (14.180n). This was
just as well, for Ruskin praised them. (The Ruskins were
further help that year when Lewis fell seriously ill,
advancing him money for commissions and buying more
work (Hewison 2000, p.9).) The works bought from the
Royal Academy were *Lilies and Roses* (currently untraced)
and *An Inmate of the Hhareem, Cairo*. Ruskin's description
of the work, and its date, make it almost certain that
cat.120, which was bought by the Victoria and Albert
Museum in 1893 as *Life in the Hhareem, Cairo*, is in fact the
Ruskins' picture. During the 1890s Ruskin's guardians,
Joan and Arthur Severn, began to sell off works.

121

William Henry Hunt

The Shy Sitter

Watercolour
22.9 x 18.4

Inscribed 'w.HUNT'

Bought by
John James Ruskin
as *Country Girl*
1859

Harris Museum and
Art Gallery, Preston

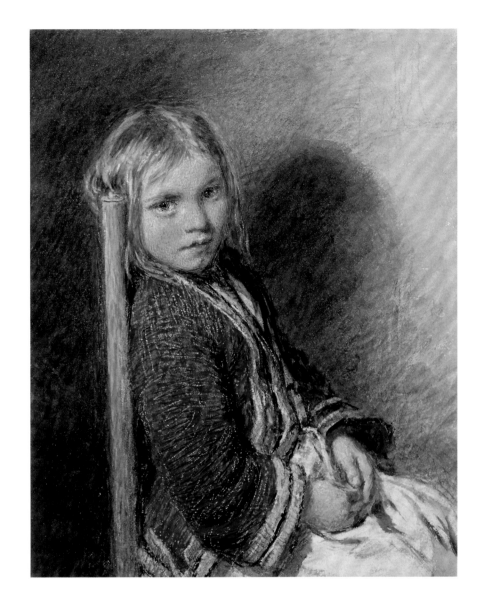

'I am aware of no other pieces of art, in modern days, at once so sincere, and so accomplished' (*Notes on Prout and Hunt*, 1879, 14.384)

Like J.F. Lewis (cat.120), William Hunt was one of the artists Ruskin praised in his pamphlet *Pre-Raphaelitism* (1851). The association is less surprising when it is learned that Rossetti kept drawings by Hunt pinned to his studio wall (Surtees 1980, p.12). While Hunt's still lifes (cat.35) and genre studies harked back to the earlier days of the Old Water Colour Society, where John James Ruskin first bought from the artist in 1833, his technique was highly respected. Ruskin took 'lessons' – probably meaning being allowed to watch the artist at work – from Hunt in 1854 and 1861, a practice he also followed with Rossetti (36.230). Hunt's techniques are recommended in Ruskin's teaching manual *The Elements of Drawing* (1857): 'practise the production of mixed tints by interlaced touches of the

pure colours out of which they are formed, and use the process at the parts of your sketches where you wish to get rich and luscious effects. Study the works of William Hunt' (15.152).

The Ruskins owned more than thirty watercolours by Hunt. Between 1856 and 1861 Ruskin commissioned a series of still lifes intending to present them as examples of good practice to the government-run Schools of Design. Hunt did not enjoy working to commission however, and the scheme proved abortive, although Ruskin did place eight works by Hunt in his Drawing School at Oxford.

Known to the Ruskins as the *Country Girl*, Ruskin sold this picture in 1869, but borrowed it from its new owner, James Orrock, for a retrospective exhibition of Prout and Hunt that he organised at the Fine Art Society in Bond Street in 1878. There it appears as *The Shy Sitter*, appealing to Ruskin as an image of a purer rural life (14.447–8).

122

Sir Edward Coley
Burne-Jones, Bt
(1833–1898)

Fair Rosamond
1863

Oil and bodycolour,
heightened with gold
83.2 x 41.3

Inscribed in tablet
'Edwardus Jones Pinxit
MDCCCLXIII'

First exhibited
Old Water Colour Society
1864

Bought by
John James Ruskin 1863

Private collection

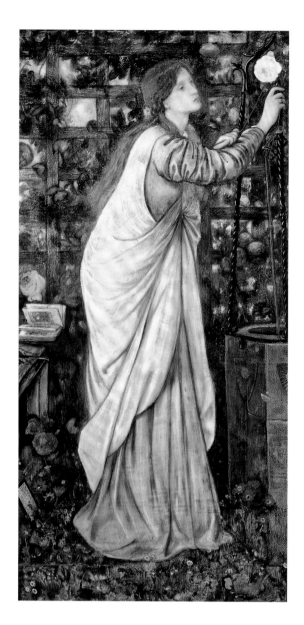

'Jones, you are gigantic!' (Burne-Jones 1904, vol.1, p.182)

Burne-Jones first met Ruskin in January 1856, when he
was on the point of moving to London as a pupil of
Rossetti. In October, to Burne-Jones's delight, they began
to meet regularly after Ruskin's classes at the Working
Men's College. He, like Rossetti, was later recruited to
teach there. In 1857 Burne-Jones contributed to the
murals of the Oxford Union Debating Hall (see cat.91)
and began to design stained glass. In the summer of 1858
he was a guest at Little Holland House, the Prinsep
family's *salon* formed around G.F. Watts (see cat.216).
Ruskin frequented Little Holland House and helped to
secure Burne-Jones's invitation in order to encourage
him to learn from Watts.

　　Although it is possible that Burne-Jones's drawing
Bouondelmonte's Wedding (1858, Fitzwilliam Museum) had
been originally intended for Ruskin, Ruskin's first sur-
viving acquisition is the drawing *Childe Roland* of 1861

(Cecil Higgins Art Gallery, Bedford). John James was
suspicious of his son's generosity to this new friend, and
with Ruskin's relationship with his father deteriorating,
the artist became a bone of contention. Ruskin wrote
furiously to his father in August 1862, 'you try all you
can to withdraw me from the company of a man like
Jones, whose life is as pure as an archangel's, whose
genius is as strange and high as that of Albert Durer or
Hans Memling – who loves me with the love of a brother
… try to forget he is poor' (WL.370). John James took this
to heart, for having at last met Burne-Jones, in February
1863 he bought for himself cat.122 for £52 10s, intending
it as a peace offering.

　　The subject, the legendary mistress of Henry II
murdered by his wife Eleanor of Acquitaine, had par-
ticular associations for Burne-Jones, for she was buried
at Godstow Abbey outside Oxford. He visited the site
in January 1854, where he had an epiphanic vision of
the medieval world (Burne-Jones 1904, vol.1, p.97).

123

Sir Edward Coley
Burne-Jones, Bt

*Study of the Head
of Tintoretto's
Bacchus from the
picture in the Doge's
Palace, Venice*
1862

Pencil
27.1 x 41.6

Commissioned
by Ruskin 1862.
Given to the Ruskin
School of Drawing
by 1873

The Visitors of the
Ashmolean Museum,
Oxford

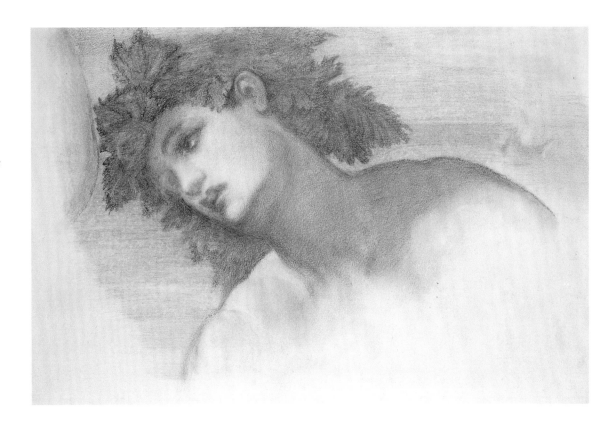

*'The most wonderful of all the PreRaphaelites in redundance of
delicate and pathetic fancy – inferior to Rossetti in depth – but
beyond him in grace and sweetness'* (Letter to Margaret Bell,
3–4 Apr. 1859, WL.150)

Burne-Jones first visited Italy, at Ruskin's expense, in
1859, and made a second journey in 1862. In 1859 he
took Ruskin's writings as his guide; in 1862 he and
Ruskin travelled for some of the time together, and made
studies in Milan from Bernardino Luini (1481–1532) side
by side. Burne-Jones and his wife Georgiana then moved
on to Venice, where he made a number of studies such
as this one, commissioned by Ruskin.

Ruskin was anxious to record paintings that were
threatened by restoration, but as John Christian argues,
the subjects were 'clearly selected with the copyist's

artistic welfare very much in mind' (Wildman & Christian
1998, p.83). He was trying to steer Burne-Jones away
from the medievalising influence of Rossetti towards the
more classical repose of Tintoretto and Veronese. Ruskin's
own aesthetic principles were in transition during the
1860s, as a result of his abandonment of Evangelicalism
in 1858. He did not like the way Burne-Jones's early,
Rossetti-influenced, pictures required him to 'get into a
state of Dantesque Visionariness before one can see them'
(LN.59). For his part, Burne-Jones wrote to Ruskin from
Venice, 'you have done me so much good by giving
me the chance of seeing the old miracles' (Burne-Jones
1904, vol.I, p.246). These Ruskin-sponsored visits to
Italy laid the foundations of Burne-Jones's mature work
(see cats.219, 220).

124

Sir Edward Coley
Burne-Jones, Bt

*Love bringing Alcestis
back from the Grave*
1863

Watercolour
134.5 x 135

First exhibited
Royal Institution
7 June 1867

Acquired by Ruskin

The Visitors of the
Ashmolean Museum,
Oxford

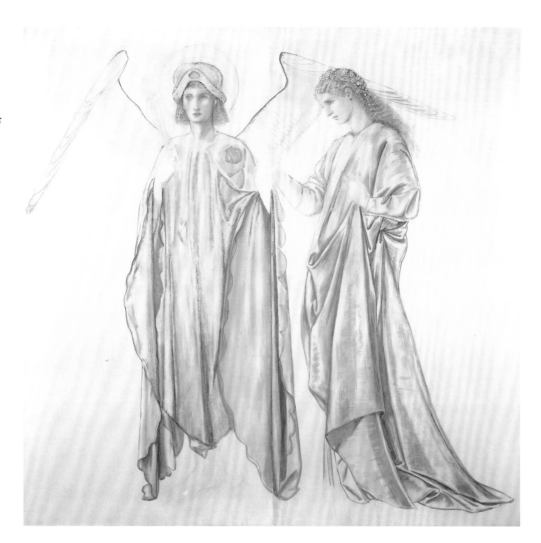

*'In its purity and seeking for good and virtue as the life of all
things and creatures, his designs stand, I think unrivalled and
alone'* (*'On the Present State of Modern Art'*, 1867, 19.207)

In 1859 Ruskin became a regular visitor to Winnington
Hall, Cheshire, where Miss Margaret Bell (1818–89) had
opened a residential school for young ladies. Miss Bell
had progressive views on education, and Ruskin became
an occasional drawing master, tutor and patron. (The
school is the setting of his *Ethics of the Dust*, published in
1865.) He took innocent pleasure in the company of the
girls and the school became a refuge during the difficult
period with his parents leading up to his father's death
in 1864. In August 1863 Burne-Jones also began to visit
the school.

By that time Ruskin's unhappiness in England had
become so extreme that he was contemplating permanent
exile in the Alps. Burne-Jones proposed to keep him in
England by suggesting he build himself a house there,
rather than abroad. At its centre would be a room hung
with tapestries illustrating his favourite Chaucer, *The*

Legend of Good Women, embroidered by the Winnington
girls: 'The ground thereof will be green cloth or serge,
and a fence of roses will run all along behind the figures'
(Burne-Jones 1904, vol.1, p.269). He produced a number
of cartoons but the tapestry was never made.

In 1867 Ruskin showed cat.124, which depicts
Alcestis, who gave up her life for her husband, being
returned to him by the figure of Love, as an illustration
to a lecture at the Royal Institution, 'On the Present State
of Modern Art'. In it he made a new distinction between
what he called 'constant' and 'dramatic' art (19.203).
Constant art expressed a classical tranquillity and repose,
while most modern art vulgarly concentrated on the
dramatic action of the story being told. Burne-Jones's
dramas, he argued, were tempered by his 'purer sympathy
for the repose of the Constant schools' (19.206), a factor
that would lead to his pre-eminence as a contemporary
artist. Ruskin was indicating a shift in his appreciation
from the naturalistic and narrative painters of the 1850s
to the artists who shaped the Aesthetic movement.

125

Andrea del Verrocchio
(1435–1488)
and workshop

*The Madonna
adoring the Infant
Christ (also known
as 'The Ruskin
Madonna')*
c. 1470

Egg tempera on canvas,
transferred from wood
106.7 x 76.3

Bought by Ruskin
in 1877

National Gallery
of Scotland, Edinburgh.
Purchased with the
aid of the National Art
Collections Fund and
the Pilgrim Trust 1975

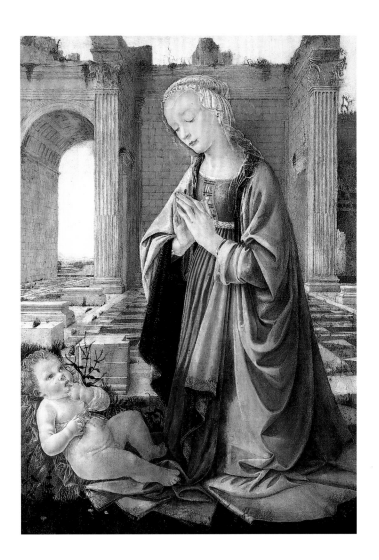

*'I bought it for a hundred pounds, out of the Manfrini Palace at
Venice; and consider it an entirely priceless painting, exemplary
for all time'* (*Catalogue of the St George's Museum*, 1907,
30.193)

Ruskin bought cat.125 through the agency of Charles
Fairfax Murray, who also acquired cats.79 and 127 for
him. At the age of 16 Murray had become Burne-Jones's
studio assistant, as a result of Ruskin's patronage. He
became an accomplished copyist, and in December 1871
he was commissioned by Ruskin to make copies in Italy.
He continued to work for him until there was a falling
out in 1883. While living in Italy Murray developed a
second, highly successful, career as a collector and dealer.
While working as a copyist and assistant to Ruskin in
Venice in the spring of 1877, he drew his attention to 125,
which had been on sale from the Manfrini Collection.

Ruskin bought the picture to place it in the museum
he was creating in a small house in Walkley, Sheffield,

for the Guild of St George (see fig.10). He had started
the Guild in 1871 as a practical expression of the values
expressed in his monthly letters *Fors Clavigera*, begun the
same year. The Guild opposed industrialism and promoted
pastoralism and craft work. Sheffield, with its tradition of
small workshops in the cutlery trade, was a suitable place
to launch an educational museum. Verrocchio, as a sculp-
tor and goldsmith as well as painter, was an appropriate
artist to represent. Ruskin said that the picture 'was an
answer to the inquiry often addressed to him, "What do
you want to teach us about art?"' (30.311–20).

The painting was in poor condition when bought
by Ruskin, who had it transferred from its original
wood panel to canvas and restored. In 1960 an Italian
scholar, Alberto Martini, suggested that Verrocchio's
pupil, Leonardo da Vinci (1452–1519), may have assisted
with the picture. It was restored again before being sold
by the Guild of St George to the National Gallery of
Scotland in 1975.

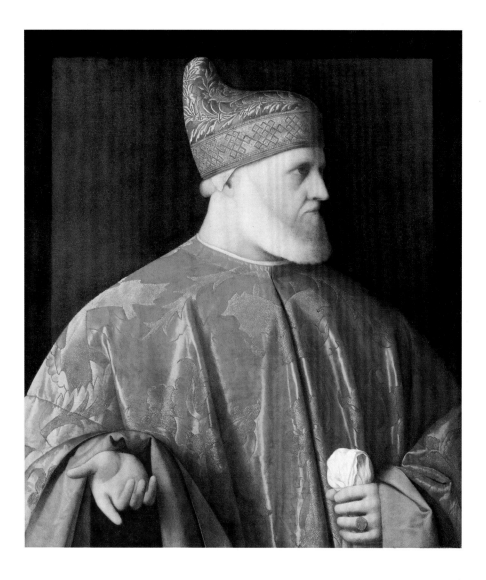

126

Vincenzo Catena
(c. 1480–1531)

*Portrait of the Doge,
Andrea Gritti*

Oil on canvas
97.8 x 79.4

First exhibited
in England as by Titian,
British Institution 1863

Bought by Ruskin
in 1864

The Trustees of
the National Gallery

'*The Venetian picture should be especially interesting to us
English, for it is the portrait of a Merchant King*' ('*The Flamboyant Architecture of the Valley of the Somme*', 1869, 19.248)

Ruskin bought the portrait, then attributed to Titian
(c. 1487–1576), from Dr Gilbert Elliott, Dean of Bristol,
for £1000 in 1864, after he had seen it exhibited at the
British Institute the year before. On 2 September he
wrote to his friend Rawdon Brown in Venice, 'I've
been trying to get it ever since – and have got it at last'
(24.184n). His father had died in March 1864, and he
was beginning to spend his inheritance.

Ruskin considered Venice to be the ideal form of
government. In 1869 he displayed the portrait – also
attributing it to Titian – at the Royal Institution as an
illustration to his lecture 'The Flamboyant Architecture of
the Somme'. He commented that it 'tells you everything
essential to be known about the power of Venice in his
day – the breed of her race, their self-command, their
subtlety, their courage, their refinement of sensitive
faculty, and their noble methods of work' (19.250).

When Whistler sued Ruskin for libel for his
comments on his pictures in the Grosvenor Gallery in
1877 (cat.224), the portrait was taken into court as
evidence of what a properly finished work was like.
In the witness box Burne-Jones described it as 'a most
perfect specimen' (Merrill 1992, p.174). The trial judge's
doubts about showing the painting in court because it
could not be proved to be by Titian were later justified,
when in 1931 the painting was re-attributed to Catena. It
would have been painted between Andrea Gritti's election
as Doge in 1523 and Catena's death in 1531.

Ruskin owned four other Venetian works: a preparatory oil sketch of *Doge Alvise Mocenigo Presented to the
Redeemer* by Jacopo Tintoretto (1518–94) (Metropolitan
Museum of Art, New York); *An Allegory of Fidelity* by
Domenico Tintoretto (1560–1635) (Fogg Art Museum,
Harvard University); a panel by Vittore Carpaccio
(c. 1455–1526), *The Story of Alcyone* (Philadelphia Museum
of Art); and a fragment of a fresco from the Fondaco de
Tedeschi by Giorgione (c. 1476–1510) (Saltwood Heritage
Foundation).

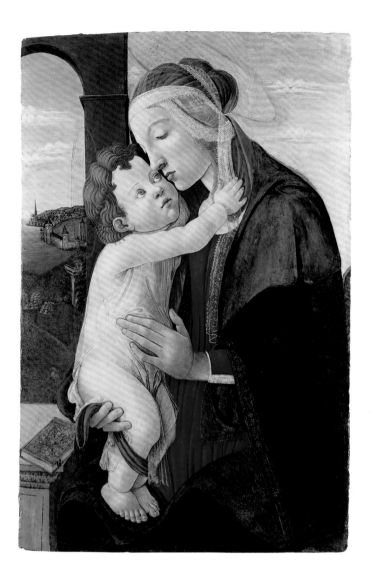

127

School of Botticelli
[Sandro Botticelli
(1444/5–1500)]

Virgin and Child

Oil on panel
88 x 57.9

Bought by Ruskin
in 1877

The Visitors of the
Ashmolean Museum,
Oxford

'The only painter of Italy who thoroughly felt and understood Dante; and the only one also who understood the thoughts of Heathens and Christians equally, and could in a measure paint both Aphrodite and the Madonna' (Fors Clavigera, Letter 22, 1872, 27.371–2)

As with cat.125, Ruskin acquired the picture through Fairfax Murray, paying £300. In July 1877 he had written of Murray in *Fors Clavigera*, 'You may give *him* any sum you like to spend in Italian pictures, – you will find that none of it sticks to his fingers: that every picture he buys for you is a good one; and that he will charge you simply for his time' (29.155n). This was before this picture was delivered to him in Oxford in December. He had authorised the purchase on the basis of a photograph, and was disappointed. He wrote to Murray that the Botticelli 'is so ugly that I've not dared to show it to a human soul. Your buying such an ugly thing has shaken my very trust in you' (Letter, 22 Dec. 1877, Pierpont

Morgan Library). The painting was dirty and in need of restoration, and while it remained in his collection until his death, Ruskin makes no mention of the picture in his published writings.

Sandro Botticelli (*c.* 1445–1510) was a late enthusiasm of Ruskin's that coincided with the vogue for the artist in the Aesthetic movement. It is probable that Burne-Jones drew his attention to the artist, as he did with Carpaccio. Ruskin mentions him for the first time in a lecture at Oxford in 1871 (22.19). In 1872 he visited Rome after a gap of thirty-one years, where he discovered Botticelli's frescoes in the Sistine Chapel (cat.174), and returned to study them closely in 1874. Botticelli figures largely in his lectures on engraving, given during the Michaelmas Term at Oxford in 1872 and published as *Ariadne Florentina* in 1876. The significance of the artist to Ruskin was that he represented the continuity and synthesis of Greek and Christian traditions, a quality he was to discover in the mature work of Burne-Jones (see cat.220).

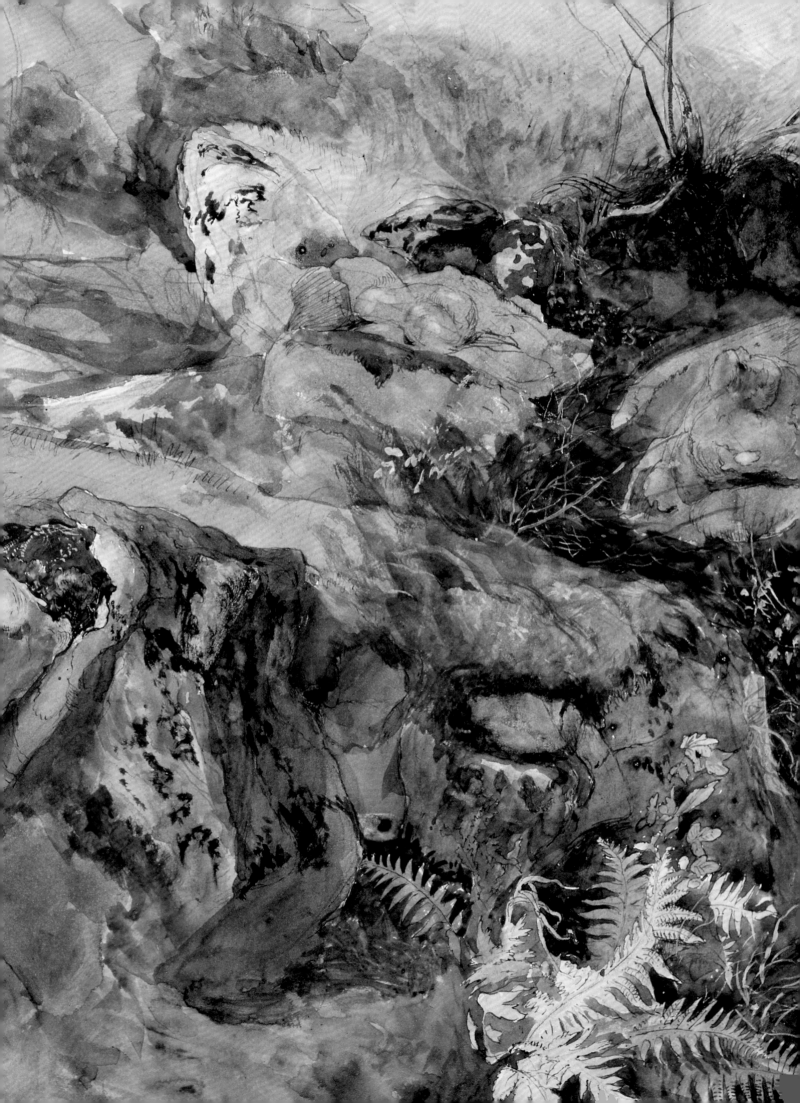

VI

Ruskin's Drawings
1844–1882

There is a strong instinct in me, which I cannot analyse, to draw and describe the things I love – not for reputation, nor for the good of others, nor for my own advantage, but a sort of instinct, like that for eating and drinking.
(Letter to his father, 2 June 1852, Cook 1911, 1.263)

As part of his passion for observing nature and looking at art and architecture, Ruskin drew constantly. One of his fundamental beliefs was that understanding came from close observation, and could be enhanced by the hand copying what the eye could see. 'My eyes … are better than nine pairs out of ten, and I am very thankful to have such' (36.73).

Tuition from Charles Runciman, Copley Fielding and J.D. Harding, and a friendship with Samuel Prout, whose work his father bought at the Old Water Colour Society, developed the young Ruskin's talent as a draughtsman to a point in the early 1840s when, had he not been of independent means and intellectual ambition, he might have become a professional artist. 'Interested in everything, from clouds to lichens' (35.238), he was aware, too, of his natural gift and command of technique: 'Architecture I can draw like an architect, and trees a great deal better than most botanists, and mountains rather better than most geologists … I have done some good to art already, and I hope to do a great deal more' (Letter to his mother, 24 Aug. 1845, 4.xxvi–xxvii).

Ruskin was modest about the drawings of Alpine rocks and peaks (cats.128–30, 141) made between 1844 and 1849, seeing them essentially as memoranda in the great flow of work on *Modern Painters*, yet they represent his first individual achievement. The intervening continental tour of 1845 was in many ways a turning-point in his confidence, not least in the realisation that his own ambitious brown ink drawings (cats.131–3), although stylistically old-fashioned, were no less successful than those of Harding, who had accompanied him. The development of a more confident handling of colour in the later 1840s (cats.137–9, 142) brought him to a stage where his work as a watercolourist stands comparison with any of his peers.

Curiously, what he lacked at this point, as an artist, was purpose and imagination. He had no need to produce immaculately finished pictures for public exhibition, his drawings and watercolours still being made mostly to complement his writings, especially *The*

Stones of Venice and the later volumes of *Modern Painters*. Without the incentive to travel constantly, and to paint a variety of subject matter as professional artists like Prout and Harding had to, Ruskin confined himself to visiting only those places which he liked – on a fairly set route through France, Italy and the Alps – and then mostly in the footsteps of his artistic idol, Turner, whose style he emulated.

Although gaining in confidence, he was also conscious of his limitations, telling George Richmond in 1846 that 'I can do nothing that I haven't before me; I cannot change, or arrange, or modify in the least, and that amounts to a veto on producing a great picture … Anybody can pick the picturesque things and leave the plain ones, but [Turner] doesn't do this … [and] of the *ugly* things he takes and misses and cuts and shuffles till everything turns up trumps, and that's just what isn't *in* me' (36.64).

His growing frustration – which paradoxically was also a strength – was in feeling only able to draw exactly what he saw. This principle he had famously expounded in the passage of *Modern Painters* vol.1 urging the aspiring artist to go to Nature 'rejecting nothing, selecting nothing, and scorning nothing' (3.624), and when he took it to extremes in his own work, he was capable of matching the young Pre-Raphaelites, in the obsessively meticulous watercolours of *Gneiss Rock, Glenfinlas* (1853) (cat.143) and *In the Pass of Killiecrankie* (1857) (cat.148). There is something airless and two-dimensional about these compositions, however, and when it came to completing large landscapes (such as the grand view of the *Bay of Uri* in Switzerland in 1858 (cat.149)), Ruskin found himself in difficulty, unable to combine attention to detail with the breadth of imaginative expression he so admired in Turner. To his father, on 24 May 1858, he confided that, although 'getting on well with my drawing, the worst of it is that unless it be as good as Turner's, it doesn't please me; so that on the whole I am seldom pleased' (1858L.14). An equal problem was simply that of time: 'my standard is now too high to admit of my drawing with any comfort,' he wrote again to his father, 'at least unless I gave up everything else for it' (1858L.55). The books and essays that were germinating in his mind, after he had completed the final volume of *Modern Painters* in 1860, precluded this choice.

This dissatisfaction with his abilities as an artist coincided with the lessening of his close involvement in the practice and

criticism of art, following the last *Academy Notes* in 1859, and his gradual withdrawal from teaching at the Working Men's College. There were still to be regular attempts at ambitious watercolours, such as *The Walls of Lucerne* (1866) (cat.162), *Church of St Wulfran, Abbeville* (1868) (cat.165), and some big Venetian subjects (cats.77, 78), but much more of Ruskin's later work was to be on a smaller scale.

The impetus to an extraordinary revival in his creativity came in 1869 with the appointment as Slade Professor of Fine Art at Oxford. Having soon conceived the idea of establishing a Drawing School, he threw himself into providing a wide range of 'examples', of the focused kind that best suited his exacting powers of observation and transcription. Exquisite studies of twigs, rocks, animals and birds (cats.154, 167–171) descended on Oxford throughout the 1870s, providing not only the means for students to learn by making copies of them, but also fulfilling Ruskin's incessant urge to portray 'the true appearance of things'. At the narrowing of focus he was unrepentant: 'The system of the world is entirely one; small things and great are alike part of one mighty whole' (7.452).

Forever learning by drawing, Ruskin made many studies of Old Master paintings and ancient buildings, especially early Renaissance painting and Gothic architecture, as it came under review. He developed a method, also used in his books and lectures, of focusing on a detail – a lively figure from a major fresco by Botticelli (cat.174), or a wonderful piece of moulding from Rouen Cathedral (cat.179) – the minutiae of a specific feature standing for the significance and humanity of the larger work of art.

Often using such studies as visual aids during his lectures, Ruskin exhibited more of his work in public than is generally realised. One or more of his juvenile drawings, obtained by Dr Elias Magoon without Ruskin's knowledge, had appeared at the New York Academy of Design in 1855. This may have spurred Ruskin to send his *Fragment of the Alps* (Fogg Art Museum) on the American tour of an exhibition of British art arranged by William Michael Rossetti in 1857–8, and a drawing of *Alpine Roses* was shown at the Hogarth Club in 1860. He accepted honorary membership of the Old Water Colour Society in 1873, and exhibited sporadically from

1874; his finest architectural watercolour, the *North West Porch of St Mark's* (cat.77), was submitted in 1879. The celebrated copy of Botticelli's *Zipporah* (cat.174) was sent to an exhibition in Brighton in 1876, and Ruskin was confident enough to include groups of his own drawings in exhibitions he arranged for the Fine Art Society, alongside those of Turner (in 1878) and of Prout and William Henry Hunt (in 1879) (cats.71, 145, 149). The latter year witnessed the largest display of his work ever held in his lifetime, though it was one he never saw, assembled in Boston by his American friend Charles Eliot Norton.

Ruskin only once offered a drawing for sale – a study of box leaves, at the Dudley Gallery in 1882. Soon after, he was deterred from exhibiting when in 1884 his architectural watercolours were criticised in the *Art Journal*, the reviewer taking him to task for showing works 'in the unfinished state he condemns in others'. The question of 'finish' was one that dogged Ruskin throughout his working life: few of his watercolours were ever taken to a significant degree of completion, chiefly because this was never necessary. The painter Hubert Herkomer noted that Ruskin 'never finishes his work to the edges', and Ruskin himself chided Kate Greenaway that she was 'nearly as bad as me, that way' (37.453); yet he did not need to produce work which would please an exhibition audience, and was usually content when the immediate effect or purpose had been obtained. And in purely practical terms, he would not have had time for tedious studio work, with so many other constant calls on his concentration. 'I could have done something,' he mused in 1878, 'if I had not had books to write' (21.179).

Ironically, we now hold in the highest admiration those drawings which combine the two dominant aspects of his character: passionate, fiercely precise detail – often with a distinctive combination of pencil and bodycolour – and an impatient, spontaneous rendering of space and atmosphere, through loose and often vibrant watercolour washes (cats.175, 178). Along with this trademark of high detail amid unconcerned incompletion comes a fresh and exceptional directness in nearly all his drawings, whether of mountain, spire, or plant, which brings an instant recognition that they could belong to no other hand.

sw

128

John Ruskin

Panorama of the Alps from above Brieg (the Bernese Alps from the Fletschhorn to the Matterhorn). The Simplon and Bernese range seen from the Bell'Alp
1844

Pencil, watercolour and bodycolour
35.7 x 270
(five joined sheets, each approximately 35.7 x 53.3)

Given to the Guild of St George 1876

The Ruskin Gallery, Guild of St George Collection

'The hills are as clear as crystal, more lovely, I think, every day, and I don't know how to leave off looking at them'
(Diary, 16 June 1844, D1.284)

Ruskin first crossed the Alps in 1833, but it was not until stays in 1842 and 1844, chiefly at Chamonix, that he fell in love with the mountains. Still travelling with his parents, Ruskin found escape on the 1844 trip through long daily walks and scrambles to obtain new views and vantage points. He recorded in his diary for 16 July an ascent from Simplon to where he could see 'the Bernese Alps in their whole extent, unbroken, and two mountains beyond the valley of Saas … The wind was violent and the slaty ridge, shattered and broken into deep crevices, afforded small footing, so that I stayed not long; but it was a glorious panorama' (D1.303). He loved hilltops – where it was his habit to stop and pray – but rarely encountered such spectacular demonstrations of the apparently 'united movement in these crested masses, nearly resembling that of sea waves … governed by some grand under-sweep like that of a tide running through the whole body of the mountain chain' (6.242).

Back at Simplon in September 1876, Ruskin recalled his youthful climb in a preface to chapter x of *Deucalion*, headed 'Thirty Years Since': '[In] one panorama are seen the the Simplon and Saas Alps on the south [left of image], with the Matterhorn closing the avenue of the valley of St. Nicolas; and the Aletsch Alps on the north, with all the lower reach of the Aletsch glacier. This panorama I drew carefully; and slightly coloured afterwards, in such crude way as I was then able; and fortunately not having lost this, I place it in the Sheffield Museum, for a perfectly trustworthy witness to the extent of snow on the Breithorn, Fletschhorn, and Montagne de Saas, thirty years ago' (26.222).

129

John Ruskin

Alpine Peaks
?1846

Pencil, watercolour
and bodycolour,
on three joined sheets
16.8 x 25.2

Inscribed by Ruskin
with names of peaks:
Schreckhorn [twice],
F[inster], Aarhorn [twice],
Mettenberg, Eiger [twice],
Jungfrau

Probably placed in the
Ruskin School of Drawing,
but later withdrawn

Birmingham Museums
and Art Gallery

'Perhaps in describing mountains with any effort to give some
idea of their sublime forms, no expression comes oftener to the
lips than the word "peak"' (Modern Painters IV, 1856, 6.222)

In the first volume of *Modern Painters* (1843), Ruskin's
fascination with mountain tops leads to a comparison
between their geological appearance and Turner's
vignette of the *Alps at Daybreak* for Rogers's *Poems*
(see cat.17). He notices that 'it does not always follow,
because a mountain is the highest of its group, that it
is in reality one of the central range. The Jungfrau is
only surpassed in elevation, in the chain of which it is
a member, by the Schreckhorn and Finster-Aarhorn, but
it is entirely a secondary mountain. But the central peaks
are usually the highest, and may be considered as the
chief components of all mountain scenery in the snowy
regions' (3.431).

 This remarkable sheet of studies at first looks like
a compilation, but seems to conform with Ruskin's own
description of drawings he made on the spot (in 1846,
according to his editors Cook and Wedderburn, but
as likely in 1854), which he originally gave to Oxford
but withdrew in 1887. 'I had only one bit of paper,'
he remembered (or rather, one made up of smaller
fragments), 'and packed the mountains all over it; but
the Schreckhorn and Finsteraarhorn are all right as they
first appear behind the brown rocks of the Faulhorn.
Then, the summit of the Schreckhorn becoming clear,
I sketched it above the Finsteraarhorn. Presently the
Finsteraarhorn throwing off its clouds, I saw I had got
it too steep, and drew it again below itself. Farther to
the right the Eiger and Jungfrau had to be packed in
at the left-hand bottom corner, and a final study of the
quite clear Schreckhorn filled up what was left. These
memoranda recall to me a most lovely scene, and I think
the method of their execution is the most serviceable
that can be adopted for such rapid work' (21.277–8).

130

John Ruskin

Mountain Rock and Alpine Rose
?1844/9

Pencil, ink, chalk, watercolour and bodycolour
29.8 x 41.4

Ruskin Foundation
(Ruskin Library,
University of Lancaster)

'the Alpine rose clinging to its warm and tiger striped crags, the pines above stretching their arms over one's head like nets'
(Diary, 28 June 1849, D2.397)

Close examination of this, one of Ruskin's most beautiful early drawings, reveals a degree of haste and impatience that suggests it was brought to completion on the spot, probably in the region of Chamonix in 1844 or 1849. In a diary entry for 28 June 1849, he describes 'a long scramble' up to the Cascade des Pèlerins, where he 'got some pines, in Dag[uerreotype], then finished my drawing successfully'.

Over hasty pencil under-drawing, the rocks and trees are outlined in ink, but their boughs and contours are only quickly defined before Ruskin provides some basic solidity by the addition of watercolour wash and a little red chalk. His final concentration is on the flowering shrubs clinging to the rock, especially the Alpine rose in the foreground: the most delicate scratching-out and placing of bodycolour indicates the red blossom, in which Ruskin delighted as one of the rare spots of colour in a snowy landscape.

The bloom was celebrated in the poetical account of his 1833 tour of the continent – 'where no other flower would blow | There you might see the red rose grow' (2.371) – and he made several attempts at individual studies. In a letter of 12 August 1844 to George Richmond, Ruskin confessed to difficulty in drawing its leaves ('Infinity multiplied into infinity – what can white lead or black lead do with it?' 36.39), but seems to have exhibited such a study at the Hogarth Club in 1860 (38.226).

131

John Ruskin

Stone Pines at Sestri
1845

Pencil, brown ink,
sepia and bodycolour
on two joined sheets
44.5 × 33.5

Given to the Ruskin
School of Drawing 1870

The Visitors of the
Ashmolean Museum,
Oxford

'I have been working all day like a horse, and have got a most valuable study of stone pine' (Letter to his father, 30 Apr. 1845, 1845L.46)

Ruskin made this drawing on Wednesday 30 April 1845, en route from the south of France into Italy. In one of his daily letters to his father – this was the first foreign tour without his parents – Ruskin reported having secured 'capital rooms' at Sestri, with windows 'commanding the whole sweep of the bay towards Genoa, and a window looking out on the rock promontory & its pines'. Earlier in the day he had made this drawing, with 'rock to sit on – under the shade of an ilex – no wind – air … all scented by the pines & wild flowers – and the birds singing so loud you can hardly hear the sea' (1845L.46). This unusually joyous mood produced one of Ruskin's finest early drawings, which thereafter hung in pride of place in his father's bedroom. It demonstrates Ruskin's later testimony that by the spring of 1845 he 'was able to study from nature accurately in full chiaroscuro, with

a good frank power over the sepia tinting' (35.340).

The drawing subsequently formed part of Ruskin's gift to his Drawing School at Oxford, and his various explanations of its significance are revealing. As a piece of drawing, Ruskin admits it to have been done 'with the utmost possible speed consistent with care' (21.297). As part of the Educational Series, one of the sequences of examples he created for his classes, its subject evokes classical allusion: 'the true pine … [which] is properly the one sacred to Poseidon. This piece of landscape, showing a bay of the Mediterranean through the stems of the pines, will give you some idea of the mingled grace and strength of the tree, where it grows on crag, and is tried by storms, as among the Greek islands' (21.116). Finally, it takes its place in the Rudimentary Series as part of a sequence, between a plate from Turner's *Liber Studiorum* (*Berry Pomeroy Castle*, called by Ruskin *Raglan*), indicative of 'the expression of foliage in middle distance', and a monochrome drawing, after Turner, of *Scotch Firs*, showing 'complexities of light and shade' (21.296–7).

132

John Ruskin

Trees and Rocks
*c.*1845

Pencil, brown ink,
ink wash and
bodycolour
33 x 27.7

Ruskin Foundation
(Ruskin Library,
University of Lancaster)

'I shall climb but little, and only so far as I find necessary to get mountain illustrations – and so stop to draw' (Letter to his father, Macugnaga, 24 July 1845, 1845L.159)

Another brown ink study deposited at Oxford with *Stone Pines at Sestri* is a smaller *Rough sketch of tree growth*, 'marking simply the lights and darks … of real shadow' (21.296). This is inscribed 'Macugnaga Aug. 4th', again of 1845, which must be the date and probably the location of this more detailed study, *Trees and Rocks.* The energy in the penmanship and swift application of wash suggests that this was also made on the spot.

This brown ink method, partly inspired by Turner drawings and the mezzotints for the *Liber Studiorum* (cat.51), and which Ruskin was to recommend to students himself in *The Elements of Drawing*, was common drawing-master practice in the early nineteenth century, as advocated by such artists as David Cox (see cat.26) and James Duffield Harding (see cat.37), of whom Ruskin had been a pupil.

Harding was indeed a travelling companion for part of the 1845 tour and, in a letter of 26 August to his father, Ruskin bemoaned the 'brown, laboured, melancholy, uncovetable' drawings of his own, in comparison with 'such pretty things, such desirable things to have' that Harding had done. However, Ruskin could see the essential and significant difference between Harding's picturesque compositions and his own pragmatic observation of nature: 'Harding's are all for impression – mine all for information' (1845L.189) (see cat.37).

133

John Ruskin

Mountain Landscape,
Macugnaga
1845

Pencil and brown ink
with brown and grey
ink wash
29.8 x 40.5

Inscribed by Ruskin
'MACUGNAGA / J Ruskin
1845'

Yale Center
for British Art,
Paul Mellon Collection

'although not quite what I want for drawing, the place is a perfect
Paradise for feeling, and the want of Zermatt sublimity makes it
even more delicious to live in, all hay fields & cascades' (Letter
to his father, 24 July 1845, 1845L.159)

From Florence, where he had spent six weeks in 1845
from the end of May to the beginning of July, Ruskin
moved on to Bologna, Milan and Como, before resting
for two weeks at Macugnaga in the Piedmontese Alps
below Monte Rosa. Here he interspersed strenuous
walks (and occasional help with haymaking) with
intensive reading of Shakespeare: 'by the light of the

little window at Macugnaga,' he wrote in *Praeterita,*
'and by the murmur of the stream beneath it, began
the courses of study which led me into fruitful thought'
(35.367).

Although there were 'mountains of all sizes within
the stretching of an arm', Ruskin reported that he found
'no views of interest in the valley, nothing grand or
striking' (1845L.159). Making something from what little
there was – as he did in the similar large ink drawing of
The Road to Florence (Ruskin Foundation) – he produced
this striking view, showing the village's 'group of half-a-
dozen chalets in a sheltered dip of moorlands' (35.364–5).

134

John Ruskin

Copy of 'The Annunciation' by Fra Angelico
1845

Pencil
21 x 24.3

Ruskin Foundation
(Ruskin Library,
University of Lancaster)

'*There are three perfectly preserved works of Fra Angelico, the centre one of which is as near heaven as human hand or mind will ever, or can ever go*' (Letter to his father, 4 June 1845, 1845L.96)

Ruskin's stay in Florence between 29 May and 6 July 1845 revealed to him 'the art of man in its full majesty', not least in Santa Maria Novella, where he was 'very much taken aback' at his first sight of masterpieces by

Giotto, Ghirlandaio and especially Fra Angelico (4.354). The work by Angelico that he found 'near heaven' was the *Annunciation* (c. 1430–4, together with an *Adoration of the Magi*), a panel from a reliquary then in the church sacristy. He preferred the artist's smaller works, which he thought 'stand altogether alone in art … Beside them Perugino is prosaic – and Raphael sensual' (1845L.97). Volume II of *Modern Painters* (1846) would contain further praise of Fra Angelico, and the figure of the Virgin in the *Annunciation* was engraved as the frontispiece to volume v (1860).

Having never found the work 'engraved or spoken of', Ruskin made arrangements to be let into the sacristy 'to draw the Angelico Annunciation, – about eleven inches by fourteen as I recollect, then one of the chief gems of Florence, seen in the little shrine it was painted for, now carried away [to the Museo di San Marco, where it remains] … The monks used to let me sit close to it and work, as long as I liked, and went on with their cup-rinsings and cope-foldings without minding me' (35.360–1). This kind of personal engagement with a work of art in its original setting was for Ruskin a vital ingredient in the aesthetic experience.

135

John Ruskin

Copy of the central portion of Tintoretto's 'Crucifixion'
1845

Pencil, chalk, black ink, ink wash and bodycolour
27 x 53.5

First exhibited
Royal Society of Painters in Water Colours, Ruskin Memorial Exhibition 1901

Ruskin Foundation
(Ruskin Library,
University of Lancaster)

'*But for that porter's opening [of the door to the Scuola di San Rocco], I should … have written The Stones of Chamouni, instead of The Stones of Venice … But Tintoret swept me away at once into the 'mare maggiore' of the schools of painting which crowned the power and perished in the fall of Venice; so forcing me into the study of Venice herself; and through that into what else I have traced or told of the laws of national strength and virtue*' (Praeterita, 35.372)

No artist made a greater impression on the young Ruskin than Jacopo Robusti (1518–94), known as Tintoretto. The

contrast of the Venetian master's rich, powerful works with the refined Tuscan art Ruskin had previously been studying was dramatic, and after his first visit to the Scuola di San Rocco in Venice on 24 September 1845, Ruskin confessed to his father that 'I never was so utterly crushed to the earth before any human intellect as I was today, before Tintoret' (1845L.211). In the cycle of vast canvases depicting the Life of Christ, 'he lashes out like a leviathan, and heaven and earth come together. M Angelo himself cannot hurl figures into space as he does, nor did M Angelo ever paint space itself which would not look like a nutshell beside Tintoret's' (1845L.212).

This powerful drawing is one of Ruskin's most concentrated and expressive copies, also reflecting the gloomy interior of the Scuola and the darkened condition of the paintings. Typically, Ruskin focuses on a small but telling detail, which he had originally described to his father – a 'touch of quiet thought in his awful crucifixion – there is an ass in the distance, feeding on the remains of strewed palm leaves. If that isn't a master's stroke, I don't know what is' (1845L.212). Again, Ruskin noted how Tintoretto had 'filled his picture with such various and impetuous exertion, that the body of the Crucified is, by comparison, in perfect repose' (4.270–1).

136

John Ruskin

*Trees in a lane,
perhaps at Ambleside*
1847

Pencil, black and brown
ink, and ink wash
44.5 × 57.2

Inscribed by Ruskin
'Best way of studying
Trees, with | a view
to knowledge of their
leafage. | Young Shoots
of the Oak and Ash,
in Spring. | J.R. 1847.
(Unfinished)'

Ruskin Foundation
(Ruskin Library,
University of Lancaster)

'as soon as you have drawn trees carefully a little while, you
will be impressed, and impressed more strongly the better you draw
them, with the idea of their softness of surface' (The Elements of
Drawing, 1857, 15.123)

Ruskin spent a short holiday in the Lake District in the
spring of 1847, staying at the Salutation Inn, Ambleside.
Writing to his father on 24 March, he reported a walk to
look at Wordsworth's house at Rydal, 'then climbed to
Fairfield (2900 feet) … Fine day, and fine view – Scawfell,
Grisedale Pike – Helvellyn close by – moors of Penrith,
Lancaster, Windermere, Coniston, etc., and some snow on
the top really pretty deep and wide; but as for *mountains*,
they're nothing of the sort, nothing – mere humpy
moorlands, mighty desolate' (36.70).

To compensate, he may have devoted more time to

this, one of his most elaborate surviving pen and ink
drawings, which has been formerly (but not conclusively)
identified as a lane at Ambleside, largely on the evidence
of the 'Spring' date in the unusually precise inscription.
The extremely detailed attention to leaf, bark and creeper
foreshadows such future writings as *The Elements of
Drawing* (1857) and 'Of Leaf Beauty', part VI of the last
volume of *Modern Painters* (1860).

In *The Elements of Drawing*, Ruskin takes the student
through the stages of drawing leaves on the bough that
he would have followed himself in compositions such
as this, noting the difficulty of transcribing exactly the
superimposition of adjoining branches. He recommends
a concentration on the forking of a tree's branches:
'When once you have mastered the tree at its *armpits*,
you will have little more trouble with it' (15.67).

137

John Ruskin

*Coast Scene
near Dunbar*
1847

Pencil and watercolour
32.5 × 47.5

Birmingham Museums
and Art Gallery

'had a happy day, drawing by the sea shore'
(Diary, 21 Aug. 1847, D1.362)

Feeling despondent in the summer of 1847, Ruskin went
for a month's 'cure' at Leamington Spa in July under
Dr Jephson (as he had done before, in 1841; see cat.40).
He was rescued from the tedium of this by an invitation

from a young family friend, William Macdonald, to stay
at his estate in Perthshire. In accepting, Ruskin also
entertained hopes of seeing the 18-year-old Effie Gray,
in solace for the failure of J.G. Lockhart's daughter
Charlotte to return his affection.

On the way, Ruskin stopped at Dunbar for a few
days, the gloomy weather (matching his mood) lifting
as he entered Scotland: 'I was never more touched in my
life than by the look of the heathery knolls and wild
happy streams … God grant I may gain in mind and
health of body from being here' (D1.362). A retrospective
list of his tours gives this the heading 'Scotland. First
careful colour study' (35.632). By 'careful', Ruskin must
have meant the simple but precise way in which he
delineates the outlines of the rocks before adding their
local colour and the decorative drapery of the seaweed.
The following day brought wild weather, turning the
view into 'one white, quavering, vaporous field, more
like a desert of white sand than sea' (D1.363), with gold-
tipped waves evoking in Ruskin's mind comparison with
Turner's *Slavers* (cat.47).

138

John Ruskin

*Rocks and Ferns in a
Wood at Crossmount,
Perthshire*
1847

Pencil, ink, watercolour
and bodycolour
32.3 × 46.5

Abbot Hall Art Gallery,
Kendal

*'a little valley of soft turf … enclosed by jutting rocks and
broad flakes of nodding fern'* (*Modern Painters* v, 7.268)

This highly coloured study corresponds closely in
technique with the work known as *Mountain Rock and
Alpine Rose* (cat.130), but is even more enclosed and
concentrated on botanical and geological detail. Such
a transformation of foreground detail into a wholly

enclosed and concentrated composition foreshadows
one of the principal features of Pre-Raphaelite landscape.

Writing to his father from nearby Dunkeld, before
he reached Crossmount, Ruskin had described a walk
along the Tay, where he marvelled at an assemblage of
plants and trees far more varied than in the Swiss Alps,
'all put together with a freedom and sentiment beyond
everything – a peculiar softness and wildness mixed,
like the finest Scotch music – and an intense melancholy
too' (36.76). A further letter to his friend W.H. Harrison,
written from Crossmount on 25 September, gives a lively
word-picture of 'a dark dingle with a rattling, glittering
stream giving you light at the bottom of it', to be crossed
on 'two birch trunks with some turfs upon them' (36.79),
probably a spot close to the subject of this watercolour.
Its exceptional state of preservation, and of finish –
Ruskin did not often cover the sheet, even with loose
washes as here, to its edges – demonstrates his powers
of observation and handling, which include an innate
awareness of when to leave 'reserve' (the whiteness of
the paper) to full effect, as in the foreground ferns and
background rocks.

139

John Ruskin

'La Merveille',
Mont St Michel,
Normandy
1848

Pencil, watercolour
and bodycolour
16.5 x 25

Richard Orders

'It is picturesque – beyond bettering, almost – and the interior as
a piece of baronial gloom and lordliness, noble above all I ever
saw' (Letter to his father, 8 Sept. 1848, Links 1968, p.42)

Ruskin and Effie toured Normandy between August and
October 1848 (see cats.74, 75), a good deal of the time
being spent at Rouen, which Ruskin regarded as 'the
place of north Europe as Venice is of the South' (Links
1968, p.45). He was also looking forward to visiting
Mont St Michel, expecting its setting to match that of

St Michael's Mount in Cornwall, which he had visited in
1839 and which he knew from engravings after Turner.

The reality, as he reported in a letter of 8 September
to his father, came as a surprise: 'I have not often been
more disappointed than in this place … instead of being
like our St Michael's – dashed upon by the deep green
sea – and pure and cold in the sea breezes – [it] is
surrounded by a flat of filthy sand.' Worse still were the
visible 'remnants of fish and offal and street cleansings …
I am prepared to bear this kind of thing in pursuit of the
picturesque but the flat masses without water are fearful
things for wind – and stench' (Links. 1968, p.42–3).

The three superimposed thirteenth-century Gothic
halls known as 'La Merveille' were at that time being
used as a prison following the Revolution of 1848, and
although Ruskin considered it 'impossible to make
drawings under such depressing circumstances', he found
'so much in the architecture that is marvellous that I am
going to look at it from the outside for two days more
in order that I may not need to undergo the penance of
coming here again' (Links. 1968, p.44). That he never did
return seems to be confirmed by a letter of 10 September
1873 to his assistant and agent William Ward, whom he
had sent to make studies: 'I couldn't draw when I was
there, for convicts' (37.71).

140

John Ruskin

Glacier des Bossons,
Chamonix
c. 1849

Pencil, brown ink,
ink wash and
bodycolour
33.7 x 47.6

Given to the Ruskin
School of Drawing *c.* 1875

The Visitors of the
Ashmolean Museum,
Oxford

And we high o'er those cliffs so sheer
Must climb the mountain barrier,
Until unfolded to the eye
The fruitful fields of Chamouni.
('*A Tour on the Continent*', Poems, 1833–4, 2.383)

Chamonix exerted a special influence over Ruskin, and
he was always happy to return there (at least, until a

casino was opened in 1851). A diary entry for 6 June 1844
records 'A lovely day, to light me to my own valley'
(D1.277), and when pressed in 1854 by his friend Jemima
Blackburn to name his favourite place, other than the
village itself, Ruskin declared himself torn between 'the
top of the Montanvert and a small rock on the flank of
the Breven. I have been *happiest* on the Montanvert, but
oftenest at this rock, where I generally pass my evenings
when at Chamouni' (36.193).

Following the first winter of his inauspicious
marriage, when his time was largely taken up completing
The Seven Lamps of Architecture (see cat.106), Ruskin
travelled abroad with his parents in April 1849, leaving
Effie with her family in Scotland. After a month together
at Chamonix, John James and Margaret Ruskin returned
to Geneva, leaving John to stay for another month, in the
company of his valet John Hobbs (known as 'George')
and his old mountain guide Joseph Couttet. This large
sepia drawing, offering a general view of the valley
looking south, would in all likelihood have been reserved
for indoor work: 'I have got on well with my drawing
of the Glac[ier] des Bossons,' he records in a diary entry
of 16 June, on a day of incessant rain (D2.388).

141

John Ruskin

Aiguille Blaitière, Chamonix
c. 1849

Pencil, ink and
watercolour
25 x 35.8

Inscribed
'J.R. on the spot, 1849'

First exhibited
Fine Art Society 1878

The Syndics of the
Fitzwilliam Museum,
Cambridge

*'the hollow in the heart of the aiguille as is as smooth and
sweeping in curve as the cavity of a vast bivalve shell'*
(*Modern Painters* IV, 1856, 6.231)

While working on volume IV of *Modern Painters* (part V,
'Of Mountain Beauty') in 1854, Ruskin made a list of
his Chamonix studies from that and previous years,
which runs to more than sixty items: it includes six of
the Aiguille Blaitière, of which this is certainly one. It
was a favourite spot of Ruskin's, and a letter to his father
of 21 August 1849 was written 'on a grey stone in the
middle of the glacier, waiting till the fog goes away'
(5.xxix).

The sharp mountain peaks or 'aiguilles' (literally
'needles') had intrigued Ruskin since boyhood – his
father, recognising no business sense in the young John,
ruefully commented in 1837 that he knew 'the shape of
every needle round Mont Blanc, [but] could not tell you
now where Threadneedle Street is' (2.xxxiv) – and were
the subject of chapter XIV of *Modern Painters* volume IV.

The upper part of the present drawing was engraved by
J.C. Armytage as plate 31, partly to show the 'white shell-
like mass' of the glacier below, 'which in its beautifully
curved outline appears to sympathize with the sweep of
the rocks beneath, rising and breaking like a wave at the
feet of the remarkable horn or spur which supports it on
the right' (6.230). So taken was Ruskin by this beautiful
curve that he used it as an example of perfect 'abstract
line' in a discursive passage in volume I of *The Stones of
Venice* (1851), on the 'proper material of ornament', this
being 'whatever God has created; and its proper treat-
ment, that which seems in accordance with or symbolical
of His laws' (9.265–6).

In his note on this drawing for the Fine Art Society
exhibition of 1878 (under the title *Granite Cleavages:
Aiguille Blaitière*), Ruskin recollected of his 1849 Alpine
studies that he was 'led at that time into a quantity of
anatomical work on mountains, of which the service,
if any, is yet to come, for I don't think the public ever
read the geological chapters in *Modern Painters*' (13.524).

142

John Ruskin

Cascade de la Folie, Chamonix
1849

Pencil, ink, watercolour
and bodycolour
46.1 x 37.3

Birmingham Museums
and Art Gallery

'I never saw the valley look so lovely as it did to-night, with its noble quiet slopes of deep, deep, green and grey' (Diary, Chamonix, 15 Aug. 1849, D2.425)

Writing a little disingenuously of the Chamonix drawings in 1878, Ruskin thought he had 'lost much artistic power through the necessity of making these geological studies wholly accurate, without allowing aërial or colour effect to disturb them' (13.525), but this disclaimer may only have been to satisfy his perpetual modesty in placing his own work beside that of Turner, since these watercolours of 1849 are among his subtlest and most impressive works.

There are two versions of this scene of the north side of the valley, identified as a view from the Hotel de l'Union: one concentrates on the course of the waterfall (repr. Library Edition, 5 pl.c), whereas the present sheet includes the whole of the upper mountain range and is taken to a greater degree of overall finish, its tones evened out into an icy blue-grey tint reminiscent of the work of J.R. Cozens (1752–97). One of Ruskin's finest achievements in watercolour, it matches such breathless word-pictures in his diary as this, made on the evening of 10 July 1849: 'At the top of [a promontory] the glacier was seen against the sky through the most fantastic pines, and the grand rocks falling to the source, nodding forwards (like a wave about to break), and the great cascade bounding from its narrow way' (D2.407).

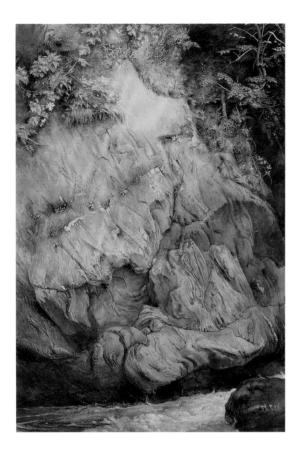

143

John Ruskin

Study of Gneiss Rock, Glenfinlas
1853

Pen, brown ink,
ink wash (lamp-black)
and bodycolour
47.7 × 32.7

Given to the Ruskin School
of Drawing after 1872

First exhibited
Fine Art Society 1878

The Visitors of the
Ashmolean Museum,
Oxford

'all touched and troubled, like waves by a summer breeze; rippled, far more delicately than seas or lakes are rippled: they only undulate along their surfaces – this rock trembles through its every fibre, like the chords of an Eolian harp – like the stillest air of spring with the echoes of a child's voice'
(*Modern Painters* IV, 1856, 6.152)

While Millais was at work on his famous portrait (cat.1) during the fateful summer months of 1853 at Glenfinlas, Ruskin made his own drawings of the rocks and stream: 'we all go out,' Ruskin wrote to Lady Trevelyan on 6 September, 'to the place where he is painting – a beautiful piece of Torrent bed overhung by honeysuckle and mountain ash – and he sets to work on one jutting piece of rock – and I go on with mine, a study for modern painters vol.III, on another just above him' (RLPT.57). Along with two smaller studies focusing on the water (one in pen and ink, one in watercolour; both in the Ruskin Foundation), he completed this highly detailed rendering of part of the same rock wall that forms the background to Millais's canvas, although it was not eventually used as an illustration.

Ruskin particularly liked gneiss rock, an 'inexpressably marvellous' geological phenomenon, with its undulating folds and curving lines, only narrowly resisting the temptation to 'devote half a volume to a description of the fantastic and incomprehensible arrangements of these rocks' in volume IV of *Modern Painters* (6.150).

According to his diary, Ruskin only 'finished my *rocks at Glen Finlas*' on 8 February 1854 (D2.490), but by his own testimony, at the time of its exhibition in 1878, he still considered it incomplete: a work 'which really had a chance of being finished, but the weather broke; and the stems in the upper right-hand corner had to be rudely struck in with body-colour. But all the mass of this rock is carefully studied with good method' (13.524). Bodycolour is used as a highlight elsewhere on the sheet, however, along with scratching-out (notably to add sparkle to the foaming water), and together with a more concentrated overall gradation of tones in the ink washes, it represents a subtle development in style from his previous large pen drawings (cats.133, 140). Ruskin was sufficiently pleased with the drawing, which was presented to the Ruskin Drawing School as part of the Reference Series, to authorise photographs of it to be made and supplied through his agent, William Ward.

144

John Ruskin

The Rocky Bank of a River
?1853/7

Pencil, pen and black ink, ink wash and bodycolour
32.5 x 47.3

Yale Center for British Art, Paul Mellon Fund

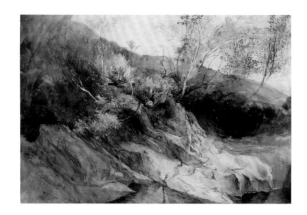

'All rivers, small or large … will always, if they can, have one bank to sun themselves upon, and another to get cool under'
(*The Elements of Drawing*, 1857, 15.172)

The location of this subject has not hitherto been identified, but a similar combination of identical foliage and rock, and the quite painterly use of bodycolour, raises the possibility that this is a drawing made in the Scottish Highlands either in 1853 at Glenfinlas, or in 1857 at the same time as *In the Pass of Killiecrankie* (cat.148). The sheet is exactly the same size as *Gneiss Rock, Glenfinlas* (cat.143), and even at the later date it is likely

that Ruskin would have been carrying the materials for his usual memorialisation of a favourite place, through a large pen and ink drawing.

That it has less of the Pre-Raphaelite detail of these other two drawings may be explained by another possibility: that Ruskin was seeking out the location of one of the subjects he most admired from Turner's *Liber Studiorum*. In his 1871 *Lectures on Landscape*, Ruskin commended Turner's subjects as models of 'the delineation of solid form by outline and shadow' (22.35), but wondered how in the plate of *Near Blair Athol*, he 'could have made so little of so beautiful a spot', even though, by reducing the scene to its bare component parts, 'he has put into one scene the spirit of Scotland' (22.36).

Ruskin identified the scene as being 'on the stream which comes down from Glen Tilt, about half a mile above its junction with the Garry' (21.135), one that he claimed to have sought out himself in 1857. Although his description of the projecting rock in Turner's view as 'covered with lichens … and wild vegetation' is perhaps identifiable with that depicted by *In the Pass of Killiecrankie*, the location above Blair Atholl, some distance from Killiecrankie itself, is an equally likely one as the scene of Ruskin's broader ink drawing, in which the emphasis on chiaroscuro and the feathery handling of the trees surely owe more to Turner than to Millais.

145

John Ruskin

Chamonix: Rocks and Vegetation
c. 1854

Pencil, watercolour and bodycolour
25 x 26.7

First exhibited Fine Art Society 1878

Abbot Hall Art Gallery, Kendal

'Every day here I seem to see farther into nature, and into myself, and into futurity' (Diary, Chamonix, 18 July 1854, D2.498)

In a number of drawings on this smaller size sheet (see also cat.148), Ruskin extends his meticulous 'portraits' of the living rock from monochrome (cat.143) to colour. In this example, long identified as a subject at Chamonix, he takes great care to detail the Alpine plants in every crevice, before finally splashing the sheet with bodycolour, more out of apparent impatience than from the wish to add what the modern eye might take as an expression of feeling.

It still represents a perfect illustration of his famous dictum from volume IV of *Modern Painters* (1856): 'There are no natural objects out of which more can be … learned than out of stones. They seem to have been created especially to reward a patient observer … For a stone, when it is examined, will be found a mountain in miniature … [Nature] can compress as many changes of form and structure, on a small scale, as she needs for her mountains on a large one; and taking moss for forests, and grains of crystal for crags, the surface of a stone, in by far the plurality of instances, is more interesting than the surface of an ordinary hill; more fantastic in form, and incomparably richer in colour' (6.368).

146

John Ruskin

Towers of Fribourg
1854

Pencil and watercolour
28 x 20.5

Engraved by J.C. Armytage
for *Modern Painters* IV
(6 pl.24)

The British Museum

'Fribourg is ... the only mediaeval mountain town of importance left to us ... [and] retains much of the the aspect it had in the fourteenth and fifteenth centuries' (*Modern Painters* IV, 1856, 6.456)

En route to Chamonix in 1854, Ruskin visited the towns of Thun, Fribourg and Lucerne, and, according to *Praeterita*, conceived the idea of a work on Swiss history that could be illustrated by etchings or engravings after his own drawings. Such a book would have continued the interweaving of art and social history pioneered in *The Stones of Venice* (1851–3). This plan developed on his return with his parents to the same places in 1856 (the year of 'Study of Swiss towns', 35.632) and again on his own in 1858 (adding Rheinfelden and Bellinzona) and 1859. His father was keen to see him finish *Modern Painters*, however, and Ruskin was able to justify the distraction by adopting the not wholly inaccurate excuse of also following in Turner's footsteps, seeking out the subjects of an 1802 tour as well as those of the 1842–5 watercolours, some of the finest of which were hanging on the walls at Denmark Hill (cats.54, 111, 114).

Even on his visit in 1835, Ruskin had thought Fribourg 'a remarkable city' (DI.59), and was pleased to find it still unspoiled in 1856. Abandoning work on an ambitious scale emulating Turner, he concentrated on the city's towers, walls and densely grouped houses. This brilliant study of the Tour des Chats and the Porte de Berne, consciously given the appearance of a Turnerian vignette, was engraved by J.C. Armytage as plate 24 (*The Towers of Fribourg*) in volume IV of *Modern Painters* (1856). In the accompanying text, Ruskin discusses the faithfulness of such images. His own drawing was made on 'a misty morning with broken sunshine, and the towers were seen by flickering light through broken clouds, – dark blue mist filling the hollow of the valley behind them' (6.46). Inevitably it contained exaggerations, and a daguerreotype which he had made at the same time, Ruskin argued, should have been 'not only ... the more right, but infinitely the grander of the two'. He thought the sketch, however, represented 'a truer idea of Fribourg', and pointed out that the photographic image failed to convey a discernible bend in the wall climbing the hill beyond: 'yet the notablest thing in the town of Fribourg is, that the walls have got flexible spines, and creep up and down the precipices more in the manner of cats than walls' (6.46).

147

John Ruskin

Fribourg
c. 1854–6 (inscribed 1859)

Pencil, ink, watercolour
and bodycolour
on grey-blue paper
22.5 x 28.7

Inscribed 'Fribourg.
Sketch for etchings of
Swiss towns. 1859.
Signed (1879). J Ruskin'

First exhibited Boston
and New York 1879

The British Museum

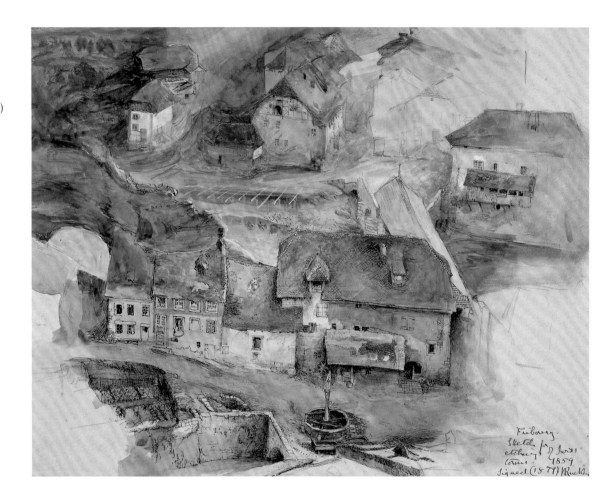

'Out of four months on the Continent, I have taken only ten days of whole work, and ten days half work: those were to make some drawings of old bits of Thun and Fribourg, likely to be destroyed before I get back to them again' (Letter to Pauline, Lady Trevelyan, 26 Sept. 1856, RLPT.114)

Commenting in 1857 on a sheet from the 1841 *Fribourg* sketchbook (Turner Bequest, CCCXXXV 18), Ruskin enthused at how Turner continued to use 'the pencil and pen together' to the last, even though 'his own special gift was that of expressing mystery, and the obscurities rather than the definitions of form' (13.316). 'If a single title were to be given,' he continued, 'to separate him from others, it ought to be "the painter of clouds": this he was in earliest life; and this he was, in heart and purpose, even when he was passing days in drawing the house roofs of Fribourg.'

This remark has an autobiographical ring, since in 1854 and 1856 Ruskin was making just such studies of his own. Two smaller drawings (Fitzwilliam Museum, Cambridge; Hayman 1990, nos.53–4) are of the same scenes as surviving daguerreotypes, taken for Ruskin by his valet Frederick Crawley. Whether Ruskin intended using these photographic images to enhance his drawings at leisure, or whether he simply wanted a comparative 'accurate' record of the scenes, is not clear. Both are taken from above, looking down on the river and eliminating the horizon line. In the larger British Museum watercolour here exhibited, Ruskin has adopted the same startling, but quite natural viewpoint, adding a good deal more local colour and thus atmosphere. He spent time at Thun in August 1859, and may have re-visited Fribourg, but it is equally possible that the remembered date on this sheet – added twenty years later – is in error.

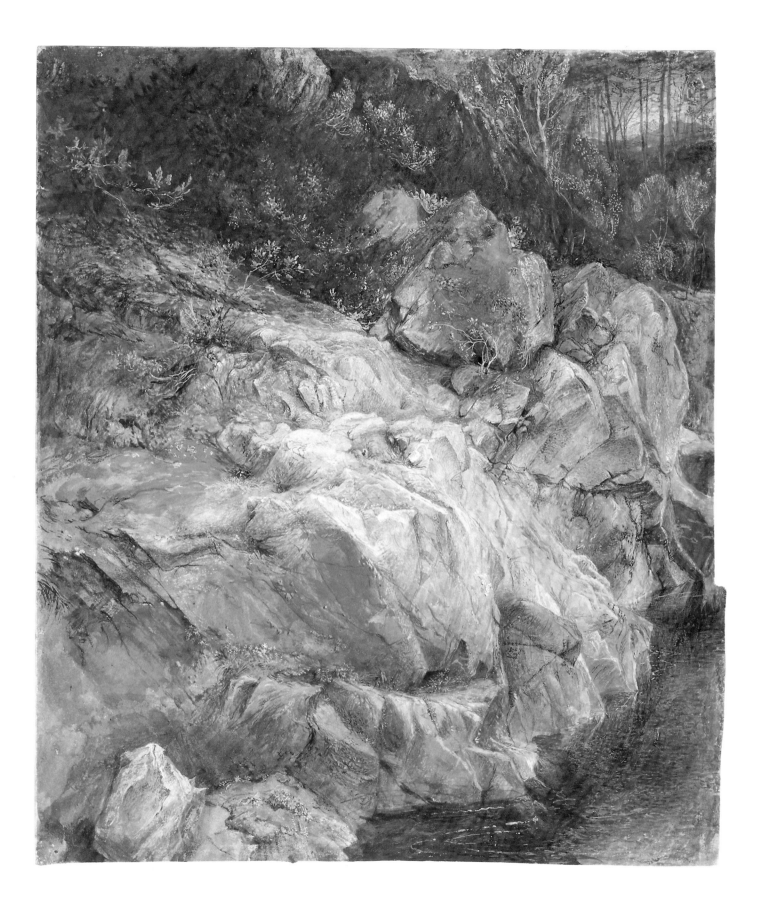

148

John Ruskin

*In the Pass of
Killiecrankie*
1857

Pencil, ink, watercolour
and bodycolour
28.2 x 24.8

Inscription on old
backboard: 'In the pass of
Killiecrankie / J.R. 1857'

First exhibited
Dudley Gallery 1881

The Syndics of the
Fitzwilliam Museum,
Cambridge

*'The projecting rock … was covered with lichens having as many
colours as a painted window … and the wild vegetation in the
rock crannies [made] a finished arabesque of living sculpture'*
(*Lectures on Landscape*, 1871, 22.35–6).

Ruskin was extremely busy in the early part of 1857,
working on his first selection from the Turner Bequest,
completing *The Elements of Drawing*, and preparing the
seminal lectures on *The Political Economy of Art* to be
delivered at Manchester in July. After a visit to Sir Walter
and Lady Trevelyan at Wallington, in Northumberland,
he was reluctantly hauled off for a holiday with his
parents, who wanted to 'show their Scotland to me'
(35.484). His patience ran out when they reached the
Bay of Cromarty at Inverness – 'doubtless now the
extreme point of my northern discoveries on the round
earth' – and having persuaded them that 'the town of
Dingwall is not like Milan or Venice', he engineered
their return.

On the way back to Edinburgh, they stopped at Blair
Atholl at the end of August, where Ruskin painted this
exceptionally meticulous watercolour, adding full local
colour to the similar sort of study he had undertaken in
monochrome four years before at Glenfinlas (cat.143).
Perhaps this was done to impress his father – perhaps to
prolong the stay and avoid further tedious sightseeing –
but whatever the reason, by his own account it took him
'a week at six hours a day' (16.xxxviii). On this occasion,
a patch of tree-laced sky is placed in the upper corner,
but it barely relieves the claustrophobic obsession with
capturing every leaf and crevice. The overall result bears
comparison with even the most painstaking compositions
of J. W. Inchbold or John Brett – whose *Val d'Aosta*
(cat.207) Ruskin was to chastise in 1859 as 'Mirror's
work, not Man's' – and has always been categorised as
his most Pre-Raphaelite picture. Ruskin clearly cherished
the drawing, and sent it for exhibition at the Dudley
Gallery in 1881.

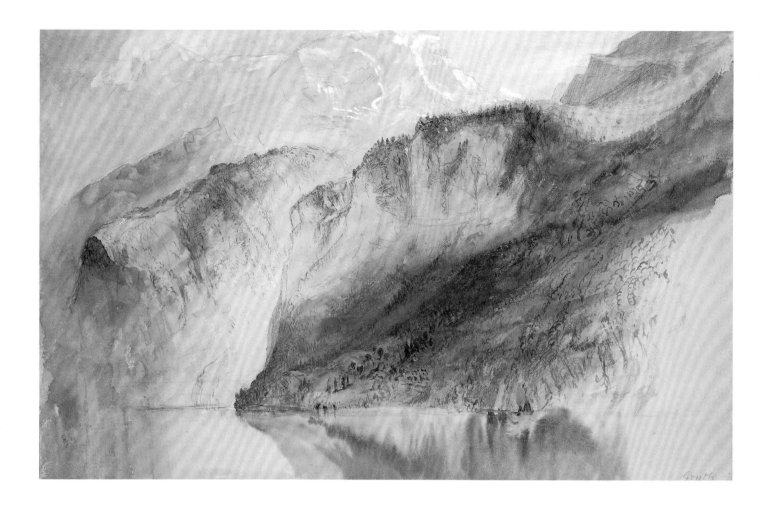

149

John Ruskin

*Bay of Uri,
Lake of Lucerne*
?1858

Pencil, watercolour
and bodycolour
34.5 x 54

Inscribed 'Grutli'

First exhibited
Fine Art Society 1878

Private collection

'*I have seen that it is possible for the stranger to pass through
this great chapel, with its font of waters, and mountain pillars,
and vaults of clouds, without being touched by one noble thought,
or stirred by any sacred passion; but for those who received from
its waves the baptism of their youth … I will not believe that
the mountain shrine was built, or the calm of its forest-shadows
guarded by their God, in vain*' (*Modern Painters* v, 1860, 7.114)

Ruskin travelled again to Switzerland in May 1858,
staying for several days each in Rheinfelden, Zug and
Brunnen, before reaching Fluelen, on Lake Lucerne,
where this drawing was probably made on 9–10 June.
In an exceptional state of preservation, retaining most of
the strength of the fugitive tones of blue which have so
often faded in Ruskin drawings, this watercolour has an
unexpected significance beyond the one which Ruskin
outlined in part VI of the final volume of *Modern Painters*
(1860), where he identified the scene – close to the field
of Grütli [modern Rütli], the traditional birthplace of
Swiss confederacy – as one symbolic of the national
character.

 The atmospheric nature of the watercolour would
appear to match Ruskin's further word-picture of the
lake and its shore, where 'the walls of its rocks ascend
to heaven. Far in the blue of evening, like a great
cathedral pavement, lies the lake in darkness; and you
may hear the whisper of innumerable falling waters
return from the hollows of the cliff, like the voices of a
multitude praying under their breath' (7.114). But in fact,
Ruskin was greatly dissatisfied with the result. He
included a *Cliff of the Bay of Uri*, probably a smaller study,
in his 1878 exhibition, regarding it as an 'example of the
best I can do, but still useless to express the pine beauty'
(13.510). Writing in *Praeterita* nearly thirty years later, he
saw his Swiss landscape drawings of 1858, the last of a
large number of serious studies stretching back to 1844,
as failures: 'my drawings did not prosper that year,' he
wrote, 'and, in deepest sense, never prospered again.' The
one he singled out is in all likelihood the present water-
colour, 'a too ambitious attempt at the cliffs of the Bay of
Uri, which crushed the strength down in me' (35.494).

 Both to Norton and to Elizabeth Barrett Browning,
in letters of October 1858, he further confessed to having
'got tired of the hills' (36.292). Even a visit to old friends
in Chamonix on the way home could not dispel the
feeling that 'the mountains are not what they were to me'
(LN.47), and the central chapter in the story of Ruskin's
life as an artist had closed.

150

John Ruskin

Bellinzona
1858

Pencil, watercolour
and bodycolour on
blue-grey paper
31.2 x 51.3

Inscribed 'Bellinzona'

First exhibited
Royal Society of Painters
in Water Colours, Ruskin
Memorial Exhibition 1901

Abbot Hall Art Gallery,
Kendal

'I still think this place the most beautiful I have yet found among the hills' (Letter to his father, Bellinzona, 20 June 1858, 1858L.53)

After crossing the Alps in 1845, Ruskin wrote to his father that 'Neither you nor I need trouble ourselves hereafter about Bellinzona or the head of the Lago Maggiore. It is ugly and unhealthy – Bellinzona fine in form, but Turner's sketch worth the whole valley with all the towns in it' (1845L.178). In his first selection of a hundred watercolours from the Turner Bequest, prepared to demonstrate the value of exhibiting unfinished sketches, Ruskin had included eight views of Bellinzona, chosen from the 'sample studies' of 1842–3, which he had come to prize more highly than the related finished watercolours. By then, he had been won over to the charm of the place, which he described in the accompanying catalogue as 'on the whole, the most picturesque in Switzerland, being crowned by three fortresses, standing on isolated rocks of noble form, while the buildings are full of beautiful Italian character' (13.207; Warrell 1995, pp.85 ff.).

Arriving on 12 June 1858 for a month's stay, Ruskin now found Bellinzona 'quite like a wonderful dream' (1858L.45), with a range of mountain landscapes, rushing torrents and interesting buildings to hand. His letters home were so full of vivid descriptions that his father told a friend, 'John seems to have arrived in the happy Valley for his letters are delightful' (1858L.xv). He was soon beset, however, by the same problem he had faced at the Bay of Uri (see cat.149), of trying to capture the whole experience of the place – as Turner had done so successfully – in large, ambitious watercolours. In retrospect, he remembered making 'a persistently furious [attempt] to draw the entire town, three fortresses and surrounding mountains' (35.494).

A view of the Castello Grande from the walls of Schwyz Castle, this is the largest surviving example from the campaign. For Ruskin, the finished product excited only disappointment and frustration, while to modern eyes it offers a powerful and idiosyncratic combination of detail and atmosphere.

151

John Ruskin

Near Bellinzona
1858

Pencil, watercolour
and bodycolour on
buff paper
22.1 x 16.5

Inscribed 'Near
Bellinzona. J. Ruskin –
1858'

Ruskin Foundation
(Ruskin Library,
University of Lancaster)

'always some new place to explore' (Letter to his father, Bellinzona, 17 June 1858, 1858L.48)

A letter of 26 August 1858 to the painter John Frederick Lewis (see cat.27) expressed Ruskin's disappointment with his work at Bellinzona. Describing how, at the start of his trip, he was 'beginning to be too fond of minor detail', Ruskin recounted his intention 'to sketch a great many subjects of the Grand kind – in an impressive and "eclectic" manner' (1858L.186). Having made himself 'entirely miserable in a week', he had gone back to the old plan, but having started a drawing 'in complete light and shade' – that is, in the Pre-Raphaelites' (and Lewis's) method of exacting detail in sharp focus – had calculated that 'it would take to finish the drawing … Fifteen years, six months, & some days'. This was a humorous reiteration of a genuine dilemma explained to his father a few months earlier: 'I am very much displeased with all I do myself: my standard is now too high to admit of my drawing with any comfort, at least unless I gave up everything else for it' (letter of 22 June, 1858L.55).

Ruskin did not give up lightly, however, and a group of subjects in the surroundings of Bellinzona demonstrates that he did finish some 'complete light and shade', to his own satisfaction. In *Praeterita*, he recalled his original ambition 'gradually taming and contracting itself into a meekly obstinate resolve that at least I would draw every stone of the roof right in *one* tower of the vineyards' (35.494) – probably a reference to this image.

152

John Ruskin

Copy of a Girl in Van Dyck's portrait of The Wife of Colyn de Nole and her daughter
1859

Pencil, pen, sepia wash and bodycolour
51 x 35.5

Inscribed "J.Ruskin after VANDYCK MUNICH 1859

First exhibited Royal Society of Painters in Water Colours. Ruskin Memorial Exhibition 1901

Brian Sewell

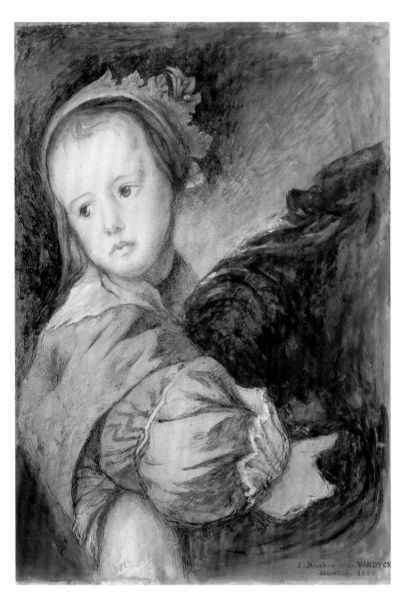

fig.8 Van Dyck, *The Wife of Colyn de Nole and her Daughter* (Bayerische Staatsgemäldesammlungen, Pinakothek Munich)

'Most pictures of the Dutch school … excepting always those of Rubens, Vandyke, and Rembrandt, are ostentatious exhibitions of the artist's power of speech, the clear and vigorous elocution of useless and senseless words' (Modern Painters I, 1843, 3.90)

In 1857 Ruskin was asked to give evidence to a government commission charged with investigating the possibility of moving the National Gallery to a new site. To his embarrassment he was asked if he had seen the new art galleries of Dresden and Munich and had to admit that he had not been to Germany for twenty years (13.543). In 1859, partly to rectify this omission and partly to make further studies of Veronese in preparation for the final volume of *Modern Painters*, Ruskin visited Berlin, Leipzig, Dresden and other German cities, spending 13–25 July in Munich. This was the last time he travelled abroad with his parents.

Ruskin made extensive notes on the pictures in the Munich Gallery, and produced this study of Van Dyck's portrait of the wife of the sculptor Colyn de Nole (fig.8). Typically, this is a response to a detail in the painting that attempts to capture its dynamic qualities as a human gesture in a more formal portrait, rather than be an exact copy. Ruskin's scattered references to Van Dyck in his published writings, such as that quoted above, show that he adopted his father's conventional view of the painter, listing him in *The Elements of Drawing* (1857) as one of the painters "You may look [at] with admiration, admitting, however, question of right or wrong" (15.220). He was none the less appreciative of the artist's portraits of children (36.lxxxi). This appreciation may be a cause or consequence of this study. Ruskin's thoughts could have been running on children, for in 1858 he had met Rose La Touche for the first time (see cat.230).

RH

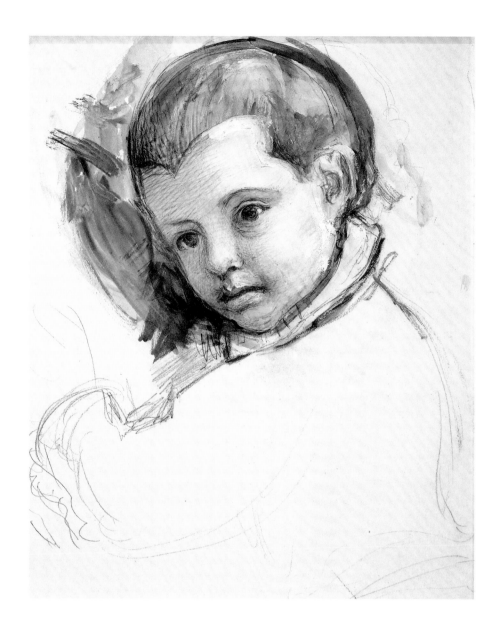

153

John Ruskin

*Copy of the Head of
a Boy, from Veronese's
'Cuccina Family'*
1859

Pencil, ink, ink wash
and bodycolour
28 x 22.3

Ruskin Foundation
(Ruskin Library,
University of Lancaster)

'*All ones* [sic] *little character and life goes* [sic] *into the minute
preferences which are shown in the copy. In one's own feeble sort,
it must be prettier than the original – or it is dead*' (Letter to
Charles Eliot Norton, 11 Apr. 1874, LN.313)

Ruskin spent two months in Germany in the summer of
1859, and visited the Dresden Gallery. Among its famous
collection of Old Masters he found the large painting
then thought to represent the family of the artist, Paolo
Veronese (*c.*1528–88), but now known as a *Madonna and
Child with the Cuccina Family of Venice*. The studies Ruskin
made from it were put to use in a long explanation of the
picture in volume v of *Modern Painters* (1860), one of the
prime examples of his deep and imaginative readings of
such compositions. In the previous summer, Ruskin had
spent six weeks in Turin, intensely studying Veronese's

masterpiece *Solomon and the Queen of Sheba*, which had
made a great impression on him. Having previously
considered Veronese 'thoughtless' in comparison with
the graver qualities of Tintoretto, Ruskin warmed to
what he called the 'gorgeousness of life' embodied in
such majestic canvases (7.xli).

Although he was always hesitant about figure
drawing, this strong but sensitive study of the boy on
the left of the family group demonstrates Ruskin's ability
to reproduce human form sensitively. In his commentary,
he describes the boy as 'about nine years old – a black-
eyed fellow, full of life ... He is a little shy about being
presented to the Madonna, and for the present has got
behind the pillar, blushing, but opening his black eyes
wide' (7.292).

154

John Ruskin

Oak Spray in Winter
c. 1860

Pencil, ink, watercolour
and bodycolour
on blue-grey paper
21.9 x 26.6

Inscribed 'By itself'

Engraved by R.P. Cuff
for *Modern Painters* v
(7, pl.59)

Presented to the Ruskin
School of Drawing before
1874

The Visitors of the
Ashmolean Museum,
Oxford

*'nor can the character of any tree be known at all until not only
its branches, but its minutest extremities, have been drawn in the
severest foreshortening'* (Modern Painters v, 1860, 7.96)

Tree twigs and leaves were commonly provided for copy
in Ruskin's classes at the Working Men's College from
1854, as he believed that an understanding of natural
laws and patterns of growth would follow from the act

of copying the living model – to the extent that one
poor fellow ('a joiner by trade') was defeated by a six-
foot lilac branch, as 'before he could get it quite right,
the buds came out and interrupted him' (7.92).

Ruskin set an example through his own immaculate
studies. Two drawings of the same oak spray were
engraved (by R.P. Cuff) as illustrations to the section
'On Leaf Beauty', which opens the final volume of
Modern Painters, published in 1860. One is viewed
from the side – 'the most uninteresting position in
which a bough can be drawn; but it shows the first
simple action of the law of resilience' (7.94) – and
the other (the present sheet), seen from end on, with
extreme foreshortening. Ruskin copes brilliantly with
the difficulty of drawing this to make a point about
the branch's natural curve to its right, while balancing
its main growth on the other side. He then draws
comparison with such a piece of foreshortening in
a detail from Turner's *Aske Hall* (private collection),
to demonstrate that 'in this final perfection of
bough-drawing, Turner stands wholly alone' (7.95).
A characteristic note of symbolic mystery is added to
the mundane by calling the two drawings *The Dryad's
Toil* and (this) *The Dryad's Waywardness*.

155

John Ruskin

*Fast sketch
of withered oak*
1879

Watercolour,
bodycolour and ink
14 x 18

Inscribed 'J Ruskin
Brantwood 1879'
Given to the Guild of
St George 1879

First exhibited
Fine Art Society 1879

The Ruskin Gallery,
Guild of St George
Collection

*'the conditions of form which a true sculptor looks for – not
outline'* (St George's Museum at Walkley, 1888, 30.175)

A further study in *Modern Painters* volume v (see cat.154)
of oak leaves touched by frost was given the title *The
Dryad's Crown*. He contrasted his own accurate obser-
vation of this 'noble leaf form' with instances in Dutch
painting of vague and stylised treatments, to make his
readers understand 'why, having never ceased to rate
the Dutch painters for their meanness or minuteness, I
yet accepted the leaf-painting of the Pre-Raphaelites
with reverence and hope' (7.54).

Ruskin particularly liked the sculptural qualities of
drying leaves, such as those of the horse-chestnut which
he used to illustrate a lecture on 'Tree Twigs' at the Royal
Institution on 19 April 1861 (a chaotic but compelling
performance, witnessed by Thomas Carlyle). He returned
to oak leaves in this and another watercolour, apparently
made as a demonstration of his technique to his friend
and neighbour at Coniston, Susan Beever (1806–93).
This example was then shown at the Fine Art Society's
1879 exhibition of drawings by Samuel Prout and
William Henry Hunt, to which Ruskin added some
works of his own.

156

John Ruskin

Moss and wild strawberry
c. 1870–2

Pencil and white chalk
on blue-grey paper
54 x 37.5

Given to the Ruskin
Drawing School after 1872

The Visitors of the
Ashmolean Museum,
Oxford

'I am essentially a painter and a leaf dissector ... I ought to be out among the budding banks and hedges, outlining sprays of hawthorn and clusters of primrose' (*Time and Tide*, 1867, 17.415, 376)

That nothing is known of the origin of this beautiful drawing is itself a demonstration of Ruskin's modesty as an artist. It carries only slight touches of white highlighting, relying for effect on the subtlest accumulation of pencil strokes overlaid on the fibrous texture of the paper. It thus matches Ruskin's comment, in an unpublished letter of 30 August 1855 to Elizabeth Salt, one of the many young women who sought his advice, that 'all good drawing consists merely in dirtying the paper delicately

... Nearly the beginning & end of everything is gradation. All form is expressed by subtility of this' (15.489).

Nicholas Penny has drawn attention to the architectural spirit of this composition, as if it could be a design of natural ornament for spandrel decoration, as well as to another study of wild strawberry among the Oxford drawings, a watercolour painted at Brantwood in June 1873. This Ruskin called 'The rose of Demeter in her cleft of rocks', choosing to associate particular plants with mythological figures as a reminder 'of what is most pure and true in the Greek thoughts of the Gods as givers of life to the earth ... I give the strawberry-blossom to Demeter because it is the prettiest type of the uncultured and motherly gifts of the Earth' (21.107, 111).

157

John Ruskin

*The Kapellbrücke,
Lucerne*
1861

Pencil, watercolour
and bodycolour
18.4 x 29.2

First exhibited
Royal Society of Painters
in Water Colours, Ruskin
Memorial Exhibition 1901

Given to the Ruskin
School of Drawing 1871

The Visitors of the
Ashmolean Museum,
Oxford

'the old bridge at Lucerne, with the pure, deep, and blue water of
the Reuss eddying down between its piers' (*Modern Painters* IV,
1856, 6.394)

Still pursuing the idea of a book on Swiss towns, Ruskin
painted this telling view of the ancient wooden bridge
in Lucerne, whose rafters were hung with paintings of
historical scenes, providing from the seventeenth century
a focus of national pride; sadly, the bridge was almost
completely destroyed by fire in 1998, although it has
since been rebuilt.

His diary records three days spent at work on this
picture in October 1861, with the terse comments, '17th.
Thurs[day]. Paint bit of Lucerne Bridge. Determine to
stay. 18th. Friday. Painting Bridge. Get on badly. 19th.
Sat[urday] Paint Bridge; get on well, but stopped by cold'
(D2.554).

Turner had made of the bridge an ethereal, skeletal
presence as the focal point of his watercolour *Lucerne
by Moonlight* (British Museum), which Ruskin regretted
not having purchased – it went to his great rival, Hugh
Munro of Novar – from among the group of six com-
pleted Swiss scenes of 1843 (see cat.111; Warrell 1995,
p.152). Ruskin took for his own composition an unusual
oblique view, concentrating on the old wooden planks
and fishing paraphernalia, which give a more effective
sense of human history than the more solid but less
picturesque watch-tower, or Wasserthurm, at the right.

158

John Ruskin

Old Houses on the Rhône Island, Geneva
1862–3

Pencil, watercolour and bodycolour on grey-green paper
38.2 x 46

First exhibited
Royal Society of Painters in Water Colours, Ruskin Memorial Exhibition 1901

Birmingham Museums and Art Gallery

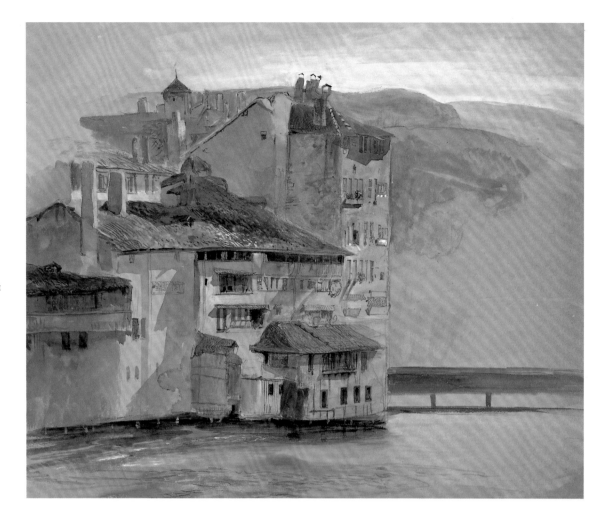

'this bird's-nest of a place … the centre of religious and social thought, and of physical beauty, to all living Europe' (Praeterita, 35.321)

Ruskin declared himself fortunate to have been 'born in London, near enough to Geneva for me to reach it easily' (35.320), but his pleasure in the place diminished over the years, as it changed from a characterful Swiss town to a modern European city. His four visits between 1833 and 1844 were remembered fondly in *Praeterita*, and when he was drawing there in 1862 and 1863 he still focused on the 'little town, composed of a cluster of water-mills, a street of penthouses, two wooden bridges, two dozen of stone houses on a little hill, and three or four perpendicular lanes up and down the hill' (35.321).

Most of a substantial group of pencil drawings, possibly made in the spirit of those in the sketchbooks recording Turner's visits in 1836 and 1841, with which Ruskin would have been familiar, concentrate on buildings overlooking the Rhône. The river's blue, translucent presence – 'its surface is nowhere, its ethereal self is everywhere' (35.326) – permeates this watercolour study of houses on the Rhône Island, which is Geneva's equivalent of the Île de la Cité in Paris. Ruskin's eye for architectural detail picks out the honest vernacular style of these old buildings with their broad eaves and solid beams: 'stately and ancient without decay, and rough, here in mid Geneva, more than in the hill solitudes' (35.328).

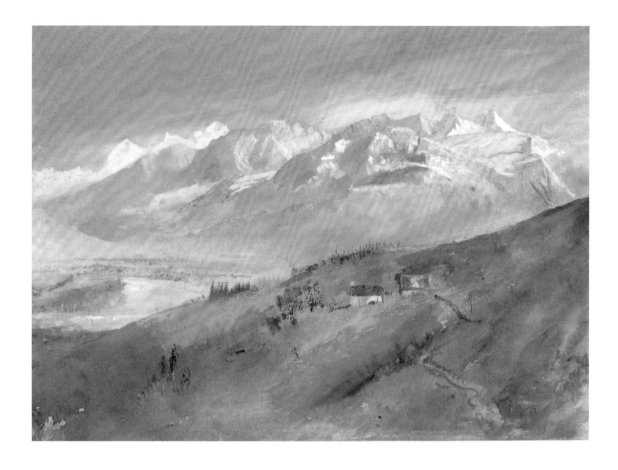

159

John Ruskin

*View from my
Window at Mornex*
c. 1862–3

Pencil, watercolour
and bodycolour
26 x 36.7

Inscribed 'View from my
Window – Mornex where
I stayed a year'

First exhibited
Royal Society of Painters
in Water Colours, Ruskin
Memorial Exhibition 1901

Abbot Hall Art Gallery,
Kendal

*'Mont du Reposoir, and Mont Blanc, and the aiguilles
of Chamouni, which I can see from my pillow'*
(Letter to Charles Eliot Norton, Dec. 1862, LN.74)

In the summer of 1862, Ruskin took Edward and
Georgiana Burne-Jones off to the Continent (see cat.123).
Parting company with them at Milan, and completing
his work of copying from frescoes by Bernadino Luini
(c. 1485–1532), Ruskin returned to the Alps and estab-
lished himself for the winter in the village of Mornex,
in the Haute Savoie a few miles south of Geneva, on the
road to Chamonix.

Dissatisfied with the first rooms he found for his
party – as well as Crawley and the guide Joseph Couttet,
George Allen and his wife soon joined them – Ruskin
rented a second 'cottage ornée', a little further down the
hill. This had a good garden, leading to the edge of a
ravine, and a better view, described in a letter to his
father, 'the lovely plain of La Roche, [extending] to the
foot of the Brezon, above which I have the Mont du
Reposoir, and then the Aiguille de Varens; then Mont
Blanc and the Grandes Jorasses and the Aiguille Verte;
and lastly the Môle on the left, where my own pear-trees
come into the panorama' (17.lvii).

He had expressed a half-hearted idea to settle in
Switzerland, or at least to buy (or even build) somewhere
to which he could escape whenever he chose, but the
winter weather at Mornex was a disappointment – no
storms or fine sky effects, only cold wind and snow –
and he was unable to endure 'the rabid howling, on
Sunday evenings, of the holiday-makers who came
out from Geneva to get drunk in the mountain village'
(17.356). His social conscience was also, by this time,
tending to get the better of his aesthetic appreciation
of the mountains, and he gave up the house at the end
of May, disturbed at 'the contrast of spring and its
blossoming with the torpor and misery of the people;
nothing can be more dreadful than their suffering, from
mere ignorance and lethargy, no one caring for them'
(17.lxxii).

Ruskin re-visited the house in September 1882,
to find it turned into an hotel (Richard Wagner had
stayed there for a few weeks). Local memories of him
persisted well into the next century, the writer Augustin
Filon reporting in 1904 stories of an eccentric English-
man pottering about the garden, installing a bell and
paving the courtyard (although, as E.T. Cook noted,
'it was Mr Allen who did most of the paving' (17.lix)).

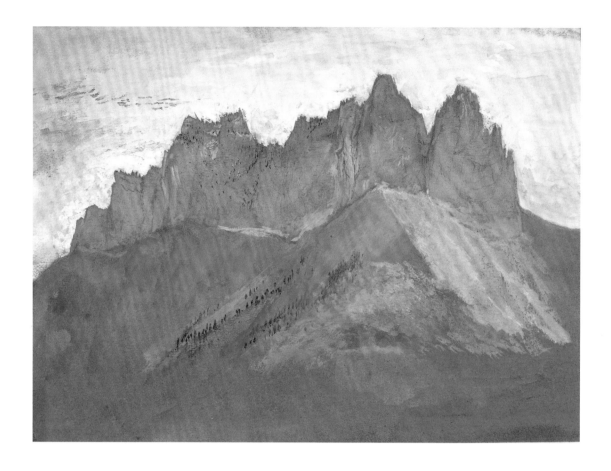

160

John Ruskin

*Rochers de Lanfon,
Lake Annecy*
1863

Pencil, watercolour
and bodycolour
13.5 x 18.6

First exhibited
Coniston Institute, Ruskin
Memorial Exhibition 1900

Abbot Hall Art Gallery,
Kendal

'I have had a good day, to-day; feeling strong in drawing and enjoying myself generally' (Letter to his father, Annecy, 10 Apr. 1863, 17.lxxi)

Towards the end of his residence in Mornex over the winter of 1862–3, Ruskin went in April for a few weeks to Annecy, in the heart of the Haute Savoie, staying latterly in lodgings in the old Benedictine Abbey at Talloires, on the east side of Lake Annecy. The site is dominated by the Rochers de Lanfon, a group of 'aiguilles' not up to Chamonix standard, but still highly impressive.

Putting aside work on the essays on political economy being published in *Fraser's Magazine* (and later re-issued as *Munera Pulveris*), Ruskin took up work on a lecture for the Royal Institution (delivered on 5 June),

on 'Forms of the Stratified Alps of Savoy', the first of a number of geological papers that would culminate in *Deucalion* (1875–83). The present watercolour, possibly worked up from a sketchbook study conceived as no more than an *aide-memoire*, is not related to any of the drawings or diagrams used in that lecture, but does reflect Ruskin's description of the Savoy Alps as 'true sculptured edifices' (26.12). In more informal works such as this and the view from Mornex (cat.159), he adopts a style quite different from that of the passionate earlier drawings of the Alps at Chamonix. There is hardly any pencil under-drawing, and most of the effect – made only for his immediate purpose, without thought of reproduction or public inspection – is achieved by swift washes of a heavily loaded brush, enlivened by quick, almost schematic penwork.

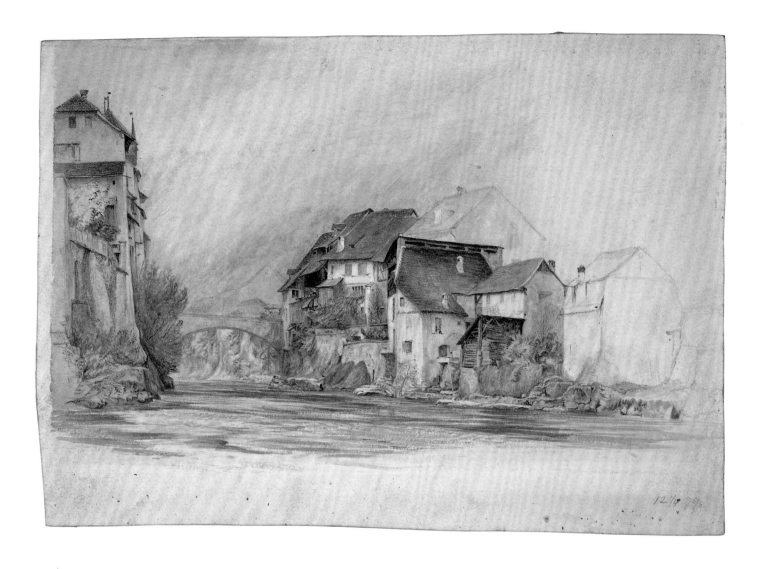

161

John Ruskin

Brugg
1863

Pencil, watercolour
and bodycolour
22.3 x 32.4

Hunterian Art Gallery,
University of Glasgow

'Every day to Brugg. Monday did the tower, Tuesday the distance, Wednesday the houses, Thursday worked on all, and began the second sketch in pencil. So two days on second sketch' (Diary, 20–4 Oct. 1863, D2.583).

Enthusiasm for the projected work on Swiss history flagged as Ruskin tired of life at Mornex in the early part of 1863. His last concerted effort came at the end of that year, when he visited Lauffenburg, Schaffhausen and Baden (again, of course, following Turner). Here he produced a remarkable collage of five sheets depicting the town from an aerial perspective akin to that in the Fribourg drawings (private collection, c/o Agnew's; see cats.146, 147). This was to be his last attempt for many years at work on any considerable scale, and it is perhaps a reflection of his uncertainty and frustration as an artist at this period that it should be both fragmented and unfinished.

From Baden, Ruskin travelled often – usually by train, but on at least one occasion on foot – to nearby Brugg, another old walled town, with a ruined Habsburg castle and a fine view of the Alps. His diary, quoted above, gives a succinct account of what he managed to draw in less than a week: this sheet is a good example of what he could accomplish in two days' work. On the 25th, a Sunday, he made only 'small sketches', and also wrote to his father, explaining that a 'piece of modern barbarism' had determined the oblique angle chosen for this view: 'I never saw anything so lovely as the green Aar between the rocks at Brugg … [but] I can't draw the houses on either side – they are merely a succession of privies' (quoted in Hayman 1990, p.59).

162

John Ruskin

*The Walls
of Lucerne*
c. 1866

Pencil, watercolour
and bodycolour on
grey-green paper
34 x 48

Ruskin Foundation
(Ruskin Library,
University of Lancaster)

*'after a time the walls and pinnacles of the Alps themselves are
hardly more dear to the observant and thoughtful traveller than
the noble towers and ramparts of Friburg and Basel, Schaffhausen
and Lucerne'* (manuscript draft for *The Two Paths*, 1857–8,
16.260)

One of Ruskin's most famous watercolours, *The Walls of
Lucerne* typifies what is most appealing to modern eyes
about his best work, which combines small patches of
precise detail and high colour with bold, loose washes
of background tints and whole areas of paper left
untouched or carrying only the beginnings of form.
This treatment of subjects, which becomes characteristic
in his work of the 1860s, invoked the well-known
comment by Kenneth Clark, on the occasion of the
Arts Council's 1960 exhibition of Ruskin drawings:
'His eye focuses on one or two points with such intensity
that it seems to be exhausted before it can comprehend
the whole, and after a frenzy of emotion ends abruptly,
like a piece of oriental music. Sometimes the points
of excitement are disconnected from one another with
dream-like inconsequence, as in the beautiful drawing
of the walls of Lucerne.'

In fact, this is a faithful view of the wall linking
the Dachliturm, in the centre, with the Allenwindenturm
beyond, and may have been that from the Schweizerhof,
Ruskin's favoured hotel. Although not related to any
of the eight thumbnail sketches of Lucerne subjects
given in a letter of 6 November 1861 to Mrs Simon,
it may have been conceived or begun during his stay
in the city between 16 October and 27 December.
Returning in the summer of 1866 for little more than
a week, Ruskin recorded in his diary for 18 June having
'sketched first bit of great view' (D2.591): this may refer
to the present watercolour, in which there seems to be
an indication of flowers among the foliage.

163

John Ruskin

*The Château of
Neuchatel at dusk,
with Jura mountains
beyond*
1866

Pencil and watercolour
13.3 x 21

Private Collection

'*O redly broke the dawn, and Jura smiled*' (*A Tour through
France*', Poems, 1833–4, 2.409)

This is a sheet from a sketchbook which Ruskin kept on
his Swiss tour of 1866, undertaken in the company of his
cousin Joan Severn, Sir Walter and Lady Trevelyan, and
their niece Constance Hilliard. The drawing is unusually
poignant, reflecting Ruskin's mood: 'it makes me entirely
melancholy,' he wrote to his mother, 'to be at places my
father delighted in so much' (18.xxxviii). Arriving with
the two younger women at Neuchatel on 7 May, Ruskin
spent time sketching while waiting for the others to catch
up, Pauline, Lady Trevelyan being in poor health. Having
arrived at Neuchatel on 12 May, Lady Trevelyan died
suddenly the following day. In memory of his good
friend, Ruskin made a pen and ink drawing of her grave
in the cemetery overlooking the lake (Ruskin Foundation),
which he later worked up in watercolour for Sir Walter.
This view of the Château of Neuchatel is also from the
direction of the cemetery, but from further down by
the lake.

164

John Ruskin

*Afternoon in Spring,
with South Wind,
at Neuchatel*
1866

Pencil, ink, watercolour
and bodycolour
17 x 25

Given to the Ruskin
Drawing School,
before 1874

The Visitors of the
Ashmolean Museum,
Oxford

*'the green of a Swiss lake is pale in the clear waves on the beach,
but intense as an emerald in the sunstreak six miles from shore'*
(*The Elements of Drawing*, 1857, 15.158–9)

This bright study may also have been made soon after
Ruskin's arrival in Neuchatel on 7 May 1866, although
the sheet is larger than those of the now dismembered
sketchbook (cat.163). Possibly the unusual degree of
completeness – shared with a similar subject, *Morning
in Spring, with North-east Wind, at Vevay*, also part of the
Oxford gift – is a result of further colour being added
in the evening after the day's sketching.

Having been protected from light in cabinets and
solander boxes at Oxford, it is in exceptional condition,
and reveals Ruskin in his more informal mode, using
both watercolour and bodycolour in a most painterly
way, the latter to delineate the crests of waves on the
lake. As in most of the surviving Neuchatel studies,
Ruskin aims to capture atmospheric effect, but he
cannot resist the need accurately to define the distant
pines in the middle ground by tiny touches of pen
and ink.

165

John Ruskin

Abbeville: Church of St Wulfran from the river
1868

Pencil, watercolour and bodycolour
34.3 x 50.2

First exhibited
Royal Institution 1869

Ruskin Foundation
(Ruskin Library,
University of Lancaster)

'My most intense happinesses have of course been among the mountains. But for cheerful, unalloyed, unwearying pleasure, the getting in sight of Abbeville on a fine summer afternoon, jumping out in the courtyard of the Hotel de l'Europe, and rushing down the street to see St Wulfran again before the sun was off the towers, are things to cherish the past for, – to the end' (Praeterita, 35.157)

Abbeville had been one of Ruskin's favourite haunts since his first visit on the continental tour of 1835. He found the town an 'entrance … into immediately healthy labour and joy', a place almost entirely unspoiled by the modern world, each of its fine old buildings 'keeping its place, and order, and recognized function, unfailing, un-enlarging, for centuries' (35.157).

He particularly admired the late Gothic style in evidence at the church of St Wulfran: in 1848 he had visited Salisbury shortly before travelling to Abbeville, and was struck by the heady contrast between the severity of Early English and the '*luscious* richness' of the porch of St Wulfran, 'so full, so fantastic, – so exquisitely picturesque that I seem never to have seen it before' (8.188). This kind of architectural memory remained clear in Ruskin's mind, and he welcomed the opportunity to give Abbeville proper study, in preparation for a lecture at the Royal Institution on 29 January 1869, 'The Flamboyant Architecture of the Valley of the Somme'. With a short break in Paris, he worked in Abbeville from 25 August to 21 October 1868, drawing nearly every day, but also receiving visits from friends, including Charles Eliot Norton. On 9 September he was able to tell his mother, 'I think I shall be able to write a little Stones of Abbeville when I have done, as I shall know every remnant of interest in the town' (19.xli).

The most finished of several large drawings under-taken during the campaign, this was one of a number exhibited by Ruskin on the evening of his lecture; curiously, although a catalogue was printed, the lecture itself was not published during his lifetime.

166

John Ruskin

Dead Pheasant
1867

Pencil, watercolour
and bodycolour
25.7 x 52

First exhibited
Royal Society of Painters
in Water Colours, Ruskin
Memorial Exhibition 1901

Ruskin Foundation
(Ruskin Library,
University of Lancaster)

*'I once painted with the utmost joy a complete drawing of
a pheasant – complete with all its patterns, and the markings
of every feather, in all its particulars and details accurate'*
(In conversation with M.H. Spielmann 1884, 34.670)

Ruskin owned two watercolours by Turner of a dead
pheasant, and this is an exercise in the same manner as
the one given to Oxford in 1875, although not an exact
copy (the other, he sold in 1869 (Whitworth Art Gallery,
University of Manchester)); he also owned a study of a
dead grouse (Indianapolis Museum of Art). (For all of
these see Lyles 1988.) Although he termed the Oxford
drawing an example of 'elementary zoology', he also
recognised its beauty as a work of art and the evidence
it presented of a great artist of the imagination still
prepared to observe nature in detail.

At the beginning of 1867 Ruskin was occupied
with bird drawings, including two of a pheasant: this
is presumably the larger one, painted between 16 and
19 January. Since this predates his preparation of natural
history drawings for teaching purposes at Oxford, they
can only be regarded as having been undertaken chiefly
in homage to Turner, although his long-standing interest
in ornithology bore fruit in the book on birds, *Love's
Meinie*, published in parts between 1873 and 1881.

167

John Ruskin

Plumage of Partridge
*c.*1867

Pencil, ink, watercolour
and bodycolour
27.8 x 39.7

Given to the Ruskin
School of Drawing 1872

The Visitors of the
Ashmolean Museum,
Oxford

*'…began partridge. Yesterday worked hard and to-day harder,
and finished it'* (Diary, 21 Jan. 1867, D2.609)

One of the finest of Ruskin's small bird studies, this
is even more elaborate than the *Dead Pheasant* (cat.166)
in its handling and detail. Its immaculate condition
reveals how Ruskin captured the brightness of the tufts
of feathers, as well as his use, in highlighting the wings,
of tiny touches of local colour added to opaque pigment
while still wet – a technique he must have learnt from
examining the work of William Henry Hunt (see cat.35).

The image recalls Hunt's watercolour of a dead bird,
commissioned by Ruskin and exhibited at the Old Water
Colour Society in 1861, and subsequently known as
John Ruskin's Dead Chick (Walker Art Gallery, Liverpool).
Ruskin had intended this to be the first of a series
distributed to provincial Schools of Art for copying
purposes, but ironically he was disappointed with Hunt's
rendering of the feathers.

168

John Ruskin

Kingfisher
c. 1870–1

Pencil, ink, watercolour
and bodycolour
25.8 x 21.8

Given to the Ruskin
School of Drawing 1872

The Visitors of the
Ashmolean Museum,
Oxford

'I have made a great mistake. I have wasted my life with miner-
alogy, which has led to nothing. Had I devoted myself to birds,
their life and plumage, I might have produced something worth
doing' (Conversation with M.H. Spielmann, 1884, 34.670)

Described by Ruskin as having 'dominant reference to
colour', this is part of a group of studies of kingfishers
placed in the Rudimentary Series of his Oxford gift,
under 'Exercises in colour with shade, or patterns of
plumage and scale' (21.227). In view of the practicality
of drawing such a quick and elusive bird, which even
in Ruskin's day was not often seen, this exquisite study
was made from a stuffed specimen; it nonetheless
captures the bird's natural brilliance and liveliness. Ruskin
also made use in his bird studies of the remarkable large-
scale models of feathers made by his 'ingenious friend'
W. E. Dawes, Naturalist, Furrier and Plumassier, of 72
Denmark Hill (several of these, including one from a

humming-bird, are in the Ruskin Museum, Coniston).

Ruskin liked birds, both in nature and in art. He
once reared an injured blackbird chick at Brantwood,
and confided to Charles Eliot Norton that 'one can't
be angry when one looks at a Penguin' (LN.59). In a
typically unexpected aside during a discussion of a
painting in the Scuola di San Rocco, Venice, he thought
that Tintoretto 'must somewhere or another, the day
before, have seen a kingfisher; for this picture seems
entirely painted for the sake of the glorious downy
wings of the angel, – white clouded with blue as the
bird's head and wings are with green' (11.425).

He was also an admirer of Turner's *Book of Birds*
(Leeds City Art Gallery). Edith Fawkes recalled that
on his last visit to Farnley Hall in 1884, Ruskin
examined the kingfisher drawing 'for a long time with
a magnifying glass, and he said he could not find words
to describe its exquisite beauty' (21.671).

169

John Ruskin

*Eagle's head
(common Golden),
from life
(two studies)*
1870

Pencil, watercolour
and bodycolour
8.8 x 14.9

Pencil, ink, watercolour
and bodycolour
16.3 x 19.5

Given to the Ruskin
School of Drawing 1872

The Visitors of the
Ashmolean Museum,
Oxford

*'Somebody once said to Ruskin that he had the eye of an eagle.
"I would be sorry," he replied, "if my eyes were no better than
an eagle's. Doth the eagle know what is in the pit? I do."'*
(*Daily News*, 17 Feb. 1900, 34.722)

Ruskin's Slade lectures at Oxford in the Lent Term of
1872, 'The Relation of Natural Science to Art', were
published later in the year as *The Eagle's Nest*. In the
eighth lecture, he argued that observation from life
revealed far more than could be obtained from anatom-
ical theory, which 'will not help us to draw the true
appearance of things' (22.229).

'To keep the sunshine above from teasing it,' Ruskin
continued, ' the [eagle's] eye is put under a triangular
penthouse, which is precisely the most characteristic
thing in the bird's whole aspect … he is distinct from
other birds in having with his own eagle's eye, a dog's
lips, or very nearly such; an entirely fleshy and ringent
mouth, bluish pink, with a perpetual grin upon it.' All
this he had discovered by drawing an eagle himself, in
the London Zoological Gardens on 9 and 11 September
1870. The second of these studies he declared to be
'a failure in the feathers but useful' (21.136).

170

John Ruskin

Sketch of Head of Living Lion
1870

Pencil on buff paper
16.2 x 19.7

Given to the Ruskin
School of Drawing 1871

Lion's Profile, from life
1870

Pencil, ink, watercolour,
and bodycolour
on buff paper
16.5 x 16.1

Given to the Ruskin
School of Drawing 1872

The Visitors of the
Ashmolean Museum,
Oxford

'the majesty of the lion's eye is owing not to its ferocity but to its seriousness and seeming intellect' (*Modern Painters* II, 1846, 4.160)

Now mounted together, these studies were placed in quite different contexts when originally presented to the Ruskin School of Drawing. The more careful watercolour was at first paired with an engraving of a *Lion and Lioness* by J.F. Lewis, and was part of a characteristically idiosyncratic sequence in the Educational Series, including his studies of a sculpted lioness and cubs from the pulpit of the Duomo at Siena; further leonine profiles from Egyptian and Greek sculpture; and an impression of

Dürer's *St Jerome and his Lion*. The upper study, placed in the Rudimentary Series, he was clearly quite proud of: 'A really good sketch of my own which may serve to show that I could have done something if I had not had books to write. It is to be copied by all advanced students as an exercise in fast pencil drawing' (21.179).

Ruskin was a Life Fellow of the Zoological Society, and often visited the Gardens; a diary entry for 30 August 1870 records his drawing a lion there. He was not always confident of getting animals right, however, telling Mrs Russell Barrington that 'I not only can't draw anything moving, but anything that *can* move, for it fusses me to think that it may begin to do it!' (37.715).

171

John Ruskin

Velvet Crab
c. 1870–1

Pencil, watercolour
and bodycolour,
on grey-blue paper
24.5 x 31.4

Given to the Ruskin
School of Drawing *c.* 1871

The Visitors of the
Ashmolean Museum,
Oxford

'*the great zodiacal crustacean*' (*The Art of England*, 1884, 33.337)

Some of Ruskin's natural history drawings are dramatically beautiful, and rise above their intended purpose – this example was placed in the Educational Series in the 'Elementary Zoology' section – to become individual works of art not far short of Dürer's nature studies. Sometimes criticised for such obsessive attention to detail – Millais said in 1859 that 'his eye is only fit to judge the portraits of insects', and the French painter Rosa Bonheur accused him of seeing nature 'with tiny eyes, just like a bird' (14.173) – Ruskin conveyed in work such as this his fundamental belief in art as mimetic truth.

As well as the iridescent colours of the shell, a material which Ruskin always enjoyed painting, he has relished the challenge of imitating the extraordinary range of colours in the lower legs, and has not even overlooked such details as the tiny shadow under the tip of the bottom left claw. The background is given subtle complementary washes, with bodycolour loaded in the brush, as if physically evoking the sand of the creature's natural habitat. Ruskin has captured the very essence of the crab, with a sympathy of the kind he expressed in a letter of February 1886 to the *Pall Mall Gazette*, bemoaning the dearth of 'intelligible books on natural history. I chanced at breakfast the other day, to wish to know something of the biography of a shrimp, the rather that I was under the impression of having seen jumping shrimps on a sandy shore express great satisfaction in their life' (34.587).

172

John Ruskin

*Study of Carpaccio's
'St George and
the Dragon'*
1870/2

Pencil, sepia, ink
and bodycolour,
on two joined sheets
18.1 x 46.1

Given to the Guild
of St George 1877

The Ruskin Gallery, Guild
of St George Collection

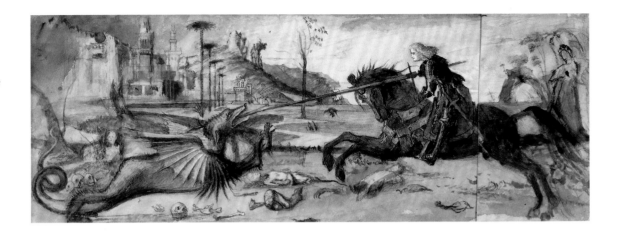

173

John Ruskin

*Upper part of the
figure of St George*
c. 1872

Pencil, watercolour
and bodycolour
33.8 x 48.5

Given to the Guild
of St George 1877

Sheffield Museums
and Galleries Trust
(Guild of St George
Collection)

The Ruskin Gallery, Guild
of St George Collection

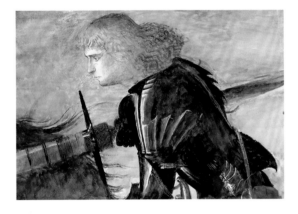

'This Carpaccio is a new world to me' (Letter to Edward
Burne-Jones, Venice, 13 May 1869, 4.356)

Ruskin came late to an appreciation of Carpaccio
(c. 1450/60–1525/6), a debt to Burne-Jones which he
gratefully acknowledged, but the Venetian painter's
work was to hold an important place in his later life and
thought. While the *St Ursula* cycle of paintings in the
Accademia become symbolically associated in Ruskin's
mind with his relationship with Rose La Touche, the
paintings in the Scuola di San Giorgio degli Schiavoni
inspired him more creatively. In the depictions of the life
of St George, Ruskin found an embodiment of chivalry

and self-sacrifice, which led to the nomination of his
idealistic social and artistic community as the Guild
of St George.

Ruskin spent several days' study in the Scuola during
May 1870 and June 1872 (a diary entry for 26 June reads
'Up early for Carpaccio'). The lively monochrome copy
is probably of 1870, Ruskin referring to it as only a 'rough
sepia sketch, showing the whole subject; the Dragon
being made to serve as the type of lustful pleasure,
from which the soul (the Princess figure – here indicated
merely by a few lines) is delivered by knightly and
Christian purity and courage' (notes supplied for Howard
Swan, *The Preliminary Catalogue of the St George's Museum*,
Walkley, 1888, p.36). 'St. George and the Dragon –
combatant both, to the best of their powers;' Ruskin
later wrote in *St Mark's Rest*, 'perfect each in their natures
of dragon and knight. No dragon that I know of, pictured
among mortal worms; no knight I know of, pictured in
immortal chivalry, so perfect, each in his kind, as these
two' (34.340). A large copy in watercolour (Birmingham
Museums and Art Gallery) was one of Ruskin's first
commissions from Charles Fairfax Murray.

The large coloured detail of the Saint was only a
beginning, according to Ruskin, made 'for my own
satisfaction, also as well as I could in the year 1872';
he hoped 'to get him some day better done, for an
example to Sheffield in iron-armour' (34.341).

174

John Ruskin
after Botticelli
(1444/5–1510)

Zipporah
1874

Pencil, watercolour
and bodycolour
143 x 54

First exhibited
Royal Pavilion Gallery,
Brighton, Apr. 1876

Ruskin Foundation
(Ruskin Library,
University of Lancaster)

'When I can paint a life size figure to my own tolerable satisfaction in 14 days, I am quite sure I ought to go on doing them' (Letter to Joan Severn, Whit Sunday 1874, Ruskin Library)

Apart from his version of the *Adoration of the Magi* by Tintoretto (cat.81), this is the largest copy Ruskin made from an Old Master painting. The figure appears in one of the paintings by Botticelli in the Sistine Chapel at Rome, illustrating *The Trials of Moses*, and represents Zipporah, daughter of Jethro, priest of Midian, where Moses had fled after slaying the Egyptian; she later became his wife.

Ruskin knew little of Botticelli's work until after his re-discovery by Algernon Swinburne and Walter Pater in the late 1860s, but introduced references into several of his early Slade lectures, especially those of 1872 on engraving later published as *Ariadne Florentina*, where he is described as 'the greatest Florentine master' (22.305). Among the chief purposes of Ruskin's trip to Italy in the summer of 1874 were to study Giotto at Assisi and Botticelli in Rome. Although he had no love of the architecture, Ruskin had enjoyed seeing again the paintings in the Sistine Chapel two years before, and now set himself the task of making at least one substantial watercolour, having also commissioned Fairfax Murray to make copies of the Botticellis. As well as capturing Gershom's dog, a lively detail which had typically attracted his attention, he began this copy on 6 May, and worked on it for the rest of the month, sending regular progress reports in letters to his cousin Joan Severn.

He was pleased enough with the result to send the picture to an exhibition in Brighton in 1876, adding explanatory notes in which he discerned a correspondence with the divine Athena of classical mythology: Botticelli had retained 'every essential character of the Etrurian Pallas … yet changing the attributes of the goddess into such as become a shepherd maiden' (23.478–9). Ruskin was also taken with Zipporah's entirely human animation: 'Anything like the way she has stuck those olive leaves over her ear isn't in living coquetry' (letter to Joan Severn, 18 Aug. 1874, Ruskin Library). The figure was to acquire an additional significance as an inspiration for the character of Odette in *A la recherche du temps perdu* by Marcel Proust, a student and translator of Ruskin.

175

John Ruskin

*A Vineyard Walk,
Lucca*
1874

Pencil, watercolour
and bodycolour
33.5 x 42.3

First exhibited
Royal Society of Painters
in Water Colours, Ruskin
Memorial Exhibition 1901

Ruskin Foundation
(Ruskin Library,
University of Lancaster)

'up to village with old masonry in tower'
(Diary, Lucca, 18 Aug. 1874, D3.805)

What Ruskin called 'a furious six months work' (LN.343)
in 1874 involved daily study in Assisi, Rome and Florence,
where a multiplicity of new projects left him excited
but exhausted. Short stays in Lucca at the beginning of
August and end of September provided some respite, but
even there he renewed his attempt to capture in drawings
the elusive essence of Jacopo della Quercia's effigy of
Ilaria del Carretto, which had intrigued him since his
first visit in 1845.

Like all his favourite towns, Lucca was succumbing
to architectural change, but walks in the nearby country-
side cheered him. The diary entry for 17 August is typical:
'Worked hard, a little vainly, on both Ilaria and the porch.
Examined Niccolo's [Pisano's] sculpture on ladder; got bit

of brecciate vein. Then up on promontory among chest-
nuts. Solemn purple sunset, slanting rays of gold, on
Carrara hills. Talk with old farmer' (D3.805).

The precise subject of this well-preserved watercolour
has been only recently identified, as the campanile of
a Romanesque church in the small village of Pozzuolo,
a little to the south-west above Lucca. In exhibitions
after his death, it was given the title *A vineyard walk:
lower stone-work of tower, 12th cent.*, presumably deriving
from a contemporary inscription now lost: it may
therefore correspond with the 'old masonry in tower',
which he saw on 18 August, or the 'country church'
he drew on 24 September (D3.812). Ruskin very success-
fully turns the work of at most an hour or two into a
memorable image, by combining just enough detail with
vigorous brushwork and the selection of vivid colours
to evoke a timeless summer's day in Tuscany.

176

John Ruskin

View on the upper reach of the Grand Canal, Venice, with the Palazzi Corner and Pesaro
1876

Pencil and bodycolour
36.2 x 52.1

?First exhibited
Fine Art Society 1878

Ruskin Foundation
(Ruskin Library,
University of Lancaster)

'I shall set to work to make a few pencil outline drawings from general scenes, such as are left, to illustrate the new edition of Stones of Venice' (Letter to Charles Eliot Norton, 2 Aug. 1876, LN.384)

Writing only a few months after Rose La Touche's death in May 1875, Ruskin described himself as 'A thing of the past … like a wrecked sailor, picking up pieces of his ship on the beach … People gone – and things. My Father & Mother and Rosie – and Venice – and Rouen. All gone – but I can gather bits up, of the places for other people' (letter to Charles Eliot Norton, 31 Oct. 1875, LN.368). His decision to return to Venice for the winter of 1876–7 was partly motivated by a plan to revise *The Stones of Venice*, 'gathering bits up' again of his beloved city. As he also told Norton, his intention was to make 'pencil outline drawings from general scenes', to round out the original text and thereby perhaps make it more appealing to the general reader. He also gave a sense of personal retrieval of happier past experience – or of simple nostalgia – by adding: 'I will make new drawings giving some notion of my old memories of the place, in Turner's time' (LN.384).

There is certainly enough detail overlaying the hatched and shaded under-drawing for an engraver to work up the row of palaces on the left – focusing on the two bulky façades of the Palazzo Corner and Palazzo Pesaro – but Ruskin seems to have abandoned his attempt at the oblique angle of the Ca d'Oro, on the right, his pencil wandering into expressive, sketchy outline. This reflects the frequent distraction and depression he suffered during his stay. The drawing is probably identifiable as one exhibited at the Fine Art Society in 1878, under the title *View of the Upper Reach of the Grand Canal, looking north, and – (given up in despair).*

177

John Ruskin

Funeral Gondola, Venice
c. 1876–7

Pencil on
grey-green paper
24 x 34

Ruskin Foundation
(Ruskin Library,
University of Lancaster)

'"These must be dangerous waters indeed," he muttered, "where people go to sea in coffins"' (*Chronicles of St Bernard*, 1835–6, 1.539)

Occasionally, Ruskin would draw something simply because it was striking or unusual – a vase, a necklace, a coiled snake. Here, it is one of the funeral gondolas (in modern times, replaced by motor boats) which act as *mementi mori* in the city of pleasure, and remind resident and visitor alike of the last journey to the cemetery island of San Michele. In the background is the tower of the Dogana di Mare, which stands at the junction of the Grand Canal and the Giudecca. Ruskin was much more responsive to atmosphere in later years, and his diary entry for New Year's Day 1877 opens with this word-picture of Venice: 'Soft dawn rising through mist. The Salute Dome beautiful in visionary outline, dark against light, but dark blue grey' (D3.927).

The loose, expressive – and oddly Whistlerian – style of drawing suggests that it dates from his last working visit of 1876–7. The unoccupied boat seems to offer a symbol of Ruskin's darker moods, and to foreshadow the final poignant words in his last diary of 1888: 'Sunday. 30th September. – but I don't know what is going to become of me. Venice. Wednesday 10th October. And less still here … ' (D3.1150)

178

John Ruskin

*Rouen: the Seine
and its Islands from
Canteleu*
1880

Watercolour, bodycolour
and ink wash
29.4 x 41.6

Ruskin Foundation
(Ruskin Library,
University of Lancaster)

'*the whole of Northern France … dull as it may seem to most
travellers, is to me a perpetual Paradise*' (*Modern Painters* IV,
1856, 6.419)

There is no evidence of any pencil under-drawing in
this late watercolour. Its effects are achieved entirely by
loose washes – some of them, as in the sky, mixed with
opaque pigment – and quick strokes with the rapidly
drying brush. A little black ink is employed for some
final touches, just as Ruskin had done in the much
more elaborate Swiss watercolours of the late 1850s
(see cat.149).

It would be tempting to attribute to the company
of the young painter Hercules Brabazon Brabazon

(1821–1906) a greater freedom of handling – E.T. Cook
found 'an impressionist "breadth" not always character-
istic of Ruskin's work' (33.xxiv) in some of the 1880
sketches – but this watercolour must have been painted
on the first leg of that summer's tour of northern France,
Brabazon and Arthur Severn joining Ruskin only for the
trip to Amiens in October. Rather, this is a style of quick,
informal recording which Ruskin had been adopting
for many years. His visit to Rouen in 1880 may have
contributed to the introductory essay he wrote for an
edition of *Turner's Rivers of France* six years later (Warrell
1997, p.247). He owned two watercolours by Turner of
Rouen, one of which was taken from the popular
viewpoint at the top of the incline in this drawing.

179

John Ruskin

Spiral relief from the north transept door, Rouen Cathedral
1882

Pencil, watercolour and bodycolour
21.3 X 17.2

Inscribed 'Feb 1882'

Ruskin Foundation (Ruskin Library, University of Lancaster)

'in late [Gothic] work you have no sculpture – but are to enjoy the moulding' ('The Flamboyant Architecture of the Valley of the Somme', 1869, 19.258)

Of all aspects of medieval architecture, Ruskin delighted most in what he termed the Gothic workman's 'peculiar fondness for the forms of Vegetation' (10.235). This he found both in Venice and in Northern Gothic, and even noted in Roman buildings such as the Arch at Orange, which had a 'writhing roll of flowing leafage' (9.299) similar to that on the portals of Rouen Cathedral. The north transept doorway at Rouen he regarded, along with the south door of the Duomo at Florence, as one of 'the two most beautiful pieces of Gothic work in the world … both in the thirteenth century covered with sculpture as closely as a fretted morning sky with sands of cloud' (19.262).

This study must derive from his visit in September 1880, when Ruskin was pleased to find his 'old favourite porch and pinnacle bit at Rouen, all safe' (D3.986). So eager was he to see this piece of Gothic workmanship preserved for the use of future students that he had this same part of the relief – on the inner moulding of the door jamb – cast in plaster for the Guild of St George Museum at Sheffield, and commissioned Arthur Burgess to photograph the whole doorway. He may have used these aids in the making of his own homage to the anonymous Gothic craftsman; both this and another incomplete study of the carving (Ruskin Library) bear the inscriptions 'Feb 1882' and 'Herne Hill'.

Furniture

As a keen and well-funded collector of books, manu-
scripts, pictures, missals, coins and minerals, Ruskin took
great care over the design of furniture suitable for his
collections' conservation and display. He was also
generous with his acquisitions and gave many of them
away to friends or educational institutions. These are four
examples of specially designed furniture from three of
the institutions he supported.

Most of Ruskin's furniture, for private and public
use, was made for him by the firm of cabinet-makers and
upholsterers William and Edward Snell of 27 Albemarle
Street. In 1818 they furnished the first Ruskin home in
Hunter Street, London WC1, and they continued to serve
the family throughout John James Ruskin's life. They built
the large bookcase with special sliding compartments to
hold pictures, and the cabinets for geological specimens
that Ruskin had as an undergraduate at Oxford, now in
the Ashmolean Museum (Hewison 1996, pp.126–8).
They were also called in when Ruskin bought and began
to enlarge Brantwood, his house overlooking Coniston
Water, in 1871. The frame-makers for his pictures were
Foord and Dickinson of Wardour Street, who were also
regularly employed as packers and shippers.

180

Turner Cabinet
1861

Ruskin Foundation
(Ruskin Library,
University of Lancaster)

Mahogany, 77 (height) x 63.4 (base width) x 51 (base depth). The top of the cabinet is divided and hinged length-wise. When the top is raised and supported by its brass ratchet the projecting front flange is raised to clear four free-standing boxes, also in mahogany. Each box has its own door secured by a brass hook fastener and is numbered with an ivory disc, numbered one to four. When opened, these doors reveal five oak frames, 43.2 x 51.5 (external), in each box. The frames are grooved at the top and bottom to fit into runners in the boxes. Each frame has an ivory oblong number label on its edge, corresponding to a similar label on the box. The frames were originally fitted with leather tabs to facilitate removal. The boxes may be withdrawn from the cabinet and each has a stout leather-covered metal carrying handle on top.

In 1861 Ruskin decided to give the University Galleries in Oxford (now the Ashmolean Museum) part of his personal collection of Turner drawings. He told his friend Henry Acland, 'I don't care to keep 1500 pounds worth of him in my table drawers, while I go abroad – or work on political matters' (Herrmann 1968, p.31). The reference to 'political matters' indicates his change of direction following the completion of *Modern Painters* in 1860. In addition to 48 Turner drawings and twelve pages from a sketch-book, worth in Ruskin's estimation £2000, Ruskin provided two specially designed boxes for their protection, of which this is one.

The prototype for all the special cabinets made for Ruskin is a double-sided library cupboard, with four drawers above and cupboards below with slots to hold picture frames, made for his study in his parents' third London home in Denmark Hill, and later moved to his study in Brantwood, where it can still be seen. In 1857, as part of his work in cataloguing and conserving the watercolours in the National Gallery from the Turner Bequest, he designed and had built a series of special frames and cabinets to hold his selection of one hundred key works (Warrell 1995, p.25). Sadly, these earlier Turner cabinets no longer exist.

181

Reference Series Cabinet
1871

Ruskin Foundation
(Ruskin Library,
University of Lancaster)

Mahogany, 99 (height) x 84 (base width) x 63.5 (base depth), with ivory number labels (right hand missing), Gothic brass handles and key holes. The front doors are centrally divided; inside are ivory-numbered slots for 25 picture frames, 76.9 x 56.5. The cabinet was made to hold Reference Series frames 101–125.

In his inaugural lecture as Slade Professor at Oxford in February 1870 Ruskin announced not only his intention to found a school of drawing (see cats.255, 256), but also to 'arrange an educational series of examples of excellent art, standards to which you may at once refer on any questionable point, and by the study of which you may gradually attain an instinctive sense of right' (20.34). From this decision grew four separate series of examples, housed in three groups of specially designed cabinets, and kept in the drawing school. Cabinets and framed examples can be seen in fig.9. In effect, these served as the equivalent of a modern slide-library.

The first series to be begun was, as Ruskin's inaugural lecture stated, the 'Standard Series', containing a mixture of engravings, photographs and watercolour copies of works of art. To this sequence, numbered one to fifty, was added the 'Reference Series' which was used as a repository for images referred to by Ruskin in his lectures, or used in general teaching. Provision was made for 150 examples in the Reference Series. The Standard

and Reference Series were housed in eight cabinets, of which this is an example.

Ruskin went on to create two further sequences of examples, with the more specific purpose of providing a series of subjects for copying and study, as part of the process of learning to draw. The 'Educational Series', intended for use by undergraduates, was begun in 1871; the 'Rudimentary Series', intended for use by members of the 'town class' taught by the Ruskin Drawing Master, Alexander Macdonald, was begun in 1872. These were also housed in mahogany cabinets, twelve for each series of 300 frames. Though similar in design, these cabinets are smaller (77 (height) x 60.5 (width) x 45 (depth)) and less lavish than the Standard and Reference series cabinets, and have plain oak frames.

Between 1870, when he began to assemble the teaching collections, and 1885, when he resigned his Professorship for a second time, Ruskin changed and re-arranged the contents of the sequences several times, and left none in complete order. Since then they have been absorbed into the general holdings of the Ashmolean Museum; some items have deteriorated or been lost. The cabinets, which for conservation reasons could no longer perform their intended function, have been dispersed, so that the original sequences only exist in catalogue form.

fig.9 The Ruskin Drawing School, Oxford, *c.* 1904 (The Visitors of the Ashmolean Museum, Oxford)

182

*Frame for Reference
Series no 120*
1870/1

Ruskin Foundation
(Ruskin Library,
University of Lancaster)

[Not illustrated]

Grooved wood frame decorated with a pattern of roses in plaster and gilt and numbered '120', 76.9 (height) x 56.5 (width) x 3.8 (depth). The side of the frame has a leather handle and an ivory number panel. The back of the frame bears the label of 'Foord and Dickinson, Wardour Street'.

For the purposes of display, a colour photograph of the drawing that Ruskin placed at no 120 in the Reference Series has been put in the original frame. The drawing is by Ruskin, *The Baptistery, Florence,* 1872 (watercolour over pencil 52 x 34.6, Ashmolean Museum, Oxford).

183

Picture stand

The Visitors of the
Ashmolean Museum,
Oxford

[Not illustrated]

Oak frame, 48.5 (height) x 37.5 (width)

Stands such as this one were provided in the Drawing School to support a selected example chosen by a student for copying. See fig.9.

184

The Ruskin Cabinet, Whitelands College
1881

Whitelands College

Mahogany, 50 (height) x 139 (width) x 51 (depth) (when closed), with small brass lock. Brass plate on front inscribed 'Presented to Whitelands College, Chelsea, by Prof. Ruskin LL.D. Master of St George 1881–3'. Paper label on inside of lid inscribed 'Cabinet presented to Whitelands College by Mr Ruskin October 28 1881. The first nine pictures complete, from Richter's *Unser Tägliches Brod* came at the same time. J.P. Faunthorpe Principal'. The cabinet has a four-legged oak stand from which it may be detached, 30 (height) x 143 (width) x 56 (depth). The stand formerly had castors. When opened, the contents are revealed as 60 oak picture frames in slots numbered on ivory labels 1–60, with corresponding numbers on ivory labels on the frames. The frames are 45.6 x 40.5 (external), with recently renewed leather lifting straps. Some frames bear two labels, one inscribed 'Foord & Dickinson, Carvers and Guilders, 129 Wardour Street W. Drawings mounted. Pictures Cleaned and Restored', the other inscribed 'Presented to the Library of Whitelands College, By Professor Ruskin, LL.D. 1881–3'.

Whitelands College, now part of the Roehampton Institute, opened in 1842 in the King's Road, Chelsea, as an Anglican teacher-training college for women. The college was successful, and following expansion the Rev. John Faunthorpe (1839–1924) was appointed Principal in 1874. Under Faunthorpe the college became recognised as a leading teacher-training establishment. Faunthorpe was a reader of Ruskin's *Fors Clavigera*, and from 1877 a friendship developed. Faunthorpe became unofficial 'chaplain' to the Guild of St George (see cat.187) and

Ruskin began to send books and pictures to the college. In 1881 Ruskin decided to have a cabinet made to receive some of these gifts, and the frames were filled between 1881 and 1883. The sequence remains as originally established.

The contents of the Ruskin Cabinet are catalogued at 30.348–55, with comments by Ruskin. Frames 1–15 are woodcuts by Ludwig Richter (cat.185), 16–30 woodcuts and engravings by Albert Dürer (cat.186), and the remainder are a miscellany of prints, photographs, and facsimiles after Turner.

In 1881 Ruskin also instituted the annual May Queen Festival at Whitelands. He had been asked by Faunthorpe to present an annual prize of one of his books, but Ruskin suggested that instead of a competitive award, the students themselves should elect one of their number as May Queen. In addition to presenting books, Ruskin provided a gold cross, renewed each year, to be worn by the May Queen. A special costume was designed, and the May Queen Festival developed into an elaborate annual ceremony which continues to this day. Ruskin was also responsible for securing the services of Morris and Burne-Jones to decorate the college chapel, dedicated, at Ruskin's suggestion, to St Ursula (see cat.244). In 1931 Whitelands removed to purpose-built premises in Putney, where the principal decorations to the chapel were reinstated.

185

Adrian Ludwig Richter
(1803–1884)

*Thanksgiving
(Dankgebet der
Schnitter)*

Whitelands College

Woodcut, 25.5 x 20 (sight). Top: 'Thanksgiving of the Reapers';
below: 'Psalm cvi 1 : "O thank the Lord for He is friendly
and His mercy endureth for ever"', from *Unser Tägliches Brod*.
Frame no.5 in the Ruskin Cabinet

*'If you want to make presents of story-books for children,
[Richter's] are the best you can now get' (The Elements of
Drawing, 1857, 15.224)*

Ruskin was critical of the popular German illustrator
Richter's technique in *The Elements of Drawing* (1857), but
when he came to discuss book illustration in his lectures
published as *The Art of England* (1884), he recommended
the designs from *Unser Tägliches Brod* for distribution in
schools: 'Perfect as types of easy line drawing, exquisite
in ornamental composition, and refined to the utmost
in ideal grace, they represent all that is simplest, purest,
and happiest in human life, all that is most strengthening
and comforting in nature and in religion' (33.285). The
combination of piety and sentiment in Richter's woodcuts
appealed to the ageing Ruskin, and a teacher-training
college was an appropriate place to receive them. He
wrote to Kate Greenaway, whom he also praised in *The
Art of England*, 'Ludwig Richter and you are the only real
philosophers and Divines of the nineteenth century'
(37.383) (see cat.227).

186

Albert Dürer
(1471–1528)

Life at Nazareth

Whitelands College

Woodcut, 30 x 21 (sight). Frame no.25 in the Ruskin Cabinet

*'These will not give nearly so much pleasure, but in many respects
will be more instructive, being much stronger art, than Richter's'
(The Ruskin Cabinet at Whitelands College, 1883, 30.351)*

Ruskin used works by Dürer as a teaching aid throughout
his life, frequently making loans or presents of prints,
recommending him in *The Elements of Drawing* (1857)
and placing prints in the Ruskin School of Drawing.
In the case of Rossetti and Burne-Jones, he regretted
holding up Dürer as an example. In 1858 he told G.F.
Watts, 'I am answerable for a good deal of this fatal
medievalism in the beginning of it – not indeed for
the principle of retrogression – but for the stiffness and
quaintness and intensity as opposed to classical grace
and tranquillity' (Watts 1912, vol.1, p.173).

187

*Gothic Revival
'Prie-Dieu'
Display Case*
c. 1885

The Ruskin Gallery,
Guild of St George
Collection

Oak, 103 x 93, on base 46 x 86.5, supporting an angled, glazed display case (internal 40 x 83) with brass lock and hinges. The oak is carved and the front panel below the case pierced in Gothic style. Maker unidentified; made for the Museum of the Guild of St George.

The Museum of the Guild of St George, Ruskin's utopian society launched in 1871, was originally established in a small cottage bought in 1875 in the district of Walkley, Sheffield. Sheffield was chosen because of the presence of a former pupil of Ruskin's at the London Working Men's College, Henry Swan (1825–89) who had gathered together a group of working men who were interested in Ruskin's ideas. The cottage housed both

Swan as curator, his family and a rapidly expanding collection. The building was first extended in 1877, but after the arrival of J.W. Bunney's *West Front of St Mark's, Venice* (cat.257) in England in 1882, an extension to the rear of the cottage had to be built to accommodate the painting and other materials (fig.10). Over time the Museum acquired tables, bookcases, chairs and a modified version of the cabinets designed for the Ruskin Drawing School. This unique display case, modelled on a piece of church furniture, and probably locally-made, is visible in fig.10, and it is likely that it was acquired when the extension was built. For the purposes of display, it holds one of the visitors' books from the Museum.

188

*Visitors' Book for
Museum of St George*
Sept. 1880–Sept. 1881

15.2 x 25.3
when closed

The visitors' book is open at a page for November 1880, showing four visits by Frank Saltfleet (1860–1937), describing himself as a 'student'. Saltfleet was born in Sheffield, the son of a house and sign painter who trained as a cabinetmaker, but became a professional artist with Ruskin's encouragement. The following exchange is recorded between Ruskin and Henry Swan: '"Will he be a master?" asked the curator. "Why, Swan," replied Ruskin, "Saltfleet *is* a master"' (30.xlvi). Saltfleet studied at the Academy of Fine Art in Antwerp in 1884–5, had an exhibition at the Fine Art Society in London in 1900, and served as President of the Sheffield Society of Artists.

fig.10 Interior of the Museum of the Guild of
St George at Walkley, Sheffield, c. 1885

VII

Ruskin's Pre-Raphaelitism

'... a new and noble school in England.'

When Ruskin took up the Pre-Raphaelite cause in 1851, he did so as a practical gesture of support for a group of idealistic young men whose interests, as he was made to see, ran in parallel with many of his own. But in advocating their work he was also able to vindicate his belief that the majority of contemporary pictures were produced according to stock, academic formulas, based on no real observation of the real world. He had lamented exactly this circumstance in *Modern Painters* I (1843), and had closed his book with an exhortation to artists to follow Turner's example and to seek truth uncritically in their depictions of nature (3.623–4). In his pamphlet *Pre-Raphaelitism* of August 1851, he reiterated this celebrated injunction, claiming that the movement had followed his guidelines, and as a result was on the point of generating a new national style.

Holman Hunt was certainly deeply impressed by Ruskin's writings, and is known to have stayed up all night to read a borrowed copy of the second volume of *Modern Painters*, but the degree to which Ruskin's passionate plea for verisimilitude directly inspired the works that he, Millais, Rossetti and their friends produced between 1848 and 1851 has been questioned. Nevertheless, it is clear that the artists were delighted at the time to be endorsed by such a noted figure.

Putting to one side his distaste for the new movement's interest in Medievalism, which was tainted for him because of its associations with Catholicism, Ruskin defined Pre-Raphaelitism in his and the public mind as essentially a pursuit of visual truth above all other considerations. The potentially revolutionary idea that artists should neither reject, select, nor scorn what lay before them was, as far as he was concerned, its central tenet. Ironically, those who scrupulously followed this principle did not always receive his approval. Ford Madox Brown, for example, painted a view from a window of his lodgings in Hampstead only to be reproached by Ruskin that it was 'such a very ugly subject' (*English Autumn afternoon, Hampstead – scenery in 1853*, Birmingham Museums and Art Gallery; Bryant 1997). Subject-matter continued to be an abiding concern, and even those artists who worked directly under Ruskin's supervision, such as Inchbold (cat.211) or Brett (cat.207), found that their anti-picturesque views frequently failed to meet with his approval.

Direct contact with Ruskin also proved to be a mixed blessing for the leading members of the Pre-Raphaelite circle, who had not actually encountered him until after he began to adopt the guise of their exponent (cats.189, 190).

In order to encourage Pre-Raphaelite adherents in the Royal Academy exhibitions, Ruskin began to write an annual 'circular letter' in which he set down his appraisals of the key pictures. Under the title *Academy Notes*, the first of five parts was issued in 1855 (a sixth addressed the exhibition of 1875). Initially this dealt chiefly with the Royal Academy, but its range expanded in subsequent years to include the displays of the two watercolour societies, the French Gallery in Pall Mall, and the Society of British Artists. These pamphlets bore Ruskin's name boldly on their cover, unlike the unsigned reviews in the newspapers and art journals. Though this tended to enhance his position as an authority on art issues, it also meant that Ruskin could be held directly accountable for his published views.

Almost immediately, he caused ill feeling among practising artists by ignoring some and castigating others for their failure to meet his ideals for a new school of English painting. George Richmond, for example, was reprimanded for the foggy, and insufficiently Pre-Raphaelite, background in his portrait of *Sir Robert Harry Inglis* (Bodleian Library, Oxford; 14.19). Ruskin was particularly disparaging about a picture by his friend David Roberts in the 1855 notes, effectively writing the artist off as 'nothing more than an Academician' (14.28). Outraged at such a personal attack, Roberts promised to give him a sound thrashing the next time he saw him. Reactions from other quarters were similarly alarmed at the position Ruskin was adopting, forcing him to defend his stance in a supplement to the third edition of the 1855 pamphlet. 'Whenever I blame a painting,' he wrote, 'I do so as gently as is consistent with just explanation of its principal defects. I never say half of what I could say in its disfavour.' Acutely aware of the power of the published word, he went on to warn his opponents that it would be counter-productive to challenge his opinions (14.35).

Not surprisingly, Ruskin's new role as an apparently unassailable arbiter of public taste made him a target himself. When his *Academy Notes* appeared for the second time in 1856, practical

objections to his way of dismissing an artist's main chance of commercial gain were neatly articulated in a satirical piece in *Punch*, supposedly written by a 'Perfectly Furious Academician':

'I takes and paints,
Hears no complaints,
And sells before I'm dry;
Till savage Ruskin
He sticks his tusk in,
Then nobody will buy.

NB. – confound Ruskin;
only that won't come into poetry
– but it's true'

The year 1856 was also that in which Ruskin claimed the Pre-Raphaelite style had become thoroughly assimilated into the more traditional mainstream. He exulted that 'the battle is completely and confessedly won', and ventured to state that 'a true and consistent school of art is at last established in the Royal Academy of England' (14.47). The display included Hughes's *April Love* (cat.198), Henry Wallis's *Chatterton* (Tate Gallery), Holman Hunt's *The Scapegoat* (cat.196), Windus's *Burd Helen* (cat.199), but Ruskin also detected evidence of the diligence and sincerity that he associated with Pre-Raphaelitism in pictures by Robert Hannah (1812–1909), F.R. Pickersgill (1820–1900) and W.P. Frith (1819–1909).

Most relevant to his hopes for the future were Millais's *Peace Concluded*, 1856 (Minneapolis Institute of Arts) and *Autumn Leaves* (Manchester City Art Galleries), which he considered placed the artist in the same league as Titian. It was all the more galling for him the following year, therefore, to find that Millais had abandoned the by-now accepted, meticulously detailed Pre-Raphaelite style in favour of a more expressive application of paint (cat.200). Ruskin pronounced this to be evidence of 'backsliding' and petulantly dismissed the sketchiness of the pictures, suggesting that they were incomplete, simultaneously putting down a marker for the aesthetic issue at the heart of his confrontation with Whistler twenty years later (cat.223).

His hopes of finding an artist who could fulfill his specific aspirations for Pre-Raphaelite landscape were similarly thwarted a year or so later when he supervised John Brett's view of the Val d'Aosta (cat.207). No other artist was made to follow Ruskin's principles more diligently, but the result failed to please him because of what he felt was a lack of engagement with the subject by the artist. By this stage he had begun to articulate his belief that there were two different types of Pre-Raphaelitism: one prosaic and factual, best represented by the work of men such as Brett and Thomas Seddon (cat.195); the other inventive, with shades of meaning. He found these latter qualities in Holman Hunt's paintings (cat.192), and also in those of Rossetti, who became increasingly close to him throughout the 1850s, partly as a result of their shared involvement in the teaching at the Working Men's College.

The instincts that prompted Ruskin to write *Academy Notes*, to become involved in teaching illiterate craftsmen, or to produce self-improvement manuals such as *The Elements of Drawing* (cat.210), all stem from his overwhelming need to enlighten his fellow men and women, and his didactic urge to pronounce. But curiously he limited his views on contemporary art to the parameters of the London art world. Though this occasionally included foreigners such as Rosa Bonheur (1822–99), Edouard Frère (cat.205), and Louis Ernest Meissonier (1815–91), whom Ruskin either collected or mentioned in his notes, he does not seem to have felt it his prerogative to venture any detailed opinions on what he saw of modern art during his travels abroad. One would be fascinated to know, for example, what he might have made of pictures by his exact contemporary, Gustave Courbet (1819–77), who was pursuing his own type of truth to nature.

London during the 1850s offered a very different type of art, however, where the norm was increasingly for paintings to have complex narrative or moral themes. Given this background, Ruskin was in many ways the perfect person to evaluate and decode such meanings for an audience who had until then been unaware that art could carry intellectual matter. Indeed the extent of his influence can be gauged from the fact that many years later, in the 1880s, even a former detractor like Ford Madox Brown conceded the value of Ruskin's efforts, and particularly those on the side of Pre-Raphaelitism. These reflections arose from a recent work by Arthur Hughes, then languishing unsold, which forced Brown to state that 'A few years ago Ruskin would have been writing about it, and *everybody* would have been talking about it' (Roberts and Wildman 1997, p.30; my emphasis).

IW

189

William Holman Hunt

Our English Coasts, 1852 ('Strayed Sheep')
1852

Oil on canvas
43.2 x 58.4

First exhibited
Royal Academy 1853

Tate Gallery. Presented
by the National Art
Collections Fund 1946

'Of all the sheep that are fed on the earth, Christ's Sheep are the most simple ...: always losing themselves; doing little else in the world but lose themselves; – never finding themselves; always found by Some One else; getting perpetually into sloughs, and snows, and bramble thickets, like to die there, but for their Shepherd, who is for ever finding them and bearing them back, with torn fleeces and eyes full of fear' (Notes on the Construction of Sheepfolds, 1851, 12.534)

In June 1851, less than a month after Ruskin had written to *The Times* in defence of the Pre-Raphaelite pictures of Millais and Hunt, the latter read *Notes on the Construction of Sheepfolds*. Ruskin's pamphlet addressed the increasing divisions between the Evangelical and the Tractarian (or High Church) wings of the Protestant faith, and advocated the need for these extremes of the English Church to join forces in opposing Catholicism.

Hunt was apparently influenced by this contemporary debate in his picture *The Hireling Shepherd*, which he painted in the summer of 1851 (RA 1852; Manchester City Art Gallery). The underlying theological symbolism he created may have been understood by Charles T. Maud, who asked him to paint a copy of its wayward sheep. Indeed, though the commission was eventually altered to allow Hunt to produce a different composition, the sheep were retained as the principal element of the image. The setting selected was the cliffs at Fairlight, to the east of Hastings, possibly in an attempt to develop a reference in Ruskin's text that lamented the confining of 'Christ's

truth' within the 'white cliffs of England' (although those at Hastings are reddish limestone rather than chalk). Hunt himself was steeped in contemporary theological controversies, and was acquainted with key Tractarian figures, but his choice of landscape was just as probably a response to contemporary fears of French aggression during 1852. English artists have often focused on the coasts as a way of suggesting the dual strength and vulnerability of the island's natural defences.

By the time he embarked on the canvas, Hunt had at last met Ruskin. He told the Pre-Raphaelite sculptor Thomas Woolner that he was 'more pleased than I thought I should be altogether, in spite of meeting with the patronising tone. He draws with great ability, much more than I could think any would who admires the two Turners in his dining room' (Amor 1989, p.97). Though Hunt was clearly not an admirer of Turner himself, Ruskin claimed to detect similarities in their realisation of 'magnificent effects of sunshine colour', just as he had sought to link Turner and Millais in *Pre-Raphaelitism* (14.226). Hunt's naturalism was also the aspect celebrated by Ruskin, when discussing the picture in *The Art of England* lecture series (1883): 'It showed to us for the first time in the history of art, the absolutely faithful balances of colour and shade by which actual sunshine might be transposed into a key in which the harmonies possible with material pigments should yet produce the same impressions upon the mind which were caused by the light itself' (33.272–3).

IW

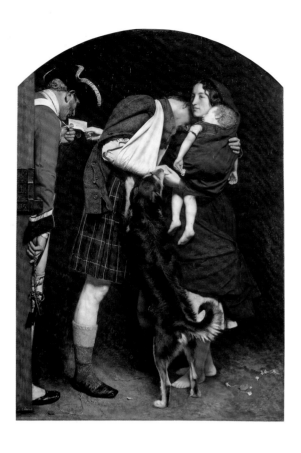

190

Sir John Everett Millais, Bt

*The Order of
Release, 1746*
1852–3

Oil on canvas, arched top
102.9 x 73.7

Inscribed 'JMillais 1853'

First exhibited
Royal Academy 1853

Engraved in mezzotint
by Samuel Cousins, 1856

Tate Gallery. Presented
by Sir Henry Tate 1898

*'It has cost me 7 years' labour to be able to enjoy Millais
thoroughly. I am just those seven years' labour farther in advance
of the mob than I was, and my voice cannot be heard back to
them. And so in all things now – I see a hand they cannot see;
and they cannot be expected to believe or follow me: And the
more justly I judge, the less I shall be attended to'* (Letter to
his father, 15 February 1852, RLV.181)

In one of the few direct references to Millais in *Pre-
Raphaelitism* (1851), Ruskin had admired his 'considerable
inventive power' and his 'exquisite sense of colour'
(12.360). During the subsequent eighteen months, his
enthusiasm gradually intensified, as he began to realise
that Millais was capable of far more than the straight-
forward transcription of reality.

As a gesture of support, but one that strayed ouside
the conventions of the period, he permitted his young
wife, Effie, to pose for Millais early in 1853. At first
Millais planned to use her for his picture *The Proscribed
Royalist* (private collection). But it was for his other 1853
Academy exhibition piece, at that stage called *The
Ransom*, that she eventually sat. This was a subject that
was perhaps suggested by Sir Walter Scott's *Waverley*
novels, and concerns a Highlander, imprisoned after the

Jacobite Rebellion of 1745, whose release from prison is
secured by the actions of his heroic wife.

Millais was at first flattered by the critic's praise and
friendship, and spoke 'highly of Ruskin as a friend of
Art'. But as 1853 progressed his increasing intimacy with
Effie led him to view Ruskin in a different light. There
was clearly a flirtatious, if innocent, element to the
modelling sessions, during which he sought to paint
Effie's enigmatic half-smile accurately. Her approval
of the results, as 'exactly like', testifies to his success in
this respect.

The picture was also a huge success with the public.
So great was the throng in front of it that a protective
barrier was introduced in the Academy for the first time
since Wilkie's *Chelsea Pensioners* of 1822. Among the
reviewers, the critic for *John Bull* proclaimed that Millais's
works that year had established him 'as our greatest
living painter'. Though there continued to be unfavour-
able comments, including some in *Blackwood's Magazine*
about the 'hardness' of the woman's expression, the
public's response suggests the rapidity with which some
aspects of the new Pre-Raphaelite art were being
absorbed into the mainstream.

IW

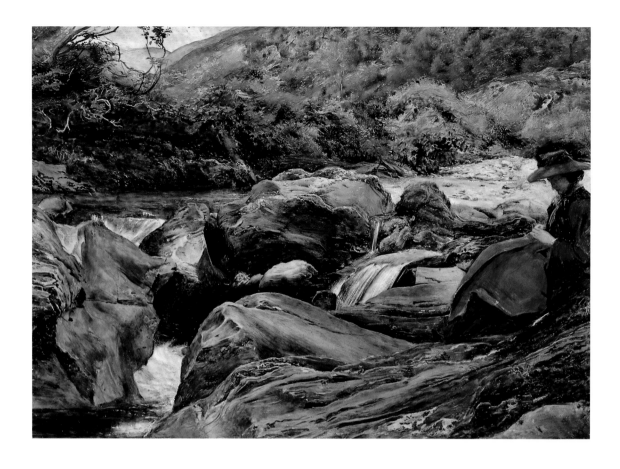

191

Sir John Everett Millais, Bt

A Waterfall in Glenfinlas
1853

Oil on paperboard
26.7 x 31.8

Inscribed 'JM'
in monogram

First exhibited
?Liverpool Academy 1862,
as *Outdoor study*

Delaware Art Museum,
Samuel and Mary R.
Bancroft Memorial

We have been out all day again sitting on the rocks – painting and singing and fishing … Millais is doing a bit for practice … beautiful thing it will be when done' (Letter to his father, 8 July 1854, Lutyens 1967, p.64)

During the first weeks of the momentous visit to Brig o'Turk in the summer of 1853, Millais set to work on this small picture, while he waited for the arrival of suitable canvas for his portrait of Ruskin (cat.1). Though the falling waters and the gneiss rocks, with their exquisitely realised textures, were the true focus of Millais's intense scrutiny, the eye is drawn repeatedly to the peripheral figure of Effie Ruskin, who came to assume a more central position in the artist's life as the summer passed into autumn, reflecting his awakening love for her. At the beginning of the stay he planned to paint a picture of Effie as a companion to that of Ruskin, with her standing beside a window in Doune Castle. All that survives of this idea is a pen and ink sketch, but between June and October Millais produced a group of images of her in other settings (Funnell and Warner 1999).

Even before they arrived in Scotland, Millais admitted to Holman Hunt that he considered her 'the sweetest creature that ever lived' (Lutyens 1967, p.55). After a couple of weeks of studying the Ruskins at close quarters, he wrote to Hunt once again: 'Having the acquaintance of Mrs Ruskin is a blessing. Her husband is a good fellow but not of our kind, his soul is always with

the clouds and out of reach of ordinary mortals – I mean that he theorises about the vastness of space and looks at a lovely little stream in practical contempt.' (Lutyens 1967, p.69). On his side, Ruskin continued to rate Millais in the highest terms, telling one correspondent he was 'gifted with powers of penetration into character and of pictorial invention such as assuredly have not hitherto existed in my time, and capable it seemed to me of almost everything, if his life and strength be spared' (Lutyens 1967, p.87).

By late October the weather had broken, and an awkward intimacy had been established between Effie and Millais, which led ultimately to the breakdown of the Ruskin marriage. After meeting up in Edinburgh, where Ruskin delivered a series of lectures (cat.86), the party drifted back to London. Soon afterwards Ruskin wrote to Lady Trevelyan, stating that he was 'so delighted to get back to my Turners after those stupid stones' (Surtees 1979, p.69). Millais, however, was forced to return to Glenfinlas the following year, so that the portrait could be completed according to the Ruskin-approved ideal of truth to nature.

Soon after his return to London in December 1853 Millais managed to sell this smaller picture to B.G. Windus (cat.38). It was in his collection that it was seen by Effie herself on 30 March 1854, just a month before she finally walked out of her marriage to Ruskin.

IW

192

William Holman Hunt

*The Light of
the World*
1851–3
Retouched 1856, 1886

Oil on canvas over panel,
arched top
125.5 x 59.8

Inscribed 'Whh 1853' and
'Non me praetermisso
Domine' (hidden by frame)

First exhibited
Royal Academy 1854,
accompanied by the
following text from
the book of Revelation
(as inscribed on the frame):
'Behold, I stand at the
door, and knock: if any
man hear my voice, and
open the door, I will come
unto him, and will sup
with him, and he with me'
(ch.3, v.20)

Engraved by
W.H. Simmons

Warden, Fellows and
Scholars of Keble College,
Oxford

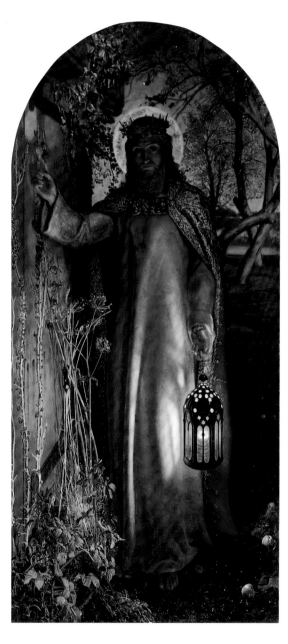

*'For my own part, I think it is one of the very noblest works of
sacred art ever produced in this or any other age'* (Letter to
The Times, 5 May 1854: 12.330)

Holman Hunt's picture has become one of the most
celebrated Protestant icons. It was, however, received
with considerable hostility when first exhibited in 1854.
In order to check this response, Ruskin sent a letter to
The Times, which both defended, and sought to explain

the significance of, Hunt's presentation of Christ to the
uncomprehending public. He was no doubt aware that
Hunt had completed the painting according to Pre-
Raphaelite principles, working from nature by moonlight,
both at Worcester Park Farm, near Kingston, and also
at Hastings.

Because of his own deeply ingrained knowledge
of Biblical texts, Ruskin was acutely alert to the com-
plicated web of allusions created by Hunt in the image.
For example, the title and the lantern were suggested by
a passage in John: 'Then spake Jesus again unto them,
saying, I am the light of the world: he that followeth
me shall not walk in darkness, but shall have the light of
life' (ch.9, v.12). Explaining the symbolism of the barred
and overgrown door as the unused and unwelcoming
entrance of the human soul, Ruskin noted that it is
approached by the figure of the resurrected Christ 'in
his everlasting offices of prophet, priest and king'. The
nocturnal lighting elicited from him a commentary on
the two-fold illumination attributable to the presence
of Christ: 'first, the light of conscience, which displays
past sin, and afterwards the light of peace, the hope of
salvation' (12.329–330). In the picture these were made
manifest in the light from the lantern and in Christ's
own spiritual radiance.

A couple of years later, in the third volume of
Modern Painters, Ruskin again celebrated Hunt's
painting, referring to it as 'the most perfect instance of
expressional purpose with technical power, which the
world has yet produced' (5.52). While recognising the
impossibility of attempting to give form to a true image
of Jesus, he struck an Adventist note by congratulating
Hunt for his presentation of Christ as a 'living presence
among us now' (5.86).

Given the obscurity of much of Hunt's imagery,
combined with its interest in the outward forms of the
priesthood, it is perhaps not surprising that the picture
was accused of Romanism, a charge which had also been
levied against the earliest Pre-Raphaelite pictures, and
from which Ruskin had attempted to dissociate them
in 1851 (cat.5).

The painting is the subject of a recent essay by
Michael Wheeler (Hewison 2000).

IW

193

William Holman Hunt

The Awakening Conscience

1853–4
Retouched 1856, 1857, 1864, 1879–80, 1886

Oil on canvas, arched top 76.2 x 55.9

Inscribed 'Whh LON / 1853'

First exhibited Royal Academy 1854, with lines from Ecclesiastes (xiv.18) and Isaiah, while the frame is inscribed, 'As he that taketh away a garment in cold weather, so is he that singeth songs to a heavy heart' (Proverbs, ch.25, v.20)'

Tate Gallery. Presented by Sir Colin and Lady Anderson through the Friends of the Tate Gallery 1976

'Examine the whole range of the walls of the Academy ... there will not be found [a picture] powerful as this to meet full in the front the moral evil of the age in which it is painted; to waken into mercy the cruel thoughtlessness of youth, and subdue the severities of judgment into the sanctity of compassion'
(Letter to *The Times*, 25 May 1854, 12.335)

This work, the other major picture exhibited by Hunt in 1854, was just as misunderstood as *The Light of the World* (cat.192), calling forth a second letter to *The Times* from Ruskin. When it was published he had already set out on his long-planned continental tour, but news that his wife had left him a few weeks earlier had begun to circulate, inducing many to consider the letter a mark of hypocrisy. Millais, for example, who was admittedly bound up in these events, told Effie's mother that he thought the letter an attempt by Ruskin 'to gull the public into believing that he has the feelings of other folk' (Lutyens 1967, p.222). More significantly, he claimed that Ruskin had misunderstood Hunt's symbolism.

With his obsession for accuracy, Hunt had rented a 'maison de convenance' in St John's Wood, slavishly reproducing its interior, while also introducing the figures of a kept woman and her patron. He positioned numerous symbols to enable the viewer to understand the woman's predicament. In his letter, Ruskin leads his readers through these details, commenting that they were entirely appropriate to the subject: 'Nothing is more notable than the way in which even the most trivial objects force themselves upon the attention of a mind which has been fevered by violent and distressful excitement... There is not a single object in all that room – common, modern, vulgar (in the vulgar sense, as it may be), but it becomes tragical, if rightly read.' He noticed, in particular, how Hunt suggested that the woman stood in peril of being cast into street prostitution should her seducer choose to cast her aside: 'the very hem of the poor girl's dress, at which the painter has laboured so closely, thread by thread, has story in it, if we think how soon its pure whiteness may be soiled with dust and rain, her outcast feet failing in the street' (12.333–5).

Yet Hunt's painting was intended as a material, or secular counterpart to *The Light of the World*, and focuses on the woman at the moment when she is illuminated by the possibility of redemption. He suggests this variously: in the burst of sunlight in the foreground; in the light in the woman's eyes; and in the natural purity of the landscape on which she gazes outside the space in which she is confined (reflected for us in the mirror). The precise meaning of the painting escaped most contemporary viewers. For his part, Ruskin misconstrued some of the details in order to arrive at a contemporary morality tale, which indicates that this supposedly unworldly critic was thoroughly aware of the sexual undercurrents in the image. However, he assumed Hunt intended primarily to provoke compassion, and failed to perceive the same kind of hope he had already found in the artist's figure of Christ with his lantern. He claimed, for example, that the garden flowers simply reproached the young woman with their unsullied purity. And instead of seeing the possibility of the bird escaping from the cat (or the woman leaving the man), he referred to it only as 'torn and dying', its fate already sealed.

Despite such shortcomings, it is clear that Hunt welcomed the prominence of Ruskin's genuine support. He quoted the text in his auto-biographical volume on the history of Pre-Raphaelitism, and reflected, 'It could not but gratify and encourage me to read these words of high appreciation' (Hunt 1905, vol.i, p.419).

IW

194

Alfred William Hunt
(1830–1896)

*Styhead Pass,
Borrowdale,
in Autumn*
1854

Oil on canvas
91.4 × 71.2

Inscribed
'AW Hunt'

First exhibited
Royal Academy 1854
as *Wastdale Head
from Styhead Pass*

Harris Museum and
Art Gallery, Preston

*'Alfred Hunt has been staying with me. He is very faithful and
affectionate to me'* (Letter to Norton, 25 July 1873, LN.292)

Alfred William Hunt was an admirer both of Turner's
late watercolours and of the Pre-Raphaelites. Stimulated
by reading *Modern Painters*, he developed an approach to
landscape that met with Ruskin's approval, and towards
the end of the 1850s a long friendship began. Hunt was
the son of a Liverpool artist and like his father was to
become a member of the Liverpool Academy (see
cat.203), but he had been intended to enter the Church.
He went to Oxford, where (in Ruskin's footsteps) he won
the Newdigate poetry prize in 1851. While continuing
to paint, and without taking holy orders, he became a
Fellow of Corpus in 1853. *Styhead Pass* was his first work
to be exhibited at the Royal Academy, and he was favour-
ably noticed by Ruskin the following year in the first
number of *Academy Notes*. Ruskin consistently praised
him, but a passing remark from Ruskin in 1857 about
the hanging of Hunt's pictures in that year's Academy
show was believed to have soured Hunt's relations with
the Academy, to which he was never elected.

Encouraged by Ruskin's support, in 1861 Hunt
resigned his Fellowship in order to marry and become

a full-time landscape painter. In 1864 his second
daughter, Venice, became Ruskin's god-child. In 1873
Ruskin invited Hunt and his family to stay with him at
Brantwood, a visit that appears not to have been a total
success as far as the family was concerned (Secor 1982,
p.67), but Hunt spent much of the summer in Coniston.
The following year, while Ruskin was abroad, Hunt
returned to paint a view from Yewdale (a favourite spot
of Ruskin's), exhibited at the Royal Academy in 1875
as *Summer Days for Me* (whereabouts unknown). In his
Academy Notes, which he had revived for that year,
Ruskin recorded seeing the painting in Hunt's studio and
persuading him to alter the sky, 'but I am encroaching
enough to want it changed more' (14.298). None the less,
Ruskin attested to the painting's 'fidelity of portraiture,
happily persisted in without losing the grace of imagin-
ation' (14.298).

A watercolour of Coniston made while staying with
Ruskin in 1874, *The Stillness of the Lake at Dawn* (fig.11),
shows that in the twenty years since *Styhead Pass*, Hunt
had modified his 'fidelity of portraiture' in search of
more atmospheric, Turnerian effects, precisely the 'grace
of imagination' that Ruskin wanted the Pre-Raphaelites
to achieve. As Ruskin wrote in 1856, specifically linking
Turner and the Pre-Raphaelites in *Modern Painters*, he was
looking for 'truth so presented that it will need the help
of the imagination to make it real' (5.185).

Hunt and his wife were among Ruskin's confidants
during his unhappy love affair with Rose La Touche
(see cat.230). Hunt organised the presentation of Turner's
Splügen (cat.112) following his first breakdown in 1878,
and supported him in his disputes with Joan and Arthur
Severn (see cat.254). They met for the last time in 1888.

RH

fig.11 Alfred William Hunt, *The Stillness of the Lake
at Dawn,* 1874 (Christopher Newall)

195

Thomas Seddon
(1821–1856)

Jerusalem and the Valley of Jehoshaphat from the Hills of Evil Counsel, or *The Valley of Jehoshaphat: Painted on the Spot, during the Summer and Autumn Months*
1854–5

Oil on canvas
67.3 x 83.2

First exhibited
14 Berners Street,
London
March–June 1855

Tate Gallery. Presented by
subscribers 1857

'Mr Seddon's works are the first which represent a truly historic landscape art; that is to say, they are the first landscapes uniting perfect artistical skill with topographical accuracy, being directed with stern self-restraint to no other purpose than that of giving to persons who cannot travel trustworthy knowledge of the scenes which ought to be most interesting to them'
(Speech to a meeting of the Seddon Memorial Committee, March 1857, 14.465n)

Though not an actual member of the Pre-Raphaelite Brotherhood, Thomas Seddon shared many of the aims of its founders. He took up professional painting comparatively late, but was quick to encourage others, establishing drawing schools, first at Grays Inn Road and later in Camden Town, that anticipate Ruskin's involvement with the Working Men's College.

He had long been interested in the Holy Land, and like Ruskin had supported Roberts's set of lithographs (cat.28). This picture was the chief work he produced during the first of his visits, which partly coincided with that made by Holman Hunt (cat.196). Seddon's viewpoint focuses on the southern outskirts of Jerusalem, and includes many sites familiar from Biblical narratives: on the right is the Mount of Olives; while the white wall in the crook of the valley, in the centre of the image, encloses the garden of Gethsemane, the scene of Christ's Agony. The picture was painted painstakingly over several months from a spot close to the tent in which Seddon lived during his stay.

Once he got the canvas back to London, Seddon enlisted the help of Madox Brown to revise the picture to take account of criticisms by Holman Hunt. Seddon's new works were soon afterwards seen by Ruskin, who 'stayed a long time' and was 'much pleased with everything and especially "Jerusalem", which he praised wonderfully'. He reportedly told Seddon, 'Before I saw these, I never thought it possible to attain such an effect of tone and light without sacrificing truth of colour' (14.464n).

Sadly Seddon died of dysentery shortly after he returned to Egypt on his second tour. His friends in London attempted to perpetuate his memory by raising sufficient funds to buy the picture of Jerusalem for the National Gallery. This was also a means of providing for his widow and daughter. Ruskin became involved in the campaign early on, acting as Treasurer of the Committee. When, in May 1857, an exhibition of Seddon's works was staged at the Society of Arts (for which some of the unfinished items were completed by the likes of Hunt or Brown), Ruskin made a rather equivocal speech, denying that there was anything exceptional about Seddon's talents. On the merits of *Jerusalem*, he claimed to differ from the general view: 'It was not because he considered it remarkable, but because he considered it not remarkable, that he wished this picture to become the property of the nation; he regarded it as the type of a class of pictures and of works which might be understood and imitated by other men, and the understanding of which would be advantageous to the nation in future' (14.465–6). In spite of this ambiguous praise, the appeal proved successful and the picture therefore became the first Pre-Raphaelite picture to enter the national collections; no example by any of the major figures was acquired until almost the 1890s.

Distance lends enchantment, and by 1870 Ruskin remembered the Holy Land pictures of Hunt and Seddon with greater warmth. In his lecture on 'The Relation of Art to Use' in March that year, he said, 'I do not know an entirely faithful drawing of any historical site, except one or two studies made by enthusiastic young painters in Palestine and Egypt: for which, thanks to them always (20.105–6)

IW

196

William Holman Hunt

The Scapegoat
1854–5, 1858

Oil on canvas
86.5 x 139.8

Inscribed 'OOSDOOM
DEAD SEA / 18 WHH 54'
Frame: [top] 'Surely he
hath borne our Griefs,
and carried our Sorrows /
yet we did esteem him
stricken smitten of GOD
and afflicted [Isaiah, LIII,
4]; [bottom] And the Goat
shall bear upon him all
their / Iniquities unto
a Land not inhabited
[Leviticus, XVI, 22]', and
'THE SCAPEGOAT'

First exhibited Royal
Academy 1856, with the
note, 'See Leviticus, XVI.',
and an explanation of
the subject

Board of Trustees of the
National Museums and
Galleries on Merseyside
(Lady Lever Art Gallery,
Port Sunlight)

*'I think we shall see cause to hold this picture as one more truly
honourable to us, and more deep and sure in its promise of future
greatness in our schools of painting, than all the works of "high
art" that since the foundation of the Academy have ever taxed the
wonder, or weariness, of the English public'* (Academy Notes,
1856, 14.64)

After many delays, Hunt finally left London for the Holy
Land on 13 January 1854. The previous autumn Ruskin
had attempted to discourage him, partly for the sake
of Millais, who was deeply upset at the thought of his
friend's departure, but also because he felt Hunt was not
yet ready to make the most of the trip. He rebuked him,
saying, 'If you go to the Holy Land now, you will paint
things that you will be ashamed of in seven years'
(20 October 1853; Lutyens 1967, p.101).

In Jerusalem, shortly after his arrival, Hunt lighted
on the subject of this picture while perusing the book of
Leviticus. The narrative relates the Jewish ritual enacted
on the Day of Atonement, involving two goats: one of
which was sacrificed in the temple; while the other was
driven out of the city, and eventually to its death,
symbolically bearing away the sins of the people. Hunt
readily connected the unpleasant death of the accursed
animal with Christ's Passion, and envisaged a subject
'full of meaning'. He chose the Dead Sea as his setting
because of its associations with the ancient city of
Sodom, traditionally obliterated by God's wrath, and
selected as his backdrop the mountains of the Moab
range on the eastern shore.

The logistics of committing his idea to canvas in such
a barren place, at considerable risk to himself because of

local unrest, ultimately frustrated Hunt's attempts to
complete the picture on the spot, and he was forced
to finish his work in Jerusalem in the first half of 1855.

When the picture was shown in London a year later,
it was widely derided. The subject was thought unintel-
ligible, despite the long explanatory note Hunt appended
to the title in the Academy's catalogue. Ruskin was
among those who expressed their reservations, beginning
his extended commentary in *Academy Notes*, with the
judgement that the picture was 'in many respects faultful,
and in some wholly a failure'. He inevitably praised the
faithfulness of the landscape, remarking that 'Of all the
scenes in the Holy Land, there are none whose present
aspect tends so distinctly to confirm the statements of
Scripture as this condemned shore'. But nevertheless he
felt that Hunt's 'intensity of feeling' had made him forget
'the requirements of painting as an art'. Developing this
point, he wrote: 'No one could sympathize more than
I with the general feeling displayed in the "Light of
the World"; but unless it had been accompanied with
perfectly good nettle painting, and ivy painting, and
jewel painting, I should never have praised it; and though
I acknowledge the good purpose of this picture, yet
inasmuch as there is no good hair painting, nor hoof
painting in it, I hold it to be good only as an omen,
not as an achievement' (14.61–66).

At this time the symbolism of the image does not
seem to have appealed to Ruskin. Much later, in the
lectures of 1883 that were afterwards published as
The Art of England, he saw the picture as the logical
development of the Christian ideas in 'the first of Hunt's
sacred paintings' – *Our English Coasts* (cat.189; 33.274).

IW

197

John William Inchbold
(1830–1888)

*The Moorland
(Dewar Stone,
Dartmoor)*
1854

Oil on canvas
35.6 x 53.3

Inscribed, lower right,
'Inchbold 1854'

First exhibited
?Royal Academy 1855
(as '"The Moorland"
– Tennyson')

Tate Gallery.
Bequeathed by
Sir J. Russell Reynolds, Bt
1896

*'The only thoroughly good landscape in the rooms of the
Academy. It is more exquisite in its finish of lichenous rock
painting than any work I have ever seen. Its colour, throughout,
is as forcible as it is subtle and refined; and although it appears as
yet to display little power of invention. The appreciation of truth
in it is so intense, that a single inch of it is well worth all the rest
of the landscapes in the room'* (Academy Notes, 1855, 14.21–22)

Although he only began to exhibit landscapes at the
Royal Academy in 1851, Inchbold quickly established
himself as one of the most promising younger artists
among those pursuing the meticulous methods of the
first Pre-Raphaelites. A year later, for example, William
Michael Rossetti specifically mentioned his work as
evidence of how the Pre-Raphaelite aesthetic was
gaining ground.

These early expectations of success were, however,
rudely overturned when the 1854 Academy selection
committee rejected his picture of a Devonshire cove
(Fitzwilliam Museum, Cambridge). This action, which
must have seemed a deliberate rebuttal of the Pre-
Raphaelite style, provoked Ruskin to take Inchbold's
part. His letter to *The Times* about Holman Hunt's *Light

of the World* (cat.192) at the beginning of May 1854
had originally included comments about Inchbold,
presumably in his defence, but these were dropped in
its published form (Newall 1993, pp.11, 50).

This picture of Dartmoor is almost certainly one
of the three that Inchbold sent to the Academy the
following year. In his *Academy Notes* for 1855 Ruskin
lauded its merits, at the same time revealing that he had
studied it more intently than was permissible where it
was hung on the Academy walls. This is a reference to
an occasion a couple of months earlier, when he had
borrowed works by Inchbold and Rossetti as a means
of attempting to convert Charles Kingsley to Pre-
Raphaelitism.

Though it has sometimes been thought that Ruskin
bought the picture entitled *At Bolton* from the 1855
exhibition (Leeds City Art Gallery), it seems that it
remained unsold and that he did not begin to acquire
examples of Inchbold's work until the following year
(cat.211). Inchbold may, however, have benefited
financially from Ruskin's useful injunction to the
collector Ellen Heaton that she ought to commission
a work from him.

IW

198

Arthur Hughes
(1832–1915)

April Love
1855–6

Oil on canvas,
arched top
88.9 x 49.5

Inscribed, lower right,
'Arthur Hughes 1856'

First exhibited
Royal Academy 1856
with a quotation from
Tennyson's poem,
'The Miller's Daughter':
Love is hurt with jar and fret,
Love is made a vague regret;
Eyes with idle tears are wet,
Idle habit links us yet.
What is love? For we forget:
Ah, no! no!

Tate Gallery.
Purchased 1909

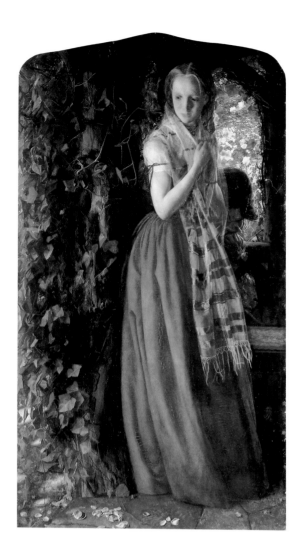

'Exquisite in every way; lovely in colour, most subtle in the quivering expression of the lips, and sweetness of the tender face, shaken, like a leaf by winds upon its dew, and hesitating back into peace' (*Academy Notes*, 1856, 14.68)

Ruskin first met Hughes in November 1855, soon after the completion of *April Love*. Though ostensibly an illustration of lines by Tennyson, this evocation of romantic intimacy is more truly the occasion for a diligent, Pre-Raphaelite nature study. Not surprisingly, Ruskin was initially very enthusiastic about the picture, no doubt struck by the scrupulous attention to detail in the way the ivy is painted. He returned to see it a second time accompanied by his father, evidently with the intention of persuading him to buy it. According to Hughes, all looked promising, and 'the old gentleman's enthusiasm equalled if not surpassed Ruskin Junior's'. But the visit was followed by a letter explaining that neither man was minded to purchase the painting, although Ruskin expressed a wish to possess something by Hughes in the future. Such trifling with the impecunious young artist's hopes exasperated his friend William Allingham.

'Not to buy is preposterous in a rich enthusiastic man,' he declared (quoted in Roberts and Wildman, p.134).

Though unwilling to acquire the painting himself, Ruskin did his best to induce others to consider it. He wrote to his friend Ellen Heaton in Leeds, telling her, 'I think Hughes quite safe – everybody will like what he does... You ought to have a Hughes too, someday – for his sense of beauty is quite exquisite.' She, however, was unhappy about the way Hughes had painted the young woman's face, and therefore also refused the picture. Yet during the next few years, while abstaining from purchasing anything himself, Ruskin successfully managed to entice Heaton to give Hughes two commissions (*Aurora Leigh's Dismissal of Romney*, 1860; *That was a Piedmontese*, 1862; both Tate Gallery).

In the meantime, *April Love* had been shown at the Royal Academy exhibition, where Ruskin's comments (quoted above) attracted the attention of his eager admirer William Morris. Though still just a student at Oxford, he got his friend Burne-Jones to buy the picture on his behalf, thereby drawing both men into the Pre-Raphaelite orbit.

IW

199

William Lindsay Windus
(1822–1907)

Burd Helen
1855–6

Oil on canvas
84.4 x 66.6

Inscribed with initials
in monogram 'WLW 1856'

First exhibited
Royal Academy 1856

Board of Trustees of the
National Museums and
Galleries on Merseyside
(Walker Art Gallery,
Liverpool)

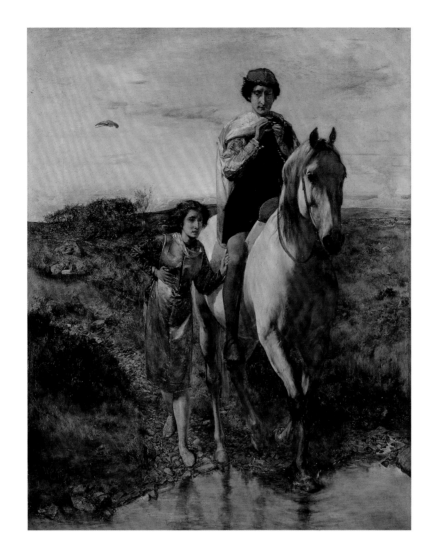

'*The worst Pre-Raphaelite picture has something* in *it; and the great ones, such as Windus's* 'Burd Helen'*, will hold their own with the most noble pictures of all time*' (Letter to the *Edinburgh Witness*, 1858, 14.330)

Ruskin's praise for *Burd Helen* comes, not from his *Academy Notes*, but a letter to the *Edinburgh Witness* in 1858, supporting the newspaper's favourable position on Pre-Raphaelitism. The painting illustrates a Scottish ballad in which a cruel lover is finally won over by the devotion of Burd Helen, here seen running at his side as they reach a ford in the Clyde. Ruskin made no mention of the painting in the first two editions of his *Academy Notes* for 1856 because it had been hung out of sight and the subject did not immediately appeal. Rossetti, however, admired it, and according to Ford Madox Brown 'forced Ruskin to go with him in a cab instanter because he had not noticed it in his pamphlet and extorted the promise of a postscrip [*sic*] on its behalf' (Surtees 1981, p.173).

A 500-word postscript duly appeared in the third edition in which Ruskin declared, 'further examination of it leads me to class it as the second picture of the year; its aim being higher, and its reserved strength greater, than those of any other work except [Millais's] *Autumn Leaves*' (14.86) (Manchester City Art Galleries). The girl's expression and her hand pressed to her breathless side were 'marks of the action of the very grandest imaginative power' (14.86). Windus was a Liverpool artist, a member of the local artist-run Liverpool Academy and a valuable ally of the London Pre-Raphaelites, who consistently won prizes in the Liverpool Academy exhibitions during the 1850s (see cat.203). *Burd Helen* was his first Pre-Raphaelite-influenced work. He wrote to Rossetti, 'I assure you that you and Mr Ruskin were the two persons in the world whose approbation I most ardently wished and scarcely dared to hope for' (14.85n).

Sadly, Windus was a depressive, and Ruskin's curt dismissal of *Too Late* (1859, Tate Gallery) for its melancholy atmosphere – even though apologised for in a postscript when Ruskin learned Windus had been ill (14.233–4, 239–40) – contributed to the abandonment of his ambitions.

RH

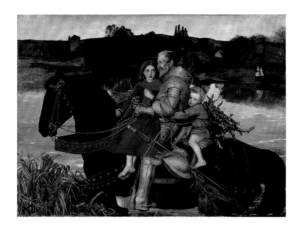

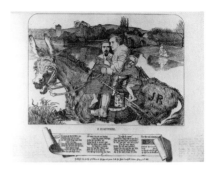

fig.12 Frederick Sandys, *A Nightmare*, 1857, Board of Trustees of the National Museums and Galleries on Merseyside (Lady Lever Art Gallery, Port Sunlight)

200

John Everett Millais

*A Dream of the Past:
Sir Isumbras at
the Ford*
c.1856–7

Oil on canvas
125.5 x 171.5

Inscribed '18JM57'

First exhibited
Royal Academy 1857
with lines from a 'Metrical
Romance of Sir Ysumbras'

Board of Trustees of the
National Museums and
Galleries on Merseyside
(Lady Lever Art Gallery,
Port Sunlight)

[Not exhibited]

*'For Mr Millais there is no hope but in a return to quiet
perfectness of work'* (*Academy Notes*, 1857, 14.111)

Despite the awkwardness of their enmeshed private lives, Ruskin continued to praise Millais's work at the Royal Academy. This culminated in his review of the 1856 exhibition, where he suggested that *Peace Concluded*, 1856 (Minneapolis Institute of Arts) and *Autumn Leaves* (Manchester City Art Galleries) would 'rank in future among the world's best masterpieces'. He went on to speculate: 'I am not sure whether [Millais] may not be destined to surpass all that has yet been done in figure painting, as Turner did all past landscape' (14.56). This was praise indeed, but the hopes it raised for the future were thrown into doubt the following year.

In 1857 Millais's chief exhibit was the elegiac large depiction of a chivalrous knight bearing children on his horse across a river. Abandoning the absolute fidelity to detail of his earlier works, Millais here introduced a much broader style, painting the expressive background from nature on the banks of the Tay in around a fortnight (Bennett 1988, p.132). A poem in the exhibition catalogue suggested that the subject was taken from a medieval romance, though in fact this had been specially written by the journalist Tom Taylor (1817–80).

Most critics were bemused by the picture, but none was quite so damning as Ruskin, who covered many pages of his *Academy Notes* with exasperated observations of what he felt were its shortcomings, amongst which he also chastised Millais for his choice

of subject. However, the painting's crucial failing in his eyes was the betrayal of the early Pre-Raphaelite style: 'The change in his manner, from the years of "Ophelia" and "Mariana" [cat.6] to 1857, is not merely Fall – it is Catastrophe; not merely a loss of power, but a reversal of principle' (14.107). Essentially he considered the exhibited painting nothing more than a sketch or first draft that would need to be laboriously reworked; a perception that foreshadows his later disagreements with Whistler (cats.223, 224).

Millais was so deeply upset by Ruskin's criticisms that he admitted to having kicked the picture in a frenzy of frustration. Support of a satirical kind came his way shortly afterwards when the artist Frederick Sandys (1829–1904) produced a caricature of the painting (fig.12). In this the three mounted figures become Rossetti, Millais and Hunt, and instead of riding a horse they are shown sitting on an old braying donkey bearing the initials 'J.R. / OXON'. Sandys' joke was made more explicit in the old English parody appended to the image:

> 'A Tournor's asse he annes had bene,
> Millare him cleped Russet – skene,
> But dames y wis and men konninge,
> Cleped him Graund Humbugge.'

Millais's own dissatisfaction with the picture caused him to revise it several times. The state of the painting prior to the last of these changes is recorded in a small panel version of the image (private collection).

IW

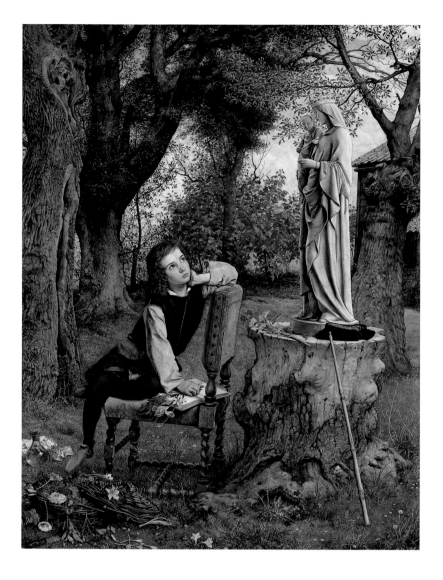

201

William Dyce
(1806–1864)

*Titian preparing to
make his first Essay
in Colouring*
1856–7

Oil on canvas
100 x 79

First exhibited
Royal Academy 1857

City of Aberdeen Art
Gallery and Museums
Collections

'Well done! Mr Dyce, and many times well done!'
(*Academy Notes*, 1857, 14.98).

In 1850 Dyce had 'dragged' Ruskin up to Millais's *Christ
in the House of His Parents* (cat.5) and forced him to look
for its merits (37.427–8). The reason for this unexpected
enthusiasm from a Royal Academician can be traced to
Dyce's Anglo-Catholicism and to his coming under the
influence of the Nazarene school during his visits to
Rome in the 1820s. From 1844 onwards he was occupied
with painting a series of frescoes on Arthurian themes
for the new Houses of Parliament, whose medievalism
influenced the Pre-Raphaelites. In 1850 he gave practical
assistance to Holman Hunt by paying him to copy his
Jacob and Rachel (whereabouts unknown; second version,
Leicestershire Museums and Art Gallery) and offered to
take him on as an assistant.

Dyce in turn was influenced by the Pre-Raphaelites'
use of colour, colour being the theme of *Titian preparing
his first Essay*. The story is that as a boy Titian used the
juice of flowers to colour a drawing of the Madonna;
Dyce makes a dramatic contrast between the mono-
chrome statue and the bright flowers, alluding to
Titian's future reputation (much emphasised by Ruskin)
as a colourist.

Ruskin took the success of Dyce's picture at the
Academy in 1857 as an indication of progress in his
campaign to promote his version of Pre-Raphaelitism.
He had dismissed Dyce's *Christabel* (Glasgow Art Gallery)
in 1855 as 'an example of one of the false branches of
Pre-Raphaelitism' (14.19), but in his long review of
1857 he declared the *Titian* 'the only one quite up to the
high-water mark of Pre-Raphaelitism in the exhibition
this year' (14.98). He praised its 'sculpturesque sense of
grace in form' as an innovation, but was critical of Dyce's
colour as insufficiently Venetian. He also cavilled at
Dyce's tidy and domesticated conception of the scene,
but having begun with 'Well done! Mr Dyce' he con-
cluded with a guarantee of the painting's value to a
mid-Victorian audience: 'It will take about an hour to
see this picture properly' (14.100). The review healed
a rift between the two men caused by Dyce's attack on
Ruskin's pamphlet *Notes on the Construction of Sheepfolds*
(1851; see cat.189) in his own *Notes on Shepherds and Sheep.
A Letter to John Ruskin Esq. M.A.* of the same year.

RH

202

John Brett
(1831–1902)

*The Glacier
of Rosenlaui*
1856

Oil on canvas
44.5 × 41.9

Inscribed, bottom left,
'John Brett Aug. 23/56'

First exhibited
Royal Academy 1857

Tate Gallery.
Purchased 1946

*'There are no natural objects out of which more can be thus
learned than out of stones … For a stone, when it is examined,
will be found a mountain in miniature'* (*Modern Painters* IV,
1856, 6.368)

In the fourth volume of *Modern Painters*, published in
April 1856, Ruskin lamented that no contemporary artist
seemed interested in creating representations that would
be of value to geologists: '[it is] only in ancient art that,
generally speaking, we find any careful realization of
Stones' (6.365).

These words were read by John Brett, who was just
then preparing his first exhibits for the Royal Academy,
where he had studied for the last two years. Brett
immediately seized the implicit challenge in Ruskin's
volume, and within a couple of months was on his way
to Switzerland. In his personal journal, he later described
this action as like being possessed by a passion that
would 'listen to no hindering remonstrance'. He was
already an admirer of Ruskin, whom he described as 'one
of the greatest lights of the age' after reading an earlier
volume of *Modern Painters* (quoted in Parris 1994, p.147).

Once in Switzerland he selected as his subject the
glacier of Rosenlaui, above Meiringen. According
to Murray's *Handbook for Travellers*, the glacier was
'celebrated above all others in Switzerland for the
untarnished purity of its white surface, and the clear
transparent azure of its icebergs'. This peculiarity
apparently arose from the characteristics of the surround-
ing rocks. In Brett's painting these include boulders of
both granite and gneiss (the latter is represented by the
larger stone with layers of curving lines). This confirms
the idea that he was drawn to the setting as a means of
illustrating Ruskin's book, which included an analysis
of precisely these rock types.

Brett's laborious precision in the painting was a
stylistic departure from his recent work, and was in
fact encouraged by Inchbold, another artist in thrall to
Ruskin (cat.211). Inchbold was painting in an adjacent
valley that summer, and lent Brett money so that he could
stay longer in order to complete the picture satisfactorily
before returning to London. Later that year the finished
work was seen by Rossetti, who took it to show to
Ruskin. The latter was clearly pleased to find the ideas
he had adumbrated in *Modern Painters* given such potent
visual form, and sent Brett a letter of appreciation. It is
all the more surprising, therefore, that he did not refer
to the picture in his *Academy Notes* when it hung at the
Royal Academy the following spring.

I W

203

James Campbell
1828–1893

The Wife's
Remonstrance

Oil on canvas
73.7 x 48.6

First exhibited
Society of British Artists
1858

Birmingham Museums
and Art Gallery. Presented
by the Trustees of the
Feeney Charitable Trust

*'By far the best picture in the Suffolk Street rooms this year, full
of pathos, and true painting'* (*Academy Notes*, 1858, 14.187)

Like Windus (cat.199), Campbell was a member of the
Liverpool Academy who came under the influence of the
Pre-Raphaelites, and gave his genre paintings a Pre-
Raphaelite edge. The poacher father and reproachful
mother and child are interlocked against a closed back-
ground in the manner of Millais's compositions, such as
cat.8 and cat.190. The foreground foliage on the right
has a Pre-Raphaelite intensity. Yet although Ruskin
praises the picture, he is put off by its socially conscious
subject matter, where the wife's grasp on her impover-
ished husband's guilty wrist suggests he will go to prison
for his crime: 'Campbell is unredeemably under the fatal
influence which shortens the power of so many Pre-
Raphaelites – the fate of loving ugly things better than
beautiful ones' (14.188). The comment has a bearing on
his note on Wallis's *The Stonebreaker* (cat.204), shown at
the Royal Academy the same year.

Ruskin mentioned works by Campbell in the 1856
and 1859 exhibitions of the Society of British Artists,
a less prestigious institution than the Royal Academy.
In 1858, as part of his campaign to promote Pre-
Raphaelitism, Ruskin intervened in the affairs of the
Liverpool Academy, where a dispute had broken out
among the members over the award of its 1857 prize
to Millais's *The Blind Girl* (1856, Birmingham Museums
and Art Gallery). Appealed to by Alfred William Hunt
(see cat.194), one of the pro-Pre-Raphaelite judges,
Ruskin wrote a letter subsequently published in the
Liverpool press: 'Let the Academy be broken up on the
quarrel; let the Liverpool people buy whatever rubbish
they have a mind to; and when they see, as in time they
will, that it *is* rubbish, and find, as find they will, every
Pre-Raphaelite picture gradually advance in influence
and in value, you will be acknowledged to have borne a
witness all the more noble and useful, because it seemed
to end in discomforture' (14.328). The Liverpool Academy
was broken up by the quarrel, in which Hunt's father was
on the opposing side.

RH

204

Henry Wallis
(1830–1916)

The Stonebreaker
1857–8

Oil on canvas
65.4 x 78.7

Inscribed with initials
in monogram 'HW 1857–8'

First exhibited
Royal Academy 1858

Birmingham Museums
and Art Gallery. Presented
by Rt. Hon. W. Kenrick

*'On the whole, to my mind, the picture of the year;
and but narrowly missing being a first-rate of any year'*
(*Academy Notes*, 1858, 14.170)

The Stonebreaker was originally exhibited without any
title, but the socially-conscious nature of the subject –
the dead body of a pauper, forced to work under the
Poor Law regulations – was underlined by a quotation
in the Royal Academy catalogue from Thomas Carlyle's
Sartor Resartus (1833–4): 'Hardly-entreated Brother! For
us was thy back so bent, for us were thy straight limbs
and fingers so deformed; thou wert our Conscript,
on whom the lot fell, and fighting our battles wert so
marred' (Carlyle 1996, p.181).

Carlyle (1795–1881) was an admired figure in Pre-
Raphaelite circles (see cat.212), a close friend of Ruskin's
and a profound influence on the development of his
social thought. Yet Ruskin's comments both on Wallis's
painting and John Brett's *The Stonebreaker* (fig.13), also
shown at the Royal Academy in 1858, while praising
both pictures, make almost no mention of their social
context. The reason for this paradoxical evasion of social
issues by the future author of *Unto This Last* (1860) may

be found in his general comment in 1858: 'I look with
deep respect and delight on the steady purpose of doing
good, which has thus in a few years changed the spirit
of our pictures, and turned most of them into a sort of
sermons; – only let it always be remembered that it is
much easier to be didactic than to be lovely, and that it
is sometimes desirable to excite the joy of the spectator
as well as his indignation' (14.154).

RH

fig.13 John Brett, *The Stonebreaker*, 1858, Board of
Trustees of the National Museums and Galleries
on Merseyside (Walker Art Gallery, Liverpool)

205

Pierre Edouard Frère
(1819–1886)

The Evening Prayer
1857

Oil on panel
46.5 x 38.5

Inscribed 'Ed. Frère 57'

First exhibited
French Gallery,
121 Pall Mall, 1857

Rijksmuseum, Amsterdam

'I cannot tell how I am ever to say what I want to say about Frère's pictures; I can find no words tender enough nor reverent enough' (*Academy Notes*, 1857, 14.142)

The French genre painter Edouard Frère was one of the few contemporary foreign artists Ruskin discussed, or approved of, and is the only one represented in this catalogue. The annual 'French Exhibition' had been established in 1854 by the leading picture-dealer Ernest Gambart (1814–1902), who made large sums of money from exhibiting Holman Hunt. Gambart recognised Ruskin's power as a critic, and got him to write the letter-press for a new edition of Turner's unfinished series of engravings of southern ports, *The Harbours of England*, published in 1856 (cat.60). Ruskin, who also met the leading French woman artist Rosa Bonheur (1822–99) through Gambart, began to review the French Exhibition the following year. In 1859 the entrepreneurial Gambart set up and managed a lecture tour by Ruskin to Manchester and Bradford.

In his review of Frère in 1857 Ruskin admitted, 'the reader may be surprised at my caring so much for what seems slight in work and poor in colour. But its very poverty and slightness are, in some sort, a part of its beauty' (14.142). The humble sentiment and subject matter of *The Evening Prayer* plainly touched him in a way Campbell (cat.203) or Wallis (cat.204) did not. However, his opinion of Frère changed for the worse. Ten years later, in his lecture on 'Modern Art', he cited Frère as an example of the 'Compassionateness' of contemporary art (19.198), which, with its domesticity, sensationalism and shallow emotions, was weak in comparison with the nobler art of the past, or of painters like Turner, Rossetti and Burne-Jones, who sought to learn from and emulate it.

As for the depiction of poverty by artists such as Frère, 'The beginning of all ideal art must be for us in the realistic art of bestowing health and happiness. The first schools of beauty must be the streets of your cities, and the chief of our fair designs must be to keep the living creatures round us clean, and in human comfort' (19.214–5). Ruskin was advocating direct social action, unmediated by art.

RH

206

Edward William Cooke
(1811–1880)

Sunset on the Laguna of Venice, San Giorgio in Alga and the Euganean Hills in the distance
1857

Oil on canvas
65 x 105

Inscribed 'CH'

First exhibited
Royal Academy 1858

Maureen Mitchell
trading as Anthony
Mitchell Fine Paintings

'I can answer for the truth of this study, representing one of the calm sea-glories of Venice, which painters are too apt to despise, though poets never' (Academy Notes, 1858, 14.169).

Cooke was a successful marine painter, elected to the Royal Academy in 1854. Ruskin had met him in Venice in 1851, describing him to his father as 'A most curious small man. Good – and kind – and pious – but a perpetual buz from one thing to another' (RLV.58). Ruskin was impressed by Cooke's concern for architectural accuracy: 'I have led him to look into the detail – and he is as enthusiastic as I am' (RLV.58–9).

This personal acquaintance may account for Ruskin's largely favourable notices of Cooke in *Academy Notes*, but the subject matter here would have caught his attention, for two years before Ruskin had used a drawing of his own of the same view at sunset as the basis for plate xv in the third volume of *Modern Painters* (fig.14). Hence his judgement of the accuracy of the view. His praise for *Sunset on the Laguna of Venice* shows Ruskin's willingness to go outside the immediate Pre-Raphaelite circle in search of merit. In his introductory comments on the 1858 Academy exhibition, he remarked on there being 'hardly a single interesting sky in the whole gallery', citing Cooke's acknowledgement of 'the existence of clouds as a matter of serious interest' (14.153).

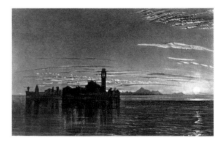

fig.14 Thomas Lupton after John Ruskin,
St George of the Seaweed (*Modern Painters* III, pl.xv)

RH

207

John Brett

Val d'Aosta
1858

Oil on canvas
87.6 x 68

Inscribed 'John Brett 1858'

First exhibited
Royal Academy 1859

Acquired by Ruskin
1859–60

Lord Lloyd-Webber

'If he can make so much of [chalk flint], what will Mr Brett not make of mica slate and gneiss! If he can paint so lovely a distance from the Surrey downs and railway-traversed vales, what would he not make of the chestnut groves of the Val d'Aosta! I heartily wish him good-speed and long exile'
(*Academy Notes*, 1858, 14.172)

With these remarks Ruskin concluded his review of Brett's picture *The Stonebreaker* (fig.13) in the 1858 Royal Academy exhibition (Walker Art Gallery, Liverpool). The specific reference to the Val d'Aosta reveals that he was privy to Brett's immediate plans, which had quite probably been shaped by Ruskin's own decision to travel to nearby Turin. From there he would be close enough to superintend Brett's work regularly during the summer (Staley 1973, p.128). The choice of location may also have been affected by the details Ruskin had recently learnt of Turner's trip to the Val d'Aosta in 1836 (7.446–7n). Having failed in his attempts to make Millais take on Turner's mantle, he perhaps hoped to be more successful with Brett and this Turneresque setting.

Brett arrived at the Château St Pierre, close to Villeneuve, by the end of June and took rooms there in the ancient fortress. The castle was already known to Ruskin, who had sketched its battlements as a sixteen-year-old, back in 1835 (14.xxiv; repr. 2.pl.21). Turning away from such obviously picturesque material, Brett focused in his painting on some very Ruskinian lichenous

boulders, beyond which the view stretches away up the Dora Baltea valley, culminating in the peaks of Monte Paramont and the snow-capped Testa du Rutor to the west.

His progress on the canvas was appraised by Ruskin in August, when the critic sought to chivvy Brett towards his own ideals for landscape, much as he had done with Inchbold a year earlier (cat.211). He admitted to his father, 'He is much tougher and stronger than Inchbold, and takes more hammering; but I think he looks more miserable every day, and have good hope of making him completely wretched in a day or two more – and then I shall send him back to his castle' (14.xxiii–xxiv).

In spite of these initial disappointments, the finished picture is perhaps the most perfect realisation of Ruskin's hopes for 'historical landscape', by which he meant a type of painting that would offer the viewer precise information about the scene depicted (he had earlier praised Seddon for similar achievements; cat.195). This was the chief point he made in his long review of the picture in the *Academy Notes* for 1859: 'So if any simple-minded, quietly-living person, indisposed towards railroad stations or crowded inns, cares to know in an untroubled and uncostly way what a Piedmontese valley is like in July, there it is for him' (14.235).

The picture represents a watershed in the development of Ruskin's aesthetic, for while the first part of his review sang its praises as a piece of factual representation, he went on to regret that Brett had not managed to instil the scene with any profoundly expressed emotion of the kind he had demonstrated to be the essence of Turner's work (cats.55–7): 'I never saw the mirror so held up to Nature; but it is Mirror's work, not Man's' (14.237).

Ruskin's verdict found echoes in many quarters, not least from Millais, who considered the painting 'a wretched work like a photograph'. Writing in the *Critic*, one reviewer went so far as to describe the picture as 'Truly an epitaphical gravestone for Post-Ruskinism'. As a result of all this Brett was unable to sell his work until Ruskin took pity on him in November 1859, when he offered him £200, followed by a further £50 the following June.

Although Ruskin referred to Brett as 'one of my keenest-minded friends' in the final volume of *Modern Painters* (1860: 7.360), relations between them subsequently cooled. Their difference of outlook intensified as Brett, following the path already taken by Millais, went on to paint subjects that Ruskin dismissed as overlarge sketches. In 1869, five years after an exchange of insults, Ruskin tried to sell the *Val d'Aosta*, but as the painting failed to reach its reserve, it in fact remained in his collection until his death.

IW

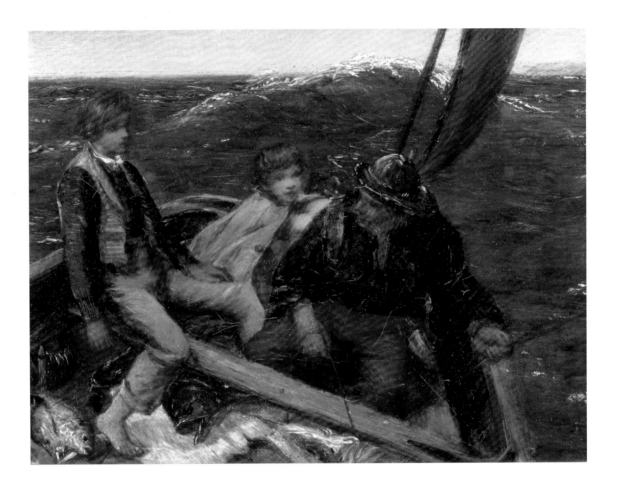

208

James Clarke Hook
(1819–1907)

Luff, Boy!
1859

Oil on canvas
17.8 x 22.2

Small version painted by
the artist as a replica of the
original first exhibited at
the Royal Academy 1859

Royal Pavilion, Libraries
and Museums, Brighton
and Hove

'A glorious picture – most glorious!' (*Academy Notes*, 1859, 14.228)

Hook was a popular painter who began by painting in an Italianate manner, but then adopted a more Pre-Raphaelite naturalism during the 1850s (cat.209). In 1855 he made his first visit to Clovelly in North Devon and painted the first of his 'Hookscapes', paintings of fishermen and the sea for which he became famous. The original version of *Luff, Boy!* (62.2 x 92.2, private collection), of which this is an artist's small-scale copy, was painted at Clovelly in 1858. Ruskin had favourably commented on Hook in his *Academy Notes* for 1855, 1857 and 1858, but his enthusiasm for the picture derived as much from contemporary events as from the picture itself.

As in 1852, when Holman Hunt painted *Our English Coasts* (cat.189), there was a war scare because of Napoleon III's meddling in the Italians' struggle for independence from Austria. Ruskin's comment on *Luff, Boy!* begins, 'War with France? It may be; and they say

good ships are building at Cherbourg. War with Russia? That also is conceivable' (14.228). In the face of Napoleon III's naval building programme, Ruskin's nationalist ardour led him to interpret the painting in terms far from the painter's mind: 'If our enemies want to judge of our proved weapons and armour, let them come and look here. Bare head, bare fist, bare foot, and blue jacket! If these will not save us, nothing will!' (14.228).

Ruskin, however, was not alone in responding to contemporary events. Tennyson's poem 'Riflemen, Form!', calling for a volunteer Rifle Corps, was published in *The Times* on 8 May, 1858; Ruskin's *Academy Notes* were issued on 9 May. An Artists' Corps of Volunteers was established, which Rossetti, Morris, Holman Hunt and Burne-Jones joined, and of which Ruskin became an honorary member. Ruskin thought the Rifles 'The only thing to save us from our accursed commerce – and make us men again instead of gold shovels' (s1.225). He resigned, however, in January 1861.

RH

209

James Clarke Hook

The Brook
1859

Oil on canvas
67 x 105.5

Inscribed '18JCH59'

First exhibited
Royal Academy 1859

Private collection,
Greenwich, Connecticut

'The distant landscape in that brook scene is one of the sweetest ever found by painter —for found it evidently is, not composed' (*Academy Notes*, 1859, 14.229).

Ruskin's praise for *Luff, Boy!* (cat.208) almost certainly encouraged Hook to concentrate on seascapes henceforward, but Ruskin also favourably mentioned *The Brook* in the same review. The painting shows the extent to which Ruskin's view of what constituted a 'Pre-Raphaelite' manner had become established beyond the Pre-Raphaelite circle by the end of the 1850s. It depicts an actual scene near Chiddingfold in Surrey; the setting is closely observed and, as Ruskin points out, satisfyingly naturalistic rather than contrived. On the other hand, the choice and arrangement of the figures in the picture have been calculated to have symbolic meaning.

The painting was first exhibited without a title, but the Royal Academy catalogue printed lines 182–5 from Tennyson's 'The Brook' (1855):

> And out again I curve and flow,
> To join the brimming river;
> For men may come and men may go,
> But I go on for ever.

The figures represent the stages of life, from babyhood on the right to old age on the left, and are shown in relation, to use Ruskin's title in *Academy Notes*, to the 'Brook of Human Life' (14.229) that the cart is about to ford. Though not in Ruskinian terms a 'noble' subject, the 'sweetness' of the scene derives partly from the moral drawn on the theme of continuity and renewal.

RH

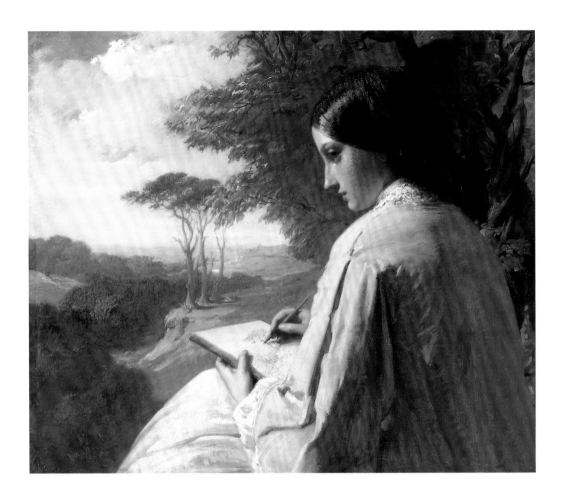

210

Henry Le Jeune
(1819–1904)

*A Young Lady
sketching in
a landscape*
Late 1850s

Oil on canvas
26.5 x 31.5

Inscribed with
the artist's name

Private collection

*'You will see that all the boughs of the tree are dark against the
sky. Consider them as so many dark rivers, to be laid down in a
map with absolute accuracy; and, without the least thought about
the roundness of the stems, map them all out in flat shade,
scrawling them in with pencil, just as you did the limbs of your
letters'* (*The Elements of Drawing*, 1857, 15.40)

The instructions that Ruskin set down for amateurs in
his 1857 manual *The Elements of Drawing* proved hugely
influential with their immediate audience, and moreover,
as a result of recent reprints, continue to exert an
influence today. Founded on Ruskin's own progress as
a draughtsman, and his real skill in tutoring the patient
hand, the book offers a programme of exercises intended
to instil in its readers the value of a thorough scrutiny of
natural forms.

Henry Le Jeune was one of the thousands of men
and women who read this book, which in his case had
a special interest. He was himself a drawing master, and
had acted in this capacity at the Royal Academy from
1845, becoming the institution's curator three years later,

though he was only elected an Associate in 1862. His
aspirations to produce history paintings seem to have
been admired by Ruskin, who praised the biblical subject
that Le Jeune submitted to the 1856 exhibition
(14.69–70).

Though this picture seems at first glance to be
simply a charming study of a young woman sketching
from nature, it is actually a tribute to Ruskin's teaching
methods, making direct reference to one of the
illustrations in *The Elements of Drawing*. As explained
under cat.61, Ruskin had recommended the trees in
Turner's painting *Crossing the Brook* as a model for study,
but here the young woman seems to be working from
an incongruous group of pine trees that are themselves
an approximation of Ruskin's engraving (fig.4).

It should be noted that, at a time when women were
attempting to make advances as professional artists,
Ruskin played an important role as a generally sympath-
etic advocate of their work, inspiring many to continue
in their endeavours (Marsh and Gerrish Nunn 1998).

IW

211

John William Inchbold

The Lake of Lucerne, Mont Pilatus in the Distance
1857

Oil on panel
35.5 x 48.8

Inscribed
'I.W.Inchbold / 57'

Probably first exhibited
Liverpool Academy 1860

The Board of Trustees
of the Victoria and Albert
Museum

'Switzerland has done him no good'
(Letter to his father, 11 June 1858, 1858L.38)

The Lake of Lucerne is the only surviving painting from three visits Inchbold made to Switzerland between 1856 and 1858. As with Brett (cat.207), the decision to paint Alpine scenery was inspired by volume IV of *Modern Painters* (1856) and Ruskin part-financed these journeys by commissioning drawings, and giving the artist hospitality when they met at Lauterbrunnen in 1856; in 1858 at Fluelen on the Lake of Lucerne and Bellinzona in Italy. But after Ruskin's initial enthusiasm for Inchbold as a Pre-Raphaelite landscape painter, these meetings led to disenchantment.

The commissioned drawings were a disappointment. Ruskin told his father in 1858 that Inchbold had 'got entirely off the rails at Chamouni ... I stayed with him some time, or rather made him stay with me at Bellinzona, in order to make him understand where he was wrong. He was vexed with his work and yet thought it was right, and didn't know why he didn't like it, nor why nobody liked it. It was a delicate and difficult matter to make him gradually find out his own faults – (it's no use *telling* a man of them) and took me a fortnight of innuendoes. At last I think I succeeded in making him entirely uncomfortable and ashamed of himself' (1858L.121).

This well-intentioned bullying, to which Brett was also subjected (see cat.207), cannot have suited Inchbold's uneasy temperament. The reasons for Ruskin's disappointment are evident in the lack of architectural rigour in a surviving example of a commissioned Swiss drawing (private collection), and *The Lake of Lucerne* which, as Christopher Newall has pointed out, was painted *without* Ruskin's guidance (Newall 1993, p.53). It lacks the mountain gloom and mountain glory of Brett's *Glacier of Rosenlaui* (cat.202), the foreground vine-leaves are weak, and the pale tone shows Inchbold abandoning Pre-Raphaelite intensity, the direction his art was later to take. According to Newall, Inchbold 'did not bear a grudge against Ruskin for the ill treatment he received', preserved drawings by Ruskin from their time together and remembered him in his will (Newall 1993, p.15).

RH

212

Ford Madox Brown
(1821–1893)

Work
1852, 1856–63

Oil on canvas, arched top
137 × 197.3

Inscribed
'F.MADOX BROWN 1852–/65'
Inscribed on the original
frame, 'Seest thou a man
diligent in his business, He
shall stand before kings',
and 'In the sweat of the
face shalt thou eat bread'

First exhibited
Brown's one-man show
at 191 Piccadilly in 1865

Manchester City Art
Galleries

'*Do not buy any Madox Brown at present. Do you not see that
his name never occurs in my books – do you think that would be
so if I could praise him, seeing that he is an entirely worthy
fellow? But pictures are pictures, and things that arn't arn't*'
(Letter to Ellen Heaton, 12 Mar. 1862, 36.406)

Though the working lives of Ford Madox Brown and
Ruskin frequently overlapped, they never enjoyed a close
or happy relationship. To some extent, this was because
they approached the same key contemporary issues from
radically different positions. Brown's early training had
given him practical experience of recent trends of con-
tinental art, as well as a deep respect for the so-called
'primitives' of the northern school, knowledge of which
he was able to pass on to his pupil D.G. Rossetti. This
background also encouraged him to challenge Ruskin's
aesthetic opinions in an article in the *Builder* in 1848,
setting the combative tone of their association.

In the early 1850s the initial burst of Ruskin's interest
in the artists of the Pre-Raphaelite circle did not radiate
out as far as Brown. Even before they met in 1855, he
was critical of pictures such as *Jesus Washing Peter's Feet*
(1852, Tate Gallery), and then more pointedly of Brown's
'ugly' Hampstead landscape, though this was ostensibly
painted following Ruskin's advice to record nature
uncritically, as it lay before the artist (see p.203).

The painting *Work* was also inspired by a scene in
Hampstead in 1852, although it was not completed until
more than a decade later. Here the view of Heath Street

is peopled by a cross-section of society as a means of
celebrating the value of work, while simultaneously
contrasting the dignity of the labourers toiling in the
foreground with the peripheral figures, who benefit from
their efforts (Treuherz 1987, pp.31–3). Ruskin's pamphlet
Pre-Raphaelitism (1851) had included a similar eulogy of
the working man, which, like Brown's painting, was
derived in essence from the ideas of Thomas Carlyle
(1795–1881), particularly his book *Past and Present* (1843).
Fittingly, Carlyle appears on the right of the canvas,
looking out at the viewer. His presence had actually been
requested by the collector T.E. Plint, but Brown rejected
his suggestion that the writer Charles Kingsley (1819–75)
should also appear, and instead introduced the Founder
and Principal of the Working Men's College, F.D.
Maurice (see cat.109).

From its beginnings, Ruskin taught at the College,
where Brown noted grudgingly he was 'wildly popular
with the men'. Though Brown admired the aims of
the institution, he had at first resisted any involvement
because of his antipathy for Ruskin. However, from
October 1858 he took over Rossetti's drawing class,
seeking to counter aspects of Ruskin's teaching
programme.

Meanwhile, though Ruskin himself declined to buy
Brown's pictures, and discouraged important patrons,
such as Ellen Heaton, his father had bought in 1857 a
preparatory drawing for Brown's now untraced *Beauty
before She became Acquainted with the Beast*.

IW

213

Albert Goodwin
(1845–1932)

*Venezia – from
Riva Schiavoni*
1896

Oil on canvas
100 X 120

Inscribed '96'
and 'Venezia –
from Riva Schiavoni'

Private collection

*'Ruskin did me the honour soon after I first knew him, to ask me
to come and give him a lesson in watercolour painting. It was a
flattering way of inviting me, and I went'* (Albert Goodwin's
diary, 17 March 1909, Goodwin 1934, p.105).

Goodwin became a professional painter after a Pre-
Raphaelite apprenticeship with Arthur Hughes, to whom
he had been introduced by Holman Hunt, and then with
Ford Madox Brown. Hughes probably introduced him to
Ruskin, who in 1871 proposed taking him to Switzerland
and Italy but, prevented by the Franco-Prussian war,
invited him instead to Abingdon, where Ruskin was
staying while carrying out his duties as Slade Professor
at Oxford. Ruskin bought two drawings made at this
time for the Drawing School (Ashmolean Museum).
Goodwin then accompanied Ruskin to Matlock where
Ruskin fell severely ill (see cat.232). In 1872 Goodwin
travelled on the continent with Ruskin's party for three
and half months, visiting Florence, Rome and Venice.
Their friendship lasted until Ruskin's incapacity in the
1890s.

 Ruskin bought work by Goodwin for the Guild
of St George (now lost), but did not employ him as a
copyist, contrasting Goodwin's 'flying memoranda' with
the careful copies made by other artists for the Guild
(30.178). As in the case of Goodwin's friend Alfred
William Hunt (see cat.194), Ruskin was interested in him
as a sensitive and imaginative landscape artist capable
of 'Pre-Raphaelite veracities' (14.434) and 'Turnerian
precision' (33.405).

 Goodwin, who had a strong religious sense, felt
guilty about his love of colour, and in 1872 was made by
Ruskin to concentrate on drawing. He wrote in the year
of Ruskin's death, 'I owe much thanks to Ruskin, who
ballyragged me into love of form when I was getting too
content with colour alone; and colour alone is luxury.
Liberty, which, too much used, ends in licentiousness.
The study of form is the needful curb to check this'
(Goodwin 1934, p.37). Goodwin believed that Ruskin's
own love of bright colour blinded him to Whistler's
sense of tone and values (see cats.223, 224), though 'the
plane on which Ruskin stood was immeasurably higher'
(Goodwin 1934, p.448). He tried to learn from Whistler
as well as Ruskin, while the influence of Turner was
never far away, as this view of Venice at night shows.

 RH

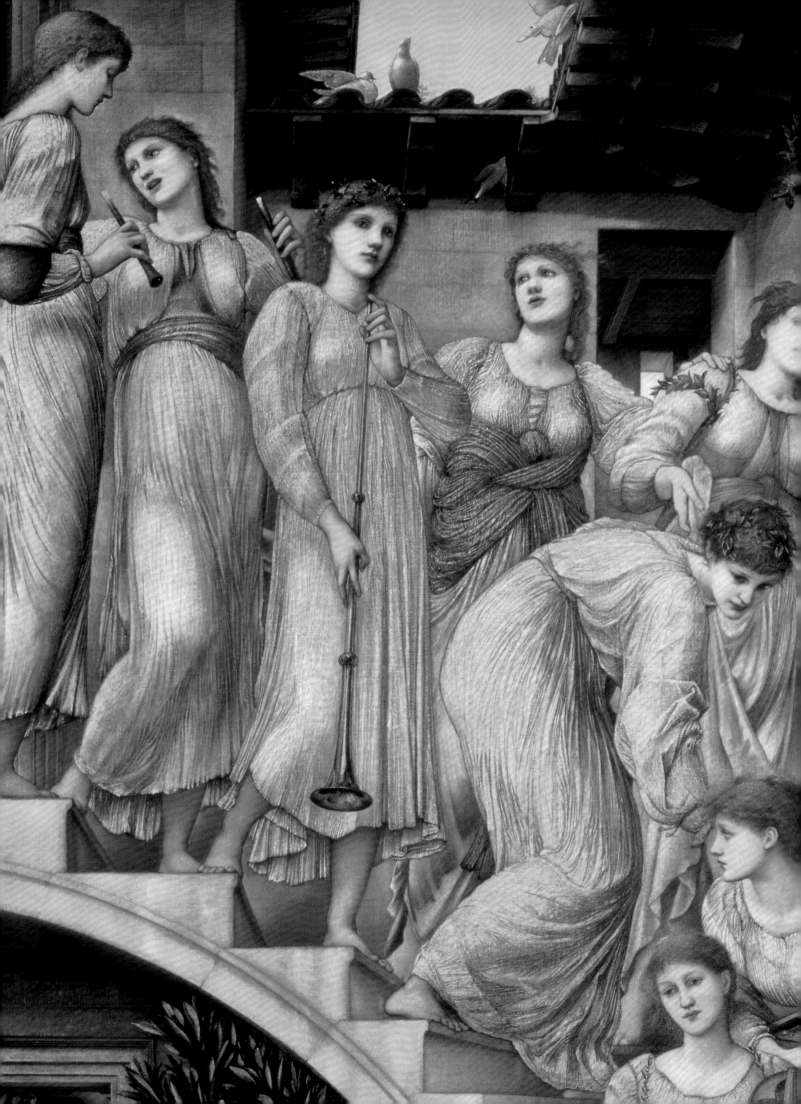

VIII

A New Era of Art

'the highest truths and usefullest laws must be hunted for
through whole picture-galleries of dreams'

After Ruskin published the final volume of *Modern Painters* in 1860, he turned his attention from the visual economy to the political economy that supported it, beginning with his most celebrated work of social criticism, *Unto This Last*. For five years he was silent, in print at least, on matters of art. His silence reflected a crisis felt throughout Victorian culture as a confident materialism became undermined by religious doubt. Ruskin's abandonment of Evangelical Protestantism in 1858 was part of a wider shift in feeling. Artists sought new forms of transcendental expression, finding inspiration in an imaginary past. Beauty became the new religion, art for art's sake its doctrine. From these cross-currents there emerged the Aesthetic movement, which reached its apogee in 1877 when Sir Coutts Lindsay opened the commercial Grosvenor Gallery as a 'palace of art' in order to challenge the authority of the official exhibiting bodies and find new patrons for the contemporary avant-garde.

Ruskin's attack on Whistler's work there, and his defeat in the libel case that Whistler brought against him, appeared to signal that he had lost touch with contemporary art. But Ruskin had always insisted on the higher importance of the imagination, and in the later 1860s he advocated an approach to painting that became one of the strands within the art of the 1870s. Part VIII shows that Ruskin's relationship with the artists associated with the Aesthetic movement was more complex, and more positive, than the clash with Whistler suggests.

As early as 1856 Ruskin had suggested that works by Rossetti and G.F. Watts represented 'the dawn of a new era of art' (5.137). These were not in the naturalistic mode popular at the Royal Academy, nor did they deploy Holman Hunt's symbolic realism. They were works of the imagination, at the same polarity in Ruskin's aesthetic as Turner's visionary allegories, with which he compared them (see cat.4). They presented neither the natural world, in terms of landscape, nor the contemporary world, in terms of people or events, but an ideal world constructed out of images drawn from the past, in order to render atmospheres and emotions rather than tell stories.

Ruskin was not alone in being drawn more and more to the art of Ancient Greece. He, like others, had become tired of the romantic medievalism of the 1850s. His imaginary Greece was constructed out of the sculpture, pottery and coins that he knew, but above all from mythology, which allowed him to invest the natural world with numinous qualities, as in his celebration of Athena in his book *The Queen of the Air* (1869). His interpretation of Greek mythology filled the gap torn by the loss of his literalist faith, so that 'the gods' became 'the totality of spiritual powers, delegated by the Lord of the universe' (35.558n).

Ruskin's appreciation, however, did not extend to the supposedly archaeologically correct realism of a painter like Lawrence Alma-Tadema (1836–1912). Ruskin's Hellenism was still clothed in the religious art of Italy, with which he saw an essential continuity, a continuity broken by the Roman – not Greek – Renaissance. Since becoming 'a conclusively *un*-converted man' (29.89), as a result of his study of Veronese in Turin in 1858, he found new values in the Venetian masters. In his first Oxford lectures in 1870 he set up a dialectical opposition between 'line and light' represented by the Greek and 'line and colour' represented by the Gothic, neither of which was complete in itself, but which in synthesis became the 'Mass, Light and Colour' of the Venetian school (20.126–9).

This was the synthesis he urged on Burne-Jones. The results can be seen here. For Ruskin, Burne-Jones was an exemplar of the necessary balance between 'constant and dramatic art' (19.203), where constant art retained a classical repose and tranquillity that tempered the drama of pictorial narrative, while none the less evoking moods of pleasure, languor or unease. These are the values embraced by the Aesthetic movement, whose acknowledged leader Burne-Jones became with the opening of the Grosvenor Gallery.

The idea of a picture that appeared to do *nothing* (cat.223, 224), however, was beyond Ruskin's comprehension. Whistler's legal victory over his critic, who advocated not only the Beautiful, but the True, has obscured Ruskin's contribution to Aestheticism ever since.

RH

Sir Edward Coley Burne-Jones, Bt (cat.220, detail)

fig.15 D.G. Rossetti,
Bocca Baciata 1859
(Courtesy, Museum of Fine Arts, Boston.
Reproduced with permission. © 1999
Museum of Fine Arts, Boston. All Rights
Reserved)

214

Dante Gabriel Rossetti

Regina Cordium
1860

Oil and gold leaf
on panel
26 x 21.5

Inscribed 'Regina
Cordium'

Acquired by Ruskin
1860

Johannesburg Art Gallery,
Johannesburg, South Africa

'Yes, Rossetti's a great–great fellow and his wife's as charming as the reflection of a golden mountain in a crystal lake which is what she is to him' (Letter to G.F. Watts, 5 Nov. 1860, Chapman 1945, p.155)

Rossetti painted this portrait of Elizabeth Siddal shortly after their marriage. It was acquired by Ruskin, who kept it until his death. The composition and treatment bears a strong resemblance to Rossetti's portrait of his model and mistress Fanny Cornforth painted the previous year, *Bocca Baciata* (fig.15) (Museum of Fine Arts, Boston). That better-known portrait has rightly been described as 'a landmark in the emerging Aestheticism of the post-Pre-Raphaelite era' (Wilton & Upstone 1997, p.96), but Rossetti modelled the tilting of the head on an earlier watercolour, owned by Ruskin, *Golden Water* (1858, Fitzwilliam Museum, Cambridge). Ruskin was therefore in a position to witness at first hand the turn in Rossetti's style towards the Aesthetic portraits of the 1860s and 1870s, and his purchase and retention of this image show that the change did not repel him, even if the identity

of the sitter may have been a motive for the acquisition.

Ruskin's comment to Watts shows that in 1860 he still regarded Rossetti as a friend. Rossetti, however, was critical of Ruskin behind his back, describing his first essay on political economy in the *Cornhill* (reprinted in book form as *Unto This Last*), as 'bosh' (Doughty & Wahl 1965–7, vol.1, p.371). The relationship deteriorated after Siddal's death in February 1862, and in 1865 the portrait of Siddal contributed to the break between them. Rossetti accused Ruskin of selling off some of his pictures, to which Ruskin replied, 'Am I so mean in money matters that I should sell Lizzie? You ought to have painted her better, and known me better. I'll give you her back any day that you're a good boy, but it will be a long while before that comes to pass' (36.489). After a further exchange of letters in which Ruskin expressed his distaste for Rossetti's bare-breasted *Venus Verticordia* (1864–8, Russell-Cotes Art Gallery, Bournemouth), he told Rossetti they could not 'be companions any more, though true friends, I hope, as ever' (36.493).

215

Dante Gabriel Rossetti

Beata Beatrix
1864–70

Oil on canvas
86.4 x 66

Inscribed 'DGR'
in monogram.
Frame designed by the
artist, inscribed top 'Jun:
Die 9: Anno 1290',
bottom 'Quomodo sedet
sola Civitas!' ('How doth
the city sit solitary!',
Lamentations 1.1)

First exhibited
Royal Academy Rossetti
retrospective 1883

Tate Gallery. Presented
by Georgiana, Baroness
Mount-Temple in memory
of her husband, Francis,
Baron Mount-Temple 1889

'All the mythic scenes which he painted from the Vita Nuova *and*
Paradiso *of Dante, are of quite imperishable power and value'*
('The Three Colours of Pre-Raphaelitism', 1878, 34.168)

In December 1866 Ruskin attempted to resume his
friendship with Rossetti, and, encouraged by the artist's
brother William Michael Rossetti, on 5 December visited
his studio in Cheyne Walk. W.M. Rossetti recorded,
'I was not present, but learned that 'all went off most
cordially – Ruskin expressing great admiration of the
Beatrice in a Death-trance' [*Beata Beatrix*] on which my
brother was then engaged' (Rossetti 1895, vol.1, p1.262).
Although the visit was not followed up, there were
occasional further contacts between the critic and artist.

The work was a *post-mortem* tribute by Rossetti to
his wife. He had begun the canvas while Siddal was
still alive, but laid it aside. He was persuaded to take it
up again, probably in 1864, by Charles Augustus Howell
(1839–90). For some time after the death of Ruskin's
father in 1864, the notoriously fraudulent Howell acted
as Ruskin's secretary. By 1866 the painting had become
a commission for Ruskin's friend William Cowper-
Temple, possibly as a result of Ruskin's introduction.

Rossetti wrote to Mrs Georgiana Mount-Temple in
1871, 'You are well acquainted with Dante's *Vita Nuova*

which it illustrates, embodying, symbolically, the death
of Beatrice, as treated in that work. It must of course be
remembered, in looking at the picture, that it is not at
all intended to represent Death, ... but to render it under
the resemblance of a trance, in which Beatrice seated at
the balcony over-looking the City is suddenly rapt from
Earth to Heaven' (Surtees 1971, p.93–4). Florence's Ponte
Vecchio is discernible in the background. On the right
Dante looks across to the figure of Love. A sundial
symbolises the passing of time and a dove, emblematic
of the Holy Spirit, bears a white poppy, suggesting sleep
(and the laudanum from which Siddal died).

Ruskin's use of the word 'mythic' to describe
Rossetti's approach to Dante and his admiration for this
painting show that he approved of the proto-symbolist
development in Rossetti's work. A further reason for
appreciating an image of a trance-like state was that in
1864 the Cowper-Temples, who were leading figures
in the burgeoning spiritualist movement, had begun
inviting Ruskin to seances, while at the same period
Rossetti was also attempting to contact his dead wife
in this way. It explains not only the Cowper-Temples'
interest in the painting, but Ruskin's willingness to
engage with visionary art.

216

George Frederick Watts
(1817–1904)

Psyche
1880

Oil on canvas
188.6 x 59.7

First exhibited
Grosvenor Gallery 1880

Tate Gallery. Presented by
the Trustees of the Chantry
Bequest 1882

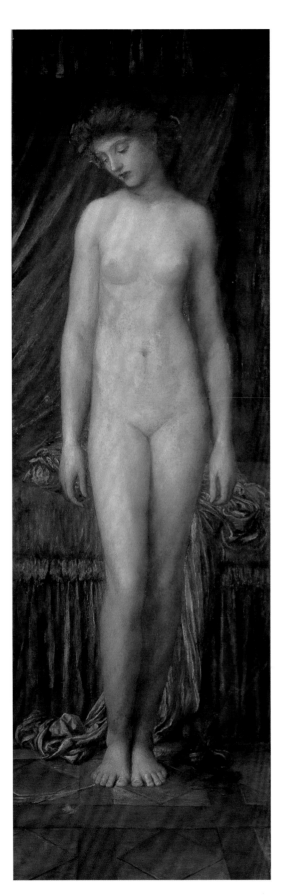

'*When we have only an idea to paint, or a symbol, I do not feel
authorised to insist any longer upon those vulgar appearances,
or mortal and temporal limitations*' (*The Art of England*, 1884,
33.298)

Ruskin first met Watts in 1847; their last contact was
in 1893, when illness prevented Watts from beginning
a long-intended portrait. Close contemporaries, they
both were marked by Evangelical childhoods, and had
unconsummated marriages. In 1871 Watts, always a
devoted reader of Ruskin, was one of the first to offer to
help the Guild of St George. A little-known connection
is that through their interest in spiritualism they both
became honorary members of the Institute for Psychical
Research founded in 1882: Watts in 1884, Ruskin in 1887.

Ruskin's appreciation of Watts fluctuated, as a remark
about the painter's 'genius' in 1855 shows (see cat.116).
Watts, who was chiefly known as a portrait painter until
Love and Death (Tate Gallery) made such an impression at
the opening of the Grosvenor Gallery, showed a portrait
drawing of Effie Ruskin at the Royal Academy in 1851
(National Trust, Wightwick Manor). Ruskin bought
an oil sketch, *Michael the Archangel contending with Satan*
(whereabouts unknown), at this time and borrowed one
of his earliest allegorical works, *Time and Oblivion* (1848,
Eastnor Castle). None the less he urged Watts 'to study
botany not Phideas' (Barrington 1905, p.24). Watts's lack
of interest in Ruskinian 'fact' was a permanent issue
between them, but when in 1856 Ruskin linked Watts
and Rossetti as harbingers of 'a new era of art' (5.137),
it was in recognition of the symbolist tendencies in his
work. In 1875 Ruskin praised the monumental allegory
The Spirit of Christianity, dedicated to all the Churches (Tate
Gallery), though warning against further 'substituting
the sublimity of mystery for that of absolute majesty
of form' (14.266).

Ruskin encouraged Burne-Jones to learn from Watts
during the 1860s, and linked them as leaders of the
'mythic school' in his 1883 lectures, *The Art of England*
(1884). Privately he deprecated Watts's love of Greek
sculpture, telling him 'you must learn to paint more like
Titian!' (Chapman 1945, p.157). This allegorical figure
of Psyche ('spirit'), to be compared with Moore's classical
figures (cat.217) and works here by Burne-Jones (cats.219,
220), bears out Ruskin's point, for the face appears to
have been painted from a model, but the torso from a
cast. The reference to Titian is apposite: Ruskin praised
Titian's nudes in *Modern Painters* volume v (7.296–7).
Of the nude as subject matter, Ruskin commented in
1872, 'There is no question that if shown at all, it should
be shown fearlessly, and seen constantly' (22.234).

217

Albert Moore
(1841–1893)

Blossoms
1881

Oil on canvas
147.3 X 46.4

Inscribed with Moore's
anthemion signature-mark

First exhibited
Grosvenor Gallery 1881

Tate Gallery. Presented
by Sir Henry Tate 1894

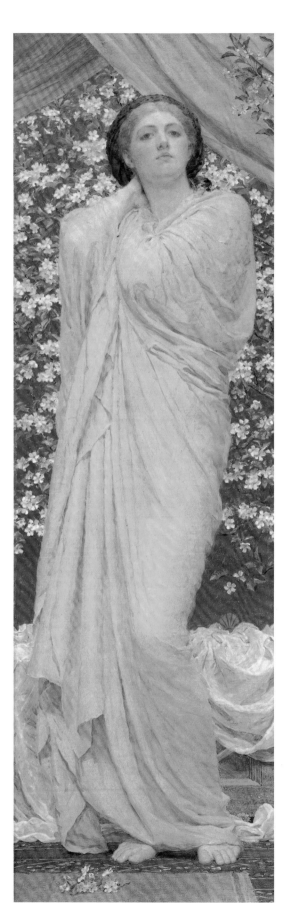

'Consummately artistic and scientific work'
(*Academy Notes*, 1875, 14.272)

Albert Moore was Whistler's most effective prosecution witness in 1878; his work offers a remarkable synthesis of the neo-classical and Aesthetic style. After experimenting with Biblical subjects in the manner of Holman Hunt in the early 1860s, and carrying out wall-decorations for churches, which were to have a lasting influence on the decorative, panel-like format of his mature works, Moore began to find his style with narrative-less images of girls in quasi-classical dress and flowered settings. These figures have the quietness and repose that Ruskin had begun to advocate in his lecture 'On The Present Condition of Modern Art' in 1867, and are certainly 'doing nothing' (19.203). This style had become set by the time he exhibited three small works at the Royal Academy in 1875, of which two, *Pansies* (whereabouts unknown) and *A Flower Walk* (Art Museum, Princeton), Ruskin singled out for the praise quoted above. Ruskin was discussing *The Sculpture Gallery* (Dartmouth College, New Hampshire) by Lawrence Alma-Tadema, and compared Moore's colouring favourably with Tadema's 'elementary method' (14.272).

Moore exhibited three single figures very similar to *Blossoms* at the opening of the Grosvenor Gallery. *Blossoms* repeats the performance, but adds a distinctly Aesthetic element by featuring the delicate petals associated with Japonisme. The foreshortened foreground is similar to those used by Whistler, to whom he had been close since 1865. Before Whistler's libel suit, he reminded the lawyers that Ruskin had praised Turner's late works, such as *Snowstorm – Steamboat off a Harbour's Mouth* (cat.3), but the prosecution did not make good use of the potential comparison with Whistler. At the trial he said of Ruskin, 'The wonder is that he should not have been a painter. I believe he has done something in watercolour' (Merrill 1992, p.159).

218

Frederic Lord Leighton
(1830–1896)

*A Girl with a Basket
of Fruit (Eucharis)*
*c.*1862–3

Oil on canvas
83.8 x 57.8

Inscribed 'F.L.'

First exhibited
Royal Academy 1863

Private collection

'The pretty girls are very nice – very nearly *beautiful. I can't say more can I? If once they* were *beautiful, they would be immortal too. But if I don't pitch into you when I get hold of you again for not drawing your Canephora's basket as well as her head and hair!'* (Letter to Frederic Leighton, June 1863, 36.446)

Ruskin's letter commenting on this work and *A Girl Feeding Peacocks* (private collection), also shown at the Academy in 1863, encapsulates the mixture of praise and blame he used with artists whom he hoped to influence. He had met Leighton in 1855, the year Leighton launched his career at the Royal Academy with *Cimabue's Celebrated Madonna is Carried in Procession through the Streets of Florence* (Royal Collection, on loan to the National Gallery). Leighton had taken to heart Ruskin's insistence on truth to nature in *Modern Painters*, but while praising the Venetian influence on *Cimabue's Madonna*, Ruskin thought the picture only promising. For him Millais's dramatic *The Rescue* (National Gallery of Victoria) was 'the only *great* picture exhibited this year' (14.22).

By 1863, however, both Ruskin and Leighton had moved on. *Modern Painters* volume v laid a renewed emphasis on the Venetian colourists; Leighton was developing his interest in classicism, mediated by Italian Renaissance art, of which this is a good example. Ruskin

commented in 1883 that Leighton's 'ideal of beauty is more nearly that of Correggio than any seen since Correggio's time' (33.319). 'Eucharis' means grace, and the elegance of the pose, another figure 'doing nothing', (19.203) appealed to Ruskin. He was not satisfied with the perspective of the basket, however, telling Leighton 'the meshes are all wrong – *inelegantly* wrong – which is unpardonable' (36.446).

This criticism is significant, for Ruskin, who remained on good terms with Leighton, had had high hopes of his technical skill. Lecturing on Leighton at Oxford in 1883, he displayed two drawings which Leighton had lent him, *A Byzantine Well-head* (1852, private collection) and *Study of a Lemon Tree* (1859, private collection), as examples of 'perfect early drawings' demonstrating 'the necessity of delineation as the first skill of a painter' (33.319). Leighton's evolution into a leading Classical Revivalist after 1865 had disappointed Ruskin, however. In the same lecture he expressed his dislike for those of Leighton's works 'which have been the result of his acutely observant and enthusiastic study of the organism of the human body. I am indeed able to recognise his skill; but have no sympathy with the subjects that admit of its display' (33.318).

219

Sir Edward Coley
Burne-Jones, Bt

The Mill
1870–82

Oil on canvas
90.8 x 197.5

Inscribed 'EBJ/1870'

First exhibited
Grosvenor Gallery 1882

The Board of Trustees
of the Victoria and Albert
Museum

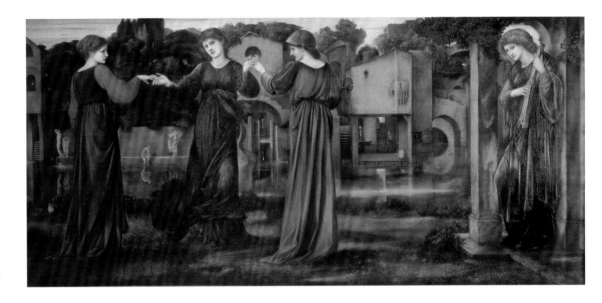

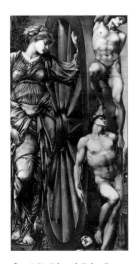

fig.16 Sir Edward Coley Burne-
Jones, Bt, *The Wheel of Fortune*
1875–83 (Musée d'Orsay, Paris)

'It would be utterly vain to attempt any general account of the
works of this painter, unless I were able to give abstract of the
subtlest mythologies of Greek worship and Christian Romance'
('The Three Colours of Pre-Raphaelitism', 1878, 34.173)

Burne-Jones's transition from medievalising Pre-
Raphaelite to classicising Aesthete was closely observed
by Ruskin, and began with his earnest encouragement.
Although *The Mill* was not ready for exhibition until
1882, Ruskin would have been able to watch the
development from its inception in 1870 into a striking
example of the 'constant art' that Ruskin had advocated
in 1867 (19.203), bearing as it does the fruit of Burne-
Jones's Ruskin-sponsored visits to Italy (see cats.123, 124)
as well as his independent tour of 1871.

There is 'Christian Romance' in the foreground
figures, especially the suggestion of a halo above the
musician's head, but a 'Greek' element in the dancers'
pose, evoking the Three Graces. The colour is more
richly Venetian, however, than the classicising cat.220,
the atmosphere recalling Giorgione (*c.* 1476–1510).

Above all, the painting embodies the Ruskinian value
of 'repose' advocated in *Modern Painters* volume II: 'all
art is great in proportion to the appearance of it. It is
the most unfailing test of beauty' (4.117).

Where critic and artist differed was in Burne-Jones's
enthusiasm for Michelangelo (1475–1564), expressed here
in the nude bathers in the background. In 1871 there was
a serious falling-out when Ruskin gave Burne-Jones a
preview of a lecture at Oxford in which he attacked
Michelangelo, whose 'dishonest, insolent, and artificial'
mannerism he thought responsible for the excesses of
'dramatic' as opposed to 'constant' art (22.98). Burne-
Jones wrote, 'it didn't seem worth while to strive any
more if he could think it and write it' (Burne-Jones 1904,
vol.2, p.18). By 1872 this breach was repaired, and when
lecturing on Burne-Jones for the last time in 1883, Ruskin
raised no objection to the Michelangelo-derived male
figures in *The Wheel of Fortune* (1875–83, Musée d'Orsay)
(fig.16), which he cited as an example of how 'the mythic
school seeks to teach you the spiritual truth of myths'
(33.294).

220

Sir Edward Coley
Burne-Jones, Bt

The Golden Stairs
1876–80

Oil on canvas
269.2 x 116.8

Inscribed 'EBJ 1880'

First exhibited
Grosvenor Gallery 1880

Tate Gallery. Bequeathed
by Lord Battersea 1924

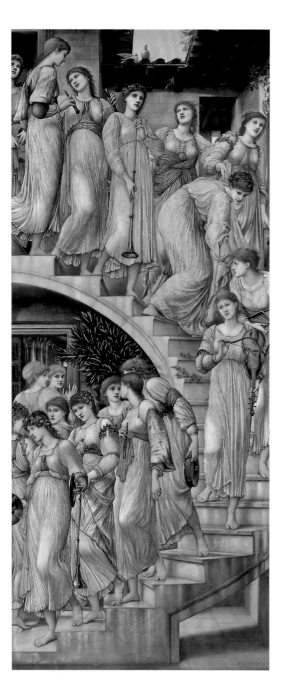

'His work, first, is simply the only art-work at present produced
in England which will be received by the future as 'classic' in its
kind' (*Fors Clavigera,* Letter 79, July 1877, 29.159)

Ruskin's comment quoted above, inspired by Burne-
Jones's work shown at the Grosvenor Gallery in 1877
(see cat.221), applies equally to *The Golden Stairs*, which
is a classic work of the Aesthetic movement, and displays
the classical influences that Ruskin – within limits – had
encouraged him to absorb. The flattened figures suggest
a sculptural frieze, while the pale colours evoke the 'line
with light' that Ruskin had identified as essentially Greek
(20.126). In 1883 Ruskin distinguished Burne-Jones from
Rossetti as 'essentially a chiaroscurist' appealing 'either
through intricacies of delicate line, or in the dimness or
coruscation of ominous light' (33.301).

The Golden Stairs is more mysterious than ominous.
As with cat.219, the presence of musical instruments
offers, but inevitably withholds, another aesthetic
dimension. (Ruskin's musical analogies anticipate those
of the Aesthetic movement, see cat.223.) The mystery,
however, is intriguing rather than sensual. In spite of
his adoption of a Hellenistic outlook from the 1860s,
Ruskin still believed that 'the true meaning of classic
art' was 'not the licence of pleasure, but the law of
goodness'(33.323). For Ruskin, Burne-Jones's art was one
of continuity and synthesis: 'the transition of Athenian
mythology, through Byzantine, into Christian' (33.297).

In John Christian's judgement, 'Almost alone among
Ruskin's protégés, [Burne-Jones] was genuinely helped to
self-discovery by the well-intentioned but often tactless
advice. There was, after all, no enormous gap between
the "grace and sweetness" that Ruskin rightly discerned
in Burne-Jones and the "classical grace and tranquillity"
he wished to encourage' (Wildman & Christian 1998,
p.79). It should be added that Ruskin also learned from
Burne-Jones, especially about Carpaccio and Botticelli
(see cats.172, 174). Christian is right to conclude, 'With
no other major practicing artist did he enjoy such a
fruitful relationship, on both aesthetic and personal
levels' (Wildman & Christian 1998, p.79).

221

Sir Edward Coley
Burne-Jones, Bt

St George
1873–7

Oil on canvas
155 x 57

First exhibited
Grosvenor Gallery 1877

Wadsworth Athaneum,
Hartford, Ct. The Ella
Gallup Sumner and Mary
Catlin Sumner Collection
Fund

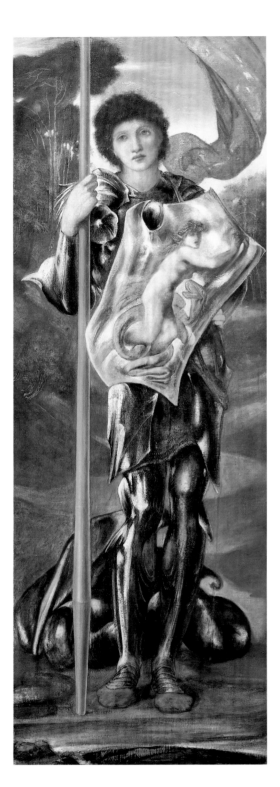

*'A painter, neither of Divine History, nor of Divine Natural
History, but of Mythology, accepted as such, and understood
by its symbolic figures to represent only general truths, or
abstract ideas'* (The Art of England, 1884, 33.292–3).

At the opening exhibition of Sir Coutts Lindsay's
Grosvenor Gallery in Bond Street in 1877, Burne-Jones
showed eight works: *The Beguiling of Merlin* (Lady Lever
Art Gallery, Port Sunlight), *The Days of Creation* (Fogg Art
Museum), *Venus' Mirror* (Calouste Gulbenkian Museum,
Lisbon), *Temperantia* (private collection), *Spes* (Dunedin
Art Gallery), *Fides* (Vancouver Art Gallery), *A Sybil* (private
collection) and *St George*. He had exhibited almost
nothing since his resignation from the Old Water Colour
Society in 1870, and his pictures caused a sensation. The
Grosvenor opened on 9 May, but Ruskin did not visit it
until 23 June, shortly after his return from a long stay
in Venice, begun the previous September. He decided
to add a discussion of the Grosvenor to the July number
of *Fors Clavigera*.

 Fors was not devoted to art criticism, and Ruskin's
comments on the Grosvenor were in the broader context
of the true meaning of value, which helps to account for
the tenor of his attack on Whistler. Ruskin described
Sir Coutts Lindsay as 'an amateur both in art and shop-
keeping' (29.157). He deplored the decor, criticised the
grouping of artists' works together, and advised Lindsay
not to show his own work. He was complimentary about
Millais's portraits in the exhibition, and enthusiastic
about Burne-Jones: 'I *know* that these will be immortal,
as the best things the mid-nineteenth century in England
could do, in such true relations as it had, through all
confusion, retained with the paternal and everlasting
Art of the world' (29.159–60). He then went on to
attack Whistler's contributions (see cat.223).

 Ruskin passed over the allegorical image of St
George, ignoring the erotic overtones of the figure on
the shield, and he forgave any 'mannerisms and errors'
in Burne-Jones's pictures because 'the work is natural
to the painter, however strange to us; and it is wrought
with utmost conscience of care, however far, to his own
or our desire, the result may yet be incomplete' (29.160).
Incompletion, or lack of finish, which is evident
especially in the lower part of the painting, was to be
a bone of contention in his attack on Whistler and the
subsequent court case.

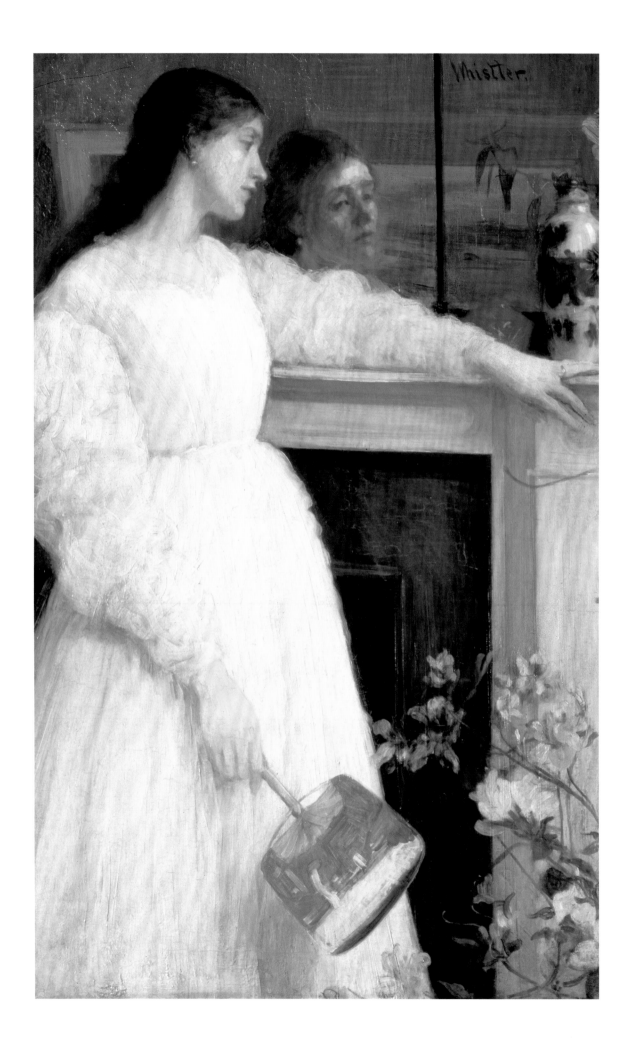

222

James Abbott McNeill
Whistler
(1834–1903)

*Symphony in White,
No.2: The Little
White Girl*
1864

Oil on canvas
76.5 X 51.1

Inscribed 'Whistler'

First exhibited
Royal Academy 1865
as *The Little White Girl*

Tate Gallery. Bequeathed
by Arthur Studd 1919

*Come snow, come wind or thunder
High up in air,
I watch my face, and wonder
At my bright hair;
Nought else exalts or grieves
The rose at heart, that heaves
With love of her own leaves and lips that pair.*

*She knows not love that kissed her
She knows not where.
Art though the ghost, my sister,
White sister there,
Am I the ghost, who knows?
My hand, a fallen rose,
Lies snow-white on white snows, and takes no care.*

A.C. Swinburne 'Before The Mirror' (1865)

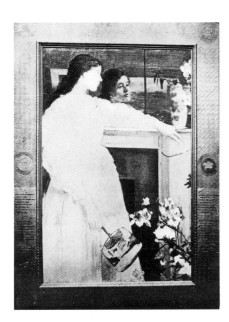

fig.17 Photography of *Symphony in White,
No.2* in original frame (Tate Gallery)

The complexity of Ruskin's relationship with the painters and poets of the Aesthetic movement is demonstrated by his connection with this picture, a portrait of Whistler's model and mistress Joanna Hiffernan. In April 1865 Algernon Swinburne (1837–1909) wrote the poem quoted above in its honour, supplying his own speculative narrative for the story-less image. Two of the four verses were reprinted in the Royal Academy catalogue, and the whole poem, on gold paper, was attached by Whistler to the original frame, now lost (see fig.17). The poem was subsequently published in Swinburne's *Poems and Ballads* (First Series) in 1866.

Ruskin, who knew Swinburne through Rossetti, was so impressed by the poem, which he would have seen in the Royal Academy, that he asked him for a copy (36.xlviii). In 1865 the future litigants were therefore both in possession of manuscript versions of the poem. It is possible that its reference to roses (there are none in the painting) appealed to Ruskin because of his love for Rose La Touche (see cat.230), but the 'repose' of the picture is consistent with Ruskin's aesthetic principles. Nor were Whistler's references to the new fashion for Japonisme in the jar and the fan necessarily objectionable. In 1863 Leighton had given Ruskin a 'nice book on Japan' (36.446) (see cat.218). It was only after Ruskin's legal defeat by Whistler that he began to tell people to 'put Oriental Art entirely out of your heads' (33.307). Whistler did not give *The Little White Girl* the more provocative title *Symphony in White, No.2* until later.

Ruskin thought Swinburne 'a Demonaic youth' (LN.96) but refused to condemn his *Poems and Ballads*, which advocated art for art's sake. As the Aesthetic movement took on a more explicitly decadent aspect, however, Ruskin's attitude hardened. Swinburne's 'exclusive worship of things formally beautiful' (Swinburne & Rossetti 1868, p.32) ultimately could not be reconciled with Ruskin's 'full comprehension and contemplation of the Beautiful as a gift of God' (4.47).

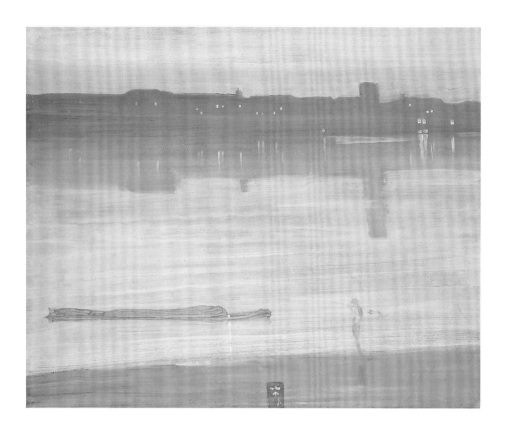

223

James Abbott McNeill
Whistler

*Nocturne in
Blue-Green*
1871

Oil on wood
(in original frame)
50.2 X 59.1

Inscribed with Whistler's
butterfly signature-mark
and '71'

First exhibited
Dudley Gallery 1871
as *Harmony in Blue-
Green-Moonlight*

Tate Gallery. Bequeathed
by Miss Rachel and Miss
Jean Alexander 1972

*'I never saw anything so impudent on the walls of any exhibition,
in any country, as last year in London. It was a daub professing
to be a 'harmony in pink and white' (or some such nonsense);
absolute rubbish, and which had taken about a quarter of an hour
to scrawl or daub – it had no pretence to be called painting. The
price asked for it was two hundred and fifty guineas'* (Val d'Arno,
1874, 23.49)

This was exhibited as *Harmony in Blue-Green-Moonlight*,
together with *Variations in Violet and Green* (private
collection) at the Dudley Gallery winter exhibition in
1871–2, price 200 guineas. Whistler did not start to
use the term 'Nocturne' until 1872, when he exhibited
Nocturne in Blue and Silver (location unknown), *Nocturne
in Grey and Gold* (Art Institute of Chicago), together with
Symphony in Grey and Green: The Ocean (Frick, New York),
again at the Dudley Gallery. Whistler frequently changed
the titles of his pictures, and *Harmony in Blue-Green-
Moonlight* was also exhibited in Whistler's lifetime as
Nocturne, Blue and Silver – Chelsea.

When Ruskin made the comment quoted above in
a lecture at Oxford on 27 October 1873, it was clearly
directed at Whistler, but he did not name the artist,
exhibition, or a specific picture, and as Nicholas
Shrimpton has argued, the expression 'last year'

could apply to either of the Dudley Gallery exhibitions
(Shrimpton 1999, p.137n). Since Whistler did not exhibit
another 'Harmony' until 1874, however, it is very possible
that he was referring to this painting.

Ruskin's attack, mentioning a price and the manner
of execution, anticipates his criticisms of 1877. The rapid
execution and lack of detail exemplifies the lack of
'finish' that Ruskin, along with most of his audience,
expected in a painting, and there is a distinct shortage
of Ruskinian 'facts'. The vague, out-of-scale figure on
the foreshore and the placing of the date and Whistler's
monogram in the manner of a Japanese wood-cut do
not conform to Ruskin's principles of composition.

Yet Ruskin had preceded Whistler in applying
musical analogies to painting. He had himself used the
expression 'harmonies of gold with grey' in relation to
Turner (14.226) and praised 'the intense harmony of
colour, in Millais's *Return of the Dove to the Ark* (12.325)
(cat.8). In *The Stones of Venice* he argued: 'the arrangement
of colours and lines is an art analogous to the compo-
sition of music, and entirely independent of the represen-
tation of facts' (10.215–16). But facts, and a moral
purpose, there had to be, and a painting apparently
having neither was another matter.

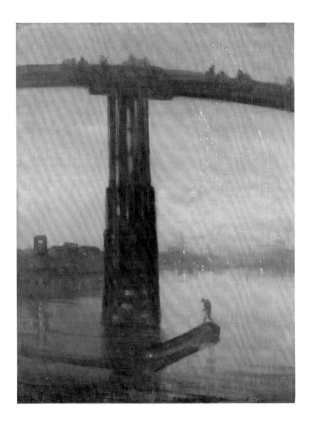

fig.18 James McNeill Whistler,
*Nocturne in Black and Gold:
The Falling Rocket* 1875
(Detroit Institute of Arts. Gift of
Dexter M. Ferry, Jr)

224

James Abbott McNeill
Whistler

*Nocturne: Blue and
Gold – Old Battersea
Bridge*
1872–7

Oil on canvas
67.9 x 50.8

Inscribed with Whistler's
butterfly mark

First exhibited Royal
Pavilion Gallery,
Brighton, 1875
Exhibited Grosvenor
Gallery, 1877 as *Nocturne
in Blue and Silver*

Tate Gallery. Presented
by the National Art
Collections Fund 1905

*'Sir Coutts Lindsay ought not to have admitted works into the
gallery in which the ill-educated conceit of the artist so nearly
approached the aspect of wilful imposture. I have seen, and heard,
much of Cockney impudence before now; but never expected to
hear a coxcomb ask two hundred guineas for flinging a pot of
paint in the public's face'* (Fors Clavigera, Letter 79, July 1877,
29.160)

Whistler showed eight works at the Grosvenor Gallery
in 1877. Four were portraits, including *Arrangement in Grey
and Black, No 2: Portrait of Thomas Carlyle* (Glasgow Art
Gallery); four were nocturnes, of which *Nocturne in Black
and Gold: The Falling Rocket* (Detroit Institute of Arts)
(fig.18), was for sale at 200 guineas. Ruskin's description
of Whistler's 'wilful imposture' (29.160) in *Fors Clavigera*
was reprinted in the *Spectator*, and Whistler sued for libel.

The case did not come to court until November 1878.
Ruskin had had his first mental collapse in February that
year, and did not appear. His instructions to his defence
counsel were unrepentant: Whistler was ill-educated
because the price demanded was unjust, the analogy
between painting and music was misunderstood, the
work was not art but ornament, unfinished and empty
of ideas. No work should leave an artist's hands 'which
his diligence could further complete, or his reflection
further improve' (Merrill 1992, p.292–3).

Whistler dominated the trial with his witticisms,
arguing the case for art for art's sake. William Powell

Frith (1819–1909), the great recorder of Victorian life,
gave robust evidence for Ruskin, Burne-Jones was more
equivocal. *Nocturne … Old Battersea Bridge*, which shows
the profound influence of Japanese woodcuts on
Whistler's art, was produced in court. Asked if it was
a 'correct representation', Whistler answered: 'It was
not my intent simply to make a copy of Battersea Bridge.
The pier in the centre of the picture may not be like
the piers of Battersea Bridge. I did not intend to paint
a portrait of Battersea Bridge, but only a painting of
a moonlight scene. As to what the picture represents,
that depends upon who looks at it' (Merrill 1992, p.151).

Whistler won, but the derisory award of a farthing's
damages without costs led to his bankruptcy. Ruskin
resigned his Slade Professorship, partly in disgust, partly
because of his mental depression. As Richard Dorment
has written, 'in the light of art history, Whistler won
hands down' (Dorment & Macdonald 1995, p.137),
but that verdict was not clear at the time. When Walter
Hamilton published his immediate account in *The
Aesthetic Movement* in 1882, Ruskin, not the critic Walter
Pater (1839–94), is presented as the new movement's
mentor: 'although Ruskin chose to speak out plainly in
the matter of Mr Whistler's pictures, there is no doubt
that the true Aesthetic School owes much to him … for
pointing out the real direction in which pure art and real
beauty are to be found' (Hamilton 1882, p.19).

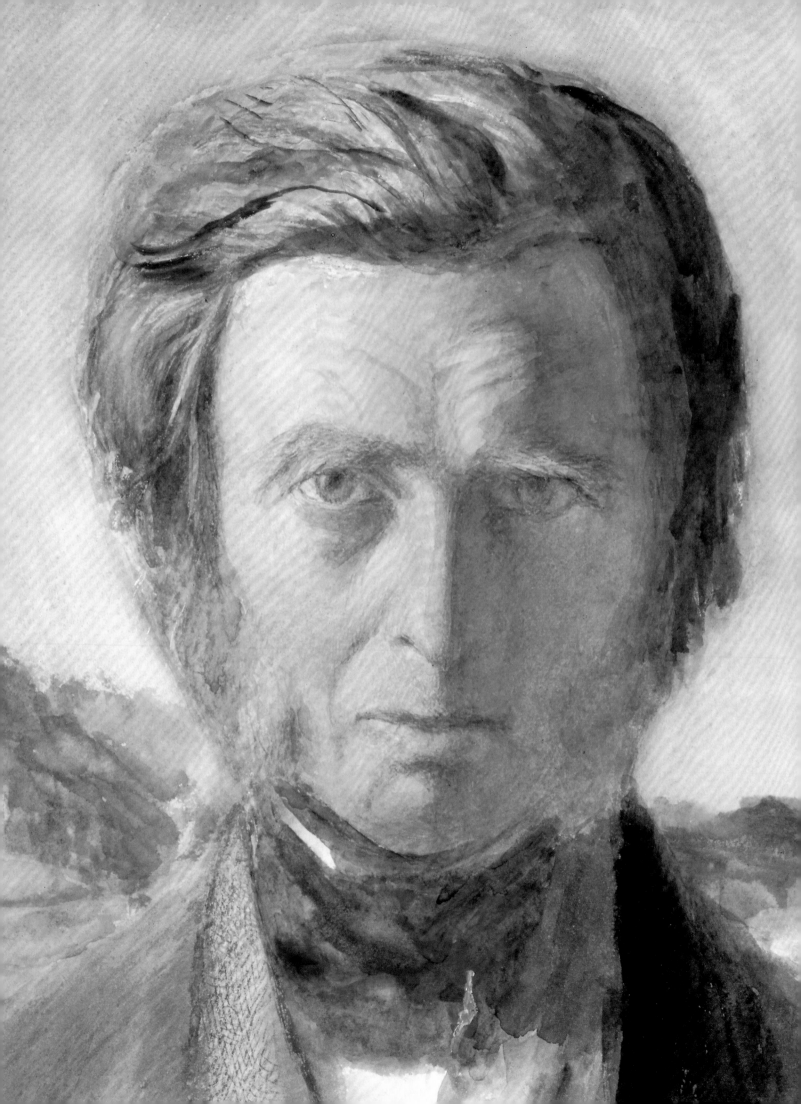

IX

The Storm-Cloud of the Nineteenth Century

'malignant aerial phenomena … plague-cloud and plague-wind'

'Once I could speak joyfully about beautiful things, thinking to be understood; – but I cannot anymore; for it seems to me that no one regards them. Wherever I look or travel in England or abroad, I see that men, wherever they can reach, destroy all beauty' (7.422–3). During the 1860s Ruskin's view of the world began to darken. He lost none of his belief in the importance of art, but his faith in people's ability to respond to its moral significance weakened. His art criticism became social criticism as he explored the reasons for the destructive greed that left people blind to the beauty of nature and indifferent to the value of art. His struggle to convey his beliefs made him both sad and angry, but there were private as well as public reasons for these feelings. He had fallen in love with a young girl, Rose La Touche, and in 1866, when she was 18 and he 47, he asked her to marry him. She did not refuse him or accept, and the next nine years were spent in an agony of hope and disappointment, until her death in 1875 left him broken-hearted.

Part IX shows these public and private emotions, reflected in drawings by Ruskin from 1858 to 1889. His study of nature, especially of the sky at dawn and sunset, led him to the conclusion that a new atmospheric phenomenon had appeared, 'the storm-cloud of the nineteenth century', the subject of a lecture given in 1884. Ruskin was right, industrial pollution had indeed darkened the skies over his home in the Lake District as it had over London, as meteorological records confirm. But Ruskin also used this as a moral metaphor for the economic exploitation that his works on political economy, such as *Unto This Last* (1860), protested against. The pollution was borne by a 'plague-wind … panic-struck and feverish; and its sound is a hiss instead of a wail' (34.34). It blew from all quarters, intermittently but savagely, bringing darkness and turning the sun not red, but white, a freezing light that meant the end of life: 'Blanched Sun, – blighted grass, – blinded man. – If, in conclusion, you ask me for any conceivable cause of meaning of these things – I can tell you none, according to your modern beliefs;

but I can tell you what meaning it would have borne to the men of old time. Remember, for the last twenty years, England, and all foreign nations, either tempting her, or following her, have blasphemed the name of God deliberately and openly; and have done iniquity by proclamation, every man doing as much injustice to his brother as it is in his power to do' (34.40).

Beginning in 1858, the year he abandoned his strict Evangelical beliefs, and ending with one of the last drawings he made before his mental illness incapacitated him entirely, Ruskin's cloud studies tell their own story. The parallel account of his relationship with Rose La Touche is traced through the portraits and self-portraits that record a doomed love affair. Ruskin first met Rose, then aged 10, in 1858 when she became one of his private drawing pupils (see cats.225, 228). By 1861 he was deeply attracted to her, but the relationship was fraught with difficulty because of the age difference, the annulment of his marriage and disputes over religion, for Rose was a devout Evangelical. To make things worse, she suffered bouts of mental illness of increasing severity. Once Ruskin had proposed to her in 1866, her parents' opposition made meetings difficult. Ruskin tried to communicate indirectly, making coded references to her in his writings and releasing his obsessions through his drawings (cats.232, 241). She finally died, possibly of anorexia nervosa, in May 1875.

Ruskin's grief was such that, having had earlier experience of spiritualism, he sought contact with Rose beyond the grave. In Venice in the winter of 1876–7 he began to identify her with the figure of St Ursula in Carpaccio's cycle of paintings in the Accademia Gallery, to the point that the two became one (see cat.244). In February 1878 his mind gave way completely for the first time: '*Mere* overwork or worry, might have soon ended me, but it would not have driven me crazy. I went crazy about St Ursula and the other saints, – chiefly young-lady saints' (LN.412).

RH

225

John Ruskin

Study of an Apple
29 Nov. 1875

Watercolour and
bodycolour over pencil
9.7 x 10.9

Inscribed on original
mount '57 Schoolroom
Nov 29 1875 JR Done
by Mr Ruskin'

Ruskin Foundation
(Ruskin Library,
University of Lancaster)

*'The facts which an elementary knowledge of drawing enables a
man to observe and note are often of as much importance to him
as those which he can describe in words or calculate in numbers'*
(Art as a Branch of Education, 1857, 16.450)

Besides publishing his own instruction manual, *The
Elements of Drawing* (1857) (see cats.61, 210), and teaching
drawing at the London Working Men's College in the
1850s and at his own Drawing School at Oxford in
the 1870s, Ruskin also gave personal tuition, often by
correspondence. His private pupils were all female, for
they did not have easy access to the training available
to men, and Ruskin enjoyed the friendships that resulted.
Some were talented amateurs such as Pauline, Lady
Trevelyan (1816–66), Louisa, Marchioness of Waterford
(1818–91), the collector Ellen Heaton (1816–94), or
Ada Dundas (1840–87) of Edinburgh. Others like Anne
Mutrie (1826–93), Henriette Corkran (fl.1872–1911),
Adelaide Ironside (1831–67), Anna Blunden (1829–1915)
and Kate Greenaway (cats.227, 228) intended to live from
their work. Ruskin's letters to his pupils could be flir-
tatious, but he found it irksome when, as in the case of
both Blunden and Greenaway, they fell in love with him.
Rose La Touche, to whom he was also asked to give
drawing lessons, was the tragic exception.

This drawing and its companion (cat.226) were made
in the schoolroom of 57, Gloucester Place, Hyde Park,
on 29 November 1875 at a lesson for the 15-year-old
Louise Blandy, daughter of his dentist. Ruskin had
known Louise since 1873, and gave her a first lesson at
the National Gallery in January 1874. While Ruskin was
travelling abroad that year she also studied with Ruskin's
assistant William Ward.
Ruskin's teaching drew on *The Elements of Drawing*
and the elementary exercises being used at the Ruskin
School of Drawing in Oxford. In January 1875 he wrote
to her, 'Remember; your chief difficulty will be in
forming your taste … *don't go to exhibitions.* Don't go
to [South] Kensington. Content yourself with the few
things I send you and with the National Gallery …
The frightful curse of modernism is to have the work
of fools thrust in one's face every instant' (Ruskin Library
MS BIX). Ruskin's flirtatiousness came out when on 10
February 1875 he thanked her for sending him flowers
for his birthday: 'It was very sweet and pretty of you,
and violetty, and snowdroppy, to send me flowers – but
I never will have birthday presents from young ladies
unless I get a kiss too' (Ruskin Library MS BIX). Later
that same February Ruskin was to see the dying Rose
La Touche for the last time (see cat.240).

226

Louise Virenda Blandy
(1860–1890)

Study of an Apple
29 Nov. 1875

Watercolour and
bodycolour
10 x 12.5

Signed lower left 'L.V.B.'

Ruskin Foundation
(Ruskin Library,
University of Lancaster)

'I must have no more oil painting. Firm pen drawing, pencil or watercolour – nothing else allowed in my schools' (Letter to Louise Blandy, 17 Dec. 1874, Ruskin Library MS BIX).

Painting an apple in the manner of William Hunt (cat.35) was a relatively advanced exercise in Ruskin's course of instruction. The slight differences between this and cat.225 show that teacher and pupil were painting the same apple from different angles.

Although there appear to have been no further lessons with Ruskin, Blandy remained in touch with him, in 1883 making a copy of a subject he had set Kate Greenaway. Her work was shown at the Grafton Galleries in 1879 and she sold a flower painting at the Grosvenor Gallery the same year. Two of her works, a drawing of a staircase in the Bargello, Florence, and a copy of part of Fra Angelico's *Resurrection* in the National Gallery, were placed in the Museum of the Guild of St George at Sheffield. She married in 1888 and moved with her husband to Ashville, North Carolina, where she died of tuberculosis in 1890.

227

Kate Greenaway
(1846–1901)

A May Day Dance
1884

Pencil and watercolour
35.7 × 50

Inscribed bottom left
'K.G. 1884'

Whitelands College

'All great art is delicate, *and fine to the uttermost*' (Ruskin on Kate Greenaway, *The Art of England*, 1883, 33.346).

Greenaway was one of a small group of women artists Ruskin promoted in the 1880s. The others were Helen Allingham (1848–1926) whom he had first praised in his 1875 edition of *Academy Notes* (14.264); the American Francesca Alexander (1837–1917) whom he met in Florence in 1882 and helped with the publication of four of her books; and the almost unknown Lilias Trotter (1853–1928), whom he had met in Venice in 1872. In the case of Alexander and Greenaway, while Ruskin genuinely admired their work, which appealed to his taste for innocent simplicity, there were strong emotional undercurrents.

He addressed Francesca Alexander as 'Sorella' – sister – for her studies of Italian peasant life accorded with the agrarian idealism of the Guild of St George (see fig.20). In the case of Kate Greenaway, matters were even more complicated, for while they had a close friendship, Greenaway's love for him was unrequited. His appreciation of her work was undoubtedly influenced by his deeply sublimated attraction to her subject matter, with its celebration of innocent girlhood, but he also sought to alter her style. This and cat.228 show the two sides to the relationship.

Greenaway was already a successful artist-illustrator when she first came into contact with Ruskin through a mutual friend, the Royal Academician Henry Stacy Marks (1829–98) whose bird paintings Ruskin admired. Although he first wrote to her in January 1880, and she reciprocated with drawings and cards drawn in the manner that had made her famous, it was another two years before they met, by which time he had suffered a second attack of mental illness. Ruskin visited her studio

on 27 December 1882, and she spent a month at Brantwood the following April. His interest was partially stimulated by the French critic Ernest Chesneau (1833–90), who was consulting Ruskin about contemporary British art, and for whom Ruskin wrote an introduction to the English edition of his *English School of Painting* (1884). Greenaway and Allingham became the topics of the fourth lecture in *The Art of England* series at Oxford, given in May 1883.

The title of this lecture, 'Fairy Land', suggests a lack of seriousness on Ruskin's part, but in fact he was addressing the issue of the contemporary illustration of books for children at a time when chromolithography had made cheap – and often poor quality – reproduction possible. While Ruskin took personal pleasure in what he called in his lecture Greenaway's 'girlies' (33.344), he sincerely believed in the encouragement of childish fancy as a means of developing the imagination. The lecture's peroration on Greenaway's treatment of landscape shows what Ruskin felt the world had lost: 'There are no railroads in it, to carry the children away with, are there? no tunnel or pit mouths to swallow them up, no leaguelong viaducts – no blinkered iron bridges? ... no gasworks! no waterworks, no mowing machines, no sewing machines, no telegraph poles, no vestige, in fact, of science, civilization, economical arrangements, or commercial enterprise!!!' (33.347).

A May Day Dance was one of Greenaway's many gifts to Ruskin, and he in turn presented it to Whitelands College (see cat.184), the women teachers' college where in 1881 a May Queen Festival had been instigated at Ruskin's suggestion. At Ruskin's request, in 1887 Greenaway designed the ceremonial dress worn by the Whitelands annual May Queen, which remains in the college's collection.

228

Kate Greenaway

*Study of Rock,
Moss and Ivy*
1885

Watercolour and
bodycolour
18.7 x 33

Given by Ruskin
to the Museum of the
Guild of St George

The Ruskin Gallery,
Guild of St George
Collection

*'I shan't be happy about you till you draw properly and colour
deeply and richly'* (Letter to Kate Greenaway, 1 Jan. 1886,
Engen 1981, p.132)

Although Greenaway's usual subject matter (cat.227)
pleased the ageing Ruskin with its echoes of Rose La
Touche and the girls of Winnington School, he was
privately very critical of her drawing-style and constantly
demanded a greater realism. Greenaway, a plain spinster
of 36 when they first met, appealed to him as a confidante
who entertained him with drawings of 'girlies' that
assuaged his love for the dead Rose. His final issue of
Fors Clavigera, at Christmas 1884, titled 'Rosy Vale', was
illustrated by a rose-strewn Greenaway drawing (29.517).
By 1883 however Greenaway was deeply in love with
him, and remained so for the rest of her life, maintaining
a one-sided correspondence with him long after he had
lost the power to communicate.

Ruskin was aware of her infatuation, but told her,
'I do hope you will manage to get it put into a more
daughterly and fatherly sort of thing' (Engen 1981, p.96).
Ruskin's paternalism was expressed in his constant
criticism of her drawing. In January 1884 he wrote,
'When are you going to be *good* and send me a study of
anything from nature – the coalscuttle or the dust pan –

or a towel or a clothes screen – or the hearth rug or the
back of a chair – I'm very cruel, but here's half a year I've
been waiting for a bit of Common sense!' (Engen 1981,
p.105). During her visits to Brantwood Greenaway would
be set exercises such as this one, which recall the realism
of Ruskin's own foreground studies (cat.232). In July 1884
he sent her a lump of fresh turf from Brantwood so that
she could continue her studies in London. Ruskin suf-
ficiently approved of cat.228 to place it in the Museum
of the Guild of St George.

Ruskin's criticism may have influenced Greenaway's
decision in 1889 to try to establish herself as a gallery
artist, and accept election as a member of the Royal
Institute of Painters in Water Colour. Both her books and
pictures, however, were going out of fashion. Ruskin's
mental illness and her own ill-health combined to make
her final years unhappy.

Although Ruskin's companion – and after 1889
effectively his keeper – Joan Severn destroyed much of
the correspondence between Ruskin and Greenaway, it
is an indication of Severn's view of the harmlessness to
Ruskin of the relationship that Greenaway was one of
the few people to be invited to visit him at Brantwood
after his complete mental breakdown. She last visited
Brantwood in 1898.

229

John Ruskin

Self-Portrait
1861

Watercolour touched with
bodycolour over pencil
15.2 x 10

Inscribed by Joan Severn
on old mount 'John Ruskin
– by himself – given by
him to me, J.R.S.'

First exhibited
Ruskin Exhibition,
Royal Society of Painters
in Water Colours, Ruskin
Memorial Exhibition 1901

The Pierpont Morgan
Library, New York

'It is very sulky, but has some qualities about it better than photograph' (Letter to his father, 12 Nov. 1861, 17.cxiv–v).

Ruskin's decision to draw himself in 1861 was almost certainly not a casual one. He was experiencing deep inner conflict at this time, and trying to find a new direction. In November 1860 he had told Elizabeth Barrett Browning, 'I am divided in thought between many things, and the strength I have to spend on any seems to me nothing' (36.350). In 1858 he had broken the bonds of his strict Evangelicalism and in the same year met Rose La Touche for the first time. The vision of Turner presented in the final volume of *Modern Painters*, at last completed in 1860, was a dark one as he probed the moral conflicts of nineteenth-century society (see cat.4). That same year he published his first essays

directly attacking contemporary utilitarian economic philosophy, *Unto This Last*, and was criticised for straying from the field of art criticism. It was Ruskin's position, however, that art could only be seen in its moral and social context, and from 1860 onwards his art criticism was increasingly absorbed into the wider issues of education and social reform.

At the same time Ruskin was experiencing deepening conflict with his ageing parents, and he spent much time between 1860 and 1863 abroad. He contemplated building a home for himself in Switzerland or the Savoy Alps. These wanderings were ended by the death of his father in 1864. Ruskin's self-portrait of 1861 proved to be the first of a series that register his deepening distress over Rose La Touche, leading to his first mental breakdown in 1878.

230

John Ruskin

Portrait of Rose La Touche
?1861

Pencil, watercolour and bodycolour in oval mount
39.4 x 26.7

Ruskin Foundation (Ruskin Library, University of Lancaster)

'I never loved many – and now – but this child, none'
(Letter to Mrs Cowper-Temple, 29 Sept. 1866, LMT.90)

Ruskin first met Rose La Touche in January 1858, just after her tenth birthday and just before his thirty-ninth. Her father, John La Touche (1814–1904), was a wealthy Irish banker of Huguenot descent with a large estate at Harristown, County Kildare. He was a follower of the popular preacher C.H. Spurgeon (1834–92), whom Ruskin also knew, and was baptised by him as an Evangelical Baptist in 1863. Maria La Touche (1824–1906) was a writer, with two published novels, and did not share her husband's Evangelical views. She was a member of an aristocratic circle of cultivated Anglo-Irishwomen, including Louisa, Countess of Waterford, to whom Ruskin had given drawing lessons, and who introduced him to the La Touches. Hoping to lionise Ruskin, Mrs La Touche asked him to give drawing lessons to Rose and her elder sister Emily. Ruskin at first demurred, but finally went to see them. This was the beginning of a relationship that ultimately destroyed Ruskin's mind.

It began as a general friendship with the whole La Touche family. Although the date of this portrait is uncertain, it shows Rose as an apparently untroubled young girl. It was possibly drawn in March 1861, when the La Touches were making one of their regular winter visits to London, or in August that year when Ruskin was invited by the La Touches to Harristown. During this visit Ruskin confided his changed religious position to Mrs La Touche. She appealed to him not to make it public. By the autumn of 1861 Ruskin felt deeply drawn to Rose, but that October she fell ill for the first time with a psychosomatic disorder – possibly the as yet unrecognised condition, anorexia nervosa – which was eventually to kill her. Rose was as devout as her father, publishing a small collection of religious verse, *Clouds and Light*, in 1870. Ruskin's new-found 'paganism' was to be one of the insurmountable obstacles between them.

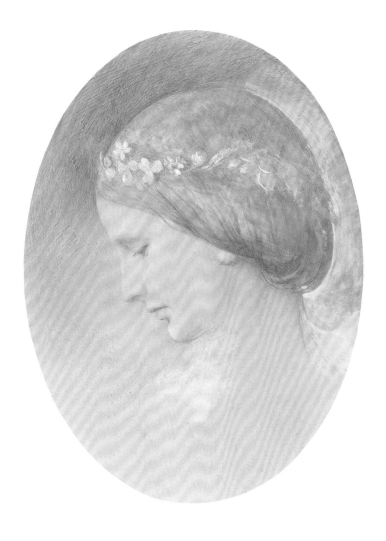

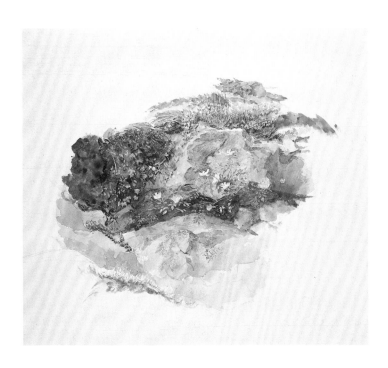

231

John Ruskin

*Portrait of Rose
La Touche*
1862

Pencil with wash
and bodycolour,
in oval mount
49.5 x 33

Inscribed by Ruskin
'Flos florum Rosa' [Rose,
the flower of flowers]

Ruskin Foundation
(Ruskin Library,
University of Lancaster)

*'I came home – the day after Christmas – and ever since then I've
been trying –in vain – ah, so much in vain-er! to draw little Rosie
La Touche'* (Letter to Lady Waterford, Apr. 1862, s1.42).

Ruskin did not see Rose between the spring of 1862 and
December 1865. There was an estrangement between
Ruskin and her parents, possibly because of her father's
religious views, or her mother's jealousy of his attentions
to her daughter. Rose suffered further bouts of illness
in 1862 and 1863. Contact by letter, however, was not
broken off and in December 1865 an apparently re-
covered Rose came to London with her parents for the
winter season, where Ruskin was able to see her.

Just after Rose's eighteenth birthday on 3 January
1866, Ruskin asked her to marry him. She asked him to
wait three years. Her parents became alarmed by the love
that was apparent on both sides, but still did not entirely
sever communications, although letters were sometimes
forbidden and meetings were infrequent, so that Ruskin
had mainly to use go-betweens. Apart from his mother's
companion, his cousin Joan Agnew, who was only two
years older than Rose, and who in 1866–7 was briefly
engaged to her older brother Percy, Ruskin relied on
Georgiana Cowper-Temple (1822–1901) and her
husband, and the writer George MacDonald (1824–1905).

In 1868 Mrs La Touche consulted Ruskin's former
wife, Effie Millais, about the legal position of Ruskin's
annulment, fearing that if Ruskin were to marry Rose
and have children, the grounds for the annulment would
be void, and Rose's marriage bigamous. Effie Millais
concurred. In further correspondence in 1870 that was
shown to Rose, she cruelly accused him of abnormality.
Ruskin sought his own legal advice, which said that
marriage was possible, but when this was communicated
to her in 1871 she rejected him. Both Rose and Ruskin
began to succumb to the mental strain.

232

John Ruskin

*Study of Foreground
Material*
1871

Pencil, pen and ink,
watercolour and
bodycolour
18.8 x 21.3

Given to the Ruskin
School of Drawing
1872

The Visitors of the
Ashmolean Museum,
Oxford

'Wild-rose, running in a cleft of Derbyshire limestone'
(Catalogue of the Rudimentary Series 1878, 21.210)

By 1871 both Ruskin and Rose la Touche were becoming
ill with the stress of their frustrated relationship. At the
end of July Ruskin had a physical and mental breakdown
while staying at Matlock Bath in Derbyshire, shortly
after Rose had rejected the legal opinion he had sent her
which argued that they could marry. Ruskin described
how her letter 'for folly, insolence and selfishness beat
everything I have yet known produced by the accursed
sect of religion she has been brought up in' (LMT.310).

Ruskin's love for Rose found expression in coded
references to her in his public writings, principally in
the form of references to rose imagery. In August 1870
he bought a fourteenth-century manuscript of the *Roman
de la Rose* (now lost), and made a careful study of the text.
At Matlock he made two fine drawings of wild roses
(cat.241), both of which he placed in his teaching
collection at the Ruskin School of Drawing. He later
blamed the exhaustion brought about by the con-
centration demanded by these works for the illness
that left the study unfinished (21.230).

It was while he was staying in Matlock that he
first declared the existence of a new phenomenon, the
'plague-wind' that he was later to describe in his lecture
'The Storm-Cloud of the Nineteenth Century' in 1884.
Writing in *Fors Clavigera* he describes the wind as
'poisonous smoke' attributable to 'at least two hundred
furnace chimneys in a square of two miles on every side
of me. But mere smoke would not blow to and fro in
that wild way. It looks more to me as if it were made
of dead men's souls', a reference, he explained later,
to the casualties in the Franco-Prussian war of that
year (27.133). The coincidence of his detection of this
new phenomenon, however, and his own mental
breakdown, is significant.

233

John Ruskin

*Portrait Miniature
of Rose La Touche*
1872

Watercolour, oval
5.8 x 4.5

Formerly in metal frame,
dated 1872, engraved on
the back 'Rose La Touche,
painted by Ruskin in 1872.
She died in 1875'

Presented to the Guild
of St George 1934

The Ruskin Gallery,
Guild of St George
Collection

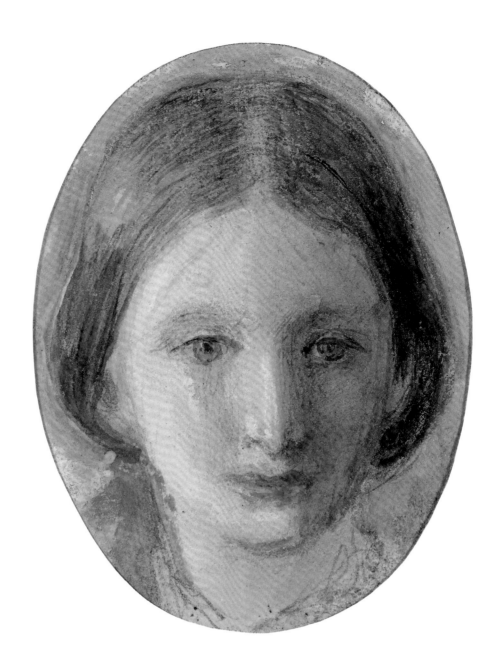

*'Oh me, that ever such thoughts and rest should be granted me
once more'* (Diary, 17 Aug. 1872, D2.729)

In June 1872 Ruskin's intermediary George MacDonald
persuaded Rose to agree to meet him. Ruskin was in
Venice at the time, however, accompanied by his cousin
Joan and her husband, the minor painter Arthur Severn
(1842–1931) whom she had married in 1871. Also in the
party were his friends Mrs Hilliard and her daughter
Constance, who was to become his secretary, and the
artist Albert Goodwin (cat.213). Ruskin was at first
reluctant and uncertain, and tried to get Rose to travel
to Geneva to meet him. On 25 July he capitulated and
hurried home, to discover that Rose was staying with
the MacDonalds in London. There was a brief
reconciliation that led to a few days of happiness in

London and at Broadlands in Hampshire, the home Mrs
Cowper-Temple's husband had inherited from his step-
father Lord Palmerston. But Ruskin once more pressed
his case for marriage, and was once more rejected. By
the end of 1872 Rose was again seriously ill. Ruskin
wrote to Mrs Cowper-Temple in October, 'Why did not
our God make me but a little stronger – *her* but a little
wiser – both of us happy? Now – granting me faultful,
her foolish, I suffer for her madness – she for my sin –
and both unjustly. Why should she go mad, because
I don't pray faithfully' (LMT.338).

The miniature, dateable by its frame, remained in
Ruskin's possession until his death, when it was given
to Juliet Morse, a friend of Ruskin through membership
of the Guild of St George, to which it was presented
in 1934.

234

John Ruskin

Self Portrait with
Blue Neckcloth
Jan. 1873

Watercolour
35.5 X 25.4

Inscribed by Joan Severn
'Di Pa by himself'

The Pierpont Morgan
Library, New York

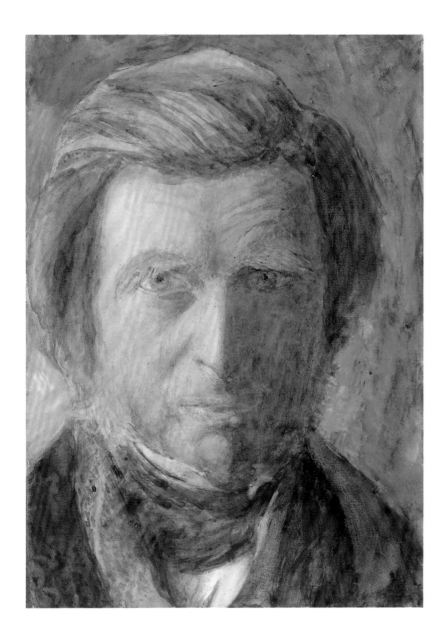

'*Began portrait of self, for Norton*' (Diary, 29 January 1873, D2.736)

Ruskin's American friend and future literary executor Charles Eliot Norton had wanted a portrait of Ruskin for many years (see cat.119). But the commission to Rossetti in 1859 resulted in what Ruskin called 'the horriblest face I ever saw of a human being' (36.497) and was abandoned. In 1865 Ruskin suggested that Burne-Jones should produce a portrait for Norton, but this was abandoned in 1866. Ruskin wrote to Norton, 'I expect

I can draw myself better than anybody else can' (LN.99). The work was not begun however until January 1873, and even then it was not sent to Norton, for Ruskin kept it at Brantwood. Norton finally received two further drawings in 1874 (cats.236, 238).

Cat.234, drawn at Brantwood, shows Ruskin wearing his characteristic blue stock. Joan Severn's inscription 'Di Pa' uses her affectionate name for him – dear papa – used in their private correspondence, where she was 'Di Ma' – dear mama. Ruskin's gaze has become more direct and more intense since the self-portrait of 1861 (cat.229).

235

John Ruskin

Two Studies of Snakes

(*left*)
*Full Face of Cobra.
From Life*
Pencil, watercolour
and bodycolour
on grey paper
20 x 11.9

(*right*)
*Cerastes from Life;
seen full front*
Pencil, watercolour
and bodycolour
on brown paper
12 x 14.5

Given to the Ruskin
School of Drawing 1871

The Visitors of the
Ashmolean Museum,
Oxford

'In the deepest and most literal sense, to those who allow the temptations of our natural passions their full sway, the curse, fabulously (if you will) spoken on the serpent, is fatally and to the full accomplished upon ourselves' ('A caution to Snakes', 1880, 26.324)

Ruskin was fascinated by the motion of snakes, and liked to draw them at the London Zoo. He wrote about them several times, most notably in *The Queen of the Air* (1869) and his lecture 'A Caution to Snakes' given in 1880. His approach, as with botany in *Proserpina* (1879) and ornithology in *Love's Meinie* (1881), was mythological, arguing that natural facts had symbolic meanings which showed 'the moral significance of the image, which is in all the great myths eternally and beneficently true' (19.300). Snakes have been an emblem of temptation since the composition of the Book of Genesis, and it appears from his references to 'deep corruption' and 'degraded forms' of serpent worship in *The Queen of the Air* that he was aware of their phallic significance (19.365).

From 1868 onwards Ruskin began to be troubled by dreams that were sexual in origin. In November 1869 he recorded 'the most horrible serpent dream I ever had yet in my life. The deadliest came out into the room under a door. It rose up like a Cobra – with horrible round eyes and had woman's or at least Medusa's breasts. It was coming after me, out of one room, like our back drawing room at Herne Hill, into another; but I got some pieces of marble off a table and threw at it, and that cowed it and it went back; but another small one fastened on my neck like a leech, and nothing would pull it off' (D2.685).

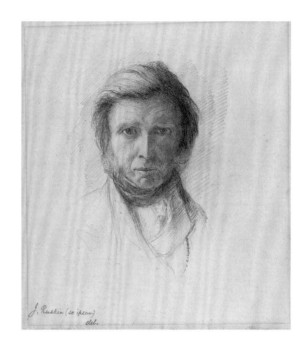

236

John Ruskin

Self-Portrait
1874

Pencil
25.4 x 20.4

Inscribed by C.E.Norton
'J.Ruskin (se ipsum) del.'
and on verso 'J.Ruskin.
His own drawing of
himself, 1873 or 4. C.E.N.
Not a good likeness'

Ruskin Foundation
(Ruskin Library,
University of Lancaster)

*'I shall make you a little drawing of myself, positively before
I go abroad'* (Letter to Norton, 15 Feb. 1874, LN.308).

By February 1874 Rose La Touche was seriously ill,
but had escaped her family and was seeking medical
treatment in London, staying at the Crystal Palace Hotel
in Sydenham. Ruskin was not allowed to see her, but Joan
Severn was, and in the same letter quoted above in which
he promises once more to draw himself for Norton, he
describes playing chess with the chess-automaton at the
Crystal Palace, while waiting for Joan Severn to return
from visiting Rose, 'She had found R. a little better; and
up, on her sofa – but it will be a week or more before
we can know how she will bear the fasting' (LN.308).
 Ruskin returned to Brantwood 'till the crisis is over'
(LN.308) and made two attempts at a self-portrait, this
and cat.238. The stress he was under shows in the tension
round his eyes.

237

John Ruskin

*The Tomb of Ilaria
del Caretto at Lucca*
1874

Wash and bodycolour
20.3 x 30.5

Given to the Ruskin
School of Drawing 1874

The Visitors of the
Ashmolean Museum,
Oxford

*'Through and in the marble we may see that the damsel is not
dead, but sleepeth: yet as visibly a sleep that shall know no
ending until the last day break, and the last shadow flee away'*
('The Three Colours of Pre-Raphaelitism', 1878, 34.171)

Ruskin travelled in Italy in the summer and autumn of
1874. He visited Rome (cat.174) and spent several weeks
in Assisi studying the frescoes in the lower church,
then attributed to Giotto. He was particularly drawn by
The Marriage of St Francis and Poverty (fig.19) where
the roses above Poverty's head could not fail to remind
him of the marriage that he realised would never take
place. (His drawing of them is now lost.) While staying
at Assisi, however, he recovered some of his former
religious faith, but he was now to call himself a
'"Catholic"', though 'no more … a *Roman*-Catholic,
than again an Evangelical-Protestant' (29.92).

Ruskin then travelled to Florence and Lucca, which
he visited twice, in July and August, making three
attempts to draw the tomb of Ilaria del Caretto, which
had been the touchstone of sculpture for him since 1845
(see cat.102). None of his attempts satisfied him, and in
Letter 45 of *Fors Clavigera,* written in Lucca, he confessed
his increasing despair: 'I feel the separation between me

and the people round me, so bitterly, in the world of my
own which they cannot enter; and I see their entrance
to it now barred so absolutely by their own resolves'
(28.146). Writing beside the tomb of a dead woman,
he acknowledges the rejection of his public message,
and his private loneliness.

Ruskin used the drawing to illustrate his lecture on
Jacopo della Quercia in November 1874, in the series *The
Aesthetic and Mathematic Schools of Art in Florence* (23.222).

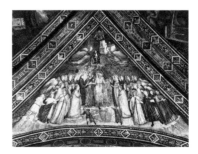

fig.19 The Master of the Veils, *The Marriage of
Poverty and St Francis* in the lower church, Assisi (Archivi
Alinari, Florence)

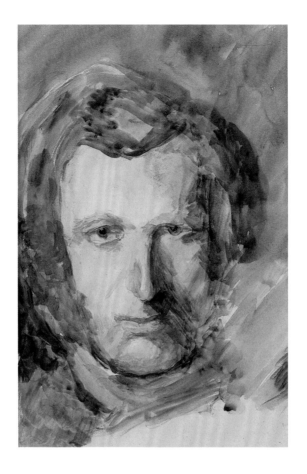

238

John Ruskin

Self-Portrait
1874

Watercolour
38 x 25

Wellesley College Library
Special Collections, Ruskin
Collection. Gift of Charles
E. Goodspeed

'All that is good in me depends on terrible subtleties, which I find will require my best care and powers of completion; all that comes at first is the worst' (Letter to Norton, 11 Apr. 1874, LN.312)

On his departure for Italy in April 1874 Ruskin sent Norton not one but two self-portraits, cat.236 and this. He described his dissatisfaction with the results: 'Continually I see accidental looks, which if I could set down you would like, – but I have been able to do nothing yet, only I let these failures be sent to show I have been trying' (LN.312).

In the same letter he wrote, 'R[ose] wouldn't see me: but dreamed of me the morning I left – and woke, to wish me good, in her usual pious, useless way. She is better – and was I think right – for my sake, in not letting me see her … there can never be anything to come between R and me, now, my life is too far broken' (LN.313). Ruskin's dashing, freehand style seems to capture a moment of inner perception.

239

John Ruskin

*Portrait of Rose
La Touche*
1874

Pencil, oval
41.9 34.3

Ruskin's visiting
card attached to old
mount inscribed by
Joan Severn '"Rose"
by [Mr Ruskin]'

Ruskin Foundation
(Ruskin Library,
University of Lancaster)

*'Finally to Rosie's; and had leave to nurse her – the dream of life
too sorrowfully fulfilled'* (Diary, 6 Dec. 1874, D3.830)

On his return to England at the beginning of October
1874, Ruskin was permitted to see Rose La Touche, who
was still in London. This drawing was catalogued by
Ruskin's editors Cook and Wedderburn as 1874, a date
they would have got from Joan Severn, whose inscription
authenticates the drawing. In the autumn of 1874 Ruskin
divided his time between lecturing at Oxford – where
he was also supervising the 'diggings' at the village of
Ferry Hinksey, a road building and drainage scheme
intended to give undergraduates a taste of manual labour
– and visits to London to see Rose. Her condition,
however, was deteriorating. In December she was taken
back to Dublin. Ruskin wrote to Norton on 28 December,
'*With* your letter came one in pencil from poor Rose –
praying me to deliver her from her father – (who has
driven her mad and is shutting her up with a Doctor in
Dublin) – I am of course helpless' (LN.349). Rose returned
to London, however, in January 1875.

fig.20 Francesca Alexander, *The Death of a Tuscan Girl* (frontispiece to *The Story of Ida* 1883, Ruskin Foundation, Ruskin Library, University of Lancaster)

240

John Ruskin

Portrait of Rose La Touche on her deathbed
1875

Pencil
17.8 x 11.8

Ruskin Foundation
(Ruskin Library,
University of Lancaster)

'The woman I hoped would have been my wife is dying'
(*Fors Clavigera*, Letter 49, Jan. 1875, 28.246)

Ruskin saw Rose La Touche for the last time on 25 February 1875. He described the scene in a letter to the artist Francesca Alexander twelve years later: 'Of course she was out of her mind in the end; one evening in London she was raving violently till far into the night; they could not quiet her. At last they let me into her room. She was sitting up in bed; I got her to lie back on the pillow, and lay her head in my arms as I knelt beside it. They left us, and she asked me if she should say a hymn, and she said, "Jesus, lover of my soul" to the end, and then fell back tired and went to sleep. And I left her' (LF.118).

The existence of this drawing became known to J.H. Whitehouse (1873–1955), whose collection is now in the Ruskin Library, Lancaster, in 1937 when an admirer

of Ruskin, the art historian Kenneth Clark, wrote to say that he had seen the drawing in the possession of a Mrs Thorold, who described it as Rose la Touche on her deathbed. J.S. Dearden in his catalogue of portraits of Rose accepts Whitehouse and Clark's view that the provenance is genuine (Dearden 1978, p.96). At this period Ruskin made recurrent references to images of girls asleep – or dying. In *Fors Clavigera* for February 1875 (written in January) he discusses a cheap woodcut of 'a beautiful little girl with long hair, lying very ill in bed' (28.257). The frontispiece (fig.20) drawn by Francesca Alexander to her book *The Story if Ida*, which Ruskin edited and helped to publish in 1883, recalls cat.240. In 1876 Ruskin began obsessively to copy Carpaccio's cycle of paintings of the life of St Ursula, which depicted St Ursula both asleep and on her bier (see cat.244 and fig.21).

241

John Ruskin

Study of Wild Rose
1871

Pencil, watercolour
and bodycolour
26.9 x 42.2

Given to the
Ruskin School
of Drawing 1872

The Visitors of the
Ashmolean Museum,
Oxford

'I ... was away into the meadows, to see buttercup and clover
and bean blossom, when the news came that the little story of
my wild Rose was ended, and the hawthorn blossoms, this year,
would fall – over her' (Letter to Thomas Carlyle, 4 June
1875, 37.168).

Rose La Touche died in Dublin on 25 May 1875. The
news reached Ruskin on 28 May, shortly before he was
due to present the teaching collection he had assembled,
together with an endowment of £5,000 for a Drawing
Mastership, to Oxford University. The deed of gift was
signed on 31 May at a ceremony attended by Queen
Victoria's eldest daughter, Princess Alice, and youngest
son, Prince Leopold, who was studying at Oxford and
who became a trustee. Before the ceremony at the
Drawing School, which occupied the west ground-floor
gallery of the Ashmolean Museum, Ruskin put a number
of drawings out on display, choosing in particular
cat.241. In the evening he wrote to Joan Severn, 'I think
I behaved pretty well on the whole, for me, and was
pleased with myself though all the time wondering when
that child's wake was – which please find out for me –
for I want to know – it would be a strange thing if today'
(Hewison 1984, p.26).

The picture Ruskin chose to display had to serve as
his wreath for Rose.

242

John Ruskin

Study of a Peacock's Breast Feather

Watercolour
22.3 × 14.7

The Ruskin Gallery,
Guild of St George
Collection

'Have been painting a peacocks breast feathers all this week'
(Letter to C.E. Norton, 14 Dec. 1875, LN.373).

In October 1875 Ruskin was invited by Mrs Cowper-Temple and her husband to make use of a suite of rooms that had been set aside for him at their house in Hampshire, Broadlands, and he became a regular visitor for a time. He was in the habit of making studies of peacock feathers, which he used as a form of drawing exercise. Whilst at Broadlands he also came once more into contact with a medium, Mrs Annie Ackworth, with whom he had attended seances, encouraged by the Cowper-Temples, in 1864 (see cat.215). The Cowper-Temples had been leading exponents of spiritualism since 1861, and Ruskin attended a number of seances between 1864 and 1868, when he told Mrs Cowper-Temple that he had 'done with "Mediums"' (Burd 1982, p.20).

At Broadlands in 1875, however, he noted in his diary that on 13 December Mrs Ackworth had given him 'the most overwhelming evidence of the other state of the world that has ever come to me' (D3.876). Mrs Ackworth was able to convince him that she had seen the spirit of Rose standing beside him and whispering to him. Ruskin saw and heard nothing, but he became pre-disposed to believe that Rose was still in communication with him from beyond the grave.

243

John Ruskin

A Street in Venice
1876

Pencil and wash, touched
with bodycolour
20.8 × 13

South London Art Gallery

'Time was, every hour in Venice was joy to me. Now, I work as I should on a portrait of my mother, dead' (Letter to C.E. Norton, Venice, 16 Jan. 1877, 37.216)

In 1876 Ruskin took leave of absence from the Slade Professorship, and at the end of August travelled through Switzerland to Venice, where he arrived in September. He planned to revise *The Stones of Venice,* but instead wrote a new 'volume', the guide-book *St Mark's Rest* (1877–84), and his *Guide to the Principal Pictures in the Academy of Fine Arts at Venice* (1877). He became involved in the campaign to stop the proposed restoration of the west front of St Mark's (cat.257). For reasons that will become clear (see cat.244) Ruskin's mood swung between exaltation and depression, and his drawings vary between careful studies such as *The North West Porch of St Mark's* (cat.77) and violent, expressive sketches such as this one.

244

John Ruskin

after Vittore Carpaccio

*Copy of the Head
of St Ursula
from Carpaccio's*
**The Dream
of St Ursula**
1877

Watercolour and
bodycolour
57 x 40

Given by Ruskin
to Somerville College,
Oxford 1884

Somerville College,
Oxford

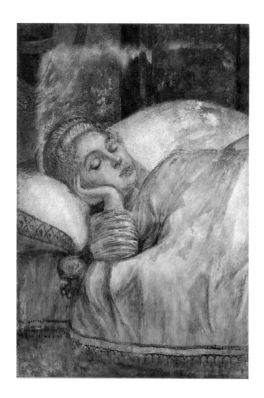

fig. 21 John Ruskin, *The Dream of St Ursula*
after Carpaccio 1876 (The Visitors of the
Ashmolean Museum, Oxford)

*'There she lies, so real, that when the room's quite quiet,
I get afraid of waking her!'* (Letter to Joan Severn,
Venice, 19 Sept. 1876, 24.xxxvii)

Ruskin became interested in the work of Vittore
Carpaccio when he visited Venice in 1869, having had
his attention drawn to the artist by Burne-Jones. He first
studied the sequence of paintings in the Scuola di San
Giorgio degli Schiavoni, with the Guild of St George
in mind (cats.172, 173), but the St Ursula cycle hanging
(albeit out of sequence and incompletely) in the
Accademia had a personal significance. The story of the
virgin saint's martyrdom begins with her betrothal to an
English prince who is a pagan, and the postponement of
their marriage for three years in order to make a pilgrim-
age, during which they and their retinue are slaughtered.
Ruskin was particularly attracted to the canvas that
depicts St Ursula asleep in bed, as an angel appears to
her in a dream. The echoes of other images have already
been pointed out (cat.240).

 On 19 September 1876 Ruskin persuaded the auth-
orities at the Accademia to have *The Dream of St Ursula*
taken down and placed in a side room, where Ruskin
was able to lock himself in. He began a series of intense
studies that continued into the following year, with a
copy of the whole picture (fig.21). The identification in
his mind between St Ursula and Rose was already present
when he wrote to Joan Severn on 19 September, 'How
little one believes things, really! Suppose there *is* a real St
Ursula, di ma, – taking care of somebody else, asleep, for
me?' (Hewison 1978, p.92).He was thus deeply immersed
in the painting as the first anniversary of the 'teachings'
he had received from the medium at Broadlands in 1875
approached. His diary records that from 21 December he
had been praying 'for a new sign from Rose' (D3.921).

On Christmas Eve what he took to be a sign came, in the
form of a sample of dried vervain sent by a botanist friend
at Kew, vervain being one of the plants on St Ursula's
bedroom windowsill. (It is also known as *Ros marina*,
Ophelia's Rosemary for remembrance (Viljoen 1971,
p.121).) He also received a letter from Joan Severn
enclosing one to her from Mrs La Touche. On Christmas
day an English visitor in Venice presented him with a pot
of carnations, the other flower represented in the painting.
He wandered about a fog-bound Venice on Christmas day
in a state of exaltation, convinced that Rose was indeed
sending him a message through St Ursula that he should
forgive Mrs La Touche: 'I received it as a direct command
from St Ursula, with her leaf: a command given by *her*,
and with the mythic power of her nature-origin used to
make me understand that Rosie had asked her' (D3.921).

 Ruskin worked on at least four separate studies from
the painting. Entries in his diary suggest that he was
working on this detail, to the same size as the original,
in February 1877. In Venice he was joined by the
American artist and teacher Charles Herbert Moore
(1840–1930) who was working at Harvard under Norton,
and who had been sent by him to study Ruskin's methods.
Moore was also set to copy the painting, and Ruskin
commissioned two further studies from his copyist
resident in Venice, John Bunney (see cat.257). In 1884 he
presented cat.244, together with a small group of precious
stones, to Somerville College, Oxford, as a gesture of
support for women's education.

 Ruskin came very close to mental breakdown in
Venice in 1876–7. He had his St Ursula copies in his
study at Brantwood when he broke down completely
in February 1878. As we have seen, he later told Norton,
'I went crazy about St Ursula and the other saints, –
chiefly young lady saints' (LN.412).

245

John Ruskin

Self-Portrait
?1875

Watercolour with some
bodycolour and pencil
47.6 x 31.1

Inscribed on verso
'John Ruskin: s.m.
circa 1875 aet 56'

Tate Gallery. Purchased
as part of the Oppé
Collection with assistance
from the National Lottery
through the Heritage
Lottery Fund 1996

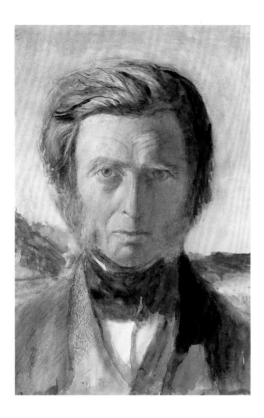

*'That death, as you so well understand, has made so much of
my past life at once dead weight to me'* (Letter to Norton,
19 July 1875, LN.363)

Although cat.245 clearly shows Ruskin more aged and
strained than in the previous self-portraits, there is no
certainty about the date of the drawing, or even if it is
by Ruskin, though the inscription, added later, and not
in Ruskin's hand, points to it being a self-portrait ('s.m.'
possibly being short for 'sua manu'), and dated 'around'
1875. There is no doubt that the subject is Ruskin, and
while the image recalls the self-portraits of 1873 and
1874 (cats.234, 236, 238), his face registers even greater
intensity and suffering.

The drawing was at one time owned by Ruskin's
copyist and dealer Charles Fairfax Murray (see cats.79,
125 and 127), who went to Venice in order to work for
Ruskin in March 1877. While in Venice, as both men's
diaries record, Murray made a portrait of Ruskin that was
completed by 20 May (Dearden 1999, p.107). Because
of its provenance, cat.245 has previously been assumed
to be this portrait, and accordingly attributed to Murray
(Hewison 1978, p.94). Further consideration of the
handling of the paint, which is much closer to Ruskin's
than Murray's, the evidence of the inscription, and the
observation that such background as there is suggests
mountains and a lake rather than Venice, leads to the
conclusion that the drawing is indeed by Ruskin.

The drawing was bought by the collector Paul Oppé,
together with works by Murray himself, in 1921. It is
possible Murray acquired the drawing after Ruskin's
death, or was given it by Ruskin.

246

John Ruskin

*July Thundercloud
in the Val d'Aosta*
1858

Watercolour
12.6 x 17.4

Ruskin Foundation
(Ruskin Library,
University of Lancaster)

*'To [Turner], as to the Greek, the storm-clouds seemed
messengers of fate'* (*Modern Painters* v, 1860, 7.189)

In the first volume of *Modern Painters* Ruskin wrote,
'It is a strange thing how little in general people know
about the sky' (3.343). He had been fascinated by its
changefulness ever since he had made his own 'cyan-
ometer' to measure the blueness of the sky, before setting
out with his parents for the Alps in 1835 (see cat.23;
35.152). Three chapters of *Modern Painters* volume I, under
the heading 'Of Truth of Clouds', demonstrate that
Turner alone was capable of rendering the infinite variety
of cloudscapes, basing his argument on the authority of
his own observations and derogatory comparisons with
Dutch and Italian old masters. He returned to the subject
in his final volume, closing his 'investigation of the

beauty of the visible world' (7.193) with four chapters
'Of Cloud Beauty'. Turner was still the master, but
Ruskin's interpretations were no longer so much art-
historical, as allusive, mythological and steeped in moral
symbolism: 'The clouds, prepared by the hands of God
for the help of man, varied in their ministration – veiling
the inner splendour – show, not His eternal glory, but
His daily handiwork' (7.196).

Ruskin was preparing the final volume of *Modern
Painters* (1860) when he made this study of the Alps of
the Val d'Aosta, 'seen from Turin' (34.29). The location
is important, for it was while spending six weeks in
Turin in July and August 1858 that Ruskin experienced
an 'un-conversion' that finally freed him from the strict
Evangelical Protestantism which had shaped the first
half of his life. He did not lose his faith entirely, as the
quotation from *Modern Painters* volume v above shows,
but it was none the less a turning point, and opened the
way for a more material and sensual enjoyment of art.
It may also have released his own physical desires, later
expressed in his love for Rose La Touche.

Ruskin showed an enlarged version of cat.246, made
for him by Arthur Severn, as an illustration to his lecture
'The Storm-Cloud of the Nineteenth Century' in 1884,
the same year in which he decided to republish his
chapters on clouds from *Modern Painters* as *Coeli Enarrant*
(1885). John Brett was working on his *Val d'Aosta*
(cat.207) while Ruskin was in Turin.

247

John Ruskin

Sunrise over the Sea

Watercolour
17.2 x 12.4

Abbot Hall Art Gallery,
Kendal

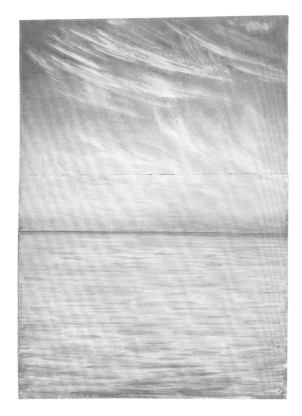

'Never, if you can help it, miss seeing the sunset and the dawn. And never, if you can help it, see anything but dreams between them' (*The Laws of Fésole*, 1879, 15.362)

It is not possible to date or place this drawing, although the gradation of the colour suggests it is a late work, and it is possible to speculate that the subject is the lagoon of Venice. In his last drawing manual, *The Laws of Fésole*, quoted above, Ruskin placed a fresh emphasis on the importance of colour as opposed to line: 'I believe you will find the standard of colour I am going to give you, an extremely safe one – the morning sky. Love *that* rightly with all your heart, and soul, and eyes; and you are established in foundation-laws of colour. The white, blue, purple, gold, scarlet, and ruby of morning clouds, are meant to be entirely delightful to the human creatures whom the "clouds and light" sustain. Be sure you are always ready to see *them*, the moment they are painted by God for you' (15.417–18). Ruskin's reference to 'clouds and light' is a covert allusion to Rose La Touche's volume of devotional verse, *Clouds and Light* (1870) (see cat.230).

According to a label on the back of the frame Ruskin gave the drawing to his assistant Arthur Burgess, who subsequently sold it to Hugh Allen, the son of his publisher George Allen, who in turn sold it to the collector Robert Cunliffe, who had the frame made.

248

John Ruskin

Dawn at Neuchatel
1866

Watercolour and
bodycolour
17.5 x 25.8

First exhibited
Noyes & Blakeslee,
127 Tremont Street,
Boston, October 1879
and the American Art
Gallery, Madison Square,
New York, December
1879, no. 37

The Fogg Art Museum,
Harvard University Art
Museums

'Up at ½ past 4. Sketched dawn. Out for morning walk'
(Diary, 11 May 1866, D2.588)

Neuchatel was a favourite spot of Ruskin's father, and was a regular part of Ruskin's own Continental itineraries. In

April 1866, shortly after his proposal to Rose La Touche (see cat.231) and when she had returned with her family to Ireland, Ruskin set out for Switzerland and Venice with a party of friends consisting of Sir Walter and Lady Trevelyan, their niece (and Ruskin's future secretary) Constance Hilliard, and his cousin and his mother's companion, Joan Agnew. It was hoped that Lady Trevelyan, who was seriously ill, would benefit from the excursion, but after visiting Paris her condition worsened. Ruskin went ahead to Neuchatel on 7 May; by the time the Trevelyans arrived on 11 May, the date of this drawing, she was too weak to move, and she died on 13 May. Ruskin stayed in Switzerland until early July, but the visit to Venice was abandoned.

Ruskin lent the drawing to Charles Eliot Norton while he was visiting London in the winter of 1868–9. Norton appears to have kept it, and he included it in the exhibition he arranged in Boston and New York in 1879. Ruskin identifies the mountain peaks, the Eiger and Jungfrau, in a letter to Norton (LN.123).

249

John Ruskin

Moonlight, Chamonix

Pencil and watercolour
22.9 x 28.6

Inscribed by Ruskin
'Moonlight Chamouni
J.Ruskin 1888'

Probably placed by
Ruskin in the Ruskin
School of Drawing,
but later withdrawn

Private Collection

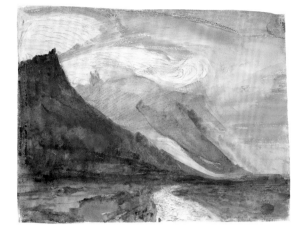

'One of the most solemn things I ever saw in the Alps; the moon-lighted clouds following the outline of the Aiguilles with a drifting halo' (Catalogue of the Educational Series 1878, 21.151)

The date given in the inscription of cat.249 refers to the date it was written, not the date of the drawing itself. At the close of his life, while preparing material for his autobiography, Ruskin was in the habit of annotating drawings in this way. Ruskin wrote his 'Epilogue' to *Modern Painters* at Chamonix in September 1888 (7.464), but this is probably coincidence. From Ruskin's comment, quoted above, and a correspondence in measurements, cat.249 appears to be one of two Alpine studies placed by Ruskin in the Ruskin School of Drawing (Educational Series 111) but later withdrawn. His comment, made in 1878, continues, 'It was daubed in on the instant with one candle so that I might see out of the window clearly, and not touched afterwards' (21.151).

250

John Ruskin

Study of Dawn. The first Scarlet in the Clouds

Watercolour
on grey paper
13.8 x 19

Study of Dawn, Purple Clouds

Watercolour on
grey paper
15.4 x 19

Presented to
the Ruskin School
of Drawing 1871

The Visitors of the
Ashmolean Museum,
Oxford

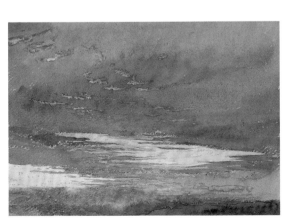

'Symbolical of the beginning of all rightly educational work – the rising of the light of heaven above the horizon of our life' (Catalogue of the Educational Series 1872, 21.106)

These are cloud studies, made in London or on a Continental tour, placed by Ruskin as drawing exercises in the Ruskin School of Drawing in 1871. They were 'chosen only for their extreme simplicity in method of work, being little more than memoranda of the skies as they passed' (21.106). None the less Ruskin also found symbolic value in such images, and drew a moral lesson from disciplining oneself to observe the sunrise. The student 'will find his thoughts during the rest of the day both calmed and purified, and his advance in all essential art-skill at once facilitated and chastised' (21.106). Ruskin's own 'art-skill' proved capable of works of almost abstract purity.

Ruskin had observed the skies and made notes on the weather all his life, but from 1871 onwards he began to be troubled by the 'plague-wind' of his lecture 'The Storm-Cloud of the Nineteenth Century' in 1884 (see cat.253).

251

John Ruskin

*Cloud Study over
Coniston Water*
?1880

Pencil and watercolour
17.9 x 26.1

Inscribed by Ruskin 'over
Coniston water J.R. 1880'

Ruskin Foundation
(Ruskin Library,
University of Lancaster)

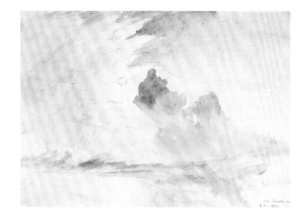

'Oh that some one had but told me, in my youth, when all my heart seemed to be set on these colours and clouds, that appear for a little and then vanish away, how little my love of them would serve me' (Notes by Mr Ruskin on his Drawings by Turner, 12 Feb. 1878, 13.410)

The view is towards the south end of Coniston Water, but the inscription may be of a later date than the drawing. Ruskin's comment, quoted above, is taken from his introduction, written at Brantwood on 12 February 1878, to the catalogue of an exhibition of his Turner drawings at the Fine Art Society. Ruskin's first attack of madness occurred during the night of 22 February.

252

John Ruskin

Cloud Study
1880

Pencil and watercolour
20.5 x 38.5

Ruskin Foundation
(Ruskin Library,
University of Lancaster)

'The curse on the sky is my chief plague – if only spring were spring! But its too hard on me, this devil in the wind and clouds and light' (Diary, 12 Mar. 1880, Viljoen 1971, p.228)

Ruskin's conviction that a new kind of 'storm-cloud – or more accurately plague-cloud, for it is not always stormy' (34.9) grew steadily from the 1870s. The weather-notes in his diary are also an index of his shifting psychological moods: 'The old story, wild wind and black sky, – scudding rain and roar – a climate of Patagonia instead of England, and I more disconsolate – not in actual depression, but in general hopelessness, wonder, and disgust than ever yet in my life, that I remember, as if it was no use fighting for a world any more in which there could be no sunrise' (Diary, 1 Mar. 1880, Viljoen 1971, p.226). Ruskin was monitoring his mental health as carefully as the weather, fearing further outbreaks of the mind-storms that eventually overwhelmed him.

253

John Ruskin

*Cloud Study –
Ice Clouds over
Coniston Old Man*
1880

Watercolour
12.5 X 17

Ruskin Foundation
(Ruskin Library,
University of Lancaster)

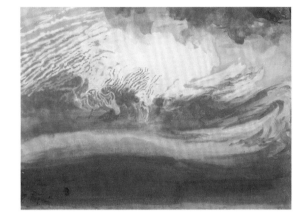

*'All sky interwoven with muslin and netting of divinest cirri
cloud, over infinite shoals and sands of mackerel cloud, – but all
flying, failing, melting – reappearing – twisting and intertwisting
– faster than eye could follow'* (Diary, 6 Aug. 1880, D3.981)

Ruskin displayed an enlargement of cat.253 as an
illustration to 'The Storm-Cloud of the Nineteenth
Century', while in the text of the lecture he gave a near
transcription of the diary entry quoted above. The entry,
which runs to some 300 words, compares the clouds he
is observing to Turner's *Flint Castle* (National Gallery of
Wales, Cardiff) and to the clouds in Turner's *Garden of the
Hesperides* (cat.3). His conclusion to his notes reads, 'these
swift and mocking clouds and colours are only between
storms. They are assuredly new in Heaven, so far as my
life reaches. I never saw a single example of them till after
1870' (34.24n). By the 1880s they had become an index
of his own disturbed mind.

254

John Ruskin

Seascale
1889

Watercolour
14.5 X 19.5

Inscribed by Joan Severn
on mount
'by John Ruskin'

First exhibited Royal
Society of Painters in
Water Colours, Ruskin
Memorial Exhibition 1901

Ruskin Foundation
(Ruskin Library,
University of Lancaster)

*'In his bedroom at Seascale, morning after morning, he still
worked or tried to work ... But now he seemed lost among the
papers scattered on his table; he could not fix his mind upon
them, and turned from one subject to another in despair'*
(W.G. Collingwood on the last days of Ruskin's
working life, 35.xxxiii)

In the summer of 1886 Ruskin suffered his fifth attack
of insanity. He was struggling to continue with his
autobiography, *Praeterita*, which he had begun in 1885,
and which he was publishing in parts as he went along,
but he was weakened by each successive attack. In May
1887 he quarrelled violently with Joan and Arthur
Severn, partly about financial matters and the making
of his will, partly about the continuation of his auto-
biography, which they feared would damage his repu-
tation. He left Brantwood and stayed at a nearby hotel
for a while, and then travelled to Folkestone, intending
to go abroad, but instead took rooms in nearby Sandgate,
where he stayed until 1888.

In June 1888 Ruskin had felt well enough to visit
northern France, and at the end of July he set out on
his last Continental journey, which took him as far as
Venice by October. But his condition was deteriorating
badly and he had to be taken back to Brantwood.
By May 1889 he had sufficiently recovered from this
episode to travel to the fishing village of Seascale, on the
Cumbrian coast. There he managed to write what turned
out to be the last chapter of the unfinished *Praeterita*.
It was published in July 1889. In August he suffered a
further devastating attack that lasted a year, and which
ended his working life.

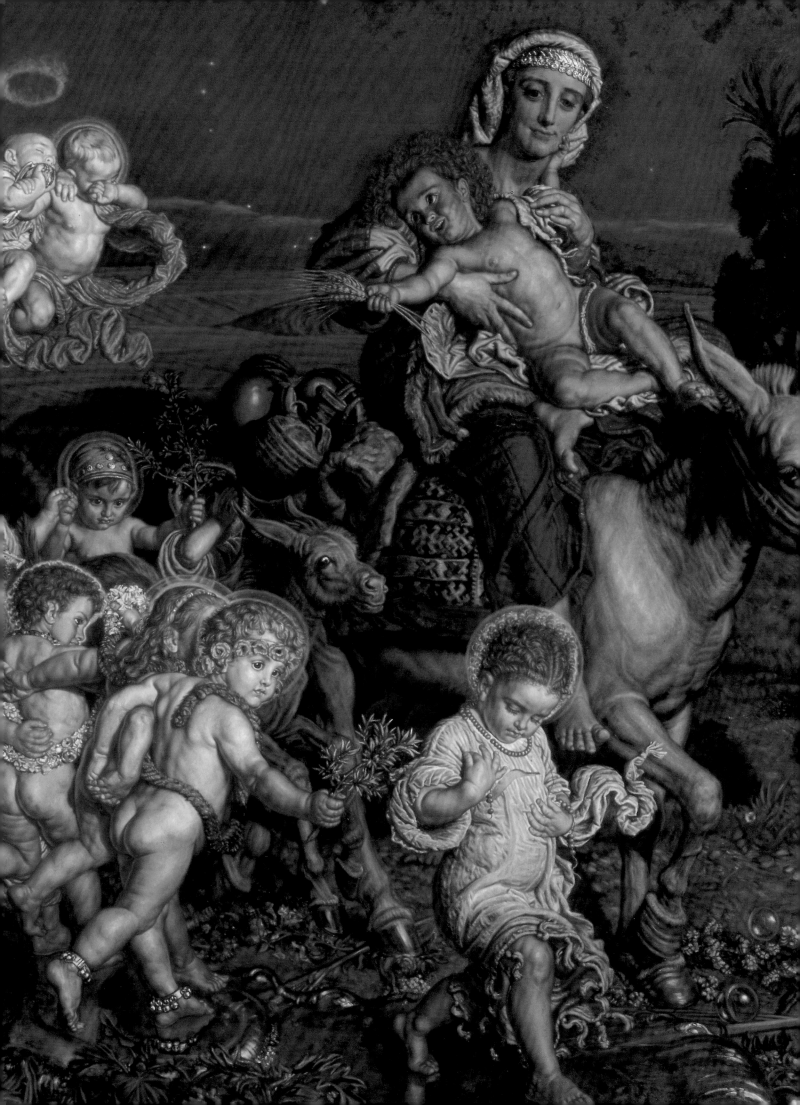

X

Conclusion

'The teaching of Art … is the teaching of all things'

Ruskin's life as an art critic began and ended with Turner. In 1889 the five volumes of *Modern Painters* were issued in a new edition, to which Ruskin had added an Epilogue where the original inspiration to write about Turner as an interpreter of God's creation shone through. One last chapter of *Praeterita*, the never to be finished autobiography, appeared in July before mental illness again descended, this time enforcing the long retreat into silence that lasted until Ruskin's death on 20 January 1900.

The work as a critic was over, but the teaching continued, as it still does. This culminating section draws on two institutions founded by Ruskin and active a hundred years after his death: the Ruskin School of Drawing in Oxford and the Guild of St George. The School and the Guild embodied the didactic purpose of Ruskin's art criticism. As its name implies, the Drawing School was a practical adjunct to the moral instruction expounded by the Slade Professor, a training for the hand and eye that would also shape the mind. The Guild of St George was a more utopian vision, but Ruskin saw its existence, in however imperfect a form, as an example of what might be done by way of social reform. It offered a counter-image to industrialism and economic individualism, and the values of co-operation and environmentalism that it expressed were to influence the founders of the National Trust and the modern Welfare State. Through the Guild's work in Sheffield it proved possible to create a new kind of museum in which education and intellectual recreation were made available to working people.

The museum also had a practical outcome, in that it provided a focus for Ruskin's intervention on behalf of Venice. He was able to use the resources of the Guild to campaign against misguided restoration and to direct the artists working for the Guild to record the art and architecture under threat. The city had been a touchstone throughout his life, and he interpreted its buildings as material expressions of moral lessons. The survival of the west façade of St Mark's, as recorded in cat.257, is a lesson in conservation for which Ruskin can claim credit.

Though he could no longer write or lecture, Ruskin's books spoke for him. From 1870 onwards, when he set up his assistant George Allen as a publisher, his influence spread to an even wider public, much of it people seeking to educate themselves. In 1879 the Ruskin Society of Manchester was founded, the first of a group of societies and reading guilds that spread his ideas in a way that no other writer of the period experienced. By the 1890s his books were in such demand that he survived the exhaustion of his original fortune, dispersed by so many acts of generosity. He also acquired disciples and interpreters: W.G. Collingwood (see cat.260), C.R. Ashbee (1863–1942) and Selwyn Image (1849–1930) leaders of the Arts and Crafts movement, and the economist J.A. Hobson (1858–1940). Mahatma Ghandi, Marcel Proust and Leon Tolstoy were among his admirers abroad. When William Morris reprinted the chapter on 'The Nature of Gothic' from *The Stones of Venice* in 1892 (cat.110), he was drawing together the two sides of Ruskin's teaching, the aesthetic and the social.

This final section concludes with an echo of the first: the juxtaposition of a work by Turner with one by a Pre-Raphaelite, Holman Hunt. In Ruskinian terms both are 'late' works, in that Ruskin began to appreciate the significance of cat.259 after Turner's death, while cat.258 is the last Pre-Raphaelite masterpiece. By the time Ruskin came to the despairing Holman Hunt's rescue with his encouragement to complete the picture, the idea of 'teachings' had acquired a private, spiritualist, significance which critic and artist understood, and which helps to account for the painting's strange combination of the natural with the supernatural.

The higher significance of the natural world was something that Turner had taught Ruskin; Holman Hunt had learned the symbolic possibilities of material facts from *Modern Painters*. However distant to modern eyes, Turner's visionary landscape, with its gods and water nymphs, is not so far from Holman Hunt's moonlit Holy Family and its 'too chubby' spirits (33.291). As Ruskin put it in the final words of the Epilogue to *Modern Painters*, 'the laws, the life, and the joy of beauty in the material world of God, are as eternal and sacred parts of His creation as, in the world of spirits, virtue; and in the world of angels, praise' (7.464).

RH

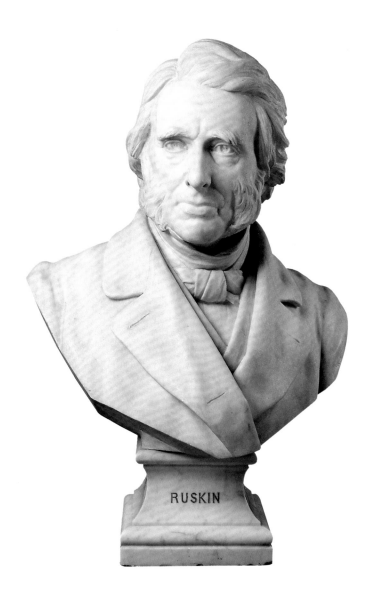

RUSKIN

255

Joseph Edgar Boehm
(1834–1890)

Bust of John Ruskin
1881

Marble, height 64
socle 14 x 14

Incised on socle 'RUSKIN'
and on right shoulder
'J.E. BOEHM Fecit'

Placed in the Ruskin
School of Drawing,
Ashmolean Museum 1881

The Ruskin School
of Drawing and Fine Art,
Oxford

'A bust of extreme and, more than perhaps I quite like – historical – veracity, – it is like a cast from life' (Letter to Sir John Simon, 6 Dec. 1879, Viljoen 1971, p.535)

This is the marble version of a portrait bust modelled in clay in November 1879, then cast in terracotta. Ruskin was asked to sit to Boehm by Henry Acland, who was also behind the appeal launched in May 1880 to raise funds for a life-sized statue: 'Many friends of Mr Ruskin have expressed a desire that a statue of the author of *Modern Painters* should be placed in the School of Drawing, Oxford, which owes its existence to his generosity and bears his name' (38.111). Burne-Jones and Frederic Leighton were on the appeal committee, but only enough money was raised to pay for this bust and an inscribed marble plinth. These were placed in the Drawing School, at that time in the west ground-floor gallery of the University Galleries, now the Ashmolean Museum. Further casts in terracotta were made from the marble version.

Ruskin had announced his intention of founding a 'school' in his inaugural lecture as Slade Professor in

1870, and began a drawing class in the Michaelmas Term that year. He also began to create a collection of examples as a teaching aid (see cat.181). Before Ruskin could create a formal institution, however, he had to agree to take over the branch school run by the government's Department of Science and Art, already functioning in the University Galleries. As he detested the government system of teaching he was glad to do so, but he had to employ the head of the school, Alexander Macdonald (1839–1921) as Drawing Master, and permit the continuation of an 'Industrial Class' using government-approved methods. In 1875 the art collection he had created and an endowment of £5,000 were formally assigned to the University (see cat.241).

Ruskin became increasingly disenchanted with Oxford and its members' failure to heed his message. His breakdown of 1878, followed by defeat in the Whistler libel case, confirmed his decision to resign his Professorship, calling it 'a farce' (Hewison 1996, p.32). He accepted re-election in 1883, but resigned again in December 1884 in protest at the University's decision to appoint a professor licensed in vivisection.

256

John Ruskin

Lecture diagram: orange and purple leafspray
1870s

Pencil, chalk or crayon, watercolour and bodycolour, on a single sheet of paper laid on canvas
167.5 x 137.7

Ruskin Foundation (Ruskin Library, University of Lancaster)

'I would rather teach drawing that my pupils may learn to love Nature, than teach the looking at Nature that they may learn to draw' (*The Elements of Drawing*, 1857, 15.13)

Ever since his first public lectures in Edinburgh in 1853, Ruskin had used a visual rhetoric of large diagrams, works of art and other objects, including, on one occasion, a ploughshare, to illustrate his argument (see cat.86). The diagrams were prepared either by Ruskin or his assistants, and some fifty examples survive. Although the attribution cannot be certain, the vigorous handling, the use of purple watercolour, and the preservation of the work itself, suggest that this is by Ruskin himself.

The subject is an acanthus leaf, a natural form adapted by Greek and Gothic carvers. There is no explicit reference to it in the published texts of the twelve series of lectures Ruskin gave at Oxford before 1878, and it is possible that it was used informally, as a large teaching example in the Drawing School. As the school developed, classes became divided between 'the Professor's class', open to undergraduates only and taught by Ruskin when he was in residence, and the 'Town' class, attended by previous pupils of the Oxford Art School, and taught by Alexander Macdonald, who also taught the 'Industrial' class (see cat.255). This explains the creation of two separate sequences of teaching examples, the Educational Series for Ruskin's class, the Rudimentary Series for Macdonald's.

As at the London Working Men's College in the 1850s (see cat.109), Ruskin was not trying to produce artists, but to train perception: 'a power of the eye and a power of the mind wholly different from that known to any other discipline' (16.440). His emphasis on outline and local colour was quite different to the drawing from casts in the Royal Academy School, or the mechanical copying from the flat enforced by the Department of Science and Art, which had 'corrupted the system of art-teaching all over England into a state of abortion and falsehood' (29.154). As he told his pupils at the Working Men's College, 'I am only trying to teach you to *see*' (Hewison 1996, p.33).

257

John Wharlton Bunney
(1828–1882)

*The West Front
of St Mark's*
1877–82

Oil on canvas
144.6 x 226

First exhibited
Fine Art Society 1882,
hung in the Governesses'
Room, Whitelands
College, Chelsea 1882,
placed in the Museum of
the Guild of St George,
Sheffield 1885

The Ruskin Gallery,
Guild of St George
Collection

'Never had city a more glorious Bible'
(*The Stones of Venice* II, 1853, 10.141)

When Ruskin returned to Venice in 1876 he discovered that the restoration was proposed of the west front of St Mark's. The north and south façades had already been spoiled by scraping and the replacement of ancient marbles, and the former undulating mosaic pavement of the north aisle had been renewed. The work was undertaken by his old enemy, G.B. Meduna (see cat.71). Ruskin's response was to make his own drawing of the north-west porch (cat.77) and commission Bunney to make a precise record of the whole façade. He also commissioned another copyist, a studio assistant to Burne-Jones, T.M. Rooke (1842–1942), to record the mosaics in the vaults. Ruskin joined in the local campaign against the restoration, writing an introduction to a pamphlet by Count Alvise Zorzi (1846–1922) and paying for its publication.

The cause of St Mark's was taken up in England by William Morris, who launched the Society for the Protection of Ancient Buildings in 1877. In 1879 Ruskin took advantage of his honorary membership of the Royal Water Colour Society to exhibit two of his drawings of St Mark's (see cat.77), together with photographs, and appealed for funds to support his 'Memorial Studies of St Mark's' (24.412–23). In 1880 the campaigns proved successful when an enquiry led the Italian government to adopt a new and more sympathetic policy on restoration.

Bunney had been a pupil at the London Working Men's College (see cat.109). In 1859 he became a professional painter. He carried out commissions for Ruskin in Switzerland and Italy, settling in Florence in 1863. He moved to Venice in 1870. His commission through the Guild of St George for cat.257 was £500, and he worked steadily on it, painting in the early mornings until his death. The dilapidation of the façade is evident in the props in the south-west portico.

The painting was exhibited at the Fine Art Society in November 1882 in order to raise funds for Bunney's widow. It was too big to be displayed in the Museum of the Guild of St George at Walkley, Sheffield (see cat.187), and so was sent to Whitelands College, Chelsea (see cat.184) where it remained until after an extension was built at Walkley in 1884. It can be seen in the photograph of the Museum's extension (fig.10).

258

William Holman Hunt

*The Triumph of
the Innocents*
(second version)
1880–4

Oil on canvas
156.2 x 254

Inscribed with initials
'WHH' in monogram
and '84'

First exhibited
Fine Art Society 1885

Tate Gallery. Presented by
Sir John Middlemore, Bt
1918

*'The most important work of Hunt's life, as yet; and if health
is granted to him for its completion, it will, both in reality
and esteem, be the greatest religious painting of our time'*
(*The Art of England*, 1884, 33.277)

'Without the spontaneous appreciation of our great writer
on art, to whose championship in the early days of Pre-
Raphaelitism I owe so much, I should scarce have per-
severed to save the work of so many alternating feelings
of joy and pain' (Hunt 1885, p.11). So Holman Hunt
acknowledged Ruskin's encouragement to persevere with
a project that had caused more than usual difficulty and
suffering. He made a first oil sketch in Jerusalem in 1870
(completed 1903, Fogg Art Museum). On his return to
Jerusalem in 1875 he began a full-size version, using
locally made linen which once he had started, sagged
in the middle. In 1878 he returned to London with the
damaged canvas and attempted repairs. By the end of
1879 he was in despair, believing the Devil was against
him. Ruskin, however, saw the unfinished picture in his
studio and expressed particular appreciation and under-
standing of the purpose of the children, though the main
figures were only blocked in. Shortly afterward Hunt
started again on a fresh canvas. In February 1880 Ruskin
wrote to him, 'I am partly grieved but much more glad,
that you began this new picture – I was so afraid of the
other's sinking away *after* you had done it. I hope the
Adversity may be looked on as really Diabolic and finally
conquerable utterly' (Landow 1976–7, p.42).

Ruskin saw the still unfinished second version again
in July 1882, his enthusiasm leading to the comments in
his lecture of 1883, in which he interpreted the painting
as an icon of the Resurrection. (Hunt reproduced them
in his autobiography as 'the fullest description' of his
intentions (Hunt 1905, vol. 2, p.341).) This version was
exhibited in 1885; Hunt then had the original canvas
repaired, and it was bought by the Walker Art Gallery,
Liverpool in 1891.

Ruskin's appreciation was based on *The Triumph*'s
combination of Pre-Raphaelite realism with visionary
invention, even if he thought 'the souls of the Innocents
are a little too chubby' (33.291); but the key to both
Hunt's and Ruskin's understanding of the picture is their
mutual interest in spiritualism. There are two lights in the
painting: the moonlight that falls on the Pre-Raphaelite
landscape background, and the supernatural light that
informs the spirits of the murdered innocents who are
joining the Holy Family (an effect that echoes *The Light
of the World*, cat.192). As Hunt explained in a pamphlet
accompanying its exhibition at the Fine Art Society in
1885, while the stream they cross reflects the night sky,
'The flood upon which the spiritual children advance
forms a contrast to this, by being in motion. The living
fountains of water – the streams of eternal life – furnish
this, mystically portrayed as ever rolling forward. Instead
of being dissipated in natural vapour, the play of its
wavelets takes the form of airy globes, which image the
Jewish belief in the Millennium' (Hunt 1885, p.4).

That the children are not angels, but spiritualist
manifestations, is confirmed by a letter Hunt wrote to
William Bell Scott in January 1880. Hunt had already
'startled and grieved [Scott] by relating a preternatural
incident, or something like one, that had happened to
him a few days past, on Christmas Day' (Minto 1892,
vol.2, p.227). (Hunt thought it an encounter with the
Devil, hence Ruskin's use of 'Diabolic', quoted above.)
In his letter Hunt explained that he was drawing on 'my
experience of the embodiment of ideal personages. These
develop in solidity and brightness by degrees, and I
imagine the Virgin to have seen these children at first,
scarcely discerning that they were not natural figures
under the natural light' (Minto 1892, vol.2, p.229).

As in the case of Rossetti (see cat.215), Hunt had
become interested in spiritualism after the death of
his first wife in 1866, and though claiming scepticism,
corresponded on the matter with the even more
sceptical Scott. He also discussed it with Ruskin. In his
autobiography he reports a conversation that, although
he does not name the picture, can only refer to *The
Triumph of the Innocents*. To Hunt's surprise, Ruskin
declared the painting 'carries emphatic teaching of the
immortality of the soul … what has mainly changed
my views is the unanswerable evidence of spiritualism'
(Hunt 1905, vol.2, p.271). Ruskin went on to say that
with his faith in immortality restored, his active interest
in spiritualism had ended, but it is evident that in Hunt's
picture he found the kind of reassurance that he needed
after the death of Rose La Touche and his own
breakdowns.

259

Joseph Mallord
William Turner

*Ulysses deriding
Polyphemus –
Homer's Odyssey*
1829

Oil on canvas
132.5 x 203

First exhibited
Royal Academy 1829

The Trustees of the
National Gallery, London
(Turner Bequest 1856)

*'"Polyphemus" asserts his perfect power, and is, therefore, to be
considered as the* central picture *in Turner's career. And it is
in some sort a type of his own destiny'* (*Notes on the Turner
Collection of Oil-Pictures*, 1856, 13.136).

Although it is probable that Ruskin saw this in Turner's
gallery during the artist's lifetime, he mentions it for the
first time in *Modern Painters* volume IV, published in 1856,
after Turner's death. Turner based his painting on Pope's
translation from the *Odyssey*. Ulysses is sailing away from
Polyphemus's cave, a red glow on the left. He holds in his
hand a burning brand such as he had used to blind the
one-eyed giant, who is lying on the smoke- and mist-
wreathed cliffs above, clutching his head. As the ship
rejoins the rest of the fleet on the right, water nymphs
appear as a phosphorescent bow wave. The horses of
Apollo's chariot, a personification of the dawn, surge
skywards, suffusing the canvas with a golden light that
contrasts with the red glow and darkness of the cave
from which Ulysses has escaped.

Ruskin's most extensive commentary is in the notes
he wrote, also in 1856, in an unofficial guidebook to the
Turner paintings on show at Marlborough House, when

Turner's major works were put on display there following
the resolution of the legal dispute over his will. By
calling this work 'the *central picture*' of Turner's career,
Ruskin meant that Turner had not only mastered the
classical tradition derived from Claude and Poussin,
but transcended it, by transforming contrasts based on
chiaroscuro to ones based purely on colour, the technique
he would use henceforward. Ruskin additionally read
these colours symbolically, specifically linking the
crimson in the clouds with death, a feature in Turner's
Slavers (cat.47). To say the painting is 'in some sort a type'
of Turner's destiny (13.136) is also significant. As a young
man, inspired by Thomas Carlyle's *Heroes and Hero-
Worship* (1841), Ruskin took Turner as his artist hero, a
modern day Ulysses who was prepared to challenge the
powerful forces of convention. By exchanging colour for
chiaroscuro, Turner defied the expectations of his critics,
and his reputation suffered. The defiant Ulysses was
to endure much suffering for blinding Polyphemus, the
sea god Poseidon's son. Having known Turner in his
declining years, Ruskin read Turner's melancholy future
in this 'central' work of 1829. It is tempting to see
Ruskin's also.

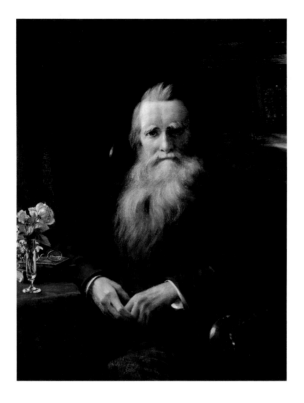

fig.22 Ruskin's grave, Coniston churchyard

260

William Gershom
Collingwood
(1854–1932)

*Portrait of
John Ruskin*
1897

Oil on canvas
90.5 x 70.5

Inscribed 'W.G.
Collingwood/Brantwood
Feby 19 1897'

Ruskin Foundation
(Ruskin Library,
University of Lancaster)

'An undoubted genius, quite unique in his powers and in his views'
(W.G. Collingwood, *The Art Teaching of John Ruskin,* p.vi)

This is the second of two very similar portraits of Ruskin at the age of 78, painted by Collingwood at Brantwood. Ruskin is in his study, seated in his favourite armchair beside the table nearest the fireside that he used in the winter months. The roses are possibly an allusion to Rose La Touche.

Collingwood was one of Ruskin's most devoted admirers. The son of a painter, he was introduced to Ruskin by Alfred William Hunt when he went up to Oxford in 1872 (see cat.194). He attended the Ruskin School of Drawing, and took part in Ruskin's road building and drainage scheme at Ferry Hincksey in 1874–5. He visited Brantwood and in 1875, in partnership with Alexander Wedderburn (1854–1931), one of the future editors of the 39-volume Library Edition of Ruskin's complete works, undertook a translation of

Xenophon's *Economist,* volume 1 of Ruskin's 'Peasant's Library' (1876). This was the first of a series of editorial and literary undertakings, including *The Art Teaching of John Ruskin* (1891) and the first official biography, *The Life of John Ruskin* (1893).

Collingwood studied at the Slade after graduating from Oxford and worked as both painter and writer. In 1883 he settled near Brantwood, travelled with Ruskin, acted as a secretary, and kept a watchful eye over him in his final years. He disapproved of Joan and Arthur Severn's well-meant but self-serving treatment of Ruskin and his legacy. In 1928 he gave important help to Helen Gill Viljoen (1900–74,) an American who visited Brantwood in order to research a projected life of Ruskin. She made important discoveries there, and with Viljoen's work modern Ruskin studies begin. Collingwood designed the elaborate Celtic memorial headstone for Ruskin's grave in Coniston churchyard, erected in 1901 (fig.22).

Chronology

1819

8 February: born at 54 Hunter Street, near Brunswick Square

1822

First visit to Lake District

1823

Family moves to 28 Herne Hill, near Camberwell

1824

In his autobiographical notes, *Praeterita*, dates first recollection to his visit to Friar's Crag, Derwent water this year

1825

First continental journey: Paris and the field of Waterloo

1830

February: publishes first poem, 'On Skiddaw and Derwent Water', in *Spiritual Times*

1831

Spring: begins drawing lessons with Charles Runciman (cat.16); starts attending Thomas Dale's school at Grove Lane in Camberwell

1832

8 February: receives Rogers's *Italy* for his thirteenth birthday (cat.17)

1833

May: visits the Royal Academy exhibition for the first time.
Continental tour of Germany, Switzerland and North Italy: first sight of the Alps (cat.19).
Meets Adèle Domecq in Paris

1834

8 February: receives Saussure's *Voyages dans les Alpes* for his birthday (cat.23).
September: publishes first geological essay on 'the Causes of the Colour of the Water of the Rhine' in J.C. Loudon's *Magazine of Natural History* (cat.23)

1835

June–December: continental tour of France, Switzerland and Italy: first stay in Venice (cat.24)

1836

Drawing lessons from Copley Fielding (cats.21, 22).
October: sends anonymous letter of support to Turner, but discouraged from seeking publication (cat.2)

1837

January: begins studies at Christ Church, Oxford, accompanied by his mother (cat.29).
Begins writing the *Poetry of Architecture*, to be published serially in the *Architectural Magazine* (cat.25): viewed in retrospect as the beginning of his real life's work.
Courtship of Adèle continues.

1839

January: family acquires its first Turner watercolour (*Richmond Hill and Bridge, Surrey*, British Museum).

June: wins Newdigate Prize for Poetry at the third attempt with 'Salsette and Elephanta'; recites the poem at the prize-giving ceremony, also attended by William Wordsworth. Begins to become acquainted with Windus collection (cat.38)

1840

Becomes a Fellow of the Geological Society.
8 February: officially came of age, in recognition of which his father gave him Turner's *Winchelsea* (British Museum) and stock worth £200 a year.
12 March: upset by news of marriage of Adèle Domecq.
Easter: comes down from Oxford because of illness.
22 June: diary records a dinner also attended by J.M.W. Turner, although this was not necessarily their first encounter (cat.31).
September–June 1841: sets out on convalescent tour to Italy, travelling with his parents (Seine and Loire, the Riviera, Pisa (cat.66), Florence, Siena, Rome, Naples, Terni. Returns via Venice (cat.67), Verona, Milan, Turin, Susa, Lanslebourg, Geneva, Rheims)

1841

Autumn: continues to convalesce at Leamington. Writes *The King of the Golden River* for his future wife Euphemia ('Effie') Chalmers Gray, then aged thirteen.
Starts drawing lessons with James Duffield Harding (cat.37)

1842

Spring: commissions his first watercolours from Turner (*Lucerne from the Walls*, Lady Lever Art Gallery, and *Coblenz with Ehrenbreitstein*, untraced).
Spring: makes first true nature study of ivy at Norwood.
May: completes studies at Oxford: honorary double fourth (BA).
May–August: continental tour: Rouen, Chartres, Fontainebleau, Geneva, returning by the Rhine and Belgium. While abroad he resolves on writing a defence of Turner.
October: the family moves to 163 Denmark Hill

1843

January–April: at work on *Modern Painters* volume I (dealing with 'General Principles' and 'Truth'; published May).
Summer: spends a term at Oxford to qualify for MA

1844

Receives Turner's *Slavers* as New Year's gift (cat.47).
Designs stained-glass windows for St Giles', Camberwell.
May–August: tour of the Alps (cat.128); returns to Paris to make studies in the Louvre.
Autumn: studies Parthenon Marbles

1845

April–November: First journey abroad without his parents, though accompanied by his man-servant John Hobbs (cats.131–3). Revelation of Fra Angelico in Florence and Tintoretto in Venice (cats.134, 135). Visits Faido to see

Turner's viewpoint (cat.55). Meets up with J.D. Harding en route to Venice (cats.70, 71)

1846

April: publishes *Modern Painters* volume II ('Of Ideas of Beauty', focusing on the theoretical and the imaginative).
April–September: takes parents to key places of previous tour (Champagnole, Geneva, Turin, Verona, Venice (cat.73), Bologna (cat.52), Florence, Pisa, Lucca, Vevay etc.).
September: significantly revised edition of *Modern Painters* volume I published

1847

January: writes to *The Times* with criticisms of the cleaning of pictures in the National Gallery, implicitly joining attacks on Sir Charles Eastlake (then Keeper, but from 1855–65 Director, of the National Gallery; and President of the Royal Academy, 1850–65).
May: writes birthday verses for Effie Gray.
August–September: travels to the Lake District and Scotland (cats.136–8); proposes unsuccessfully to Charlotte Lockhart, grand-daughter of Sir Walter Scott

1848

March: writes a negative review of Eastlake's *History of Oil-Painting* in the *Quarterly Review*, which sours their future relationship.
10 April: marries Effie Gray at Bowerswell, near Perth.
July: awkward visit to Salisbury with wife and parents.
August–October: honeymoon tour of Normandy (cats.74, 75, 139).
October: established at 31 Park Street, Grosvenor Square

1849

March: writes a tribute to Samuel Prout in the *Art Journal* (cat.20).
Becomes founder member of the Arundel Society.
April–September: continental tour focusing again on the Alps with his parents (cats.140–2), while Effie returns to her family in Scotland.
May: publishes *The Seven Lamps of Architecture* (cat.106).
October–March 1850: travels with Effie to Venice.
Meets Sir Charles Eastlake. Comes under the influence of Thomas Carlyle. Begins to collect illuminated manuscripts

1851

March: publishes *The Stones of Venice* volume I ('The Foundations'; cat.107), and *Notes on the Construction of Sheepfolds* (cat.189).
May: publishes the first part of *Examples of the Architecture of Venice* (parts 2 and 3 appear in November) (cat.108).
May: letters to *The Times* defending Millais, Hunt and Collins (cats.5–9).
June: first encounters J.E. Millais.
August: links Turner and Millais in his pamphlet *Pre-Raphaelitism*.
August–June 1852: returns to Venice with Effie: attempts to secure Tintorettos for the National Gallery; meets E.W .Cooke (cat.206).
December: Turner dies in Chelsea

1852

July: returns to London, and settles at 30 Herne Hill, near his parents.
August: meets Holman Hunt for the first time (cat.189); discusses differences of Protestant and Catholic dogma with Cardinal Manning; he and Samuel Rogers renounce their duties as Turner's executors

1853

June–October: at Glenfinlas, near Brig O'Turk in Scotland, with Effie and J.E. Millais (other visitors include W. Millais and Dr Henry Acland); works on index for the *Stones of Venice* while Millais paints his portrait (cats.1, 143, 191).
July: publishes *Stones of Venice* volume II ('The Sea Stories').
October: publishes *Stones of Venice* volume III ('The Fall').
November: at Edinburgh delivers *Lectures on Architecture and Painting* (published April 1854) (cat.86).
Publishes first part of *Giotto and his Works in Padua*, to complement the Arundel Society's production of woodcuts of the frescoes in the Arena Chapel (continued in 1854, 1860)

1854

8 February: buys his 'greatest treasure', the 'St Louis' Psalter (Fitzwilliam Museum).
April: problems in the marriage become irreconcilable and Effie leaves him.
April: meets Dante Gabriel Rossetti for the first time (cat.117).
May: letters about Holman Hunt's Royal Academy exhibits published in *The Times* (cats.192, 193).
May–October: foreign tour with his parents in France and Switzerland (cat.146).
15 July: marriage annulled on the grounds of non-consummation.
22 July: publishes a pamphlet considering the relocated Great Exhibition building, or Crystal Palace, in relation to the prospects of art.
October: Founding of the Working Men's College, where Ruskin gives lessons each week until 1861.
November: lectures at Architectural Museum on Decorative Colour; Millais completes his portrait (cat.1).
December: designs for the Oxford Museum of Natural History approved (cat.89)

1855

March: starts to act as patron of Elizabeth Siddal (cats.115, 116).
Becomes acquainted with Tennyson and Leighton (cat.218).
June: first volume of *Academy Notes* published (continued annually until 1859).
3 July: Effie and Millais marry.
13 July: meets Ford Madox Brown for the first time, a hostile encounter (cat.212)

1856

January: publishes *Modern Painters* volume III ('Of Many Things').
April: publishes *Modern Painters* volume IV ('Of Mountain Beauty').
18 April: address to Workmen at Oxford Museum.
May: claims in *Academy Notes* that the

Pre-Raphaelite style had become fully established in the Royal Academy exhibition; publishes *Harbours of England* (cat.60).
May–October: travels to Switzerland; meets Charles Eliot Norton (an American admirer and lifelong friend). Returns to London with the intention of becoming involved in the display of the Turner Bequest (cat.62).
November: Meets Rosa Bonheur

1857
January: publishes unofficial guide to the Turner oil paintings on display at Marlborough House (cat.259).
April: addresses St Martin's School of Art on the 'Value of Drawing'; gives evidence to the National Gallery committee about the display of the Turner Bequest.
May: *Academy Notes* includes damning comments on Millais's paintings (cat.200).
May: acts as Treasurer on committee formed to support the family of Thomas Seddon (cat.195).
June: publishes his drawing manual, *The Elements of Drawing* (cats.61, 210).
July: Visits the great 'Art Treasures' exhibition at Manchester and lectures there on 'The Political Economy of Art' (published in December).
July–October: tour of Scotland with his parents (cat.148).
November: begins applying his principles for the conservation and display of the Turner Bequest.

1858
January: asked to recommend means of education for Rose La Touche, then aged ten, and her elder sister, Emily (cat.230).
May: completes work preparing a selection of the Turner Bequest for public display at Marlborough House.
May–September: travelling in Switzerland and Northern Italy (cats.149, 151); meets Inchbold (cat.211); and Brett (cat.207).
July: 'unconverted' at Turin.
October: inaugural address to Cambridge School of Art.
December; destroys some of Turner's erotic sketches (cat.62)

1859
March: begins his association with Winnington Hall School (cat.124).
May: publishes *The Two Paths* (essays collected from lectures on art and design given earlier that year in Manchester and Bradford).
May–October: foreign tour focuses on German art galleries, as well as Switzerland (visits Dusseldorf, Brunswick, Berlin, Konigstein, Nuremberg, Munich; cats.152, 153).
November: publishes the *Elements of Perspective*

1860
March: publishes a paper on 'Sir Joshua and Holbein' in the *Cornhill Magazine.*
June: publishes *Modern Painters* volume v ('Of Leaf Beauty', 'Of Cloud Beauty', 'Of Ideas of Relation' and 'Of Invention: Formal and Spiritual').
August: publishes the first instalment of *Unto This Last,* his criticism of the values of contemporary political economy, in the *Cornhill Magazine* (published in collected form in June 1862).
May–August: travels alone to Chamonix and Switzerland

1861
March: gives a total of 40 watercolours attributed to Turner from his own collection to the University Galleries at Oxford.
May: gives 25 drawings by Turner to the Fitzwilliam at Cambridge.
June: depression compounded by further spiritual crisis and difficulties with parents results in him giving up his lectures at the Working Men's College.
June–August: convalesces at Boulogne.
September–December: journey to Chamonix, where plans a home

1862
May: finances a second Italian tour by Burne-Jones and his wife (the first was in 1859); joins them in Milan before sending them on to Venice (cat.123).
June: begins to contribute *Essays on Political Economy* to *Fraser's Magazine* (later collected as *Munera Pulveris*, 1872).
August: settles at Mornex (cat.159).
Autumn: forbidden from seeing Rose La Touche.
November: gives address at Working Men's College

1863
January–March: at Mornex.
March: publication of *Essays on Political Economy* suspended.
April: considers settling in Venice.
Early autumn: tour of northern England includes Winnington (with Burne-Jones) and Wallington.
September–November: travelling in the Alps and Switzerland again (cat.161); buys land at Chamonix.

1864
3 March: death of his father, John James Ruskin: leaves a fortune of £120,000, for Ruskin, plus leases and property valued at £10,000; while his widow inherited the house at Denmark Hill and £37,000; his cousin, Joan Agnew (later Mrs Severn) comes to live with his mother at Denmark Hill.
April: attends seances with D.D. Home.
December: lectures in Manchester

1865
January: lectures in Cambridge on Work; begins publishing *The Cestus of Aglaia* in parts in the *Art Journal* (continuing until April 1866).
May: delivers a lecture to the RIBA on 'The Study of Architecture in our Schools'.
June: publishes *Sesame and Lilies*, a demand for social reform, first delivered as lectures in Manchester the previous December.
December: publishes *The Ethics of the Dust: Ten Lectures to Little Housewives on the Elements of Crystallisation*

1866
February: proposes to Rose La Touche; outcome indecisive.
April–July: travels in France and Switzerland; death of Pauline, Lady Trevelyan at Neuchâtel (cats.163, 164, 248).
May: publishes *The Crown of Wild Olive. Three Lectures on Work, Traffic, and War* (first given as lectures in 1865; a fourth essay on 'The Future of England' was added to later editions)

1867
24 May: delivers a lecture on 'The Relation of National Ethics to National Arts' at the Senate House, Cambridge.
7 June: addresses the British Institution 'On the Present State of Modern Art, with reference to the Advisable Arrangements of a National Gallery'.
June–August: tours the Lake District.
December: publishes *Time and Tide by Weare and Tyne. Twenty-Five Letters to a Working Man of Sunderland on the Laws of Work*

1868
May: travels to Ireland to lecture in Dublin.
August–October: travels in Northern France (Abbeville and Paris; cat.165)

1869
January: publishes *The Flamboyant Architecture of the Valley of the Somme.*
April: sale of some of Ruskin's collection at Christie's (cats.21, 26, 47, 207).
April–August: travels in Switzerland and Northern Italy, principally at Verona and Venice, where he 'discovers' Carpaccio (cats.172, 173) and fortuitously encounters Holman Hunt.
June: publishes *The Queen of the Air: Being a Study of the Greek Myths of Cloud and Storm* (partly given as lectures at University College, London earlier in the year).
August: elected first Slade Professor of Fine Arts at Oxford

1870
February: publishes *Verona and its Rivers* (based on lectures at the Royal Institution).
February–March: inaugural lecture series begins at Oxford dealing with the relationship of art to morality and its use; decides to establish Drawing School at Oxford.
April–July: leads a party of friends on a 3-month tour of France, Switzerland and Italy; in Florence he becomes interested in Filippo Lippi.
November–December: lectures at Oxford on sculpture

1871
January: begins the serial publication of *Fors Clavigera: Letters to the Workmen and Labourers of Great Britain* (continued publication, initially monthly, until 1884).
January–February: delivers 'Lectures on Landscape' at Oxford (published 1898).
June: lectures at Oxford on *The Relation between Michael Angelo and Tintoret* as part of his series on sculpture (published April 1872).
July: ill at Matlock.
September: donates £17,000 to St George's Fund; first visit to Brantwood, the house on Lake Coniston he had bought earlier in the year (April).
5 December: death of Margaret Ruskin, his mother.

Winter: supervision of social projects, such as the street cleaning experiment at Seven Dials

1872
January–March: delivers *The Eagle's Nest. Ten Lectures on the relation of Natural Science to Art* (published September 1872).
April–July: travels in Italy over much the same route as in 1870: Tuscany and the Veneto, but also to Rome, where Ruskin studies Botticelli and Perugino in the Sistine Chapel (cat.174). Begins to take over publication of his own works, establishing his assistant George Allen as publisher.
September: moves to Brantwood.
November–December: delivers lectures on wood and metal engraving at Oxford (published in parts, continuing until 1876, as *Ariadne Florentina*)

1873
March–May: lectures at Oxford on English and Greek birds, published as *Love's Meinie* (1873–1881).
October–November: delivers lectures series entitled *Val d'Arno* (published November 1874)

1874
March: supervises students building the road at Hincksey, near Oxford.
March–October: travels in Italy (Genoa, Pisa, Assisi, Rome, Sicily, Perugia, Florence, Lucca; cat.175).
November–December: lectures at Oxford on *The Aesthetic and Mathematical Schools of Art in Florence* (published 1906).
December: opens tea-shop in Paddington

1875
January: tour of Derbyshire and Yorkshire.
April: publishes first of ten parts of *Proserpina, Studies of Wayside Flowers, while the Air was yet pure among the Alps, and in the Scotland and England which my father knew* (continuing until 1886).
May: publishes first of six parts of *Mornings in Florence* (continuing until July 1877).
25 May: Rose La Touche dies insane (cat.241).
31 May: formal gift of Ruskin Art Collection and funds for Ruskin Drawing Mastership to Oxford University.
July: founds St George's Museum at Walkley, near Sheffield.
May: resumes *Academy Notes* for this year.
October: publishes first of eight parts of *Deucalion. Collected Studies of the Lapse of Waves, and Life of Stones* (continuing until May 1883).
December: has spiritualistic experiences at Broadlands

1876
April: gives address at Walkley Museum, Sheffield.
August–June 1877: travels in Switzerland and Italy (wintering in Venice) (cats.77, 176).
Christmas: onset of mental instability

1877
March: publishes *Guide to the Principal Pictures in the Academy of Fine Arts at Venice, Arranged for English Travellers.*
April: publishes first of six parts of *St Mark's Rest: The History of Venice. Written for the help of*

the few travellers who still care for her monuments (complete edition published in 1884).
9 June: acquires 5 more Turner drawings, but is disappointed with them on his return to London (17 June); this circumstance should be connected to the events of the following day.
18 June: writes his attack on Whistler's pictures in the first exhibition at the Grosvenor Gallery for *Fors Clavigera*, no.79 (cat.224).
September: begins publishing *The Laws of Fésole* (completed 1879)

1878
February–April: first attack of mental illness.
March: exhibits his watercolours by Turner at Fine Art Society, Bond Street, for which he had begun to write a catalogue before his breakdown.
May: presented with Turner's *Splügen* by admirers (cat.112).
July: secures the loan of 250 watercolours by Turner for the museum at Oxford (they remain displayed there until 1916).
August–September: travels to Yorkshire and Scotland.
November: Whistler seeks damages in the High Court of Justice for libel resulting from Ruskin's comments in *Fors Clavigera*. Ruskin unable to attend. Burne-Jones, Frith and Tom Taylor are witnesses for Ruskin, while W.M. Rossetti, William Gorman Wills and Albert Moore (cat.217) take Whistler's part. Whistler wins his case, and is rewarded the nominal sum of a farthing

1879
January: resigns from Slade Professorship.
July: addresses Arundel Society.
October: receives Prince Leopold at St George's Museum, Sheffield.
November: organises an exhibition of the works of W.H. Hunt and S. Prout (cats.20, 35)

1880
March: lecture on snakes at the London institution (cat.235).
June: begins publishing *Fiction, Fair and Foul* (to 1881).
August–September: tour in Northern France with Arthur Severn and Hercules Brabazon Brabazon (cat.178).
October: publishes *Elements of English Prosody*.
December: begins publication of *The Bible of Amiens* (to 1885)

1881
February: second attack of madness.
December: publication of re-ordered *Catalogue of the Drawings and Sketches by J.M.W. Turner, R.A. at present exhibited in the National Gallery*

1882
March: further mental instability until April.
July: sale of 11 of his watercolours by Turner.
August–December: tour through France and Italy with W.G. Collingwood; meets the artist Francesca Alexander.
December: meets Kate Greenaway (cat.227)

1883
January: resumes Oxford Professorship.
March: begins to deliver lectures on *The Art of England* (published 1884).

September–October: travels in Scotland.
October: 'brains on the over-boil' again.
November: presides at lecture by William Morris in Oxford

1884
Delivers and publishes the lectures entitled *The Storm – Cloud of the Nineteenth Century* (cats.246–254).
October–November: lectures at Oxford on *The Pleasures of England*

1885
Begins to write his memoirs as *Praeterita* (continuing until 1889).
March: resigns as Slade Professor.
July: mental disturbance resumed at Brantwood

1887
May: serious disputes with Joan and Arthur Severn.
June: attempts to refute rumours of his illness, but overtaken by further bout of insanity.
August: travels to Folkestone, moves to Sandgate.

1888
January–May: based at Sandgate.
June–November: last trip to the continent: Northern France, then on to the Alps – where he writes 'Epilogue' to *Modern Painters* – Switzerland and Italy; proposes unsuccessfully to his follower Kathleen Olander; returns to London after collapsing in Paris

1889
May: last excursion from Brantwood to Seascale, where he writes last fragments of *Praeterita*.
August: severe breakdown until following August ends working life. Remains at Brantwood, where he is looked after by his cousin Joan Severn

1890
Ruskin Museum at Sheffield opens at Meersbrook Hall

1899
8 February: J.H. Whitehouse, Secretary of Ruskin Society of Birmingham, presents Ruskin with national address of congratulation on his 80th birthday

1900
20 January: dies at Brantwood of influenza; buried in Coniston churchyard (25th)

1901
Ruskin Museum opened at the Coniston Institute

1903–12
E.T. Cook and Alexander Wedderburn produce the complete edition of Ruskin's *Works*, the 'Library Edition', published in 39 volumes

1904–6
Marcel Proust publishes his French translations of Ruskin

1904
Mahatma Gandhi translates *Unto This Last* into Gujerati, and founds Phoenix settlement near Durban, South Africa, on Ruskinian principles

1919
J.H. Whitehouse organises centenary celebrations of Ruskin's birth, including exhibition at the Royal Academy.
J.H. Whitehouse builds Ruskin Galleries at Bembridge School, Isle of Wight, to house his growing collection of Ruskin material

1930
Ruskin Literary Trustees begin dispersal of contents of Brantwood, including all manuscripts and drawings, through sales at Sotheby's

1931
Final dispersal sale held at Brantwood

1932
Drawings by Ruskin given to Mussolini on behalf of the Italian people (cat.32);
J.H. Whitehouse buys Brantwood and its estate

1934
Brantwood formally opened to the public as a national memorial to Ruskin

1964
Kenneth Clark publishes his reappraisal *Ruskin Today*

1969
Conference at Brantwood signals revival of Ruskin studies

1985
Museum of the Guild of St George reopens in new premises in Sheffield

1994
Ruskin Foundation established to link J.H. Whitehouse's Education Trust with Lancaster University

1995
Formal agreement by Education Trust to loan Whitehouse Collection to new Ruskin Library at Lancaster University

1996
CD-Rom edition of Ruskin's *Works* produced by Cambridge University Press in association with Ruskin Foundation

1998
Ruskin Library at Lancaster officially opened

1999
Reopening of Ruskin Museum, Coniston, after refurbishment

2000
Service of celebration held at St Andrew's Church, Coniston on 20 January to mark centenary of Ruskin's death

Abbreviations

Abbreviations for Ruskin's writings and other editions

References to Ruskin's published works are taken from *The Works of John Ruskin*, Library Edition, edited by E.T. Cook and Alexander Wedderburn, 39 vols., London and New York, 1903–12, unless otherwise stated. They are indicated by volume and page number in the text, thus: 28.312.

The following editions are also cited by volume and page number, preceded by the relevant abbreviation.

D: *The Diaries of John Ruskin*, ed. by Joan Evans and John Howard Whitehouse, 3 vols., Oxford 1956–9

EV: *Effie in Venice: Unpublished Letters of Mrs John Ruskin written from Venice between 1849–1852*, ed. M. Lutyens, London 1965

LF: *John Ruskin's Letters to Francesca, and Memoirs of the Alexanders*, ed. L.G. Swett, Boston, Mass. 1931

LMT: *The Letters of John Ruskin to Lord and Lady Mount-Temple*, ed. John L. Bradley, Athens, Ohio 1964

LN: *The Correspondence of John Ruskin and Charles Eliot Norton*, ed. John L. Bradley and Ian Ousby, Cambridge 1987

RFL: *The Ruskin Family Letters: the Correspondence of John James Ruskin, His Wife and Their Son, John, 1801–1843*, ed. Van Akin Burd, 2 vols., Ithaca and London 1973

RLPT: *Reflections of a Friendship: John Ruskin's Letters to Pauline Trevelyan, 1848–1866*, ed. Virginia Surtees, London 1979

RLV: *Ruskin's Letters from Venice, 1851–1852*, ed. John L. Bradley, New Haven 1955

SI: *Sublime and Instructive: Letters from John Ruskin to Louisa, Marchioness of Waterford, Anna Blunden and Ellen Heaton*, ed. Virginia Surtees, London 1972

WL: *The Winnington Letters: John Ruskin's Correspondence with Margaret Alexis Bell and the Children of Winnington Hall*, ed. V.A. Burd, Cambridge, Mass. 1969

1845L: *Ruskin in Italy: Letters to His Parents, 1845*, ed. Harold I. Shapiro, Oxford 1972

1858L: *John Ruskin: Letters from the Continent, 1858*, ed. John Hayman, Toronto 1982

1869L: *The Correspondence of John Ruskin and Charles Eliot Norton*, ed. John Lewis Bradley and Ian Ousby, Cambridge 1987

Bibliography

Bibliographical References

Amor 1989: A.C. Amor, *William Holman Hunt: The True Pre-Raphaelite*, London 1989

Barringer 1998: Tim Barringer, *The Pre-Raphaelites: Reading the Image*, London 1998

Barrington 1905: E.I.R. Barrington, *G.F. Watts: Reminiscences*, London 1905

Bennett 1988: Mary Bennett, *Artists of the Pre-Raphaelite Circle: The First Generation. Cataolgue of Works in the Walker Art Gallery, Lady Lever Art Gallery and Sudley Art Gallery, Liverpool*, London 1988

Birch 1990: Dinah Birch, *Ruskin on Turner*, 1990

Blau 1982: E. Blau, *Ruskinian Gothic*, Princeton, NJ 1982

Brooks 1989: M.W. Brooks, *John Ruskin and Victorian Architecture*, London 1989

Burd 1982: Van Akin Burd, *Ruskin, Lady Mount Temple and the Spiritualists: an episode in the Broadlands history*, London 1982

Burne-Jones 1904: G. Burne-Jones, *Memorials of Edward Burne-Jones*, 2 vols., London 1904

Bryant 1997: Julius Bryant, 'Madox Brown's *English Autumn Afternoon* revisited. Pre-Raphaelitism and the Environment', *Apollo*, July 1997, pp.41–3

Butlin & Joll 1984: M. Butlin and E. Joll, *The Paintings of J.M.W. Turner*, rev. edn., 2 vols., London and New Haven 1984

Carlyle 1896: T. Carlyle, *Sartor Resartus*, (Centenary Edition), London 1896

Chapman 1945: R. Chapman, *The Laurel and the Thorn: A Study of G.F. Watts*, London 1945

Collingwood 1891: W.G. Collingwood, *The Art Teaching of John Ruskin*, London 1891

Cook 1911: E. T. Cook, *The Life of John Ruskin*, 2 vols., London 1911

Costantini and Zamier 1986: Paolo Costantini and Italo Zamier, *I Dagherrotipi della Collezione Ruskin*, Venice 1986

Davis 1995: Alan Davis, 'Ruskin, Turner, and *The Pass of Faido*', *Turner Society News*, no.71, December 1995, pp.1–12

Davis 1996: Alan Davis, 'Ruskin, Turner, and the Crescent Moon', *Turner Society News*, no.72, March 1996, pp.10–12

Dearden 1978: J.S. Dearden, 'The Portraits of Rose la Touche', *Burlington Magazine*, vol.cxx, no.899, Feb. 1978, pp.92-6

Dearden 1993: J.S. Dearden, *Ruskin and Victorian Art*, exh. cat., Tokyo, Japan 1993

Dearden 1994: J.S. Dearden, *Ruskin, Bembridge and Brantwood. The Growth of the Whitehouse Collection*, Keele University Press 1994

Dearden 1999: J.S. Dearden, *John Ruskin: A Life in Pictures*, Sheffield 1999

Dorment & Macdonald 1995: R. Dorment and M.F. Macdonald, *James McNeill Whistler*, exh. cat., Tate Gallery, London 1995

Doughty & Wahl 1965–7: *Letters of Dante Gabriel Rossetti*, ed. O. Doughty and J.R. Wahl, 4 vols., London 1965–7

Engen 1981: R. Engen, *Kate Greenaway: A Biography*, London 1981

Ferber and Gerdts 1985: Linda S. Ferber and William H. Gerdts (eds.), *The New Path, Ruskin and the American Pre-Raphaelites*, exh. cat., Brooklyn Museum, NY 1985

Forrester 1996: Gillian Forrester, *Turner's 'Drawing Book', The Liber Studiorum*, exh. cat., Tate Gallery, London 1996

Funnell and Warner 1999: Peter Funnell and Malcolm Warner (eds.), *Millais: Portraits*, exh. cat., National Portrait Gallery, London 1999

Goodwin 1934: Albert Goodwin, *The Diary of Albert Goodwin*, privately published, 1934

Grieve 1969: A. Grieve, 'The Pre-Raphaelite Brotherhood and the Anglican High Church', *Burlington Magazine*, vol.cxi, 1969, pp.294–5

Grieve 2000: A. Grieve, 'Ruskin and Millais at Glenfinlas' in *Ruskin's Artists: Studies in the Victorian Visual Economy*, ed. R. Hewison, Aldershot 2000

Hamilton 1882: W. Hamilton, *The Aesthetic Movement in England*, London 1882

Hayman 1990: J Hayman, *John Ruskin and Switzerland*, Waterloo, Ontario, 1990

Herrmann 1968: L. Herrmann, *Ruskin and Turner*, London 1968

Hewison 1978: R. Hewison, *Ruskin and Venice*, London 1978

Hewison 1984: R. Hewison (ed.), *The Ruskin Art Collection at Oxford: Catalogue of the Rudimentary Series*, London 1984

Hewison 1996: R. Hewison, *Ruskin and Oxford*, exh. cat., Ashmolean Museum, Oxford 1996

Hewison 2000: 'Father and Son: The Ruskin Family Art Collection' in *Ruskin's Artists: Studies in the Victorian Visual Economy*, ed. R. Hewison, Aldershot 2000

Hilton 1985: T. Hilton, *John Ruskin, The Early Years*, New Haven 1985

Hunt 1885: H. Holman Hunt, *A Description of the Picture 'The Triumph of the Innocents'*, London 1885

Hunt 1905: H. Holman Hunt, *Pre-Raphaelitism and the Pre-Raphaelite Brotherhood*, 2 vols., London 1905

Landow 1976–7: G.P. Landow, '"Your Good Influence On Me": The Correspondence of John Ruskin and William Holman Hunt', *Bulletin of the John Rylands University Library of Manchester*, vol.59, nos.1 & 2, Autumn 1976 and Spring 1977

Lewis 1978: M. Lewis, *John Frederick Lewis RA 1805–1876*, London 1978

Links 1968: J.G. Links, *The Ruskins in Normandy*, London 1968

Lister 1981: R. Lister, *George Richmond*, London 1981

Lutyens 1965: Mary Lutyens (ed.), *Effie in Venice: Unpublished Letters of Mrs John Ruskin written from Venice between 1849–1852*, London 1965

Lutyens 1967: Mary Lutyens (ed.), *Millais and the Ruskins*, London 1967

Lutyens 1972: Mary Lutyens (ed.), *The Ruskins and the Grays*, London 1972

Lyles 1988: Anne Lyles, *Turner and Natural History: The Farnley Project*, exh. cat., Tate Gallery, London 1988

Lyles 1992: A. Lyles, *Turner: The Fifth Decade: Watercolours 1830–40*, London 1992

McCoubrey 1998: John McCoubrey, 'Turner's *Slave Ship*: abolition, Ruskin, and reception', *Word & Image*, vol.14, no.4, Oct.–Dec. 1998, pp.319–53

Marsh 1991: Jan Marsh, *Elizabeth Siddal: Pre-Raphaelite Artist 1829–1862*, exh. cat. Ruskin Gallery, Sheffield 1991

Marsh and Gerrish Nunn 1998: Jan Marsh and Pamela Gerrish Nunn, *Pre-Raphaelite Women Artists*, exh. cat., Manchester City Art Galleries 1998

Merrill 1992: L. Merrill, *A Pot of Paint: Aesthetics on Trial in Whistler v. Ruskin*, London and Washington 1992

Minto 1892: *Autobiographical Notes of the Life of William Bell Scott*, ed. W. Minto, 2 vols., London 1892

Mullaly 1966: Terence Mullaly, *Ruskin in Verona*, exh. cat., Museo di Castelvecchio, Verona 1966

Newall 1993: C. Newall, *John William Inchbold: Pre-Raphaelite Artist*, exh. cat., Leeds City Art Gallery 1993

Parris 1984: L .Parris (ed.), *Pre-Raphaelite Papers*, London 1984

Parris 1994: L. Parris (ed.) *The Pre-Raphaelites*, exh. cat., rev. edn., London 1994

Phelps Gordon and Lacy Gully 1993: Susan Phelps Gordon and Anthony Lacy Gully (eds.) *John Ruskin and the Victorian Eye*, exh. cat., Phoenix Art Museum 1993

Roberts and Wildman 1997: Leonard Roberts and Stephen Wildman, *Arthur Hughes : His Life and Works*, Woodbridge, Suffolk 1997

Robertson 1978: David Robertson, *Sir Charles Eastlake and the Victorian Art World*, Princeton University Press, Princeton 1978

Rossetti 1895: W.M. Rossettti, *Dante Gabriel Rossetti: His Family Letters*, 2 vols., London 1895

Secor 1982: R. Secor, 'John Ruskin and Alfred Hunt: New Letters and the Record of a Friendship', *English Literary Studies* vol.25, British Columbia 1982

Shrimpton 1999: N. Shrimpton, 'Ruskin and the Aesthetes', in D. Birch (ed.), *Ruskin and the Dawn of the Modern*, Oxford 1999

Staley 1973: Allen Staley, *The Pre-Raphaelite Landscape*, Oxford 1973

Sumner 1989: Ann Sumner, *Ruskin and the English Watercolour: From Turner to the Pre-Raphaelites*, exh. cat., Whitworth Art Gallery, Manchester 1989

Surtees 1971: V. Surtees, *The Paintings and Drawings of Dante Gabriel Rossetti (1828–1882): A Catalogue Raisonné*, Oxford 1971

Surtees 1979: Virginia Surtees (ed.), *Reflections of a Friendship: John Ruskin's Letters to Pauline Trevelyan 1848–1866*, London 1979

Surtees 1980: *The Diaries of George Price Boyce*, ed. Virginia Surtees, Norwich 1980

Surtees 1981: *The Diary of Ford Madox Brown*, ed. V. Surtees, London and New Haven, 1981

Swett 1931: *John Ruskin's Letters to Francesca, and Memoirs of the Alexanders*, ed. L.G. Swett, Boston, Mass. 1931

Swinburne & Rossetti 1868: A.C. Swinburne and W.M. Rossetti, *Notes on the Royal Academy Exhibition, 1868*, London 1868

Treuherz 1987: Julian Treuherz, *Hard Times: Social Realism in Victorian Art*, exh. cat., Manchester City Art Galleries 1987

Trevelyan 1978: Raleigh Trevelyan, *A Pre-Raphaelite Circle*, London 1978

Unrau 1984: J. Unrau, *Ruskin and St Mark's*, London 1984

Viljoen 1956: Helen Gill Viljoen, *Ruskin's Scottish Heritage: A Prelude*, Illinois 1956

Viljoen 1971: Helen Gill Viljoen, *The Brantwood Diary of John Ruskin*, London and New Haven 1971

Walton 1972: Paul H. Walton, *The Drawings of John Ruskin*, Oxford 1972

Warrell 1995: I. Warrell, *Through Switzerland with Turner: Ruskin's First Selection from the Turner Bequest*, exh. cat., Tate Gallery, London 1995

Warrell 1997: I. Warrell, *Turner on the Loire*, exh. cat., Tate Gallery, London 1997

Watts 1912: M.S.Watts,*George Frederik Watts: The Annals of an Artist's Life*, 3 vols., London 1912

Whittingham 1987: Selby Whittingham, 'The Turner Collector: B.G. Windus', *Turner Studies*, Winter 1987, vol.7, no.2, pp.29–35

Whittingham 1993: Selby Whittingham, 'Windus, Turner and Ruskin: New Documents', *J.M.W. Turner, RA*, no.2, 19 Dec. 1993, pp.69–116

Wildman & Christian 1998: S. Wildman and J. Christian, *Edward Burne-Jones: Victorian Artist-Dreamer*, New York 1998

Wilton & Upstone 1997: A. Wilton and R. Upstone, *The Age of Rossetti, Burne-Jones and Watts: Symbolism in Britain 1860-1910*, exh. cat, Tate Gallery, London 1997

Woolner 1917: A. Woolner, *Thomas Woolner, R.A. His Life in Letters*, London 1917

Lenders

Abbot Hall Art Gallery, Kendal 138, 145, 150, 159, 160, 247

City of Aberdeen Art Gallery and Museum Collections 201

Agnew's, London 29

Museum zu Allerheiligen, Schaffhausen, Switzerland 41

Ashmolean Museum, Oxford 8, 9, 16, 39, 61, 67, 69, 70, 73, 76, 88, 123, 124, 127, 131, 140, 143, 154, 156, 157, 164, 167, 168, 169, 170, 171, 232, 235, 237, 241, 250

Birmingham Museums and Art Gallery 21, 36, 45, 46, 90, 129, 137, 142, 158, 203, 204

Museum of Fine Arts, Boston 47, 119

Royal Pavilion, Libraries and Museums, Brighton and Hove 208

Bristol City Museum and Art Gallery 27

British Museum, London 28, 38, 146, 147

Courtauld Gallery, Courtauld Institute, London 64, 66

Delaware Art Museum, Wilmington 191

National Galleries of Scotland, Edinburgh 125

Fitzwilliam Museum, Cambridge 115, 141, 148

Gabinetto Comunale delle Stampe, Rome 32

Harris Museum and Art Gallery, Preston 121, 194

Harvard University Art Museums 42, 49, 55,

Hunterian Art Gallery, University of Glasgow 161

Johannesburg Art Gallery 214

Keble College, Oxford 192

National Gallery, London 126, 259

National Portrait Gallery, London 11

Lord Lloyd-Webber 207

Manchester City Art Galleries 68, 212

National Museums and Galleries on Merseyside 58, 196, 199

Metropolitan Museum of Art, New York 83

Maureen Mitchell 206

National Trust 65

Richard Orders 139

Oxford University Archives 89

Oxford University Museum of Natural History 91

Pierpont Morgan Library, New York 54, 57, 229, 234

Private Collections 1, 26, 30, 40, 80, 85, 107, 111, 112, 116, 122, 149, 163, 200, 209, 210, 213, 218, 244, 249

Rijksmuseum, Amsterdam 205

Royal Watercolour Society, Bankside Gallery, London 37

Ruskin Foundation, Ruskin Library, University of Lancaster 10, 12, 13, 14, 15, 18, 20, 22, 23, 24, 25, 33, 34, 35, 43, 48, 71, 75, 77, 81, 84, 86, 92, 93, 94, 95, 96, 97, 98, 99, 100, 101, 102, 103, 104, 105, 106, 108, 109, 110, 130, 132, 134, 135, 136, 151, 153, 162, 165, 166, 174, 175, 176, 177, 178, 179, 180, 181, 182, 183, 225, 226, 230, 231, 236, 239, 240, 246, 251, 252, 253, 254, 256, 260

Ruskin Gallery, Sheffield 56, 72, 128, 155, 172, 173, 187, 188, 228, 233, 242, 257

Ruskin School of Drawing and Fine Art, Oxford 255

Salisbury and South Wiltshire Museum 59

Brian Sewell 152

South London Gallery 243

Tate Gallery, London 2, 3, 4, 5, 6, 7, 17, 31, 44, 50, 51, 52, 53, 60, 62, 63, 78, 113, 117, 118, 189, 190, 193, 195, 197, 198, 202, 215, 216, 217, 220, 222, 223, 224, 245, 258

Victoria and Albert Museum, London 120, 211, 219

Wadsworth Atheneum, Hartford, Connecticut 221

Wellesley College Library, Wellesley, Massachusetts 238

Whitelands College, London 184, 185, 186, 227

Whitworth Art Gallery, University of Manchester 114

Yale Center for British Art, New Haven, Connecticut 82, 133, 144

Photographic Credits

Abbot Hall Art Gallery, Kendal

City of Aberdeen Art Gallery and Museum Collections

Agnew's

Archivi Alinari, Florence

Museum zu Allerheiligen, Schaffhausen, Switzerland

Ashmolean Museum, Oxford

Bayerische Staatsgemäldesammlungen, Alte Pinakothek Munich

Beineke Rare Book and Manuscript Library

Birmingham Museums and Art Gallery

Alex Black

Bodleian Library, University of Oxford

Museum of Fine Arts, Boston

Royal Pavilion, Libraries and Museums, Brighton and Hove

Bristol City Museum and Art Gallery

British Museum

Christie's

Courtauld Gallery

Delaware Art Museum

Detroit Institute of Arts

Colin Dixon Photography

Fitzwilliam Museum, Cambridge

Gabinetto Comunale delle Stampe, Rome

Harris Museum and Art Gallery, Preston/ Bridgeman Art Library

Harvard University Art Museums

Roy Hewson

Hunterian Art Gallery, University of Glasgow

Illustrated London News Picture Library

Johannesburg Art Gallery

Keble College, Oxford

Manchester City Art Galleries

Metropolitan Museum of Art, New York

Maureen Mitchell

Jeremy Moeran

Réunion des Musées Nationaux, Paris

National Galleries of Scotland Picture Library

National Gallery, London

National Museums and Galleries on Merseyside

National Portrait Gallery, London

National Trust Photographic Library

Christopher Newall

Oxford University Museum of Natural History

Pierpont Morgan Library

Rijksmuseum

Royal Watercolour Society

Ruskin Foundation, Ruskin Library, University of Lancaster

Ruskin Gallery, Collection of the Guild of St George, Sheffield Galleries and Museums Trust

Ruskin School of Drawing and Fine Art

Salisbury and South Wiltshire Museum

Sotheby's Picture Library

South London Gallery

Tate Gallery Photographic Department

V&A Picture Library

Wadsworth Atheneum

Wellesley College Library

Whitelands College Archives

Whitworth Art Gallery, University of Manchester

Yale Center for British Art

Ways of Giving

The Tate Gallery attracts funds from the private sector to support its programme of activities in London, Liverpool and St Ives. Support is raised from the business community, individuals, trusts and foundations, and includes sponsorships, donations, bequests and gifts of works of art. The Tate Gallery is an exempt charity; the Museums & Galleries Act 1992 added the Tate Gallery to the list of exempt charities defined in the 1960 Charities Act.

DONATIONS

There are a variety of ways through which you can make a donation to the Tate Gallery.

Donations

All donations, however small, will be gratefully received and acknowledged by the Tate Gallery.

Covenants

A Deed of Covenant, which must be taken out for a minimum of four years, will enable the Tate Gallery to claim back tax on your charitable donation. For example, a covenant for £100 per annum will allow the Gallery to claim a further £30 at present tax rates.

Gift-Aid

For individuals and companies wishing to make donations of £250 and above, Gift-Aid allows the gallery to claim back tax on your charitable donation. In addition, if you are a higher rate taxpayer you will be able to claim tax relief on the donation. A Gift-Aid form and explanatory leaflet can be sent to you if you require further information.

Bequests

You may wish to remember the Tate Gallery in your will or make a specific donation In Memoriam. A bequest may take the form of either a specific cash sum, a residual proportion of your estate or a specific item of property, such as a work of art. Certain tax advantages can be obtained by making a legacy in favour of the Tate Gallery. Please check with the Tate Gallery when you draw up your will that it is able to accept your bequest.

American Fund for the Tate Gallery

The American Fund was formed in 1986 to facilitate gifts of works of art, donations and bequests to the Tate Gallery from the United States residents. It receives full tax-exempt status from the IRS.

INDIVIDUAL MEMBERSHIP PROGRAMMES
Friends

Friends share in the life of the Gallery and contribute towards the purchase of important works of art for the Tate. Privileges include free unlimited entry to exhibitions; tate: the art magazine; private views and special events; 'Late at the Tate' evening openings; exclusive Friends Room. Annual rates start from £24. Tate Friends Liverpool and Tate Friends St Ives offer local events programmes and full membership of the Friends in London. The Friends of the Tate Gallery are supported by Tate & Lyle PLC.

Further details on the Friends in London, Liverpool and St Ives may be obtained from: Membership Office, Tate Gallery, Millbank, London SW1P 4RG. Tel: 0171-887 8752

Patrons

Patrons of British Art support British painting and sculpture from the Elizabethan period through to the early twentieth century in the Tate Gallery's collection. They encourage knowledge and awareness of British art by providing an opportunity to study Britain's cultural heritage.

Patrons of New Art support contemporary art in the Tate Gallery's collection. They promote a lively and informed interest in contemporary art and are associated with the Turner Prize, one of the most prestigious awards for the visual arts.

Privileges for both groups include invitations to Tate Gallery receptions, an opportunity to sit on the Patrons' executive and acquisitions committees, special events including visits to private and corporate collections and complimentary catalogues of Tate Gallery exhibitions.

Annual membership of the Patrons is £650, and funds the purchase of works of art for the Tate Gallery's collection.

Further details on the Patrons may be obtained from: Patrons Office, Tate Gallery, Millbank, London SW1P 4RG. Tel: 0171-887 8754

CORPORATE MEMBERSHIP PROGRAMMES

Membership of the Tate Gallery's two Corporate Membership programmes (the Founding Corporate Partner Programme and the Corporate Membership Programme) offers companies outstanding value for money and provides opportunities for every employee to enjoy a closer knowledge of the Gallery, its collection and exhibitions. Membership benefits are specifically geared to business needs and include private views for company employees, free admission to exhibitions, out-of-hours Gallery visits, behind-the-scenes tours, exclusive use of the Gallery for corporate entertainment, invitations to VIP events, copies of Gallery literature and acknowledgment in Gallery publications.

Tate Gallery London:
Founding Corporate Partners

AMP
CGU plc
Clifford Chance
Energis
Freshfields
Goldman Sachs
Lazard Brothers & Co Limited
London Electricity plc
Paribas
Pearson plc
Prudential plc
Railtrack PLC
Reuters Limited
Rolls-Royce plc
Schroders
Warburg Dillon Read

Tate Gallery London:
Corporate Members

Partners
BP Amoco
Freshfields
Merrill Lynch Mercury
Prudential plc
Associates
Alliance & Leicester plc
Channel Four Television
Credit Suisse First Boston
Drivers Jonas
The EMI Group
Global Asset Management
Goldman Sachs
HUGO BOSS
Lazard Brothers & Co Limited
Linklaters & Alliance
Manpower PLC
Morgan Stanley Dean Witter
Nomura International plc
Nycomed Amersham plc
Robert Fleming & Co. Limited
Schroders
Simmons & Simmons
UBS AG

Tate Gallery Liverpool:
Corporate Members

Hitchcock Wright and Partners
Littlewoods
Liverpool John Moores University
Manchester Airport PLC
Pilkington plc
Poval Flood & Wilson
Tilney Investment Management
United Utilities plc

CORPORATE SPONSORSHIP

The Tate Gallery works closely with sponsors to ensure that their business interests are well served, and has a reputation for developing imaginative fund-raising initiatives. Sponsorships can range from a few thousand pounds to considerable investment in long-term programmes; small businesses as well as multi-national corporations have benefited from the high profile and prestige of Tate Gallery sponsorship.

Opportunities available at Tate Gallery London, Liverpool and St Ives include exhibitions (some also tour the UK), education, conservation and research programmes, audience development, visitor access to the Collection and special events. Sponsorship benefits include national and regional publicity, targeted marketing to niche audiences, exclusive corporate entertainment, employee benefits and acknowledgment in Tate Gallery publications.

Tate Gallery London:
Principal Corporate Sponsors
(alphabetical order)
BP Amoco
 1990–2000, *New Displays*
 1998–2000, Campaign for the Creation of the Tate Gallery of British Art
Channel Four Television
 1991–9, *The Turner Prize*
Ernst & Young
 1996, *Cézanne**
 1998, *Bonnard*
Magnox Electric plc
 1995–8, The Magnox Electric Turner Scholarships
 1997, *Turner's Watercolour Explorations*
 1998, *Turner and the Scientists*
Prudential plc
 1996, *Grand Tour*
 1997, *The Age of Rossetti, Burne-Jones and Watts: Symbolism in Britain 1860–1910*
 1999, *The Art of Bloomsbury*
Sun Life and Provincial Holdings plc
 2000, *Ruskin, Turner and the Pre-Raphaelites*
Tate & Lyle PLC
 1991–2000, Friends Marketing Programme
 1997, *Henry Tate's Gift*
Unilever
 2000–2004, The Unilever Series
Volkswagen
 1991–6, The Volkswagen Turner Scholarships

Tate Gallery London:
Corporate Sponsors
(alphabetical order)
Akeler Developments Ltd
 1997–8, Art Now Programme
American Airlines*
 1999, *Jackson Pollock* (in kind)
 1999, *Chris Burden, 'When Robots Rule': The Two Minute Airplane Factory*
Aon Risk Services Ltd in association with ITT London & Edinburgh
 1998, *In Celebration: The Art of the Country House*
L'Association Française d'Action Artistique
 1999, *Abracadabra*
AT&T
 1997, *Piet Mondrian*
CDT Design Ltd
 1995–6, *Art Now*
Classic FM
 1995–6, Regional tour of David Hockney's *Mr and Mrs Clark and Percy* (in kind)
Coutts Group
 1998, *Per Kirkeby*
Coutts Contemporary Art Foundation
 1997, *Luciano Fabro*
Danish Contemporary Art Foundation
 1998, *Per Kirkeby*
The German Government
 1997, *Lovis Corinth*
Glaxo Wellcome plc

283

1997, *Turner on the Loire*
1999, *Turner on the Seine*
Guardian
1999, *Jackson Pollock* (in kind)
Häagen-Dazs Fresh Cream Ice Cream
1995–6, *Art Now*
Hiscox plc
1995–9, Friends Room
HUGO BOSS
1997, *Ellsworth Kelly*
Lombard Odier & Cie
1998, *Turner in the Alps*
Morgan Stanley Dean Witter
1998, *John Singer Sargent*
1998, *Constructing Identities*
1999, *Visual Paths: Teaching Literacy
in the Gallery*
Pro Helvetia
1997, *Art Now – Beat Streuli*
Romulus Construction Limited
1996, *Bill Woodrow: Fools' Gold*
Spink-Leger Pictures
1997, *Francis Towne*
Carillon plc*
1995–9, Paintings Conservation
The Times
1999, Abracadabra
The EMI Group
1997, *Centre Stage* education project

Tate Modern:
Corporate Sponsors
(alphabetical order)
Ernst & Young
1997–2000, Tate Gallery of Modern Art
Visitor Centre

Tate Gallery Liverpool:
Corporate Sponsors
(alphabetical order)
Marconi Communications
1999–2000, Heaven
1999–2000, Peter Blake
Girobank plc
1998, *Great Art Adventure*
(education programme)
The Littlewoods Organisation PLC
1998, *EYOPENERS* (education programme)
Manchester Airport and Tilney Investment
Management
1998, *Salvador Dali*
MOMART plc
1991–9, The Momart Fellowship

Tate Gallery St Ives:
Corporate Sponsors
(alphabetical order)
Marks & Spencer
1998–9, Education Events and Workshops
Northcliffe Newspapers in Education*
1995–7, Education Programme

* denotes a sponsorship in the arts recognised
by an award under the Government's 'Pairing
Scheme' administered by Arts & Business.

**TATE GALLERY FOUNDING
BENEFACTORS**
(date order)
Sir Henry Tate
Sir Joseph Duveen
Lord Duveen

The Clore Foundation
Heritage Lottery Fund

**TATE GALLERY PRINCIPAL
BENEFACTORS**
(alphabetical order)
American Fund for the Tate Gallery
The Annenberg Foundation
Calouste Gulbenkian Foundation
Friends of the Tate Gallery
The Henry Moore Foundation
The Kreitman Foundation
Sir Edwin and Lady Manton
National Art Collections Fund
National Heritage Memorial Fund
The Nomura Securities Co., Ltd
Patrons of New Art
Dr Mortimer and Theresa Sackler
Foundation
St Ives Tate Action Group
The Wolfson Foundation and Family
Charitable Trust

TATE GALLERY BENEFACTORS
(alphabetical order)
The Baring Foundation
Bernard Sunley Charitable Foundation
Gilbert and Janet de Botton
Mr and Mrs James Brice
M. Christina Chandris
Mr Edwin C. Cohen
The Eleanor Rathbone Charitable Trust
Esmée Fairbairn Charitable Trust
Foundation for Sport and the Arts
GABO TRUST for Sculpture Conservation
GEC Plessey Telecommunications
The Getty Grant Program
Granada Group plc
Horace W. Goldsmith Foundation
John Hughes
The John S. Cohen Foundation
The John Ellerman Foundation
John Lewis Partnership
John Lyon's Charity
The Leverhulme Trust
The Henry Luce Foundation
Museums and Galleries Improvement Fund
Ocean Group plc (P.H. Holt Trust)
Patrons of British Art
The Paul Hamlyn Foundation
The Paul Mellon Centre
Peter Moores Foundation
The Pilgrim Trust
Mr John Ritblat
The Sainsbury Family Charitable Trusts
Samsung Foundation of Culture
Save and Prosper Educational Trust
The Stanley Foundation Limited
SRU Limited
Weinberg Foundation

TATE GALLERY DONORS
(alphabetical order)
London
Professor Abbott
Howard and Roberta Ahmanson
The Andy Warhol Foundation for
the Visual Arts, Inc
The Fagus Anstruther Memorial Trust
Mr and Mrs Halvor Astrup

Lord Attenborough CBE
The Austin and Hope Pilkington
Charitable Trust
BAA plc
Friends of Nancy Balfour OBE
Balmuir Holdings
The Hon. Robin Baring
B.A.T. Industries plc
Nancy Bateman Charitable Trust
Mr Tom Bendhem
Mr Alexander Bernstein
Anne Best
David and Janice Blackburn
Blackwall Green Limited
Michael and Marcia Blakenham
George and Mary Bloch
Miss Mary Boone
Frances and John Bowes
The Britwell Trust
Mr and Mrs Donald L. Bryant, Jr
Melva Bucksbaum Goldman
Mr and Mrs Neville Burston
Card Aid
Carlsberg Brewery
Mrs Beryl Carpenter
Mr Vincent Carrozza
Cazenove & Co
Charlotte Bonham Carter Charitable Trust
Christie, Manson & Woods Ltd
The Claire Hunter Charitable Trust
The Clothworkers Foundation
Cognac Courvoisier
Mrs Elisabeth Collins
Mr Christopher Cone
Ricki and Robert Conway
Giles and Sonia Coode-Adams
Mrs Dagny Corcoran
Mr Edwin Cox
Paula Cussi
Gordon and Marilyn Darling
Anthony d'Offay Gallery
Mr and Mrs Kenneth Dayton
Mr Damon and The Hon. Mrs de Laszlo
Baron and Baroness Elie de Rothschild
Madame Gustava de Rothschild
The Leopold de Rothschild Charitable Trust
Baroness Liliane de Rothschild
Deutsche Bank AG
Sir Harry and Lady Djanogly
Miss W.A. Donner
Mr Paul Dupee
Mrs Maurice Dwek
Elephant Trust
Eli Broad Family Foundation
Elizabeth Arden Ltd
Mr and Mrs Georges A. Embiricos
The Essick Foundation
European Arts Festival
Evelyn, Lady Downshire's Trust Fund
Roberto Fainello Art Advisers Ltd
First Boston Corporation
Mr and Mrs Donald G. Fisher
The Flow Foundation
Foreign & Colonial Management Limited
Miss Kate Ganz
Mr Henry Geldzahler
Ms Laure Genillard
Mr and Mrs David Gilmour
The German Government
Goethe Institut
Jack Goldhill
Sir Nicholas and Lady Goodison
Charitable Settlement

David and Maggi Gordon
Mr William Govett
Mr and Mrs Richard Grogan
Gytha Trust
Mr and Mrs Rupert Hambro
Mimi and Peter Haas
Mrs Sue Hammerson
Harry Kweller Charitable Trust
The Hon. Lady Hastings
The Hedley Foundation
Hereford Salon
Mr and Mrs Michael Heseltine
Mr Rupert Heseltine
Mr Robert Hornton
Mr and Mrs Michael Hue-Williams
Hurry Armour Trust
Idlewild Trust
The Italian Government
Lord and Lady Jacobs
Mrs Gabrielle Keiller
James and Clare Kirkman Trust
Knapping Fund
Mr and Mrs Richard Knight
Dr Patrick Koerfer
Mr and Mrs Richard Kramlich
Mr and Mrs Jan Krugier
The Kirby Laing Foundation
The Lauder Foundation–Leonard and
Evelyn Lauder Fund
The Leche Trust
Robert Lehman Foundation, Inc
The Helena and Kenneth Levy Bequest
Mr and Mrs Gilbert Lloyd
Mr and Mrs George Loudon
Mr and Mrs Lawrence Lowenthal
Mail on Sunday
Mr Alexander Marchessini
Marsh (Charities Fund) Ltd
The Mayor Gallery
Penny McCall Foundation
Midland Bank Artscard
Mr and Mrs Robert Mnuchin
Mr and Mrs Peter Nahum
Mr and Mrs Philip Niarchos
Fondation Nestlé pour l'Art
Dr Andreas Papadakis
The Paradina Trust
Mr William Pegrum
Phillips Fine Art Auctioneers
The Earl of Plymouth
Old Possum's Practical Trust
The Hon. Mrs Olga Polizzi
Paul Nash Trust
Peter Samuel Charitable Trust
Mr Jean Pigozzi
Ptarmigan Trust
The Radcliffe Trust
Sir Gordon Reece
Reed International P.L.C.
Richard Green Fine Paintings
Mrs Jill Ritblat
Rothschild Bank AG
Kathy and Keith Sachs
Mrs Jean Sainsbury
The Hon. Simon Sainsbury
Salander-O'Reilly Galleries LLC
Fondazione Sandretto Re Rebaudengo
per l'Arte
The Scouloudi Foundation
Sebastian de Ferranti Trust
Schroder Charity Trust
Mr and Mrs D M Shalit
Ms Dasha Shenkman

South Square Trust
Mr A. Speelman
Standard Chartered Bank
The Swan Trust
Sir Adrian and Lady Judith Swire
Mr and Mrs Louis A. Tanner
Mr and Mrs A. Alfred Taubman
Mrs Barbara Thomas
Time-Life International Ltd
The 29th May 1961 Charitable Trust
Lady Juliet Townsend
Laura and Barry Townsley
The Triangle Trust
U.K. Charity Lotteries Ltd
Visiting Arts
Mr and Mrs Leslie Waddington
Waley-Cohen Charitable Trust
Mr Mark Weiss
Mr and Mrs Gérard Wertheimer
Weltkunst Foundation
Mrs Alexandra Williams
Graham and Nina Williams
Willis Faber plc
Mr Andrew Wilton
Thomas and Odette Worrell
The Worshipful Company of Goldsmiths
Mrs Jayne Wrightsman
and those donors who wish to remain
anonymous

Friends Benefactors and Life Members 1958–1998

The André Bernheim Charitable Trust
Dr and Mrs David Cohen
Mrs Isobel Dalziel
Mr and Mrs Charles Dickinson
Lady Gosling
Miranda, Countess of Iveagh
Lord and Lady Jacobs
Mr and Mrs A.G.W. Lang
Sir Sydney and Lady Lipworth
The Sir Jack Lyons Charitable Trust
Mr Michael Rose
Lieutenant Commander and Mrs Shilling
Mrs Jack Steinberg
Mr John B. Sunley
Mr and Mrs Terry Willson

Tate Modern

Arthur Andersen (pro-bono)
The Annenberg Foundation
The Arts Council of England
Lord and Lady Attenborough
The Baring Foundation
David and Janice Blackburn
Mr and Mrs Anthony Bloom
Mr and Mrs John Botts
Frances and John Bowes
Mr and Mrs James Brice
Donald L. Bryant Jr Family
Melva Bucksbaum Goldman
The Carpenters' Company
Cazenove & Co
The Clore Foundation
Mr Edwin C. Cohen
Ronald and Sharon Cohen
Giles and Sonia Coode-Adams
Gilbert de Botton
Pauline Denyer-Smith and Paul Smith
Sir Harry and Lady Djanogly
The Drapers' Company
English Heritage
English Partnerships

Ernst & Young
Esmée Fairbairn Charitable Trust
Doris and Donald Fisher
Richard B. and Jeanne Donovan Fisher
The Worshipful Company of Fishmongers
The Foundation for Sport and the Arts
Friends of the Tate Gallery
GJW Government Relations (pro-bono)
The Worshipful Company of Goldsmiths
Noam and Geraldine Gotteman
Pehr and Christina Gyllenhammer
Mimi and Peter Haas
The Worshipful Company of Haberdashers
Hanover Acceptances Limited
The Headley Trust
Mr and Mrs André Hoffmann
The Horace W. Goldsmith Foundation
Lord and Lady Jacobs
The John S. Cohen Foundation
The Juliet Lea Hillman Simonds Foundation
Howard and Linda Karshan
Peter and Maria Kellner
Irene and Hyman Kreitman
The Lauder Foundation–Leonard and Evelyn
 Lauder Fund
Leathersellers' Company Charitable Fund
Edward and Agnes Lee
Lex Services Plc
Mr and Mrs George Loudon
McKinsey & Co (pro-bono)
David and Pauline Mann-Vogelpoel
The Mercers' Company
The Meyer Foundation
The Millennium Commission
The Monument Trust
Mr and Mrs M.D. Moross
Guy and Marion Naggar
Maja Oeri and Hans Bodenmann
The Nyda and Oliver Prenn Foundation
Peter Norton, The Peter Norton Family
 Foundation
The Quercus Trust
The Rayne Foundation
The Dr Mortimer and Theresa Sackler
 Foundation
The Salters' Company
Stephan Schmidheiny
David and Sophie Shalit
Belle Shenkman Estate
Simmons & Simmons (pro-bono)
London Borough of Southwark
Mr and Mrs Nicholas Stanley
The Starr Foundation
Lord and Lady Stevenson
Hugh and Catherine Stevenson
Mr and Mrs Ian Stoutzker
John Studzinski
David and Linda Supino
The Tallow Chandlers' Company
Laura and Barry Townsley
Townsley & Co
The 29th May 1961 Charitable Trust
David and Emma Verey
Dinah Verey
The Vintners' Company
Robert and Felicity Waley-Cohen
The Weston Family
Graham and Nina Williams
The Worshipful Company of Grocers
Poju and Anita Zabludowicz
and those donors who wish to remain
anonymous

Tate Modern:
Collections Benefactor
Janet Wolfson de Botton

Tate Britain

The Annenberg Foundation
The CHK Charities Limited
The Charlotte Bonham Carter Charitable
 Trust
The Clore Foundation
Sir Harry and Lady Djanogly
The D'Oyly Carte Charitable Trust
The Dulverton Trust
Maurice and Janet Dwek
Friends of the Tate Gallery
Sir Paul Getty, KBE
Pehr and Christina Gyllenhammar
Heritage Lottery Fund
Howard and Linda Karshan
Peter and Maria Kellner
Lloyds TSB Foundation for England
and Wales
David and Pauline Mann-Vogelpoel
Sir Edwin and Lady Manton
The P F Charitable Trust
The Polizzi Charitable Trust
Lord and Lady Sainsbury of Preston
Candover
The Rayne Foundation
Mrs Coral Samuel, CBE
David and Sophie Shalit
Mr and Mrs Sven Skarendahl
Pauline Benyer-Smith and Paul Smith
Mr and Mrs Nicholas Stanley
Tate Gallery Centenary Gala
The Trusthouse Charitable Foundation
David and Emma Verey
Dinah Verey
The Duke of Westminster, OBE TD DL
Sam Whitbread
The Wolfson Foundation
and those donors who wish to remain
anonymous

BP Amoco is supporting the creation of Tate
Britain

Tate Britain Library & Archive Campaign
Neville and Marlene Burston
The Rayne Foundation
and those donors who wish to remain
anonymous

Tate Gallery Liverpool
Association for Business Sponsorship
 of the Arts (ABSA)
Arrowcroft Group Plc
Arts Council of England
The Australian Bicentennial Authority
Barclays Bank PLC
The Baring Foundation
BASF
The Bernard Sunley Charitable Foundation
Boddingtons plc
British Alcan Aluminium plc
BG plc
BT
Calouste Gulbenkian Foundation
Coopers & Lybrand
Mr and Mrs Henry Cotton
Cultural Relations Committee
David M Robinson Jewellery
Deloitte & Touche

The Eleanor Rathbone Charitable Trust
The John Ellerman Foundation
English Partnerships
The Esmée Fairbairn Charitable Trust
European Arts Festival
European Regional Development Fund
The Foundation for Sport and the Arts
Friends of the Tate Gallery
Girobank plc
The Granada Foundation
Granada Television Limited
The Henry Moore Foundation
The Henry Moore Sculpture Trust
The Heritage Lottery Fund
Mr John Heyman
Higsons Brewery plc
Ian Short Partnership
IBM United Kingdom Limited
ICI Chemicals & Polymers Limited
The John Lewis Partnership
The John S. Cohen Foundation
The Laura Ashley Foundation
The Littlewoods Organisation PLC
Liverpool John Moores University
Mr & Mrs Jack Lyons
Manchester Airport PLC
Manor Charitable Trust
Marconi Communications
Merseyside Development Corporation
Mobil Oil Company Ltd
MOMART plc
The Moores Family Charitable Foundation
The Museums and Galleries Improvement
 Fund
The Nigel Moores Family Charitable
 Foundation
NSK Bearings Europe Ltd
P & P Micro Distributors Ltd
Parkman Group Ltd
PH Holt Charitable Trust
The Pilgrim Trust
Pilkington plc
Pioneer High Fidelity (GB) Ltd
Rio Tinto plc
Royal & SunAlliance
Royal Liver Assurance
Sainsbury Family Charitable Trusts
Samsung Electronics (UK) Limited
Save & Prosper Educational Trust
Scottish Courage Limited
Stanley Thomas Johnson Foundation
The Summerfield Charitable Trust
Tate Friends Liverpool
Tilney Investment Management
Trinity International Holdings plc
The TSB Foundation for England and Wales
The Trustees of the Tate Gallery Liverpool
Unilever plc
United Biscuits (UK) Limited
United Utilities plc
The University of Liverpool
Vernons Pools Ltd
Visiting Arts
Volkswagen
Whitbread & Company PLC
The Wolfson Foundation
and those donors who wish to remain
anonymous

Index